CITIZEN ONE

Andy Oakes was born in 1952 and is the son of a professional footballer and an academic. After his A-levels he worked as an engineer in the defence industry. His work with young people led him to producing a photographic study of youth in the inner city for the Gulbenkian Foundation and a career as a professional photographer.

He now lives in east Essex and works with young people, specializing in alcohol and substance abuse.

His first novel, *Dragon's Eye*, was the winner of the 2004 European Crime and Mystery Award.

Also by Andy Oakes

Dragon's Eye

ANDY OAKES

CITIZEN ONE

PAN BOOKS

First published 2007 by Dedalus Ltd

This edition published 2008 by Pan Books
an imprint of Pan Macmillan Ltd
Pan Macmillan, 20 New Wharf Road, London N1 9RR
Basingstoke and Oxford
Associated companies throughout the world
www.panmacmillan.com

ISBN 978-0-330-43443-0

1 3 5 7 9 8 6 4 2

A CIP catalogue record for this book is available from
the British Library.

Typeset by SetSystems Ltd, Saffron Walden, Essex
Printed and bound in Great Britain by
Mackay's of Chatham plc, Chatham, Kent

Visit www.panmacmillan.com to read more about all our books
and to buy them. You will also find features, author interviews and
news of any author events, and you can sign up for e-newsletters
so that you're always first to hear about our new releases.

To Annie and Tom . . . *always*

Fsi yp rz kfrnqz ufxy fsi kzyzwj . . . n znxm ymfy n mfi
pstzs ztz.

This book is dedicated to Manchester United Football
Club, its players, past and present . . . and to its manager,
Sir Alex Ferguson, and the memory of the great
Matt Busby.

Thank you for the dream.

This book is written in memory of Molly and Cliff
Wyatt, true and honest people. Alan Fisher, writer,
teacher, cravat wearer, and gentleman. And Gary Jewell,
a friend who I think about every day.
Rest in peace.

Acknowledgements

A book like this cannot be written without the help and support of many people, their expertise and skill.

My special thanks go to Juri Gabriel and Eric Lane, for their patience, insight, hard work, and faith in me. My manuscripts would simply be at the back of a bottom drawer if it were not for them!

Thank you also to Julie Crisp of Pan Macmillan for her insightful comments and editing.

I would also like to thank Sean McMinn for his expert help on the diving scene within the book. Gaurav Kumar for his tutorial on NetBIOS computer hacking. Lee Geering for explaining the tutorial on NetBIOS hacking. And a thank you to Joel Griggs for our very enjoyable lunches together and our challenging conversations about writing. All of my best wishes go to you for success in your own writing projects.

My thanks also go to my colleagues and friends at Willam Parker Sports College, Hastings, for their constant support and enthusiasm, which have really refuelled me at the times when I have needed it the most.

Also to my colleagues in the Youth Development Service, Hastings.

A special mention must go to the *CONNEXIONS* team of Intensive Support Personal Advisers, who do such valuable work, 'beyond the call of duty', with young people and their families. It is a constantly moving pleasure working with you all. Thanks especially go to Sue Fenwick, Sally Thompsett, Bev Gibbs, Sarah Church, Ruth Adams, Steve Carter, Patrick Flynn and Richard Lewis.

A debt of gratitude must also go to all of the young people that I have worked with . . . your strength, resilience and perceptiveness amaze me. I am sure that you have given me more insights than I have ever given you.

Part One

1

A Red Flag limousine pulling up. Four men piling from
it. Four men fashioned from the same blueprint: flat-
foreheaded, dull-eyed, gash-mouthed. And their smell,
of strong fingers and hard hearts. Pulling the girl from
the automobile. Prodding her forward with pistols.
Following behind, as they herd her through thick mud.
Slipping, hands, knees, sinking into ooze. Pulling her
up by her armpits. Pushing, prodding her on. Laughter.
Taunts. But still no words from the girl. The sound only
of her rasped breaths, and a breeze, keen and sighing
through a forest of scaffolding.

Behind wire net fencing, curves of concrete. Skeletal
banks of stairs, leading from mud to nowhere. And rip-
pling in the breeze, ribbons: red, yellow, black and blue,
fly above two mud-spattered banners, each with five
inter-linking rings. One with the legend:

THE PEOPLE'S OLYMPICS 2008

The other:

3

OLYMPICS 2008. The eyes of the world
watching the People's Republic of China

Beyond the fence, darkness; at its centre floodlit constructs, illuminated concrete edifices and bamboo forests of scaffolding. A country of the partial, a continent of the incomplete. The Olympic dream made real in rough textured materials, a vast oval enclosing a static ocean of mud. Half-lit, half-built. As if the moon, in its crescent phase, were imprisoned in that place. Around its edge, dark, shored-up pit holes, the foundations for the enormous banks of incomplete stands that would seat the worshippers at the altar of the struggle between the clean and the doped bloods.

At the far end of the crescent moon, activity, noise. A machine turning out its life. A rhythmic effort of cogs and pneumatics. As they approach, figures around the machine moving away into the night, as if a plague were approaching.

Ankle-deep mud, the shoeless girl dragged to the very centre of the oval. Thrown onto her knees, wild-eyed, as the men separate, receding into shadow. Equal metres of black mud between them. Laughing and joking as they mimic the pose of sprinters waiting for the starter's pistol.

Disembodied, the rasp of a shout.

'On your marks.'

Out of the night, a serrated whisper to the girl.

'Run. Your last chance for life.'

Head craned over her shoulder, the girl starting to run, slip, fall. Running again.

'Get set.'

In imaginary blocks, the men rise. Eyes pinned to the rag-doll fifty metres ahead.

Laughter, whistles, cat calls.

'Go!'

Four shadows chasing through the darkness, gaining on the string-snipped puppet ahead. A cry as she sees them emerge from a floodlit oasis. Skidding towards her. Hearing their breaths, ripped. Closer. Closer. And in their hands, so bright, so sharp ... cut-throat razors. Sobbing, stumbling, just picking herself up as the first is upon her. A blur of darkness and silver. Hearing its slash through the air. Through the material of the back of her blouse. Through her brassiere strap. And instantly, a chilling coldness, followed by a roll of sticky heat. A wave, as warm caramel down her back. Dropping to her knees, but unaware of the biting coldness of the muddy pool that she is kneeling in. Aware only of a fist, silver blade in its clasp; her blood black upon its razor edge. A scream riveted to the roof of her mouth. Sable faces, shot with diamond-beaded sweat and panted exhilaration. Suddenly to his order, silence. Just breaths, excited breaths. And then he is over her. Slowly, as with a lover's touch, a cut-throat razor gently slipping between the edges of her blouse. Buttons in slow fall. The sodden material eased aside. Silver blade to her skirt. Hands clawing at the material, pulling it adrift. Her clothes thrown aside,

falling as kites' tails. And then a pain set within so much other pain. Almost lost within it. The man with the pockmarked face making deep carvings into her abdomen. Each stroke of steel through her skin's weak resistance, matched with a squeeze of his irises. Faintly laboured breaths of papercut lips. So much concentration, in mutilating. A comrade of immense focus, even in killing. With all of her effort, through lacerated lips, one word, falling faint against his cologned cheek.

'Why?'

He laughs, amused that she should even ask. His answer, lips against her torn ear, equally faint.

'Because I can.'

His blade slicing down her flank to the side of her panties. The fine material slipping frayed. Pulled aside. More laughter, as with torn hands, she attempts to hide herself. Gently, her fingers coaxed away with the cut-throat's gleaming edge. And then as he walks away, pushing another towards her.

'Your turn, Comrade Officer.'

A reply. Words that she had no wish to hear. Her gaze falling to a gap in the far bowl of the stadium structure. The city, so near, so very far.

'I said, your turn, Comrade Officer. That is if you wish to be a member of our club.'

Pushing him again. Nearer. Through the smell of blood, metal and pepper, his reek of vinegar sweat. And at the very horizon of her hearing, their voices chanting, goading him.

An arm in a final scything sweep. The blade in a race through the cold air and across her soft throat. A shiver of excitement running through him. Standing back as he surveys her. He, at that moment, a god, bleeding her life into the puddled mud.

Her eyes, blind to her murderer dropping his trousers, deaf to his comrades' jeers. Oblivious to his callous pumps into her. Her blood baptizing him; the clench of her vagina around him, as she convulses in death, forcing him to come prematurely. His seed falling cold within her. Dead by the time he has completely ejaculated. His arch-backed act caught in icy still frames, by the man with the pockmarked face.

Withdrawing to applause. Pats on his back as they drag her to the very edge of one of the shored foundation holes. From the rear of the group, the man with the pockmarked face moving forward. His eyes meeting theirs. Only a nod, the act not even demanding words before booted feet kick her into the hole. Another nod from the man with the pockmarked face. A hand on a lever, a belch of diesel fumes with revs building. Through light and darkness, a river of concrete, rising over the chest, flowing thickly into the mouth and the nostrils. Congealing over upturned eyes. The dead girl, now a stone crucifix. The liquid concrete rising, until there is nothing to be seen.

2

Ankang – *Peace and Health*

Ankang. A hospital that punishes by custodial sentence and regime. Three years, five years, are considered to be short periods of incarceration. A hospital where you will work seven hours every day.

Ankang. A hospital that punishes by use of medical appliances and procedures. Drugs, medicines that make you dribble constantly. That make your eyes roll upwards helplessly in their sockets. That make you walk slowly, and stumble often. That make you constantly want to sleep.

Ankang. A hospital that punishes through the use of injections. Injections that swell your tongue so that it bulges out of your mouth. Unable to talk. Swallow. Injections that paralyse your facial muscles, like a waxwork mask.

Ankang. A hospital that punishes through acupuncture using an electric current, the 'electric ant'. Three levels of current; three levels of pain; three favourite acupuncture points. The *taiyang*, on the temple. The *hegu*, on the palm of the hand between the thumb and

the index finger. But the most popular, the most painful, the heart point on the sole of the foot. Screaming out, while other inmates are forced around your bed to watch the 'electric ant' administered. Threatened that they will be next if a rule is violated, a boundary infringed.

*

Do not be a *hua fengzi*, a 'romantic maniac', one that looks dishevelled, unkempt, or have an adverse effect on the social order.

Do not be a *zhengzhi fengzi*, a 'political maniac', having an opposing political viewpoint. One that challenges the Party, the government, in any form.

Do not be a *wu fengzi*, an 'aggressive maniac', one who is mentally ill or who has learning difficulties. Do not disrupt the public order of society, even if your illness means that you cannot help it.

The orders are strict. On encountering any of these types of behaviour the public security organs are to take you into custody for treatment.

Ankang awaits.

3

Beidaihe, Sea of Bohai, the People's Republic of China

Dream different dreams while in the same bed . . .

The soft-sanded resort of Beidaihe is divided into three areas.

The east beach is reserved for chosen workers and members of the military. Those who are trusted. Those who are the 'ears'. Who listen to the whispers and then report them. Those 'who pat the horse's arse'. Those *tong zhi*, those comrades who attempt to 'put the shit back up the horse's arse'.

The middle beach, the best beach with finer sand, is used by high-level Party officials. The highest of *cadres* and their hangers-on. The elite. Those who create the wind that all others must bend to.

The west beach is for foreigners. 'Big noses'. *Yang-gui-zi*, 'foreign devils'. *Wai-guo-ren*, 'external country persons'.

Confucius, in the opening passage of the *Analects*,

asked, 'Is it not a pleasure to have friends come from afar?'

Yes, it is. As long as they keep to the west beach.

★

The *zhau-dai-suo*, 'guesthouse', as they are known in China, overlooked the middle beach of Beidaihe, a private path giving it access to the fine honey-coloured sand. Rare, even amongst such privilege. Flanking its metal gate, a beach hut and a boathouse of mellow-coloured brick.

Several dachas occupy this area, none visible from any road. High walls and tall leggy swaying trees, in full leaf, standing sentry. Invisible to the eye, the *zhau-dai-suo*. Invisible also in every other way. Recorded on no documents, plotted on no maps, no name attached to them, no records of ownership, no house number, or address. Sitting on roads that have no name, in areas that, officially, do not exist.

★

She stood next to the balcony that led from the master bedrooms. A view through the fine lilac voile curtains and the swaying trees to the sea. Every day seeing the sea, noting its change. Not unlike living with somebody. But it had been a long time since she had actually chosen to live with somebody. Lovers, husbands, men . . . stepping stones across a wide, restless river. Nothing more.

Steeper now, the sun's arc to the ocean. Boats, riding the horizon, their running lights blinking into life on their imagined road into the Yellow Sea, and onward to the mouth of the Changjiang, the Long River, the mighty Yangtze.

The breeze was picking up, curtains in a loose tumble and mimicking the waves' gentle ride to the shore. She closed the balcony door, the evocative fragrance that she always associated with Beidaihe, coconut oil and camphor wood fires, cut adrift and replaced with man-made scents that came in delicate, expensive bottles. As she passed, stroking the head of the child that lay on the satin-sheeted bed. The telephone ringing, but not disturbing the child. Nothing disturbs this child. Checking her watch. The phone continuing to ring. To the minute, on time. How she loved men who were so predictable.

'*Ni nar.*'

Listening, just listening, with the occasional verbal prompt. Many could talk, few could listen. She was one of the few. The conversation meandering for many minutes before he found the right path.

'Madam, thank you for your help with my little predicament. It is much appreciated. Very much appreciated.'

'It is a pleasure to help one who is in need.'

A delay in his next words. Words that were difficult to say, as a hook caught in a carp's lip.

'Your assistance, Madam. I cannot but wonder about its timing.'

'Its timing, Comrade Chief Officer Zoul?'

'Yes, Madam. We have an association with each other. One that pre-dates your assistance to me. Pre-dates it by some time. A common acquaintance. I had not realized, Madam. Those who recommended me to you did not say.'

'Nor should they have, Comrade.'

'Of course, Madam, of course. You were the . . .'

For a second he halted, trying to find the right title. Mistress. Concubine. Lover. She smiled. A man of some sensitivity, it was a good sign. Such a man would be malleable, easily 'persuaded'.

'You were the partner of the late Minister of Security. A fine man, a great comrade. We in the PSB still mourn that life no longer possesses him.'

'Thank you, Comrade Chief Officer Zoul. I also still mourn my beloved Minister's passing to the ancestors.'

Her fingers falling to the sleeping child's blushed cheek.

'But our love did bring forth a child. Such a gift. Ten thousand ounces of gold.'

'Indeed, Madam, indeed.'

'But when you talk about a shared acquaintance, you do not talk of the late Minister of Security, do you?'

'Perceptive, Madam. You are very perceptive.'

'You talk of my husband, yes?'

Silence. Almost able to smell him, his Italian cologne and his fettled fear. She knowing instinctively when to use the right words, as if dipping into a tool box. Each

sentence a spanner, a hammer, a chisel. Each word a pick, a soft brush used to remove fine debris.

'Please, Comrade Chief Officer Zoul, speak your mind freely. This is a secure line and I am a woman who understands the sensitivities that the high *cadres* must take into account in all of their dealings.'

She laughing lightly. So natural and so well practised.

'One advantage of my now dead lover having been the Minister of Security?'

He would be blushing, Zoul. The word lover. The word dead. A hardened chief of the PSB, with such easily bruised sensibilities.

'Yes, Madam, thank you. I will speak freely, if I may. Your husband, your, your . . .'

'Estranged husband, Comrade?'

'Yes, Madam, thank you. Your estranged husband, Senior Investigator Sun Piao. I have inherited his command. I am now his Chief Officer.'

She laughed again. A laugh of perfect length and intonation.

'I do not envy you, Comrade Chief Officer. My estranged husband is a difficult man, a challenging man.'

'Exactly, Madam. Exactly.'

'My husband, my estranged husband, he does not recognize subtlety. He does not recognize the tones that lie between black and white.'

Suddenly, painfully, remembering his blue eyes. Eyes of a half-blood.

'He is not a man who cares for the natural order of our system. For the secrets that must be held in soft hands.'

'Exactly, Madam. My thoughts exactly. His investigation went far beyond what a normal investigation should encompass. As you will be aware, it impacted upon his own fellow officers. His commanding officers. Its ripples reached the Politburo, no less. It led to damaging investigations, judicial proceedings. The *fen-chu*, it was turned upside down. We are still feeling the aftershocks.'

'And it interfered with the PSB's other activities, yes, Comrade Chief Officer Zoul?'

'Yes, Madam. As I have already said, you are very perceptive. It is good to talk to someone who understands how things, how things . . .'

'How things work in the PSB and the Security Services, Comrade Chief Officer Zoul? How business is conducted?'

'Indeed, Madam, indeed. Our Senior Investigator Piao, a very dangerous man. A man who would empty the entire swimming pool just because someone might have pissed in it.'

Crude, so crude. How she hated crude men. Waiting for the next words, but many seconds before they were born.

'My call to you, Madam, it is delicate.'

'Please, Comrade, speak freely.'

Silence. Just his breaths. Tight, expectant.

'I had to contact you, Madam. You have aided me, supported me in regard to a delicate situation. One that could have ended my career.'

'One that could have ended your freedom, Comrade.'

'Indeed. Indeed. I thank you for that, Madam. I am most grateful. But I needed to see if . . .'

'You contacted me to establish if I would want *guanxi* in return?'

A polite cough at the other end of the line.

'Perhaps you thought that I would blackmail you, use this information to pressure you into releasing my husband, my estranged husband, from his incarceration in the Shanghai Ankang? Pressure you into accepting him for active duty within the PSB?'

Silence.

'Or perhaps you thought that I would blackmail you into a decisive action that might result in him never leaving *Ankang*? After all, Comrade Chief Officer, the PSB has very long arms, does it not?'

Embarrassed silence.

'I am sorry, Madam. I feel rightfully chastened. The timing of your intervention, it concerned me. Obviously, needlessly so. I see that now. Although you are estranged from Senior Investigator Piao, I thought . . .'

Her hand against the child's chest. So faint the heartbeat, that knife edge between life and death.

She had decided, she would wake the child as soon as the call was completed and matters agreed. She would

wake him and they would walk down to the beach. They would look at the lights of distant boats. Smell the smoke from wood fires and throw pebbles into the sea. Kiessling, the old German patisserie, would still be open. A cake, perhaps their famous strudel, and a coffee, hot and bitter. A small ice cream for the child. And again they would watch the running lights from boats wink out their existence.

'You are less slow-witted than I imagined, Comrade Chief Officer Zoul.'

Her tone different, like silk to leather and sand to granite.

'Madam? I am sorry, I do not understand.'

'I have a full account of your little indiscretion on file. It includes a statement from the victim. It will be sent to the new Minister of Security by courier if my demands are not met in full. You should know that the Minister's dear wife is a close, close friend of mine . . .'

Stuttered the word, like a steel security shutter falling into place.

'Demands?'

The child waking. *Nemma bai nemma pang.* Perhaps he already had dreams of ice cream.

'Do you have a pen, Comrade? This could take some time.'

4

The Shanghai Stadium, Tianyaoqiao Road

Two weeks later

Detective Di was warming his hands with his cheroot sweet breath. His eyes fixed to a crane-spiked sky, diced, sliced, and with a sun the hue of flat beer. Beside him, a deputy who was younger than his son. More spotty than his son, but less insolent.

An engine cutting the silence, inch by inch, behind discoloured screening panels, straining cables hauled a rectangular shadow.

Shouts. Brakes. A line of identically olive-garbed officers hauling ropes, swinging the concrete block onto steel chocks. Moving in a single file across the mud to a spattered Liberation truck. China Brands lit and burning tangerine in cracked lips.

'Come.'

Detective Di beckoned to the Deputy and smiled as he watched him negotiate the mud field. Shit up to his ankles, shit over the bottom of his trousers. He would have some explaining to do to his mama.

Wincing as they breached the screening, the Detective shielding his eyes from the cutting halogen light, the Deputy's hands moving urgently to his lips, guarding his mouth with lattice fingers, but through gaps, bile pulling thick as he ran from the screening. His legs folding, as he collapsed onto the mud, on his knees, over and over again a mantra of penitence for seeing what none should ever see.

'*Dao-mei . . . dao-mei . . . dao-mei . . . dao-mei.*'

Di ignored him and lit another cheroot, taking rhythmic drags and exhalations as he circled the roughly hewn concrete obelisk.

'*Ta ma de.*'

From his pocket taking a camera the size of a packet of Panda Brand. With each click, a swearword and a vision of the sort of hell that one comrade of the People's Republic can perpetrate on another comrade of the People's Republic. Nothing here that would be found in Mao's *Little Red Book*.

Moving closer, the frame filled slate grey. Entombed in concrete, the toes of a foot, cherry nail varnish, once pristinely applied. The stone topography of chin, cheek, a gagged, open mouth, a blind, upturned eye. Entombed in concrete, a girl, naked and torn.

He moved closer. Reluctantly touching a hand, within whose broken-fingered clasp there was an object's dull gleaming. Taking another photograph and then wrenching each finger aside; concrete flakings falling as grey snow. Another photograph.

'*Ta ma de.*'

Nausea filling him. From his pocket he took a blunt penknife and used the blade to lever the embedded object from its concrete vice. Carefully scraping the greyness off. At arm's length, holding the object in his palm. Taking several digital images and cursing his bad luck. Such bad luck that he should have been on duty when the call had come.

Retrieving an evidence bag from a pocket and dropping the object within its creased polythene. Sealing, labelling it. And one last look before he buried it in a deep inside pocket. A shake of his head. His body racked in a prolonged shiver. Somebody was walking over his grave. Someone with heavy boots.

The Deputy breached the screens. Di's eyes fixed on the face of dead girl and his words framed with a harshness that pressed the Deputy into immediate action.

'No one else is to see this. No one. Post guards outside. Make sure, then see how the other excavation is doing.'

'Yes, Comrade Detective.'

He took a final drag of his last cheroot. Ten a day. He had promised his wife, ten, no more. Flicking the butt of his tenth deep into the foundation's gaping hole, he reached back into his jacket side pocket for the rough cardboard packet and his eleventh cheroot which he lit as he strode from the screens.

Across the mudflat an engine choking into action.

The second crane, at the north-west corner of the site, heaving shadow. A shout to the laced canvas interior of the Liberation truck.

'Out. Out . . .'

Men jumping from the tailgate. Cigarettes thrown in the mud. Oaths to corners of lips.

'A full sweep. Anything and everything. Got it? And you . . .'

Pointing at a young, boss-eyed officer.

'Take six other officers. Check this site and the neighbouring sites. Witnesses, evidence, anything suspicious. You don't leave the shift until you've covered the whole area, do you understand?'

Nods and whispered profanities. But all of the time the Detective's eyes on the spike of the crane. Another shadow rising grey behind screening panels. Knowing, already knowing. Watching a section of screening flap apart. The Deputy stumbling through it, bracing himself against the forest of bamboo scaffolding poles. His voice lost to the language that machines speak, but Di reading his lips. Knowing the words and already running in the young Deputy's direction.

'There's more. There's fucking more.'

5

Telephone calls in the middle of the night, always with an edge, always feeling more dangerous.

'You know who this is?'

The voice, a rasp. Instantly recognizable, and with it, an image of light falling over ravaged skin. Sleep banished and instantly alert. Comrade Chief Officer Zoul sitting up in his bed, his book falling to the floor.

'Yes. Yes, I know who you are.'

'Then you will know to listen carefully, Chief Zoul. You will be receiving a call from one of your detectives. An investigator in your Homicide Division by the name of Di. He has stumbled upon something that he should not have stumbled upon.'

The man with the pockmarked face leaving room for a question that he knew would never come. Even a comrade chief officer had the sense not to ask a question that would never be answered.

'It is People's Liberation Army business. A delicate matter that will require your complete support and which I will direct personally.'

Another space. A silence filled with difficulty.

'Your Detective and his Deputy find themselves in

22

a delicate situation. They have seen things that they should not have seen. They are comrades who will not be able to see the bigger picture. Unlike you, Comrade Chief Officer.'

It was chilly in the bedroom, the weeks now turning towards winter; but Zoul wiped the sweat from his forehead with a bed sheet.

'I understand, Comrade Sir.'

'It is good that you understand, Zoul. This is what this situation requires from all parties, understanding.'

Sweat into the corners of his mouth, warning of words not to be spoken.

'My officers, Comrade Sir, they are good comrades. Detective Di and his Deputy, they are officers that can be trusted. I am sure of this. They will be diplomatic. They will keep confidences.'

'Di will telephone you. He will need heavy transport, he will need men. I have already made provision for this. The material involved will be taken to a place that does not concern you. I will assume personal charge of this operation. Is that understood?'

'Yes, Comrade Sir.'

'You will insist that Di gives to you any samples for forensic examination that he might have collected during his brief investigation. Is this understood?'

'Yes. Yes, it is understood.'

'All reports, all notes will be surrendered to me. Understood?'

'Yes, I understand, Comrade Sir.'

'I wish this situation, this investigation by your officers, to cease, to vanish, as if it had never been. You would not wish to anger me. You would not wish to anger my esteemed father.'

The voice was low. Barely audible.

'What we need is obedience. Obedience and discretion. We are involved in a struggle, Zoul. A struggle for hearts and minds. To retain the glorious values of our beloved leaders. In this process a few eggs may be broken. But what are a few eggs in such a struggle?'

'Yes, Comrade Sir.'

'We must be prepared to make sacrifices by proxy, Zoul. For the security and advancement of our Republic, indeed, for its ultimate survival. We must all be prepared to make sacrifices, even the ultimate sacrifice should it prove necessary.'

*

A breakfast of peanuts, noodles, fruits and pickled vegetables as bitter as the news that Zoul was expecting. The telephone call arriving as he ate apples past their best, and bruised and split lychees.

'Comrade Chief Officer. It's Detective Di. Sir, we have a problem . . .'

Cold now; the only warmth, Di's cheroot. His sixteenth cheroot.

'Our investigation at the construction site of the Shanghai Stadium, it has complexities that we had not envisaged . . .'

Di's eyes moved across the face of the second obelisk. A concrete elbow and foot, a clenched hand and a concrete mask of a face.

'It's hard to estimate, but there could be many poor unfortunates whom life no longer possesses. They have been entombed in the concrete foundations, Comrade Chief Officer. They all appear to be young women. They could be linked to others cases that I'm working on, Comrade Chief Officer. We will only fully know once we have transported the concrete to a suitable location and have broken it apart.'

His hand, concrete powder-stained, across the top of the mouthpiece shielded his words, his lips.

'However, Comrade Chief Officer Sir, there is an additional complexity concerning the situation that we have discovered here.'

His eyes moving from the human Braille that indented the second obelisk of the concrete foundation to his hand and the object that he had levered from a dead girl's fingers.

'I have found a cap badge, Sir, in the hand of one of the victims.'

A last inhalation from a sodden cheroot, before flicking it aside.

'It is a PLA cap badge, Comrade Chief Officer. A cap badge of a very high-ranking officer.'

6

PSB Divisional Headquarters of Hongkou, Sichuanlu, Shanghai

The *fen-chu* smelt of everything that he didn't associate with it. Toothpaste and plastic, clean shirts and clean minds. Gone the smell of men, the kind that he knew. Of used-up, disenfranchised maleness, cheap tobacco and see-saw morals, and three-day-old underpants. It was clear, in every sense, that a vicious tide of a purge had swept through this place. Almost every face of every senior officer that he had known, carried away on its white-horsed back and now posted to a series of three-donkey, one-tractor villages. Ramshackle wooden hovels, where the theft of a pitchfork would be considered a crime wave. And, with their shamed departure, also gone the very fabric of the old building that he had known as intimately as one knows one's own palm.

The *fen-chu*, not now a place to talk of murder, of rape. This place, now more a place to purchase an armchair. A place to drink coffee with a frothed top.

<p style="text-align:center">*</p>

All are equal, but some have a corner office with two windows.

Still sweating, Piao wiped his forehead with the back of his hand and knocked on the door. It was many seconds before Psychiatrist Tu invited him to enter.

The psychiatrist did not look up, did not acknowledge Piao. He was reading a report that was open on his desk, its parade of characters reflected on the lenses of his gold, wire-rimmed spectacles.

'I have read about you. The way that you investigate, it is with a total disregard for yourself. It has much in common with self-harming.'

Closing the report and considering Piao for many seconds before speaking once more.

'And this. A report from the *Ankang*. From their chief psychologist. It makes for complicated reading, Sun Piao.'

Reaching for the thick cigar that lay slumbering its life away in the ashtray. Softly into his fat mouth, kissing its moist end as if it were a lover's welcome lips.

'Tell me of your view on life, Sun Piao. I know that in *Ankang* you did not hold back with your homespun philosophy.'

'There is too much of it.'

The psychiatrist laughed, his triple chins wobbling discordantly.

'Much could be made of such a comment, Sun Piao. Dreams. Tell me about your dreams, Sun Piao. Much can be discovered in the dreams that you have.'

'The best dreams that I have ever had are the ones that I die in.'

The psychiatrist observed him, his fingers drumming on the desktop.

'At three a.m. most people think that life is a terrible thing. It is due to blood sugar levels. I do not look for a deeper explanation. But in your case . . .'

Writing more notes. Glancing at his watch. The lack of peeling gold signifying that it was a genuine Rolex.

'I think that we will need further sessions, Piao. Many further sessions . . .'

Eyes darted across characters.

'Complicated. Yes, you are a very complicated man, Sun Piao.'

'It makes me the successful senior investigator that I am, Comrade Psychiatrist.'

'Were, Sun Piao. Past tense. And if it was up to me, which it should be, it would remain that way.'

He carefully placed the cigar back onto the ashtray.

'If it was up to me, I would seek your immediate retirement from the bureau on health grounds. Your last investigation, Piao, what was it that you did to my colleague, Wu, the Senior Police Scientist? Suspended him by his ankles from the highest river bridge in the city, I believe? And your previous Chief Officer, Liping, there are still many interpretations of how he lost his life, and not all of them coincide with yours.'

He shook his head.

'Unhealthy. Very unhealthy. You investigate as if

your own life depended upon it, Piao. But apparently it is not up to me to make a final judgement about your mental wellbeing. I am merely the department's clinical psychiatrist.'

His fingertip chased around the embossed star at the top of the report.

'Quite clearly you are not fit to resume any duties within any of the departments of the PSB. I would not sanction you to even direct traffic within the city, at present. Let alone permit and authorize you to head complex homicide investigations.'

He met Piao's gaze.

'But this decision has been taken away from me. I have been by-passed. You have a friend in a very high place, Sun Piao.'

Pulling open a drawer of his desk, he took out a large rubber stamp, a large ink pad, the desk shuddered to the double concussion.

ACTIVE DUTY

*

A door opens. The world crashes in . . .

Easy to forget, when incarcerated, how complex the world is. The sounds. The smells. The images.

His first breaths beyond *Ankang*'s grasp. Traffic breathing, roaring. Ten thousand feet on paving stones. A snippet of chatter, laughter, of sworn anger. All

jumbled and laying over each other, as different ages layering an archaeological site.

A high street ... its smells. Diesel, drains, noodles, cheap cologne, and yesterday's clothes re-worn today. The yellow dragon's breath, incense, the shit on the sole of your shoe. All jumbled.

'You all right, Boss?'

He wiped the sweaty sheen from his forehead with a cuff.

'I do not want this.'

A tree trunk, the Big Man's arm, barring Piao's exit.

'They only want to say welcome fucking back, Boss.'

Spinning him around, pushing him forward, as if he were a child not wanting to see the dentist.

'And there's free beer. Although that is of course a minor consideration.'

He placed an arm around the Senior Investigator's shoulder moving him into the room. Feeling Piao's body shudder, as if concussed by a savage blow.

'It's all right, Boss, it's all right. I'm with you.'

Tsingtao. Reeb. Suntory. Yaobang grabbing a Tsingtao as he passed. Flipping its cap on the edge of one of the new workstations. Tipping the foaming bottle towards him. A loud voice cutting through the polite conversations.

'Liquid bread. Very good for you. Want a slice, Boss?'

Piao, picking up a bottle. Mineral water, Kesai.

'I do not feel ready for beer yet.'

Wiping the sweat from his face.

'Maybe soon. Maybe . . .'

'Sure, Boss. Sure. Don't worry. Overrated beer. Fucking overrated.'

Another gold-capped Tsingtao winking at him. The Big Man pulling it from the crate. His large, relentless palm pushing the Senior Investigator further forward. The crowd parting and all of the time, weaving through Piao's mind, the old adage. 'Keep your broken arm inside of your sleeve.'

Wiping his forehead once more as faces turned to greet them. Wrinkled eyes and busy mouths. At the back of the open-plan room that had been carved out from a warren of offices, corridors, cupboards, stained and stinking urinals . . . Yun. The Detective standing exactly where the down pipe for the piss and the shit would have been just a few months previously. His acne blazing as he pushed through the crowd enthusiastically and shook Piao's hand excitedly with both of his.

'Good to see you, Sun Piao. I never thought that we would ever meet again. And now look at you.'

He stepped back, hands on hips, as if viewing a painting. The lie that crowned his next words worryingly convincing.

'Looking so well and returning a hero, no less. Lilly will be so thrilled that you have returned to active duty. My sister-in-law, you of course remember Lilly?'

So long ago, so much medication, but still the fearful recollection. People's Park, ballroom dancing, and a small pink chiffon puffball of a woman with a melon

31

slice of teeth surely too white to be real. Lilly. Yes, he remembered Lilly.

Yun nudging him. Hand shielding his mouth. A whisper, in Tsingtao fumes, accompanied by a wink.

'I will let her know that we spoke. She is still single, you know.'

Piao looked around at the familiar and unfamiliar faces, but one that he had expected to see, missing.

'Where is Di? He is not here.'

A gulp of beer, a shrug of the shoulders.

'A promotion in the offing, they say. Our Detective Di will soon be a Senior Investigator. A raise in salary. An upholstered chair. Perhaps he feels that he is out-growing us?'

Yun wiped the froth from his lips.

'Actually, I've not seen much of him or his Deputy at all lately.'

Voice lowered.

'There are rumours of him working on a special case . . .'

Winking with a bloodshot eye.

'A sensitive case. Perhaps he's working undercover? But you are here, Senior Investigator, and that is what counts. Now the time is right for me to make my little speech.'

A long script unrolled. Piao noticing his own name at its top and instantly his hands becoming clammy.

'This is not necessary, Detective Yun, not necessary at all.'

'Nonsense, Sun Piao, it is my pleasure.'

Yun clapped his hands together.

'Please, please, Comrade Officers, if I could have your attention. You will have your chance to charge your glasses again shortly.'

Clearing his throat. A cement mixer crunching into life.

'Comrades. Comrade Officers, it gives me great pleasure on this most auspicious of days to welcome back a fellow officer whose reputation, deservedly, goes before him. A comrade officer whose honour we all bask in here at the *fen-chu*. Welcome back, Comrade Officer Sun Piao.'

A round of applause. Piao hearing it only faintly through the internal din engulfing him, flooding him.

'As many of you will be aware, Comrade Officer Sun Piao, in the face of threats to his career and personal wellbeing, fought against corruption and reactionary elements. Reactionary elements within our own beloved Public Security Bureau . . .'

Lost in the noise. A deep resonating hum owning him.

'This led to a series of investigations, trials. A purging of the grubs in the rice bowl . . .'

Piao feeling the sweat, like trains out of the Dong Baoxing road station, run down his face to his neck.

'Findings from the investigations were far reaching, and not only led to arrests, legal actions and *lao gai* sentences, but also resulted in a full and radical

restructuring of our service and an updating and refurbishment of our *fen-chu*. We very much have Comrade Officer Sun Piao to thank for this.'

Piao was desperate to run his shirt sleeve over his forehead and across his face, but felt as if his arms were nailed to his sides.

'Long live the proletariat of the People's Republic.'

Glasses raised. Cheering.

'Down with reactionary elements.'

Glasses raised. Cheering. Proud chests puffed out. Unity in song.

> *Arise, ye who refuse to be slaves!*
> *With our very flesh and blood,*
> *let us build our new Great Wall . . .*

A thin woman cutting through the throng. Standing. Her reflection on twenty-five shiny Tsingtao bottle tops. Piao looking up. Chief Liping, the former Comrade Officer's secretary, with a bosom as comforting as the holed soles of his shoes.

'Senior Investigator, Comrade Officer Chief Zoul wants to see you. He wants to see you now.'

Hearing the proud beer-fuelled voices of his comrades as he followed her bony arse to the new Comrade Chief Officer's domain. Each step, pondering the significance of Zoul's name . . . its literal meaning 'minnow' or 'small fish'.

*

The office had a blazing lightness to it. Two walls of windows, their glassy-eyed stares following the lazy run of the Huangpu River. Its waters as grey as a birthday without any gifts.

Zoul was smaller than Piao had imagined. Most probably smaller than Zoul imagined himself to be. A crow of a man. Fierce-looking. The juxtaposition of nose and mouth, as if he were attempting to peck at something that he could not quite reach.

'Senior Investigator Sun Piao, a name to conjure with. You look better than I imagined you would. Yes, better. *Ankang* has the habit of laying waste to an individual. Yes, laying waste.'

Smiling, but it was with the hint of a sneer.

'Of course I do not know you, and, most importantly, you do not know me. This is just as well. Those officers that you do know are either dead or in *lao gai*. Justified, however. Reactionary elements. Of course, justified.'

Moving from the window.

'I hear that speeches are being made about you. The return of the hero comrade. Good. Good for morale. Good for the *fen-chu*. Even our perfect People's Republic needs a hero or two, now that Mao is dead. Dead, and forgotten.'

Zoul moved to the front of the desk. His eyes filled with lapsed communism and of a report to the psychiatrist, not yet written.

'I imagine you have noticed many changes, yes? Fine

offices, carpets, air-conditioning, computer workstations. What have you noticed most, Senior Investigator?'

Piao, his eyes still haunted by the bony arse of the Chief Officer's secretary, was slow to respond.

'I have noticed that this office is larger than it used to be, Comrade Chief Officer. Larger than when it used to belong to the Street Market Regulations Officer and the Chief of the Dog Patrol Wardens.'

Zoul moved back around the desk and sat in his fully padded chair with adjustable height and posture controls. A chair that dreams were made of.

'As I say, things have moved on. For the better, Senior Investigator.'

He flicked through a thin file held in the bony clasp of his fingers.

'And you, Piao. How have things moved on for you?'

From the window, a thousand flaring office windows. A thousand lives lived behind them. The Senior Investigator averted his eyes and concentrated on Zoul's hands, wasted, and impossibly small.

'I am free of *Ankang*, Comrade Chief Officer. Free of the medication that they pumped into me. I have my life returned to me.'

'Good, Sun Piao. Very good.'

Zoul looked up from the report.

'But we should not forget, never forget, that *Ankang*'s shadow is long. But that is in the past. You are welcome back, Senior Investigator. This welcome

will remain as long as you fulfil your duties to the best of your abilities. The very best of your abilities.'

Gathering together the papers before Piao could read the inverted characters of print, Zoul met his eyes.

'And as long as you adhere to the command structures of the *fen-chu*. There are rules, Senior Investigator, you would do well to remember that. There are rules for you and there are rules for me. Written rules. Unwritten rules. You will obey them all. Without question. Without fail. Is this understood, Senior Investigator?'

'It is understood, Comrade Chief Officer.'

Zoul clapped his hands together sharply.

'Good, very good. Then we shall get on famously, Sun Piao. Famously.'

Opening a deep drawer. From within it, a large pristine beige envelope. Zoul's hand dipping in and out of it.

'Documents of authority and of identification. *Danwei* letter of confirmation of employment.'

The Comrade Chief Officer's gaze still drawn to the interior of the envelope. One item remaining.

'You will notice a small decrease in your salary, Senior Investigator. Very small. This is due to your transfer of departments with the corresponding reduction in grading.'

'Transfer, Comrade Chief Officer?'

Fingers pulling the last of the papers from the envelope. Folding, smoothing it open. The stamp of

the *danwei*, the Party, the Public Security Bureau, bleeding across its bottom. Inks, in black, red and blue, across the signatures of *cadres*.

'A copy of your standing orders. Your position, a senior investigator within the Public Security Bureau Vice Squad.'

It was many seconds before Piao could speak. An urge, almost palpable, To taste a sugared pill melting on his tongue.

'I am a homicide investigator, Comrade Chief Officer. This is where my skills lie.'

Zoul had risen from his seat and was facing towards the window. His only words as Piao walked from the office.

'Then acquire new skills. One day, Senior Investigator, you will thank me for this change of department. One day soon, you will thank me.'

★

The basement was a rabbit warren of offices. Dark-wood-panelled and fogged-glass-partitioned. Lights strung on spider's web cables. Only brief reminders and glimpses that there was a world above. Overhead, pedestrians' feet on thick glass blocks set into iron. And light, in degrees of slate. As if the world beyond the basement were fashioned from steel, lit by a ball-bearing dull sun.

On each desk, a spill of inactivity. Dust-covered files, silent telephones, dried pens, curled papers with faded type. Permeating all, the smell of failure and of indiffer-

ence. The big man shook his head as Piao pulled open a heavy file drawer. A stagger of dog-eared folders. On each the faded colour coding of every investigation's current status. Red for closed, amber for in progress, green signifying waiting authorization to investigate. The files were a forest of green markers. Hardly a case in progress. Violence, pimping, abduction, prostitution, corruption, blackmail, narcotics. Vice and all of its charming fringe adornments, held in an official clamp of inactivity.

Piao slammed the file drawer closed.

'Sorry.'

Yaobang sifting through files on desks. Messages, reports, letters jamming dusty in-trays. Rubbing his hands down his trousers.

'Not your fault that this is the fucking colostomy bag of the PSB. It's just life. How do you put it, Boss? "You cannot prevent the bird of sorrow from flying over your head."'

Smiling.

'Just wish that it wouldn't build a nest in our fucking hair.'

'I will make some tea. If I can find a kettle and some water.'

'No need, Investigator. No need . . .'

A voice as grey as the scoured aluminium light interrupted. Words fractured by hesitancy. Sentences splinderd by prolonged fits of stuttering.

'It is already on. Boiling its bottom off. What do you prefer, *xunhuacha* or *lucha*?'

From deep in the back of the basement, the voice. A room of amputated computer stacks, naked hard drives, unsheathed monitor innards and spraying intestinal wiring. The basement, nothing more than a mortuary of deceased hi-tech. And in the corner, a skunk of a man. His head balancing an oversized toupee and on his nose, half-lensed spectacles, their arms held on with black insulating tape.

'You are Ow-Yang?'

Adjusting his spectacles, the old man considered Piao as the cat considers the mouse.

'Yes, yes. And you are Piao. Homicide. Then disgrace. Then *Ankang*. And n-now?'

'Vice.'

The old man laughed.

'Vice? You look like you could do with some vice . . . not police it out of existence.'

Against the blistered back wall of the room, under the festooned electrical socket, the kettle whistled shrilly.

'Your kettle, old man, before you fucking blow us all up.'

Ow-Yang fended off the Big Man's pointing finger with a soldering iron. Angled glasses, rotten teeth, directed at the Senior Investigator.

'Who's the big piece over there?'

'My Deputy, Yaobang.'

The old man turned to the kettle and handed around chipped mugs. On a makeshift shelf a series of tea caddies sat, transfer-printed with images of the Great

Helmsman, his dark eyes sparkling and his rouged lips smiling. Each round of tea, the prints a little paler towards the caddy's silver base metal.

'Rude bastard, isn't he? Can't abide foul mouths.'

'I agree, *tong zhi*. A distinct lack of education in the rural provinces.'

A genteel sip of the tea. Summer rain.

'"Aspire to the principle, behave with virtue, abide by benevolence, and immerse yourself in the arts."'

The old man topped up Piao's cup, the steam across his spectacle lenses dulling the light newly lit in his eyes.

'Confucius, Senior Investigator. You are a scholar?'

'More than a scholar, Comrade. I attempt to live my life by the thoughts and adages of the "Master of ten thousand generations".'

'Excellent, Piao, excellent. We shall have many fine conversations.'

Topping up his cup once more.

'And perhaps some of the Master's wisdom will rub off on the oaf who you call a deputy.'

Following the old man into the broken interior of the basement. Against the Big Man's fast beating chest, Piao's palm, calming him.

'Look. Look. What have we come t-to?'

Ow-Yang, arms open, embracing the desolation and kicking an empty, dust-coated beer bottle across the floor. Watching it spin and settle, its long ago opened top pointing to the west.

'What fucking happened here, Old Man?'

41

'Less of the old man, fat pig!'

The Senior Investigator positioning himself between locked horns.

'Comrade, what happened here?'

The *tong zhi* pulling the words of the adage from his fading memory.

'"The gentleman understands righteousness. The petty man understands self-interest".'

A smile, but borne across Ow-Yang's life-trodden features as a grimace.

'The Vice Department was disbanded just under a year ago, Senior Investigator.'

Walking across the space and with difficulty, bending and retrieving the kicked beer bottle and gently placing it on a desk that had not received a telephone call in ten months.

'I am sorry to tell you that you have been given a job that does not exist, Piao. There is no such thing as vice.'

The Big Man pushing forward to confront Ow-Yang. Irony, a foreign continent.

'Look around, Old Man. Filing cabinets full of pimping and prostitution. Desks with files on abduction, whorehouses, drugs. In-trays full of reports on STDs, violence, shootings, HIV. What are you talking about?'

Waiting for the storm to still, the *tong zhi*. Confucian words whispered over his lips, calming the hot rise of his anger.

' "Everything has beauty, but not everyone sees it." '
Pouring more tea, before replying.

'Vice, in the People's Republic, it does not exist, Investigator. Like poverty. Like class. Like serial murderers. Did they not tell you? It is official, vice does not exist. The Politburo says so.'

★

Of all of the stratagems, to know when to quit is the best . . .

It had started to rain. Fine rain. The kind that has no body, but a soul of tempered steel, and the ability to avoid the windscreen wipers' stutter and glide. The type of rain that effortlessly soaks through one's jacket and shirt, to the skin.

'Fucking Zoul. Puts us in a department that doesn't exist, with investigations that will never be investigated. They don't need us, Boss, so what do we do?'

'We survive, like we always survive. "The ball that I threw in childhood has never reached the ground". I read that once in an American magazine. I too, am still waiting for that ball to fall to my feet. There will be a reason. I have learnt that about comrade chief officers. Always a reason. That is what they live for, to give reason to others. We survive and we wait for that reason to emerge.'

Moving from the *long* and into the dry sanctuary of a stairwell that smelt of cabbage and sesame seeds. Up

stained stairs, the third door on a landing speaking of mild neglect.

'You all right, Boss?'

No reply. His eyes fixed to the door.

'*Ankang*, Boss?'

Piao saying, 'Yes', but his thoughts were on a wife long lost.

'What was it like?'

'What was it like? *Ankang* was an insult to life and the living of it.'

Gaze moving to his palm, to the key, burning, fixed at its centre. Bitter memories seeming to be at every turn.

'In March 1993 a delegation from the International Olympic Committee arrived in the city to inspect sporting facilities, as a part of our People's Republic's bid to host the Olympic Games. The homeless, the ill, the politically undesirable, they were put into *Ankang*. Many of them never returned. One of them was Wang Chaoru. He was forty-one years old and mentally retarded. He lived with his elderly parents. I met someone when I was in *Ankang* who knew him . . .'

Piao's gaze fixed to a distant and unknown point as the words left his lips, colourless.

'After pleading, both parents were allowed to visit their son on March 9th, two days after the Olympic delegation had toured the sporting facilities. They were taken into an office, and an officer came into the room, saying, "the person has died." Wang's parents

demanded to see the body of their child. He was covered in blood. His lips were cut up. His eyes ruptured as if they had burst open. In his back were two large holes. On the day that Wang was cremated, his parents were handed a bag with 5,000 yuan in it. The price of a life. 122 yuan for each year that he had lived. That is *Ankang*.'

*

It took what felt like an hour to slip the key into the lock. To turn it. To push open the front door and to walk through it.

Beyond the door, swept back by its staggered arc, an avalanche of mail. Fastidiously picking them all up, one by one. Even after all this time, his eyes seeking meaning in the ink-bled postmarks across their stamps. Heroes of the People's Republic, wild flowers of the People's Republic, economic triumphs of the People's Republic. Scanning them for a Beijing postmark, for the familiar swirling scrawl of her handwriting. Or mixed into the smells that paper and ink possess, a faint scent of Chanel, Guerlain. Nothing. His heart vacant. But not even knowing what he would have done with such a letter in any case.

A realization that he would have to do it the hard way. Moving through each room, last of all, the bedroom. The only way to reclaim this territory. The only way to reclaim a life that had been hung on a meat hook for so long.

Focusing on nothing else but that which he needed to discover. What he was looking for would be state of the art, immune to electronic detection, crystal-controlled, mains-fed. Permanently on, day and night.

Concentrating on the living area. Everything new. Each article bought by *yuan* from other pockets. Nothing his. Only the view from the window and the rain's hammer on the cracked paving stone. Checking every electrical point, under the carpet, light switches, behind shelving, in the upholstery of chairs. A UHF transmitter behind a main's cover, another in a lighting rose, one in the far corner of the hall under the carpet. Right now someone would be listening, their ears clamped between Bakelite earphones, sweat, whispered words. Or to be trapped on tape running across the polished heads of a bank of reel to reel tape recorders, to be listened to and transcribed at a later date. His words, his life, held on gamma ferric oxide and numbered in highlighter pen.

Piao, at the top of his voice, as loud as he could, shouting into each transmitter in turn.

'Fuck off home and check your own rooms for wire taps.'

Before furiously pulling them out, wire intestines clutched in his fist.

Not able to avoid it any longer, the bedroom. Curtains still roughly pulled across. A slight gap falling between them. Light, as pale as her skin. Checking the bedroom for UHF transmitters. Nothing. In a drawer,

a large brown envelope. Throwing the bugs into it. Quickly sealing the envelope, as if afraid of them crawling back out, to re-embed themselves in hidden places. He scrawled the address in large characters across its front. An address that he knew well, the main administrative offices of the Party Central Committee. Propping the envelope on the shelf, beside it, photographs of her. The curve of her cold cheek, the slant of her dark eyes, the knife-edge taper of her eyebrow. Knowing the date, the occasion on which each was taken. Someone must have picked them up, stood them up. A gift of comfort to him. One by one, Piao placed them once more, face down.

*

He woke to a hunger that he could not label. Washing and shaving in cold water to cold thoughts. The ivory-handled cut-throat razor clumsy in his hand, stuttering across his face. Blood, as warm as a lover's kiss, trickled from a wound that would not be staunched. A quarter of a page of the *People's Daily* in limp torn strands held across the cut, and still it bled.

The Big Man was already outside, a clutch of peanuts, a lit China Brand, and across his clothes, ash and peanut shell.

'You all right, Boss? Looks like you lost the war.'

Piao's hand went to his cheek. Pulling the slivers of *People's Daily* from the wet wound, he let the paper fall to the gutter.

'Yes. Never better.'

It was late by the time that they reached the *fen-chu* after a breakfast of noodles and stingingly hot pickles, then the sheepshank knots of traffic to negotiate. And then the bulky sealed letter of wire taps to be wedged through the letter box of the administrative offices of the Party Central Committee. Late, but Detective Yun was waiting for them on the front steps. Pulling at the Senior Investigator's cuff like a playful puppy.

'Come, come.'

All the way to the basement pulling at his cuff. A line of other officers following.

'Welcome back, Senior Investigator Sun Piao. Welcome back.'

His fingers to the light switch. An instant wink of illumination.

'It was your Deputy's idea. We worked most of the night to clear it up. Ow-Yang got the telephones and computer reconnected.'

There was a round of spontaneous applause. Handshakes and pats on backs. Every surface of the basement office had been cleaned and polished. Files stowed. Messages, mail, sorted and prioritized. On a corner cabinet, a shiny new kettle. Teas. Cups.

Piao, walked into the space, his fingers trailing the desk top, the files, the telephone.

'What do you think, Senior Investigator?'

Moving to the back wall, to a bank of filing cabinets. Bracing himself against them, back to the door and to his colleagues, his head bowed.

'Senior Investigator?'

The Big Man moved to the centre of the space.

'Senior Investigator Sun Piao wishes to thank you from the bottom of his fucking heart.'

'He is lost for words and is happy. In fact, very fucking happy.'

Arms outstretched.

'We both thank you, but would ask that you now allow us to resume our investigative work. He is proud to call you his comrades. Thank you.'

More applause. Colleagues turning, moving away.

Yun was the last to leave. A nod, a smile, with teeth too white to be real. Only when the sound of footsteps had died did Piao approach the Big Man with words that were hard to dig out.

'Thank you, this means a great deal to me.'

'It's all right, Boss.'

Patting the Senior Investigator on the back.

'As Confucius says, "To have fucking friends from afar is a fucking happiness, is it not?"'

7

In a basement where no telephone had rung for ten months, a telephone ringing.

'Sun Piao. Yun. You have to get down here. Now.'

In the background of the call, the sound of distant sirens, feet running on wood, voices shouting. Detective Yun, emotional.

'Something terrible has occurred. We need your assistance.'

Yun shouting, hand over mouthpiece.

'I'm talking to him now. You, don't touch anything. For the ancestors' sakes, don't touch anything.'

Feet running. Loud voices.

'A warehouse on Pudong side. Riverside, 300 metres south of the Nanpu Bridge. Shanghai Yu Yuan Import Export warehouse. Hurry, please hurry.'

*

Forty-five minutes later

Flash of blue, red, white light across cobblestones, weathered brick and gaunt faces. Incident tape flapping to the keen breeze's roll. Documents of authority

held against the inside of the windscreen. Waved through.

Yun was waiting by the dented double doors of the empty warehouse. His face a mask of anxiety.

'Thank you, Sun Piao.'

'I am not Homicide any more.'

The words seeming alien the very instant that they had left Piao's mouth. Out of mesh with his existence. Detective Yun pushed open the heavy doors, and there was an instant reek of the abattoir, of life passed over and now discarded, of blood spilt with a callous generosity.

'On this side of the door you may not be Homicide, Sun Piao, but on that side of the door you will be Homicide once more.'

Yun, a serious man, never looking more serious.

'The discovery was made just over an hour ago, Sun Piao. By a vagrant looking for a safe night's sleep.'

His finger pointed at a ragged man in a crowd of olive-pressed uniforms. Out of place, a mushroom in a rose garden. Piao was already looking for the little things. Single elements in a multitude of possibilities. The things that snag. Studying the vagrant. Enough to know his secret, his important lie.

Moving through the doorway, into the darkness and through the massive warehouse space, feeling its cathedral presence. The only light, a small, defined pool, harshly white, set on tripods and trailing intestinal wires.

'Only the vagrant, two officers and myself have witnessed this.'

Footsteps over wood. At their feet two bodies that life no longer possessed. Splayed, spread-eagled, pinned by steel spikes to the wooden floor.

'I have kept the scene clean, waiting for your arrival. I knew that you would want to be involved.'

'Want to be involved'. Strange words to choose for such as this.

As this ... naked forms, pivoting on driven steel fulcrums, as if their lives had always turned upon those brightly lit points.

The Big Man running back to the darkness. Back to the sanctuary of cold broken wall. Bile, in a golden rivulet, choking his words. Bracing himself against the whitewash and brick powder.

Piao moved forward to examine the bodies more closely.

'He was a close friend. I have laughed with his wife and bounced his children on my knee.'

Nausea in butterfly flutters deep in his throat. Fighting against its winged crawling will. Fighting, banishing feelings, emotions. His shadow across the crucified remains of Detective Di and his Deputy. Counting five spikes. Five. One to each hand and foot. One to centre of the forehead. Five spikes, the same as there are points to the star of the People's Republic.

From his pocket the Senior Investigator pulled on his gloves. A smell of latex and talcum powder. For an instant death's odours elbowed aside.

'Take some notes for me.'

Yun's hands were shaking. An eye cast over his shoulder and into darkness, to the sound of repeated vomiting.

'Do not worry about the Big Man. He is always like that. He was not born in the city, he is a country boy used only to things that are green and things which sprout from the earth.'

The Senior Investigator guided the Detective's wavering pencil to the pad.

'He is not yet used to that which will be committed back to the earth, and from which green things will sprout. Now write. Please write.'

Pencil poised.

'They were meant to be found here.'

'How can you say this, Sun Piao? The warehouse has been empty for over two years now.'

Piao's latex fingers tested each spike in turn.

'There is a sign at the side of the building. Fresh paint. The warehouse has been let. They were bound to be discovered. They were meant to be found. Look at what we have here, it is both practical and theatrical. Their death is a warning. But it only acts as a warning if they are found. The warning has now been served.'

Fingers following the spike down to its bloody root.

'The spikes to the foreheads were the final abuse.'

'How . . . how can you tell, Sun Piao?'

'The flow of blood. See how the spikes pierce already dried blood from other wounds. The spikes to the foreheads were designed to kill them. These other wounds . . .'

In soft gesture he ran his hand down each tortured body.

'These occurred some time before. These other wounds were to extract information. Look at the placing of them. The sensitive areas of a man. The areas that would elicit pain and words.'

'These scorches, Boss, what caused them?'

Taking the torch from Yun's top pocket. Away from the arc lights' onslaught, backtracking, halfway to the door spilling yellow light and inquisitive faces. The warehouse little used. Dust of weeks, months, years, but through it, two sets of stuttered trails.

'Di, his Deputy, they were unconscious. Dragged to where they are now. Dead weights.'

He indicated the trail with the torch's steady beam. Footprints. Quite clear.

'There were four of them. One either side of each victim.'

Already the label 'victim'. Fellow comrades in arms. Officers that he had shared drinks with, investigations with.

Another, a fifth track slightly to the right . . . following. Shoes, not boots as the others. Shoes, soft-leathered, expensive. The Big Man observing.

'*Cadre*, Boss. Giving the orders.'

Piao knelt down and held the torch at an obtuse angle.

'Wheels. They were wheeling something.'

Walking back to the albino pool of light, avoiding

the fragile trail of evidence. His eyes upon the victims' wounds.

'A branding iron, Boss?'

'No. They used an oxyacetylene torch. They wheeled the cylinders and torch in on a trolley between them. Everything planned like a military operation.'

The Senior Investigator paced the circle, his eyes focused on the dead eyes.

This is where they had stood as they lit the oxy-acetylene torch. As the questions were framed and asked. As fierce blue flame bit yellow and black.

Moving out of the oasis of light, just. Stooping with the torch beam picking out a detail. Between the wooden boards, a small object. Carefully with his back turned, so that Yun would not see him, Piao pulled a set of tweezers from an inside pocket. From another pocket a clear, sealable plastic bag. Between fine steel blades, held to eyes and nose, a cigarette butt. Different. Perfumed, rich tobacco. Expensive and foreign. A cigarette from a *cadre*'s mouth. Dropping it into the bag and sealing it.

'Who hated Detective Di this much, to go to this trouble?'

Yun shook his head.

'Did he have any known enemies?'

'No, not like you, Senior Investigator.'

A smile. No, not like me.

'What was he working on?'

'I wouldn't know, Piao. Homicides. You know, nor-mal homicides.'

'Lately. Anything unusual? Anything at all?'

'No, no. Nothing at . . .'

'Speak, Detective. Speak, even of shadows.'

'Days ago Di got a call to a suspected homicide and left immediately with his Deputy. Something sensitive over in the construction site at the Shanghai Stadium. Something that only he and his Deputy saw, with all others kept away. Could have been anything.'

Loosening his tie.

'I didn't see them until the next morning. Wouldn't even talk about it. Wouldn't talk about anything, and you know what he was like, an opinion about everything and a comrade that always had a joke to tell. This time nothing.'

'But that is not unusual, Detective. Perhaps he had an argument with his wife, or a stomach ache from a late-night bowl of *jiaozi*. Or maybe one too many homicides to witness . . .'

'No. No, Piao. You know Di, a man of routines . . .'

Yes, routines. A fully completed docket to pick his nose. An action plan to scratch his arse. That was Di.

'When I saw him at ten a.m., he'd be doing his paperwork from the call-out, regular as clockwork. But this time he and his Deputy were drinking tea and whispering. I made a joke, but they walked away. Something was wrong.'

'Did Di file any report?'

'I don't think so.'

'Did he file any samples for forensics?'

Yun shook his head.

'He couldn't have. I was in the laboratories at midday filing my own samples. A domestic homicide, as usual. They went straight to the front of the queue, which they would not have done if Di had filed anything.'

It was all making sense. Piao knelt once more.

'With such an inducement as an oxy-acetylene flame, they will have got the information they required. Who could keep it from them? Or perhaps this was all just to serve as a warning?'

For an instant closing his eyes. In orange-veined silver half-light, he could have sworn that he could still hear the screams, unanswered in the dark vastness of the warehouse's interior. Like radio activity, permeating the warehouse's very brick, wood and concrete.

Voices. Movement at the other end of the warehouse floor. A line of officers moving through the far doors, across the floor.

'Stop. This is a closed area. A serious crime has been committed. No additional personnel are to enter this building.'

A voice weakened by the distance answered Piao.

'We have more lights, Senior Investigator. Also the City Scientific Officer is here and the PSB scene of crime's photographer.'

'This is a closed area. No admittance. No admittance to anybody.'

'But the City Scientific Officer is insistent, Comrade Senior Investigator. He demands entrance to the scene of the crime.'

'I am Senior Investigator Sun Piao. I have authority over this investigation.'

'But Comrade Officer, the Chief Scientific . . .'

'Do you have a pistol, Officer?'

Seconds before the answer floated back in the darkness.

'Yes, Comrade Officer. Yes, I have a standard-issue pistol.'

'Well, Officer, what I suggest is that you stick the front end of it in the Chief Scientific Officer's ear and escort him out of the premises.'

'And tell him to fuck off.'

The Big Man's leer was visible even in the meagre light. Many seconds before the last words from the officer echoed around the warehouse floor.

'Yes, Comrade Officer. Thank you, Comrade Officer.'

Double doors closing. Yun stooped close to Piao.

'We should have let them in, Sun Piao. There must be an investigation. There will be repercussions. You just cannot tell a senior *cadre* to "fuck off". I am not like you, I like order in my life. I need order in my life.'

The Senior Investigator seized Yun's hand and forced it closer to Di's head. Running the Detective's palm across Di's forehead and through his hair.

'What in the ancestor's name was that for? What is wrong with you?'

Allowing Yun to pull his hand away.

'He is dead. Life no longer possesses him. Is that enough order in a life?'

The Senior Investigator standing, pacing, a coldness shifting into him. Every body slumped at his feet, humanity discarded, meant a little more of his own humanity, frostbitten. For the first time, avoiding their open but dead eyes.

'We shall carry out the crime scene investigation ourselves. We shall take the scene of crime photographs ourselves.'

Walking into darkness, finding comfort in losing shape and form. Only Yun's voice reminding him of who he was and what he was.

'Why? Why, Senior Investigator?'

Piao was at the door before he answered.

'Because I do not wish to stand above any more comrades crucified to a warehouse floor.'

*

Revolving patrol-car lights. PSB officers against walls, on stairs, propped against patrol cars. Loud jokes about disembodied tits and pussies. Loud laughter, quiet jokes about politicians and the Party. Nervous eyes, nervous smiles.

All around him activity, Piao now slumped in a void of terrible, all pervading loss. Then, without warning and fangs bared, as if he were there, back in *Ankang*. Remembering, or thinking that he remembered, what the old man in the corner crib of the ward had said.

'If you really want to do yourself in, push the blade

in here and slice upwards. That really fucks the doctors up.'

And remembering the series of faint scars, and not so faint scars, across the old comrade's wrist. Rail tracks to nowhere. Five or six on each wrist. And noticing that none of his scars were sliced upwards. None of them.

'You really think that they'd kill us as well, Boss?'

Breath against the side of face as he was shunted back to the here and now.

Silence saying more.

'Shit.'

Scars and death still clinging to the interior of Piao's eyes. Turning in blue light. Enough, just the look. Yaobang consumed by its chill. Moving closer.

'What, Boss, there's fucking more?'

'If Di wanted forensic samples examined, but not through our *fen-chu*, not through our science laboratories, where would he go?'

The Big Man, eyes watering diamond bright.

'Nie. An old boy at the forensic science labs, Boss. He has a love of whisky and "wild pheasants". He'll do the occasional *guan-xi* job.'

'Is he good?'

'Sure, Boss, the best. Di used him a few times. Remember that triple murder in Yu Gardens a year ago, the *cadre* with high Party connections? Di used him then, he told me.'

'Find out if this Nie was given anything. If he was, I want it.'

Across Piao's face, light as red as a capsicum.

'And give him this, I want it analysed.'

From his pocket he took the pastic bag, the cigarette butt, and pressed into the Big Man's palm.

'Let us see what kind of magic he can perform. Also, help him collect what equipment he needs and get him to a safe place.'

'Sure, Boss, then we can just give it all to Zoul. Let him handle it. He's the Chief, Di and his Deputy, they were his men. We can walk away. Get on with our lives.'

Eyes meeting.

'Shit. You're not going to walk away, are you, Boss? But we're not in Homicide any more. We're in fucking Vice.'

The Senior Investigator lit two China Brands, giving one to the Big Man, as he watched a *Hong-qi* glide along the riverfront.

'Too late. We are in, whether we like it or not. You do not witness what we have seen without there being complications. It is too late to walk away. You know this.'

'Why fucking us, Boss?'

Piao spat a shred of tobacco from his tongue.

'Why not?'

*

Chief Comrade Officer Zoul's visit was brief, lasting only the time that it takes for ten steel spikes to be

levered back through flesh, bone, skin, and for triple-ply nylon body bags to be burdened with their cargo and loaded into an unmarked ambulance.

Wiping his hands, finger by finger, on a mono-grammed handkerchief, he glanced at the Senior Investigator.

'What are you doing here? This is Homicide Squad business.'

'I was informed by the Homicide Squad, Comrade Chief Officer. They thought that I might have an insight into what was found.'

Dabbing his mouth. Piao watching, thinking that it was the whitest handkerchief that he had ever seen.

'An insight. An insight, eh? Dangerous things insights, especially in a case such as this.'

Watching him. His eyes, crow black with no reflection.

'You did well, Senior Investigator. I can see why you are so highly regarded. To limit observation of what was found, the bodies in the warehouse. Sensible, extremely sensible.'

'And what now, Comrade Chief Officer, Sir?'

Zoul's handkerchief dabbed at his forehead. It was cold, but the Comrade Chief Officer was sweating.

'Now. Also a dangerous word, Senior Investigator. You make a habit, Sun Piao, of using dangerous words. Such words could lose one the power of speech.'

'Is that a threat, Comrade Chief Officer Zoul?'

'No, Senior Investigator Sun Piao. I am stating a fact.

There are things that I, that you, cannot speak of. For risk of losing our tongues. There are things that you cannot ask.'

'But you wish to speak, Comrade Chief Officer. You also wish me to ask. I see it in your manner. I see it in the hushed conversation that you had with Yun as you entered the warehouse. You knew that Yun would contact me, Comrade Chief Officer. You are a good officer, you know your men.'

Zoul's eyes filled with the blackness of the Huang-pu's waters.

'You wish to have a conversation with me, Comrade Chief Officer Sir. You wish us to have an understanding. An understanding that will be binding, but which you would deny existed within seconds of us parting.'

'Very perceptive, Piao. No wonder there are those that would fear you.'

'I will do the talking, Comrade Chief Officer, and you can remain silent for risk of losing your tongue. Yes?'

A nod, slight and unreassuring.

'Di and his Deputy, the ambulance was unmarked, they will be cremated this night. By morning their families will have received their ashes in an urn.'

Again, a nod.

'There will be no autopsy. No forensic examination. No investigation. No report. No file.'

Zoul coughed, a nod stitched into its spasm.

'There are other agendas at work here. Di, his Deputy, they are a side dish, not the main course . . .'

No reaction.

'Di, I knew him well. I will not allow his death to go unmarked, unnoticed.'

Tears to the corners of Zoul's eyes. Surely from the breeze across the river's broken back?

'I understand, as you say, that which can be said and that which cannot. But this investigation, it will go ahead. It will be an unofficial investigation. The act of a friend for a friend.'

'An investigation, official or not, is not a good idea, Piao. Not a good idea at all.'

'And you will stop me, Comrade Chief Officer?'

On the river a black ghost of a ship passing. Only its running lights visible; shivering to the engine's roll.

'I did not say that, Senior Investigator. I am only stating that the support that I, the support that the *fen-chu* can provide, will be . . .'

'Limited?'

'Extremely limited, Senior Investigator.'

'I will need some resources, Comrade Chief Officer. I will need money for *guan-xi*. I will need computer equipment. Private access to the Internet, no restrictions.'

Zoul, accepted this with a reluctant nod.

'Why the Internet?'

Knowing that he would get no answer. No answer coming.

'There are many restrictions, Senior Investigator. Laws. Permits to obtain. Personal use of the Internet with

no restrictions is as rare as a woman without an opinion. But it can be arranged.'

Buttoning the collar of his coat, the Comrade Chief Officer. Piao moving with Zoul towards the Red Flag. A sleepy-eyed chauffeur threw his cigarette onto the cobbles and opened the door; an immediate odour of antique leather and fat septuagenarian arses.

'Comrade Chief Officer, did Di express any concerns to you, or to any other comrade officer?'

'No.'

'Did he produce any reports that would throw any light on the horrors that we have just witnessed?'

'No.'

The door started to close.

'But there is a file, Senior Investigator. Tomorrow you shall have that file.'

And through the small gap at the top of the side window.

'This file, it did not come from me. It is a door. Nothing more, Piao. A door. You understand?'

Slowly pulling away, the *Hong-qi*, its window gliding fully closed.

'Yes, I understand,' said the Senior Investigator, walking back to the river.

8

Heaven lends us a soul. Earth will lend us a grave . . .

Obey the customs, the rites. Not to do so can bring ill fortune. Can wreak disaster upon the family of the deceased.

If you are old, respect cannot be shown to a younger person whom life no longer possesses. Especially a bachelor. A *guang guan*, a 'bare branch'. His body should not be brought into the house, but left in the funeral parlour. No prayers should be said for him, not even by his parents. If it is a baby that should die, your baby . . . no funeral rites can be performed. No prayers whispered. Your little one will be buried in complete silence.

There is much to do in the house of one whom life no longer possesses. All statues and deities covered with red paper, so as not to be exposed to the body or the coffin. Mirrors removed from sight. A white cloth will be hung in the doorway of the home. If the deceased is male, a gong placed on the left-hand side of the entrance and on the right-hand side if the deceased is female. Do not dress the deceased in the colour red, as this will surely cause them to become a ghost. Clothes

should be white, brown, black or blue. Their faces to be covered with a fine yellow cloth. Their body with a light blue cloth. Their hair comb, broken in two. One half placed within the coffin. The other half retained by a family member.

During the wake do not wear jewellery.

Do not wear red, the colour of happiness.

Do not cut your hair for forty-nine days.

During mourning, wail and cry. It is a sign of respect, of loyalty.

Do not be late to the mourning, or you will have to crawl to the coffin on your knees.

Burn the prayer-money throughout the wake or your loved one will not have sufficient income in the afterlife.

Provide for the monk who, with his chanted Taoist scripts, through the long night will smooth the path of the deceased soul into heaven. Provide for the musicians; music played on flute, gong, trumpet, smoothing the passage to the afterlife.

Be a volunteer to carry the coffin to its resting place. A blessing bestowed by deceased to pallbearer.

Be attentive. If the procession needs to cross water, the deceased must be informed. Not to speak of this will cause the soul of the dead to be left behind on the other side of the river.

Feng shui demands that the cemetery be located on a hill. Your plot should be high. As the coffin is lowered into the grave, all faces must be turned away, or ill

fortune will surely follow. Ill fortune will also follow if all items of clothing that have been worn for the funeral are not burnt.

Be sure to mourn your loved one for 100 days. Be sure to wear the appropriate piece of coloured cloth on the sleeve of your jacket to signify this mourning. Black for the deceased's children. Blue for the grandchildren. Green for the great-grandchildren. For up to three years you will wear these pieces of cloth.

If a child or a wife should die, do not mourn. Wait for the seventh day. On the seventh day the soul of your departed one will return to your home. You will place a red plaque with a suitable inscription outside the house. On the seventh day all family members shall remain in their rooms. Give yourself comfort on this day. Dust the floor of your home with talcum powder. Dust the floor of your home with flour. After the seventh day, when your room is left behind, witness the visitation of your loved one's soul on a field of white.

So serious, death. Treat it as you would a ripe peach. A peach, yes. Treat death as a very delicate peach.

9

Soong Ching-Ling Mausoleum, the Hongqiao Road

White, the colour of death

Dove-white clad mourners moving across delineations of brown. Earth scratched to darker earth. And smells that graveyards have, of rust, dripping out its iron life, and freshly dug sods with worms wriggling.

A view over shoulders, of shoulders. The urn, interned, bricked up. A plaque fixed in place. A chiselled name with the year of birth and of death. Stone letters carved in stone. A darker grey set in grey. Generous, the PSB. Looking after its own and meeting all of the substantial costs.

Through the graveyard, back to the house, the walk colder than when coming. Funerals, always colder on the walk back. Piao turning to the Big Man.

'This investigation, you do not have to . . .'

Ahead, Di's widow, her hands, knuckles white in the clasp of her children's hands.

'Don't worry, Boss, I'm in. What the fuck, I'm not going to wait around to get what Di got.'

Ahead, tears and comforting words. Prayers and cold feet.

Piao, hand to pocket, passing a note. The Big Man unfolding it. Reading.

'Zoul agreed to help . . .'

'Shit, he said he'd give you all these American dollars?'

Reading.

'Five thousand Panda Brand. Two thousand Marl-boro. Twenty bottles of Southern Comfort. Twenty bottles of Teacher's whisky.'

'*Guan-xi*. We will need to grease a few palms.'

'And a few throats, eh, Boss?'

'They will know our Shanghai Sedan. We will need the use of another vehicle.'

'Difficult, but leave it to me, Boss. Nothing that a handful of those dollars and a few bottles of Southern Comfort won't sort out.'

'On which subject, how far have you got with Nie? Has he got anything for us?'

'He's got stuff, Boss. Told me. And I've already arranged a meeting in two days' time.'

'He is safe?'

Outside the flat, mourners cleaning their shoes. Washing their hands in bowls of water. Remnants of the cemetery washed adrift. But not the tracks of tears down their cheeks and not their memories.

'Sure, but he didn't like it, Boss. Didn't want to leave work. Didn't want to leave his house and go to a safe address. Didn't want to do anything . . .'

'Until?'

'Until I told him what they had done to Detective Di. Soon changed his mind. Packed in two minutes flat. What about this file that Zoul was talking about, Boss? Any good?'

'A door. There were four reports in the file. Four investigations. Di had worked briefly on all of them. Four young women. The reports state that they were all prostitutes. All were attacked, cut up, mutilated. Three were found dead in the waters of the Wusongjiang. No leads. Not one. There were no witnesses. Or no one willing to say that they were a witness.'

'And this is a "door", Boss? Sounds more like a fucking wall.'

'The last attack was a week ago. The *yeh-ji* is still in the First People's Hospital on the Wu Jin Road, Hong-kou. She's too ill to be seen at the moment.'

'So we do have a witness, Boss?'

'If she survives and is willing to talk. Someone played a game with her, with a razor. She was then dumped in the river at Suzhou Creek. She only just survived.'

Moving up the communal staircase with its smells of cooking, babies and sadness. A queue of tears. Mourners in a slow-moving, staggered line. Whispered words to a widow and to fatherless children.

'What do I say, Boss, to Di's widow? What do I fucking talk about?'

A hand on the Big Man's shoulder. Words in solemn whisper.

'What you do not talk about is a crucifixion, an oxy-acetylene torch, or steel spikes.'

Images stacked in Piao's head, never far from being summoned up. Layer over layer.

'You speak of other truths. What a fine comrade he was. What a good man, fine husband and loving father.'

Closer, the front of the queue to the widow. So close. Able to smell her tears of sweet honey and the most bitter of lemons.

'You speak of other truths.'

*

In aspic, that instance of time that stands on tiptoes still. Day turning off, lights switching on.

Moving through Xietulu where it intersects Jihueilu. Piao, shielding his eyes; a black shadow stripe over a face slowly being gilded.

'If you were going to crucify somebody, how many spikes would you use?'

'Fuck me, Boss, what a question. Di's widow's tears are still warm on my face and you ask me something like that.'

'How many?'

A blast on the horn. A shoal of quicksilver Forever bicycles parting, like a carp's belly to a sharp knife.

'Two, Boss. I wouldn't want to waste any time, so I'd double over the hands and use one spike through the two of them. I'd do the same to the feet.'

'The one through the forehead?'

Turning sharply into Fuzingdonglu. Red lights in a smear across the windscreen.

'Unnecessary. Too much stuffing to the dumpling, Boss. If the spike to the forehead was to kill them, it could have been done a lot simpler. What about you, Boss, how many spikes would you use?'

'Two.'

Laughing, the Big Man.

'Practical bastards, the two of us, eh, Boss? Children of the hardships following the Cultural Revolution.'

Green flooding the Sedan's interior.

'So why did they use five, Boss?'

'I do not know. To guess is cheap. To guess wrong is expensive.'

The windscreen wipers stuttering to life. An end in view, an end of sorts. The apartment, home, clenched in shadow, squeezed in premature nightfall. A place where life was lived with the vitality of a coat hanging on a coat hook. Stepping out of the Sedan, fending off the rain's insistence. Through the open quarter window hurried words.

'Who can guess what it is that is in the heads of such murderers.'

Pulling up his collar.

'They are as the rain, unpredictable.'

Piao's whisper, at one with the snare beat rhythm of the rain falling on his head, as he walked towards his apartment.

'Five spikes. Five. As the points of the People's Republic's star.'

Public Security Bureau,
Divisional Headquarters, Hongkou

9.30 a.m. the next day

In the tray holding the incoming mail was a fastidiously wrapped package, marked for the personal attention of Comrade Chief Officer Zoul. A tick, irregular but persistent, kicking off above Zoul's left eye. Slowly peeling the layers away, as with a large gold onion. Not daring to rip the paper. Not daring to hurry the process. Last layer, gently slit and slipping aside. The Comrade Chief Officer falling back in his chair. Perspiration beading his forehead. Trembling fingers pulling the small plastic bottle from his tunic pocket. Fumbling the lid off with sweaty, panicked fingers. The pill to his heavily coated tongue; a taste of sugar giving way to an all-consuming bitterness. And all of the time his eyes never leaving the exposed contents of the package.

Slowly, the panic abating. Rising, head swimming, legs uncertain. Pulling open a deep filing-cabinet drawer. So many deep filing-cabinet drawers. So many things hidden in their locked, pressed steel innards. From its depths, removing a report, brief, sketchy,

hastily compiled. Across its print, across the name signed at its bottom, Senior Investigator Di ... fingerprints of concrete dust.

Moving to the small grey cabinet in the corner of the office. A flick of a switch. Print, signature, all shredding to meaningless tatters. A sigh, but lost in the shredder's bite.

Moving back to the deep filing cabinet, taking the contents of the package from his desk and placing it within the darkness of the drawer. But stopping before the drawer had fully closed. A last look. The contents of the package, a bright steel spike and a pair of pitted lensed oxy-acetylene goggles. And in the very back corner of the same deep drawer, cement streaked, a cap badge. A People's Liberation Army cap badge. The cap badge of a very high-ranking officer.

<p style="text-align:center">★</p>

Dialling the prefix 39. A long number, routed through its own exchange. A secure highway for *cadre* deals and gossip. Powerful *guan-xi* and powerful threats. Dialling the number, but with each digit hoping that the telephone would not be answered.

Within two rings, her voice, its edge-honed blade softened only by the sound of waves running to shore in the background.

'Madam, it is Comrade Chief Officer Zoul.'

Silence.

Closing his eyes as he spoke the next words.

'Madam, there have been complications. I have stood by my word to you. Exactly to the letter. I have kept to our, our . . .'

'Arrangement, Comrade Chief Officer?'

'Exactly, Madam. Exactly . . .'

Silence.

'I have protected him, sheltered him. I even transferred him to a new department to keep him safe. But, but . . .'

'But, Comrade Chief Officer Zoul?'

'But, Madam, he is as a river that does not recognize its banks. A river that floods and follows its own path. Sweeping, I might add, all before it.'

Silence.

'Madam, although I transferred him to the Vice Squad, a now redundant department due to the magnificent achievement of our Politburo, Senior Investigator Piao has become involved in a complex and highly sensitive investigation.'

Silence.

'The *tai zis* that he is compelled to investigate are dangerous. Very, very dangerous . . .'

Silence.

'His blunt methods. And to be candid, Madam, his refusal to, to . . . how can I put this delicately?'

'What you are attempting to say, but with little success, Comrade Chief Officer, is that he refuses to turn his back on an investigation.'

'A maggot in the rice bowl, Madam. He refuses to bend, as we all must. He refuses to sublimate his individuality for the good of the group.'

Silence. Just an electronic white noise of disembodied voices.

'You could be talking about Mao, Comrade Chief Officer.'

'Really, Madam, I must protest. I really must . . .'

'You must do what exactly, Zoul? Shred the files and reports for him? Hide the evidence, ignore the witnesses because he will not? Too late, Comrade Chief Officer. Too late. How can you wrap a fire in paper?'

Silence.

'You have failed to protect him, as was our agreement. But never let it be said that I am not understanding. Not magnanimous. You will let me have the details of the case that he is involved in. You will let me have the details of the *tai zis* that he is investigating. By courier. By tonight, Zoul. Is that understood?'

'Yes, Madam. Thank you, Madam. By tonight, without fail. By tonight. Thank you. Thank you . . .'

Still apologizing, as she placed the receiver back onto its cradle. His clammy-handed words, still filling her ears, even as the fine caramel sand fell between her toes. Watching as the child, her child, played on the sand. A dance of innocent joy, kicking over castles made of sand. And knowing that her only words to him as

she passed to feel the cool waters from India, Africa, lap against her feet would be:

'Little comrade, dance on your castles of sand. Little comrade, I know a big comrade who is just like you.'

10

Piao, waking exhausted, his head full of memories, of dreams, indistinguishable from each other. Washing and shaving with cold water, the heater broken. Dressing. The flat too small to live in, too big not to. And so much to avoid: photos, possessions, memories.

Static in the centre of the living area. Watching the minute hand's crawl. Always on time, the Big Man. Always.

To the minute, the Shanghai Sedan's horn. The spell broken. Feet across paper mosaic of letters. Door closing. Stained steps. The car. The Big Man's jokes. Through traffic, a short stuttered drive. A tea house on Jinlinglu. Tea and peanuts, pickles, *mantou* and jokes. Always the Big Man's jokes. He remembered, even at the start of the agonies of detoxification; the process that would bleed *Ankang*'s will from him. A pill, sweetly pink, between the Big Man's dirty fingertips. Holding it up high, between his eyes. Almost to his mid-forehead. A pharmacological *bindi*. And the words, slow, deliberately so . . .

'The last one, Boss. The last fucking one.'

Pushing it into Piao's mouth. His fingers a mix of sweat, chilli and ginger.

'Think of it as your virginity, Boss. Once gone you can't have it again.'

★

A day of mists. As if a damp, white teacloth had been thrown across the city.

Crossing the Nanpu Bridge and following the river's 'S' bend as far as the Lujiazui, the new financial trade zone. Billions of dollars in marble clad, chrome and neon-striped spills. Where there were once orchards, now glass and concrete in vertical soars. Where there was once paddy fields, now stripped pine floored Thai restaurants and sparse, cold-windowed designer outlets. Even the pedestrians with a different look. A new look: suits and clean underwear. Rolex gold watches, encircling wrists not turning jade. And on their breath, the smells of the *dahu*, the new money people. Fashionable smells only: lemon grass and tequila, aushi and Jack Daniel's. Where once it had been China Brands and Tsingtao, street vendor noodles and yesterday's tea.

A spike above Century Park, the Oriental Pearl TV tower. The third highest in the world: 468 metres of eleven spheres and columns of steel holding them in place. Locals saying that it looked like 'two dragons playing with a pearl'. The tourist board saying that it resembled 'a string of pearls falling onto an emerald plate.' The Senior Investigator was less poetic. Every time that he saw the tower, which was every day, think-

ing that it looked like a great ballpoint pen conceived and designed in the head of a dyslexic.

A sight-seeing floor was situated in the upper sphere. On a sunny day you could see as far as Sheshan, Chongming Island. On a sunny day you could see for ever. It was not a sunny day. A damp flannel of mist in the air. Views only of the Huangpu River, the Bund and Long Dong Avenue.

Also in the upper sphere, a revolving restaurant, a disco hall, a piano bar, and tourists smelling of '2 in 1' shampoo and traveller's cheques, drinking American beer, German beer, every beer except Chinese.

Under a crimson spotlight, a pianist in formal dress suit, smiling with cerise teeth. Over-reaching himself musically, vocally. Stumbling into a race between hands and lips. 'New York, New York', sung in Shanghainese Sinatra.

'Boss, outside. Next to the telescope.'

A middle-aged man. Someone who had, from birth, always looked a pale imitation of himself.

The door swinging, closing in a huff of squeezed air. A chill from the mist. A taint of traffic noise. A tinge of sulphurous high notes from the Yellow Dragon's breath. From 263 metres above the city looking like a place that you might want to live in.

'Boss, this is Comrade Nie.'

The scientist pulled up his collar, his eyes like two bees trapped in a jar.

'This is my boss, Senior Investigator Sun Piao.'

'Thank you for your help in this matter . . .'

Piao held out a hand. The scientist ignored it.

'Do I have a choice?'

'Choice is a luxury for those who have silk underwear and are free of holes in their shoes.'

'*Wangba dan.*'

A curse from the soul.

'The third time, Investigator. The third time this year that I have had to leave my home and my job and go into hiding.'

Shaking his head.

'Since Di gave me this job I have done nothing but look over my shoulder. I stayed away from my place of work except to do what he asked. I even stayed at my aunt's home. That is where your . . . your ape found me.'

Another curse from twisted lips.

'It is not fair. Not fair.'

A panda arm from Yaobang, across the scientist's scrawny shoulders.

'What is fair, Nie, except for a *yeh-ji*'s perfumed breasts, eh?'

The scientist smiled, as fleeting and as sincere as a politician's honesty.

'Now, my clever friend. What have you got for us? We are here to be amazed.'

Nie, his voice small, like watered-down beer.

'It will cost you . . .'

Nervously looking around.

'Two more bottles.'

'Two more bottles! What do you think we are, a fucking Friendship Store?'

Tutting, the Big Man. Shaking his head.

'What do you think, Boss?'

'The two bottles of Teacher's that we agreed. Two more if what you have will lift a little mist from this investigation.'

Licking his lips, the scientist. An indecisive cat. Yaobang gently shaking the plastic bag in his hand. Bottles of liquid gold jingling together in 40 per cent proof music.

'Tighter than an oyster's shell, you PSB. OK. OK.'

Deep pockets to his trench coat.

'What I have will do more than lift a little mist.'

He took a VHS video tape and a large manila envelope from his pocket. Tapping the black casing of the tape.

'A death sentence here, Senior Investigator. It was retrieved from a CCTV system . . .'

Looking over his shoulder, eyes darting.

'. . . overlooking the site of the Shanghai Stadium, which they are renovating for some of the events in the Olympics. Detective Di got a phone tip-off.'

Ripping open the envelope. Between nail-bitten fingers, deeply glossy monochrome prints.

'I pulled some stills off. Poor quality, though, very poor. I had to enhance some sections, holding back others. Not that I expect PSB like you to appreciate such skills.'

Print following print. Watching in silence, the grim sequence of a girl's abuse and death. In silence, till the last but one.

Spitting to the floor, the Big Man.

'They've got fucking uniforms on, Boss. Who are these bastards?'

'The photographs are too indistinct to see any detail, and everyone in our People's Republic wears a uniform. If you clip a train ticket, you wear a uniform. If you execute a sentenced prisoner by shooting them in the head, you wear a uniform. If you pick up dog shit in the park . . .'

'I know, Boss, I wear a uniform, you wear a fucking uniform. But these fuckers are no train-ticket clippers.'

The last print. Darker. Greyer. Its reticulation, reminiscent of a storm's fat-bellied clouds.

'And this?'

'The one pointing, ordering. Looks like their boss. Thought you'd like a close-up. But poor quality, though.'

Yaobang taking the photograph.

'Ugly comrade, eh, Boss? Imagine having a face like that?'

Acne, its puckered, seersucker ravage . . . not a centimetre of his face that was not filled with night's darkness.

'Well done, Comrade Scientist, you have done well. But the other three, I wish to see their faces also. You can do this?'

'Sure. Sure. I will get some prints for you, but they will be . . .'

'Yes, I know, poor quality.'

'Very poor quality, Senior Investigator. And . . .'

Hesitating, weighing up the price, the cost, every citizen going through such a process.

'It will cost another two bottles.'

'One.'

'One?'

Unflinching, Piao, his eyes as fixed as stone.

'One.'

'You PSB, tighter than an oyster shell, actually more like a duck's arse under water.'

Nie pulled out a second envelope. More prints. Colour, but dusted in delineations of grey.

Hands across mouth, the Big Man. His knuckles white, like unripe walnuts.

'What are we looking at? What are we fucking looking at here?'

But knowing, not needing an answer as print following print.

'Detective Di took them himself. Only he, his Deputy and I, knew about the images, the bodies. There were two separate foundations that he found them in. He said that he thought that they were linked to other murders of "wild pheasants" that he was working on.'

'The girl that they fucking chased, Boss?'

In concrete's aspic where it had met the earth that had cradled it, clasped hand, cherry-red nails, cut of chin, frozen sweep of hair.

'This is the other foundation that they dug up.'

Each side of the concrete block photographed, each topography of horror recorded. The Senior Investigator grasped a small magnifying glass from an inside pocket and looked closer.

'How many, Boss? How fucking many?'

'Many.'

Placing the magnifying glass back into his pocket. Giving himself time to compose himself.

'There are many.'

Nie, pacing, his collar pulled up once more, his eyes darting.

'What a mess. What a terrible mess. I will be murdered over this, and for what? Four bottles of whisky. *Wangba dan*, four bottles.'

'Two,' replied Piao, walking to the balustrade. 'Although, what else do you have, Comrade Scientist? And perhaps four bottles of whisky will indeed await you.'

Deep pockets; as the scientist retrieved the folded papers, already preparing the frame that they would be displayed in.

'I think Di knew. I'm sure he knew that it would end this way. He asked me to keep this.'

A photocopy of a report, barely a page and a half. Di's signature at its bottom. Little detail. No facts. Hurriedly put together. As if it were not a report at all, but simply and importantly, a marker. A last hand extended out of water, saying, 'I'm drowning.'

Piao speaking first.

'This is the only copy?'

'No. He said that the original was with a comrade chief officer.'

Reaching for a name, the scientist. The Big Man putting him out of his misery.

'Zoul, fucking Zoul.'

'Yes, that is it. Comrade Chief Officer Zoul.'

The Big Man's fist thudding down on the steel balustrade.

'Shit, you asked the Chief if Di had given him anything?'

'Yes, I asked him. He said that Di had given him nothing.'

Shaking his head.

'Internal politics, Comrade Scientist.'

The Senior Investigator's arm around Nie's shoulder.

'Where would our People's Republic be without internal politics?'

Smiling, Piao, but unconvincingly, tapping the report with his knuckle. On the top left-hand corner, faint, but legible, a line of numbers written in pencil. A line of numbers, that he had seen before.

473309169972

'These numbers, are they yours or Senior Investigator Di's?'

'No, not mine, Di's.'

'Did he refer to them? Did he tell you what they were?'

'No. Why, are they important?'

Smiling again, the Senior Investigator. This time, passably convincing. Yaobang, moving forward, a question with his eyebrows.

'The number, the same number, it is on the front of Di's file that Comrade Chief Officer Zoul sent me. The three girls found dead in the Wusongjiang. The fourth in the Number 1 Hospital . . .'

'So, this "door", it's now a corridor. Yes, Boss?'

A nod, Piao turned back to the scientist.

'Now tell me, do you have anything else up your sleeve? I can hear your whisky calling to you.'

Deeper pockets. Nie pulling out a sealed plastic bag. A polythene-imprisoned cigarette butt.

'The concrete blocks were placed by cranes onto heavy-duty low-loaders, covered over and taken away. Detective Di didn't know where. The operation was directed by a *cadre* and his own men. Di didn't know him, but told me that he had a scarred face. The *cadre* discarded this unusual cigarette, French, Disque Bleu.'

Piao took the polythene bag from Nie's hand.

'A high-ranking *cadre*. Very high-ranking.'

'How do you know, Boss? It's just a fucking cigarette.'

Sweet tobacco. Sweet perfume.

'Expensive, cigarettes like this would only be available from the Peking City Food Supply Place. You would need a "special purchase card" to gain entrance

to the store. Only Communist Party Central Committee members, heads of the eleven military regions and favoured Party veterans would gain admittance.'

Their gaze meeting, seeing the crows of worry take off in the horizon of each other's eyes. Yaobang shaking his head.

Another plastic bag pulled from the bottomless trench-coat pocket of the scientist. Instantly, Piao recognized his own writing upon it. The cigarette butt found in the warehouse, just metres from Detective Di and his Deputy's tortured remains.

'There is a new DNA test, Short Tandem Repeats. We stole it from the Americans.'

'We steal everything from the fucking Americans. So what?'

The scientist scowling.

'This is not hamburgers, or trainers. This is not Mickey Mouse. It is a highly sensitive test. From a single human cell enough DNA can be duplicated to "fingerprint" the owner of that cell and link them to a crime, or crime scene.'

The salve of scientific lingo soothing him.

'Criminals deposit saliva on glasses, telephones, victims. Under the Short Tandem Repeats profiling system, DNA is measured only at thirteen specific sites, where chemicals are repeated in a kind of stutter. A unique DNA fingerprint can be created from counting these repeats. Except for identical twins, these numbers are highly variable from one person to the other. It can

pinpoint an individual with a probability of one in several billion. A cigarette butt found by Detective Di where the bodies in concrete were discovered and the cigarette butt found by you, Senior Investigator, beside the dead body of Detective Di. They are identical. They bear the same DNA.'

The scientist's hands outstretched in an earnest plea.

'Now can I have my bottles of whisky, Investigator? My four bottles of whisky? I have a deep thirst and I believe that I have lifted enough mist from your investigation.'

*

Walking, although the car was in the opposite direction. Above Century Park, the sun, still mist-bound, but its heat warming the air, shimmering the trees, rippling the steel of parked cars.

Finding the nearest bench. The paths full of people. Life's cycle exposed with the graphic detail of an autopsy. Children at play, toddlers learning to walk, old people in slow-motion stumblings.

'Enough mist lifted, Boss?'

A flight of balloons had been released by a group of young people from the Communist Youth League. The start of celebrations for the Festival of the People's Army of Liberation.

'*Dao-mei*, Boss. Fucking bad luck this case. *Cadres* who smoke expensive cigarettes, who wear uniforms and

murder girls like it was a sport. *Dao-mei*. Especially for the stupid bastards who try to catch them.'

Strong, in a perfumed breeze of caramelized bananas and spent generator fuel, People's Army of Liberation songs. Black-toothed veterans leading bright-eyed boys. Baritone to soprano. Under the spread of richly leafed chestnut trees, chests puffed out in pride.

> *'Arise! Arise! Arise!*
> *March on! March! March on!'*

'We should gather evidence from wherever we can, and pass it on. Pass it on, Boss. My mama used to say, "Only when you get everyone to contribute their firewood can you build a strong fire." It's Zoul's job, let him deal with it.'

In response, Piao pulled a crushed pack of China Brand from his jacket. Lighting two, pushing one between Yaobang's lips.

'There are only so many roads from the site of the Shanghai Stadium that low-loaders would have been able to take. Check them.'

Smoke falling lazily between them.

'Even when serving argumentative customers, shop-keepers notice such things as huge low-loaders negotiating difficult corners. Shiny-shoed office workers will remember massive tyres spewing mud. Those women, those girls, they were somebody's babies, somebody's children. They will be missed, mourned.'

A deep draw on the China Brand's butt, as if his life depended upon it.

'We find out who they were. What it was that they did. Then as the flea follows the rat's back, we will find out why they died and who would have gained from such deaths.'

For an instant, closing his eyes as the nicotine hit.

'We will trace death back to its lair. We will trace death back to a man who smokes Disque Bleu cigarettes and then who crucifies PSB investigators in his spare time.'

Seeing the Senior Investigator's eyes, Yaobang's heart sank.

'Shit, Boss, you're really going to take this case on, aren't you? Why? Because they were comrades, friends?'

'We are going to take this case on because no one should die as they died, and because we both know that those who murdered were not wearing the uniform of one that clips train tickets.'

> 'Brave the enemies gunfire,
> March on!
> March on!
> March on!'

'We will collect the firewood ourselves. We will light the fire ourselves. It will be a wonderful fire. The strongest fire that you have ever seen. A fire that will light up the sky.'

*

The Shanghai Yu Yuan Import Export warehouse

Two a.m.

Frayed incident tape. Black stairs. Bolted doors. Checking his watch for a rough approximation of the time. A fake Omega, the minute hand detached within a week of purchasing it. Now following the hour hand around the dial as a faithful hound walking at its master's side.

'Shit, Boss. Time for work, and I haven't gone to fucking bed yet!'

Piao turning, one finger across his lips, calming the Big Man. Just the sound of the city breathing.

Moving around the side of the warehouse; mud and discarded things. A pram, bald tyres, a bicycle and a half-bag of dried cement, a dead dog. Rounding the rear of the warehouse, the only light from a wine bar's scarlet neon half a block away. Everything with the edgy hue of danger.

'There.'

A whisper. A point of finger. From the *long*, through the nettled undergrowth, bent weeds pointing the way to a rickety spiral staircase leading to the fire exits.

'What the fuck . . .'

Again, finger over lips. Climbing, black step over black step. Yaobang following, lifts of shoe sole, flap of coat. Levelling out, steps to gridded floor. The first floor. A floor known well. But the Senior Investigator climbing higher.

A door to the second floor, bolted closed. A whisper, as his hand gently rattled the door for effect.

'Fuck all up here, Boss.'

But Piao looking upwards toward the roof, the stars. Blue eyes seeing what he was seeking. Carefully pulling himself up, his fingers into brick handholds and his feet onto the narrow steel balustrade. High above the bolted door, slotted just below the eaves of the warehouse roof, a gap. With difficulty the Senior Investigator pulling himself up and silently in. A few seconds, and a hand coming out of the hole. Fingers beckoning, pulling on night air. Yaobang, not built for climbing, wobbling precariously, pulling himself up the steel and brickwork. Fingers, broken-nailed, scrabbling for holds. Sweaty palms grabbing the Senior Investigator's hand, as he was half-pulled up the remainder of the wall and into the hole. Still muttering gratefully his prayers to the ancestors as he lay on a darkly boarded loft floor, only ceasing as he felt Piao's finger across his lips in a cold warning. Still the city breathing, but now a new sound, of burdened hours laid down and of sanctuary from life's storm. Snoring, deeply resonant and rhythmic.

A small torch from the Senior Investigator's pocket. Yaobang, hand in pocket, unholstering his pistol, but Piao pulling his hand aside. A whisper.

'No.'

Reholstering his pistol. Following. Piao picking his way through the cathedral pitched loft. Forests of piping. Jungles of smudged shadow shifting with each step

and change of angle of the torch. And with each step the snoring louder and the smells more defined. Of sweat and dirt in layer over layer. And of sour memories.

'There.'

Between hot water pipes a collection of ripped, frayed bags. At their centre a bundle of rags. Startled, the bundle rising, forming a shape. A man, a vagrant. Struggling to get to his split-soled shoes. Yaobang blocking the vagrant's path. The man spinning towards the Senior Investigator, his face illuminated by the torch beam, dirt black. Rough, matted beard and wild eyes.

'*Tong zhi*, it is OK . . .'

Panic, turning again. Running into the Big Man. Arms engulfing him. Slowly, Piao approaching, hands open, his palms exposed.

'*Tong zhi*. Old Comrade. We are not here to harm you.'

Struggle giving way to resignation.

'You *wangba dan* . . .'

Spitting on the floor.

'*Ganbu*, thieves. What do you want of an old man? I am a veteran. A Red Guard veteran. It was I, and fellow comrades, who arrested Lin Biao.'

Gasping for breath. Fervour and uncertainty firing his fixed gaze.

'Lin Biao, the Director of the School of Political Training for the Army.'

Flexing himself against the Big Man's firm embrace. Strong for an old papa.

'The Great Helmsman gave us the order himself. Pulled the smirking-faced *ganbu* by the ears like a squealing pig.'

Spitting once more. Its reach longer. Falling between Piao's feet.

'No respect. No respect. *Wangba dan.* Now you come for me. *Wangba dan.*'

'Old man. PSB. We are fucking PSB.'

Spitting again, between Yaobang's feet.

'PSB or not, old man. One more spit near me and I'll crack your thick skull.'

A double take of the side of the old *tong zhi*'s face.

'He's the vagrant that found Di, isn't he?'

Moving forward, Piao. Bleached by torchlight the old papa's features, wrinkles washed away, suddenly forty years younger. A Red Guard in smooth-faced prime. At the back of his eyes, the light of a mission. Of orders, thoughts, enshrined in the *Little Red Book.*

'"All our *cadres*, whatever their rank, are servants of the people, and whatever we do is to serve the people. How then can we be reluctant to discard any of our bad traits?"'

A smile seeping onto the old comrade's face.

'*The Quotations of Chairman Mao Zedong,* second edition, 1967. It has been a long time since I have had the Great Helmsman's words quoted at me, Comrade.'

'It is a long time since I quoted the Great Helmsman. Fashions change.'

'Fashions! The quotations of Mao are not about fashions. *Wangba dan*. They are about a golden path. A golden path that was fought for with tears, blood. My comrades, friends, dead in the mud.'

Piao's hand falling to the old papa's collar, wet with spittle. Wet with tears coursing down his cheeks.

'*Tong zhi*, our children, only one out of every three even knows who the Great Helmsman was. Times change. People change.'

A nod to the Big Man, his tree trunk arms slowly releasing. The bundle of rags sinking to the smelly pit of holed blankets. Head in hands, the papa, sobbing.

'Too many changes. Too many changes. They strand you on an unknown beach. Your life and where you live it now unrecognizable.'

Into the torch and Piao's eyes, the old *tong zhi*'s gaze.

'I have seen much. Too much. Too much for just one lifetime.'

His face bruised black and pink.

'One of the worst things that I ever saw, a *Guomindang* officer walking across a muddy field. Walking on the bodies of my comrades in arms so that he would not get his leather boots muddy.'

Sobbing. Shoulders rising, falling, with heaving, ripped breaths.

'Too much. I have seen too much. I am haunted by the ghosts of my comrades. It is now time that life no longer possessed me.'

The back of Piao's hand across the old *tong zhi*'s cheek, wiping away discoloured tears.

'Not yet, Comrade. Not yet your time to die. Now tell me of the other worst thing that you have seen in your momentous life, *tong zhi*?'

'You already know this, Comrade Policeman.'

'Yes. I already know, but I need the power of your words.'

To the Big Man.

'Our old papa saw what happened on the first floor of this warehouse. He saw Detective Di and his Deputy interrogated and murdered.'

'How do you know, Boss?'

The Senior Investigator's eyes never leaving the old papa's.

'A vagrant is trapped by his possessions. His cross to carry. What I saw did not fit into place. In the crowd, standing, he had nothing with him. Not a bag, not a bundle. Unusual for a vagrant, who is like the tortoise. He had already made this place his sanctuary.'

Dabbing his eyes, face, the *tong zhi*, on a dirty blanket.

'You have a keen eye, Comrade Policeman.'

'Yes, but not as keen as yours, *tong zhi*. That night, tell us what happened.'

Silence.

'Their noise woke me. Footsteps; something being dragged, wheeled, and then screams.'

Rubbing the clarity back into his eyes with his frayed cuff.

'They had put them onto the floor. Two men. Your two men. They drove nails into each hand. Each foot. The screams. *Wangba dan*, the screams. As pigs make when they are castrated. Enough to wake the night. But it did not, it only woke me. I saw them through a small hole in the corner of the floor. As the last nails were driven in, I saw them. Men dressed in dark clothes. One, their boss, asking questions . . .'

'Questions?'

'Questions, mainly to the older one.'

'What questions were being asked?'

'Over and over again, about an investigation. Who else had been there. Names. Reports, had they filed any reports. Evidence. Evidence. He kept asking about evidence. Where was it? Who had it? Who had they spoken to?'

Faster the words, but more garbled.

'He said little, the man. Just one name, Zoul, I think it was. And things that did not make sense. About a video tape, or something. Then they lit the torch. *Wangba dan*, the torch. As bright as the sun, that torch . . .'

Shaking his head.

'Their screams. And through it the sound of their

flesh burning. And the smell like sweet pork past its best. They screamed and screamed. *Wangba dan*. How their screams were not heard across the river . . .'

Wiping his mouth and beard with the sodden end of the blanket.

'The boss, the one with the scarred face, he was getting impatient. He ordered that they burn them more and more. And more deeply. Even I knew that these men had nothing more to say. What this boss wanted was not in their heads or their hearts.'

Face downcast, just the top of his head in the torchlight, his long, thick, wavy hair, a curtain hiding his face.

'The boss gave an order, and suddenly it stopped. Your officers would have felt little. The hammers were very heavy and the spikes were very sharp.'

Piao kneeling, a hand on the *tong zhi*'s trembling shoulder.

'This man, this boss with the scarred face . . .'

'A *ganbu*. A *ganbu*. *Wangba dan* . . .'

'How do you know that he was a *cadre*, Comrade?'

Pulling his face up level with the Senior Investigator's, each word seared by anger.

'You think that I would not know a *ganbu*? Maggots in the rice bowl. *Wangba dan*.'

'What can you tell me about this "maggot", *tong zhi*? What else did your fine eyes see?'

'The *ganbu*, he was young. Younger than me. Younger than you. Perhaps thirty years. A Shanghainese

by birth, by his words. But his accent was afflicted. He had been educated abroad.'

'You're sure about this, old daddy?'

The vagrant fired a look at Yaobang. This *tong zhi*, now old and worn down by life's heel, but in his younger days not a man whose shadow you would want to have had passing over yours.

'I am not your daddy, Mr Policeman. Do not doubt me, a comrade who helped liberate this city and whose fellow comrades' blood washed this city's gutters clean in the process. A fact that you would do well to remember.'

Unsettling, the light at the back of the old papa's eyes. Not the first time that Piao had witnessed its coal ember glow in the eyes of old Red Guards.

'This *cadre*, you would recognize him again?'

The *tong zhi*, a hand grasping Piao's collar and pulling him forward. Close. Breaths mixing. Each word from the old papa's mouth, as fruit rotting on the branch, acidic and sweet.

'Yes, I would know this *ganbu*. There is no *ganbu* who has crossed the path of my life that I cannot remember.'

Yaobang laughing. Kneeling beside the Senior Investigator.

'It was dark, old man. A *cadre* looks like a *cadre*. The suit, the shoes, the fatty meat complexion. Seen one, you've seen them fucking all. How can you be so certain that you'd recognize this one?'

'*Wangba dan.* I said that I would recognize him and I mean it. This *ganbu*, he was once as I am.'

Piao calming the *tong zhi*, stroking his face.

'What do you mean that he was once as you were, old papa?'

'He was once like me. See, see . . .'

Grabbing Piao's hand, the old vagrant directed the beam of the torch directly onto his own face. Onto his mouth, lips. With his other hand, smoothing the hairs of his straggly moustache and beard, upwards, away from his top lip. The fruits of his mouth exposed. Harelip in split, ripe tomato hangings. Cleft palate in a dark valley of divide.

The *tong zhi*'s hands falling to his lap. Many seconds before he wiped his mouth with the blanket and spoke once more.

'In my village, in my life, there was never the privilege or the money to correct birth's mocking. Unlike him.'

Smiling. For the first time, smiling.

'Imagine, a *ganbu* and a vagrant joined together by the same curse. Imagine. A political statement in this, yes?'

Patting the old papa's face.

'Yes, *tong zhi*. One that even the Great Helmsman did not foresee. I think that identifying such a *ganbu* as this, Comrade Policeman, will be within even your capabilities.'

'I am sure that it will be, old papa. But I would sleep

better at night if you allowed us to protect you. These are dangerous criminals, powerful criminals.'

'Do you think that I am worried about your sleep, Comrade Policeman, when you have rudely woken me from mine?'

A deep, phlegmy laugh. Grubby fingers pulling the holed blanket over his head.

'Now fuck off and let me be. Even a *guang guan*, even a harelip such as me needs his beauty sleep.'

11

The mouth of the Yanandonglu Tunnel, Pudong

The Jin Mao building, 420 metres of sculpted glass and fashioned steel. The People's Republic's tallest hotel.

In the maze of *longs* beyond the entrance to the Yanandonglu Tunnel, there was a local tea house held in the permanent shadow of the Jin Mao building. An anomaly amongst chrome and marble, the tea house sat forgotten; clinging by bitten fingernails to a place that it no longer belonged to. The tea house, as a loved grandmother, now long past her best. A little frayed. A little too much make-up. A little worse for alcohol. But a little bit of how Shanghai used to be before the dollars sloshed and the diggers bit and the cranes hauled even higher. Still the same tea house, the best in Shanghai. Still the best tea and *baozi*, the steamed bread filled with meat.

But now, whether day or night, the tea house ten degrees colder than the surrounding buildings. Now, whether day or night, the tea house in darkness. As if it had been banished to another land. A darker, colder land.

In the tea house, a menu of bright smiles and easy pockets. No extra *fen* for the view, because there wasn't one, or the white linen tablecloth, because the tabletops were bare, or the marble cladding, the chrome's sparkle, the pianist's winking smile, because the tea house was devoid of all of these trappings. Just tea as you have never tasted before. And the mama's wobble-hipped sway between the tables and her broad smile at being left a tip of a few bent-coined *fen*.

A cigarette, a tea.

'Is this all you have for breakfast, Boss?'

Piao pushed a full ashtray away, pulling a fresh one closer.

'No, sometimes I vary it. I have a cigarette, a beer. Another cigarette, another beer.'

A beckon, a wink towards the mama at the kitchen hatch. Formica and steam. His best smile, the Big Man. Amalgam and macerated peanut.

'Mama Lau, more of your specialities. And more of your delightful smile.'

Minutes of crashing activity. Chipped cups, stained glasses on a wobbly tray, moving in between the tables to Mama Lau's hips in synchronous roll. Plates unloaded. Pickled vegetables, peanuts, *Mantou*, stuffed with red bean paste. *Doufu*, soya cheese. Tsingtao beers, and *hongcha*, red tea, as bitter as a widow's tears.

A full beamed glare of false teeth as the mama swept like a tanker around the tables, back towards the kitchen, followed by Yaobang's admiring gaze.

'Built like a fucking tenement block, eh, Boss? Just how I like them.'

'Like them, but never had them.'

'Now, now, Boss. A bit grumpy aren't we? Not enough sleep? Come, eat, Boss. A man needs to eat, especially active comrades like us. You have to keep your energy levels high.'

Tea washing the bitterness away with sweetness, in two gulps, the cup empty. Across its insides, across the Big Man's tongue, a seeding of shredded leafed *hongcha*.

'I mean, shit, you never know what's around the corner in this job.'

Piao stirring the tea again, three times, and then another for extra luck.

'I want you to go and see the Comrade Chief Officer. Tell him nothing about what we know or what we have seen. Tell him only of what we need now. The computer equipment. The Internet connection. We will operate from my flat.'

'Isn't that taking a bit of a risk, Boss? Why not a safe house out of the city? These murderers are not shy about blooding a PSB uniform.'

'For now we stay here. A panda is not an unusual sight amongst a group of other pandas, but place it within a herd of buffalo . . . Then see Chief Warden Mai Lin Hua at Virtue Forest. Rentang. I want him out early to do some work for us. Mai Lin Hua can fix it. He owes me. He owes me big . . .'

' "The Wizard". What's the bastard in for this time, Boss?'

'Profiteering and selling pornographic images over the Internet. Bring him to my place early tomorrow. He can base himself there.'

'Think he'll give me some free samples, Boss?'

A look over the chipped crescent moon of the cup was enough. The Wizard, not a man, as any Shanghainese mama would say, who would even give you the 'drippings from his nose'.

'Anyway, what do you want him for, Boss? You know what he's like. He'll shit in your back pocket and tell you it's loose change.'

'He has specialist skills. He can reach places that we cannot. "*Cao-mu jie-bing*", always a good tactic if you get the opportunity.'

' "Turning the dead cat", and a fucking dangerous one, Boss.'

Silence as the mama cleared plates, replacing the gaps on the table with more food, more drinks. Pickling vinegar, *hongcha*, the steam from fresh *mantou* ... the combination of sweet smells, earth smells, reminding Piao of funerals. So many funerals.

'The roads from the site, the Shanghai Stadium, you checked them?'

'Sure, Boss. What else have I got to do with my life? Two routes. One, nothing. Asked in shops, bakeries, offices. No one saw a thing. The second route less high-

profile. It runs parallel to the A-20 highway through the Nan Hui District. Past the Sun Qiao Agricultural Zone it runs north to the Huangpu, just past the Yangpu Bridge. Checked it all the way. Not a garage, house, or shop that I didn't call in on. Less high-profile route, but more twists and turns than a fucking whore's walk across the city on a Saturday night.'

Opening another Tsingtao on the side of the table.

'Two low-loaders. Everybody on the route saw them, couldn't miss them. Big bastards. Got caught at every junction, every fucking turn. Ploughed across one garden, the old mama had a right go at them.'

The thirst of a stray dog at a puddle. Finishing the bottle in three swallows.

'The route comes out on a concrete pier, an old wharf almost under the bridge itself. Checked the place out. The derricks are still working and had been greased up and used recently. Also cigarette butts in the cabs. And beer cans.'

'Any foreign cigarette butts?'

A shake of the head as Piao poured another cup of *hongcha*.

'Asked around. An office block across the river. Some of the workers – you know, suits, ties, and fucking tight arses – they saw two large barges being loaded up. Couldn't see much else, though, Boss. Everything shrouded in tarpaulins.'

The Big Man picking up another beer, his anger circling its bruised cap.

'You have more to tell me.'

'How do you know that, Boss?'

The Senior Investigator sipping the tea.

'"Investigation may be likened to the long months of pregnancy, and solving a problem to the day of birth. To investigate a problem is, indeed, to solve it."'

'So, who said that, Boss?'

'Mao Zedong.'

'He said a fucking lot, didn't he?'

Fingers worrying away at the Tsingtao's bottle cap, the Big Man.

'Should have handed this job over, Boss. A mistake, a big mistake.'

Shaking his head. Finally opening the bottle, its shiny bottle cap spinning to floor.

'The low-loaders, Boss, I've checked it over and over again. All the witnesses say it. They had PLA markings. The low-loaders had People's Liberation Army markings.'

12

'*What really counts in the world is conscientious-
ness, and the Communist Party is most particular
about being conscientious*'

Chairman Mao, Moscow, 17 November 1957

The People's Republic of China.
56 million Internet users.
17 million computers linked to the Internet.
250,000 Chinese-language websites.
200,000 cyber cafés . . .
Many open twenty-four hours a day . . .
Many with 1,000 Internet-linked computers.

Such is the hunger . . .

*

Such is the hunger that all Internet service providers are
required to install specialist software. Recording every
message sent and received. Messages that violate any
law, such messages are to be reported, and forwarded to
three government agencies. The Bureau for the Protec-
tion of State Secrets. The Ministry of Public Security.

The Ministry of Information. The message is then to be deleted.

Such is the hunger that all ISPs have signed a public pledge of thirty-one articles to promote 'self-discipline'. To promote 'patriotism and the observance of law'. Surfing, reaping the rewards that the Internet can bring, whilst creating a firewall that will save the populace of the People's Republic from what is beyond. Ideas that could corrupt. Tastes that could water the mouth. Viewpoints that might taint.

Such is the hunger that sixty sets of stringent regulations to govern Internet cafes, enforced by eight ministries, led by the Ministry of Public Security, have been released. A business must be closed between the hours of twelve p.m. and eight a.m. A business cannot be located within 200 metres of a school. A business must check the identification papers of its customers before they use a computer. A business must not allow its customers to access 'subversive' material. A business must show its records and customer details to the authorities on request. 'Walkers' are now employed in every cyber café. Looking over shoulders. Monitoring each Internet user. What they access. What they send. What they open.

Such is the hunger . . .

13

Nine a.m. A key in the lock, turning. Instantly awake. An adrenalin rush. The door opening. Her face, its residue still in his eyes.

'You all right, Boss?'

Disappointment, a lead weight to the heart. Wishing, and at the same time not wishing, that it had been her.

Yaobang stooping, picking up mail. Behind him, Rentang, the ex-PSB computer genius whom they had nicknamed 'The Wizard'. His pale face dominated by the square oversized frames of his spectacles.

'Got your package, Boss,' Yaobang nodding behind him.

'Stupid bastard. He was more nervous coming here than staying on in Virtue Forest. Some people don't know when their dumplings are stuffed or not.'

Piao pulled a blanket around himself as Yaobang 'persuaded' Rentang towards the living room. The Wizard sitting reluctantly on the edge of the worn couch, arms folded across his rough prison shirt.

'Number one, fat Detective, I'm nobody's package and you and your Senior Investigator boss are not

stuffed dumplings. As soon as your back is turned, I'm off and back to Gongdelin.'

Removing his spectacles, wiping the lenses with his cuff. His eyes, nervous black meat-flies.

'People have a habit of dying around you two. I don't intend to be one of them. *Dao-mei*. That's what you are. Fucking *dao-mei*.'

'Hasn't lost his sense of humour, has he, Boss?'

'No. No, he has not.'

Piao took the letters one by one from the Big Man's hand. One by one tearing them up and throwing them into the cold fire grate.

'The equipment?'

Looking at Yaobang.

'Zoul promised it this afternoon, Boss. The full package. Also telephone lines and an Internet connection. He'll be able to start working this afternoon.'

Smiling. The remnants from a hurried breakfast of peanuts and pickled vegetables still across the front of his teeth.

'Be happy in your work, Comrade Rentang.'

'Fuck off, fat man. I just want to do my time in Gongdelin and start afresh. Someone with my skills will always be in demand. I'm the best there is. The very best.'

Piao moving into the bathroom. The sound of water. Cold. Bitter.

'You will do as we ask. We want names. A *cadre*, Shanghainese, but educated abroad. Possibly PLA.

Possibly PSB, but look also within other bureaus. He likes killing girls, raping them. He enjoys torturing comrade officers.'

Behind spectacle lenses the Wizard's eyes expanding.

'He might already be known for his violence, or for depraved sexual acts. But he has friends in high places and they have already leant on our Comrade Chief Officer, so these records might not be in the usual places. So look in the unusual places ... and he has a harelip.'

Rentang moving to his feet.

'Harelip? Torture? Killings? Friends in high places? Your mother's a "turtle's egg", Piao. I'm doing nothing for you. *Ta ma de.*'

Turning, walking towards the door. The Big Man, one hand pushing him back into his chair. Piao, his shirt falling to the floor; water, with a reluctance, soaking into polyester. Pulling on a fresh shirt.

'I want the lot. Personal histories, personal data, *danwei* records, financial profile, associates ...'

Returning to the living room and lighting the last cigarette in the pack. The first of the day. The best of the day.

'There will be other data needed also. Data to add to a file of Investigator Di's that I am wading through. Three prostitutes murdered; a fourth, a survivor, cut up.'

'Then let him do it. *Ta ma de.* Di, the lazy fucking bastard.'

'You have more to tell me.'

'How do you know that, Boss?'

The Senior Investigator sipping the tea.

'"Investigation may be likened to the long months of pregnancy, and solving a problem to the day of birth. To investigate a problem is, indeed, to solve it."'

'So, who said that, Boss?'

'Mao Zedong.'

'He said a fucking lot, didn't he?'

Fingers worrying away at the Tsingtao's bottle cap, the Big Man.

'Should have handed this job over, Boss. A mistake, a big mistake.'

Shaking his head. Finally opening the bottle, its shiny bottle cap spinning to floor.

'The low-loaders, Boss, I've checked it over and over again. All the witnesses say it. They had PLA markings. The low-loaders had People's Liberation Army markings.'

12

*'What really counts in the world is conscientious-
ness, and the Communist Party is most particular
about being conscientious'*
<div style="text-align: right;">Chairman Mao, Moscow, 17 November 1957</div>

The People's Republic of China.
56 million Internet users.
17 million computers linked to the Internet.
250,000 Chinese-language websites.
200,000 cyber cafés . . .
Many open twenty-four hours a day . . .
Many with 1,000 Internet-linked computers.

Such is the hunger . . .

<div style="text-align: center;">★</div>

Such is the hunger that all Internet service providers are
required to install specialist software. Recording every
message sent and received. Messages that violate any
law, such messages are to be reported, and forwarded to
three government agencies. The Bureau for the Protec-
tion of State Secrets. The Ministry of Public Security.

The Ministry of Information. The message is then to be deleted.

Such is the hunger that all ISPs have signed a public pledge of thirty-one articles to promote 'self-discipline'. To promote 'patriotism and the observance of law'. Surfing, reaping the rewards that the Internet can bring, whilst creating a firewall that will save the populace of the People's Republic from what is beyond. Ideas that could corrupt. Tastes that could water the mouth. Viewpoints that might taint.

Such is the hunger that sixty sets of stringent regulations to govern Internet cafes, enforced by eight ministries, led by the Ministry of Public Security, have been released. A business must be closed between the hours of twelve p.m. and eight a.m. A business cannot be located within 200 metres of a school. A business must check the identification papers of its customers before they use a computer. A business must not allow its customers to access 'subversive' material. A business must show its records and customer details to the authorities on request. 'Walkers' are now employed in every cyber café. Looking over shoulders. Monitoring each Internet user. What they access. What they send. What they open.

Such is the hunger . . .

13

Nine a.m. A key in the lock, turning. Instantly awake. An adrenalin rush. The door opening. Her face, its residue still in his eyes.

'You all right, Boss?'

Disappointment, a lead weight to the heart. Wishing, and at the same time not wishing, that it had been her.

Yaobang stooping, picking up mail. Behind him, Rentang, the ex-PSB computer genius whom they had nicknamed 'The Wizard'. His pale face dominated by the square oversized frames of his spectacles.

'Got your package, Boss,' Yaobang nodding behind him.

'Stupid bastard. He was more nervous coming here than staying on in Virtue Forest. Some people don't know when their dumplings are stuffed or not.'

Piao pulled a blanket around himself as Yaobang 'persuaded' Rentang towards the living room. The Wizard sitting reluctantly on the edge of the worn couch, arms folded across his rough prison shirt.

'Number one, fat Detective, I'm nobody's package and you and your Senior Investigator boss are not

112

Possibly PSB, but look also within other bureaus. He likes killing girls, raping them. He enjoys torturing comrade officers.'

Behind spectacle lenses the Wizard's eyes expanding.

'He might already be known for his violence, or for depraved sexual acts. But he has friends in high places and they have already leant on our Comrade Chief Officer, so these records might not be in the usual places. So look in the unusual places ... and he has a harelip.'

Rentang moving to his feet.

'Harelip? Torture? Killings? Friends in high places? Your mother's a "turtle's egg", Piao. I'm doing nothing for you. *Ta ma de.*'

Turning, walking towards the door. The Big Man, one hand pushing him back into his chair. Piao, his shirt falling to the floor; water, with a reluctance, soaking into polyester. Pulling on a fresh shirt.

'I want the lot. Personal histories, personal data, *danwei* records, financial profile, associates ...'

Returning to the living room and lighting the last cigarette in the pack. The first of the day. The best of the day.

'There will be other data needed also. Data to add to a file of Investigator Di's that I am wading through. Three prostitutes murdered; a fourth, a survivor, cut up.'

'Then let him do it. *Ta ma de.* Di, the lazy fucking bastard.'

stuffed dumplings. As soon as your back is turned, I'm off and back to Gongdelin.'

Removing his spectacles, wiping the lenses with his cuff. His eyes, nervous black meat-flies.

'People have a habit of dying around you two. I don't intend to be one of them. *Dao-mei.* That's what you are. Fucking *dao-mei.*'

'Hasn't lost his sense of humour, has he, Boss?'

'No. No, he has not.'

Piao took the letters one by one from the Big Man's hand. One by one tearing them up and throwing them into the cold fire grate.

'The equipment?'

Looking at Yaobang.

'Zoul promised it this afternoon, Boss. The full package. Also telephone lines and an Internet connection. He'll be able to start working this afternoon.'

Smiling. The remnants from a hurried breakfast of peanuts and pickled vegetables still across the front of his teeth.

'Be happy in your work, Comrade Rentang.'

'Fuck off, fat man. I just want to do my time in Gongdelin and start afresh. Someone with my skills will always be in demand. I'm the best there is. The very best.'

Piao moving into the bathroom. The sound of water. Cold. Bitter.

'You will do as we ask. We want names. A *cadre*, Shanghainese, but educated abroad. Possibly PLA.

'He's fucking dead, you arsehole. Crucified with steel spikes, and then this harelip played on his body with an oxy-acetylene torch.'

Rentang visibly paling. His face turning as lead grey as his spectacle lenses.

'A good man, Di. A good man. Did me a few favours. Looked in the other direction more than a few times.'

Piao throwing a pad of paper onto his lap. Virgin white sheet, except for a single number spiking its centre.

473309169972

'This number is on that file. Discover what meaning it has. '

Unable to find a comb, the Senior Investigator dragging his fingers through his wet hair.

'It could be a report number. Possibly a case number. A passport number? Start close to home, PSB, Party records, *Luxingshe*, and work your way out. You will live here, sleep here, shit here, until the job is done. Deputy Investigator Yaobang will enlarge upon what I have said in his usual eloquent manner.'

The Wizard, his eyes avoiding Piao's.

'Three more months in Gongdelin and I'm a free man. A job across the river or in the New Territories. A life and dollars by the bucket-full. And so, *wangba dan*, Investigator. You keep your sad life, I'm out of the sewer that you and your fat Deputy run in.'

Attempting to stand, but the Big Man's palm in his chest, pushing him back down as Piao looked at him.

'I also want to know how I managed to be released from a hand that does not relax its grip: *Ankang*. Where the trail leads back to. Who put me in, who took me out.'

'You're not hearing me, Piao. Did *Ankang* turn you deaf, or did the medication turn you stupid? You're bad news, yesterday's news. You're dangerous, Senior Investigator. My days of doing shitty jobs for you are over.'

Again, attempting to stand, but pushed deeply back into place. The Senior Investigator carefully placing his China Brand in the ashtray. Pulling a large envelope from a drawer and tipping its contents onto the Wizard's lap. Rentang taking the spectacles from his fingers and placing them oh so carefully on the bridge of his nose. Photographs, so familiar, taking shape. Blurs into focus. Images translating into a rising pulse rate.

'Your better work, if I may say so. Of course the court did not have the opportunity to appreciate that, did they? They never got to see these more personal photographs.'

One by one, turning them over in Rentang's lap.

'That is Comrade Bai of the Supreme People's Procurate.'

Another print.

'The *tong zhi*, Lu Shiying, Head of the Institute for Legal Sociological and Juvenile Delinquency.'

Another print.

'Comrade Yang Chun Xi, Associate Professor at the Institute for Crime Prevention at the Ministry of Justice.'

Yaobang looking from behind, his hands braced on the Wizard's bony shoulders.

'Fuck me, who are the *yeh-jis*, Boss?'

'The prostitutes were brought in specially from Hong Kong. That one was sixteen years old. That one, also sixteen. The one on her knees is just fourteen years of age.'

'It's good to know that our most esteemed comrades are keeping abreast of juvenile delinquency and crime prevention, eh, Boss?'

Piao gathering the prints up and slotting them back into the folder.

'Good scam, Wizard. Your business associates put on a party. Free alcohol, drugs, sexually transmitted diseases. What *cadre* could refuse such an offer?'

Rentang's cheeks, with the crimson blooms of a 'wild pheasant's' lipsticked kisses.

'How did you get the images? From a wardrobe? A telephoto lens?'

Resealing the folder. The Wizard's eyes never leaving it.

'I stand in a wardrobe for no one. State of the art technology. Fibre optic, remotely controlled.'

Standing over him, Piao.

'I have just saved your life, Comrade Rentang. Black-mail carries a death sentence. Working for me in this flat, just the risk of a few bed-bug bites.'

In his tadpole eyes, calculations. Checks and bal-ances.

'This folder, I will get it back? It will be mine if I do what you ask of me?'

'Absolutely.'

'For me to do with as I wish?'

'Completely.'

Mathematics. The mathematics of *yuan*, dollars, euros. In his head, an instant multiplication allowing for exchange rates. The Wizard smiling.

'OK. You have a deal, Investigator.'

'No, Wizard, it is you who has a deal. "Is not the colour of a crow's arse also black"?'

Holding out his hand to shake Piao's, but the Senior Investigator already turning towards the front door, folder of photographs under his arm.

14

The First People's Hospital, Wu Jin Road, Hongkou

On the brink of the Wu Jin Road, as if too nervous to attempt to cross it, the hospital. A vast hand of discoloured white stone, from some angles seeming to beckon. From other more obtuse angles, warding all away. And even before its gaping outer doors, the odours that all hospitals seem to possess. For Piao came reminders of *Ankang*. Disinfected water in a dented bucket. Fresh shit, old vomit, doctors' eau de Cologne, and above all, lives rotting on the vine.

A room at the end of a once white-walled corridor, now yellow with nicotine.

China Brand swiftly pulled from lips, tunic buttoned, a nod from a sleepy-eyed PSB Officer as Piao and the Big Man passed. The officer running back to open the door leading to the victim's room. The Senior Investigator noticing that his boots were muddy. A good sign. Officers with pristine, shiny boots, never to be fully trusted.

Medical light, harsh, and banishing all mid-tones, and at the very centre of the room a metal bedstead.

Chrome bright bars along its sides. Wrapped in its protective weave, a bundle of bandages and dressings totally hiding a face and head.

Piao sitting, gently taking one of the delicate hands into his own. His fingertips gently over the stitches' secret Braille. His eyes closed for an instant, sensing the steel that had parted such soft, perfect flesh. She had used her hand as a shield. Turning the hand with the gentleness of a lover. Across her wrists, train-track parcels of catgut sutures. A sudden ache deep in his own wrists. Gently laying her hand back to white sheet, wrist down. Sharply turning away, not wishing to see the images starting to form in his own mind.

'You all right, Boss?'

Slowly the pain abating.

'Yes. Just somebody walking over my grave.'

Her torn lips muttering. Words louder, her eyes darting frantically. A panic, legs kicking chromed metal. Arms flailing.

'It is OK . . .'

Piao's hand to her bucking shoulder.

'We are here to help you. You were too ill to see us before. Life held you by just a thread . . .'

His hand across hers, calming the storm.

'We are PSB. We are here to help you. Protect you.'

Her eyes suddenly seeing. Darts of black recognizing the Big Man's uniform. Pupils widening to the gold and red epaulettes, the red star's crimson bloom. Her body

rearing up. A sudden eruption of arms and legs. From beneath the bandages, her mouth opening, lips curling in a piercing scream.

'Fucking pimps. Pimps, fucking pimps.'

Wilder her kicking, her flailing arms bruising against the steel cot. A frightening abandonment of self.

'The bell, get the bell.'

Yaobang wrenching at a discoloured cord. In a faraway nurses' station, a light flashing. Chipped mugs of *lucha* thudding to the table. Tales of boyfriends wandering hands and flowing bank accounts cut short. Feet running, doors slamming back on resigned hinges.

The Big Man and Piao, backs to the cold wall, as the nurse swept into the room. A doctor following, hypodermic already in his palm. The nurse holding her down.

Piao into the doctors' ear.

'Her bandages, when can they can be removed?'

'Why, Senior Investigator?'

'I need to see what has been done to her.'

'A voyeur, Senior Investigator?'

Piao's gaze nailed deeply to the doctor's dull eyes.

'Even in such violence a signature will be present. I do not wish to cause her pain, but I need to see her.'

'*Dao-mei*, Senior Investigator, for you and for her.'

The doctor, too young to shave, but old enough to amputate a leg, walked towards the door.

'But to satisfy your need, Senior Investigator, we will unbandage her tomorrow.'

The door opening. Shaking his head.

'What worth is a *yeh-ji* that has been on a butcher's slab anyway? Who will pay good *yuan* to screw her now.'

Moving through the door and into the corridor.

'They should have left her to die.'

★

The next day

'The Clinical Psychiatrist saw her late yesterday afternoon. He was impressed.'

Impressed. Never hard to impress a clinical psychiatrist, Piao knew. Sanity, insanity, both making an equal impression in the head of such a professional whose stock in trade was the weaving of words.

'He felt, however, that to remove her bandages, as you requested, Senior Investigator, could traumatize her further.'

Crab fingers adjusting the neat row of pens in his top pocket.

'She is calm, much calmer. She is now on powerful sedatives.'

Yes, the Senior Investigator remembered calmer. Dribbling, shuffling, staring into the empty hours that formed one day after another. Yes, he remembered calmer. It came in a plastic bottle, in the shape of pretty little pink pills.

Leaning forward, smiling and adding unnecessarily.

'In fact what the Clinical Psychiatrist actually said was that he was reluctant to allow this cheap show to progress any further.'

Piao moving around the anteroom, counting the steps to diffuse his anger.

'She is believed to be a *yeh-ji* and is a witness to a brutal crime that many other prostitutes have suffered and not survived.'

'But the trauma to her psyche, Senior Investigator. The Clinical Psychiatrist will not allow . . .'

'The Clinical Psychiatrist . . .'

Piao reaching into his inner breast pocket for his documents of authority. Tossing the heavy wallet onto the table. Weathered-hide flipping open; dog-eared papers and the Star of the People's Republic.

'Clinical psychiatrists can be persuaded to say anything, doctor. I know from personal experience.'

Leaving the wallet on the table. The burn of the People's Republic's star so persuasive.

'The girl also has rights in this situation. One of them being to see what the wielding of a razor has done to her. Have you or the Clinical Psychiatrist asked what her wishes are?'

'Her wishes, Senior Investigator?'

'Yes doctor, the patient's wishes. Ask her if she is ready for the bandages on her face and body to be removed. If she says yes, you and the Clinical Psychiatrist will walk away and not look back. If she says no, I will pick up my badge and walk away.'

'Such a practice is highly irregular, Senior Investigator.'

'Immerse yourself in some "irregularity", doctor. Ask her, I insist.'

The doctor was away, consulting, for precisely five complete orbited pacings of the room, Piao counting each pace. When the doctor re-entered the anteroom, he was not smiling. His gaze locked fully onto Piao's documents of authority, as if it were an angry gash that required his full and immediate attention. His words brief.

'The *yeh-ji* wants to see her face, or what is left of it,' was all that he said.

<div align="center">*</div>

Spots, to islands, to continents . . .

Last dressings. The closer to her face and skin the bandages, the stronger, the darker the hues in vicious coloration. A stained curtain of gauze, stickiness finally yielding. A nurse gently bathing her face. Cerise rivulets as tears, falling down her cheek and chin.

'Senior Investigator . . .'

Carefully rising between Piao and the Big Man, the nurse with a stainless steel bowl in her hands. Water with the colour that mature violence has. The doctor's words in Coca-Cola breath against Piao's stubble.

'She is all yours. Be gentle with her. I will return in a minute.'

Moving to the door, the nurse following; it closing in a reassuring huff of air.

The patient, her head unmoving. Slowly the Senior Investigator moving around the side of her. His eyes never leaving what had once been a beautiful face, now just pallid sections of flesh, criss-crossed by railtracks of stitches. But something about her. A brightness of eye. Even in a soporific halfway house, a posture of defiance.

For a reason that he did not fully understand, his heart was held in a vice of pain. About to speak, but the girl, Lan Li, speaking first. Words as unpractised as a baby's first steps. And calm, with the resignation of an evil lived through, conquered.

'The mirror. My face. I wish to see my face.'

From the back of the room, Yaobang bringing the scratched mirror. A look in Piao's direction. A nod. A quizzical look at first in her eyes, as if seeing a reflection that was not hers, but where her own reflection should be. And then a realization. Silent tears, in two silver tracks gliding from her eyes. Crying as she talked. Silent tears, the ones that come from the worst kind of hurt.

'They chased me. I remember losing a shoe. They caught me by the Wusong River. I could not escape.'

Her fingers exploring the reality of her new face, as if she could not trust her eyes solely.

'Three of them and a fourth with a cut-throat razor. The fourth was laughing. Even as he cut me. Laughing. I remember. I remember, but I wish that I did not. They held me down. Over and over again they cut me.

I remember looking up. His face against the sky, and the iron bridge over the river with people walking by. But nobody came. Nobody helped. I remember looking up, the blue sky turning red. My hands were held down. He pulled the cut-throat razor across each wrist. I remember the coldness of the blade.'

Her hand moving to her opposite wrist. Only as she spoke again, the Senior Investigator realizing that he had done the same. The ache inside him almost drowning out her words.

'He pushed another forward as if it was a dare, a game. Holding him on top of me. And all the time the rivers of blood from my wrists.'

Piao wiping her eyes. Dabbing her cheeks. She, calming now, a steely horizon in her eyes.

'And then I was running. I do not know how. Running down the river pathway. The noise of traffic above me. The sound of their feet on the gravel running after me. And laughter. And then I was in the water. The Wusongjiang, its current sweeping me away from them towards Suzhou Creek.'

Piao taking some cotton wool and gently drying her face of tears. So many tears. Only now able to see her beauty and to look past the rudely stitched scars. Her face one of the most perfect that he had ever seen. A rare beauty, stealing the breath away.

Pushing through the door, the doctor. Then standing, held in the Senior Investigator's gaze.

'The men that did this to you, Lan Li, would you recognize them?'

'I would recognize him . . .'

'Him?'

'The one who held the razor, I would recognize his laugh. I would recognize his holed face.'

'Holed face?'

'Acne scars. His face, it looked like the moon.'

Piao's eyes seeking the Big Man's. A glance, brief, but within it, a conversation shared. A whisper, less . . . as Piao passed his Deputy Investigator.

'Doors leading to corridors.'

The Senior Investigator's eyes returning to the girl's.

'Is there anything else that you would recognize him by?'

'His lip. His top lip stitched together. A scar, the skin shiny . . .'

A sudden barbed strike of resonance pulling her back; thinking of her own skin, her own scars. The Senior Investigator stroking her head. So gently stroking.

'And he had the smell of a PLA princeling.'

'A PLA princeling, how can you tell?'

Across her eyes a misting. The eyes of the whore staring at the ceiling, and beyond, to another place, another life, as the punter pumps his load in frantic hunt for hot sex in a cold life.

'His suit was silk from the Peiluomen Garment Store. His shirt from the Paramount in Beijing. His eau

de cologne was Gucci, not an imitation. Italian leather shoes. His nails had been manicured and he wore three heavy gold rings.'

A brief pause, as with pain, she remembered.

'He had eaten pheasant and quail's eggs. These smells were on his breath.'

'A princeling, perhaps. But how can you be certain he was PLA?'

For the first time, her eyes meeting his.

'I am a whore. I know men in a way that only a *yeh-ji* can. He was PLA.'

Delicate fingers, long crimson nails, now broken, unbuttoning her nightdress. Tears streaming, but no sound of weeping.

'And there is more that I will remember him by . . .'

Her full breasts once cushions for the soul, now a racetrack of slits, gouges, gashes. Below her navel a large padded dressing.

'Nurse.'

From the door the nurse silently advancing.

'Are you sure?'

A nod. Slowly, carefully, the nurse's fingers loosening the adhesive tape around the dressings. The last dressing gently bathed away. Cerise rivulets down her inner thighs. On her stomach, precisely fashioned by the cut-throat's geometric carve, the crimson bleed of a five-pointed star. The star of the People's Republic.

★

The tea from the machine in the corridor was bitter, but not as bitter as what he had just witnessed. Pacing, trying to understand that which had no meaning that he could contemplate. Violence, served hot and on the leash of passionate spontaneity, he had an understanding of, but what kind of comrade could coldly carve an intricate design into a woman's abdomen? A design, holy and communist, that was at the heart of every comrade within the People's Republic. Pacing, and knowing with a certain knowledge that never again would he be able to look at the crimson of the communist star and not see a deeply seated wound.

Shaking his head, but the memories of *Ankang*'s abusive legacy like a blow torch burning; emotions rising within him, as if hard-wired into his psyche. A painful empathy, knowing the brand upon the girl and sharing it, her cuts, feeling them as if stroked upon his own skin. A physical scar, a mental scar, little between them in the disabling that they invite. Little between them in the loss of face with a system that he had thought that he had been cradled within, nurtured by, but which had run over him like a stray dog in the road.

The Big Man hiding the China Brand in his jacket between inhalations, his words smoke framed.

'Where the fuck's this investigation going, Boss?'

An illness filling his mouth. Piao poured the remainder of the tea into a stained sink.

'At the moment we are as, "frogs in a well-shaft seeing only the sky". But that will change . . .'

The Senior Investigator moving to the window, through the gaps in the blinds looking out onto the street at the homeward-bound traffic. So many cars. So many homes.

'I know that it will change.'

Turning from concern to investigation. Investigation, the foundation on which he had built his life. Remembering what an old colleague had advised him when he had first been placed as a deputy within the Homicide Squad. Words, smells also, hand-rolled tobacco, moth balls, three-day-old shirt.

'Investigate your own life, yes, young Piao? Take some time from your investigations to look inside yourself.'

Remembering the warmth of the old Investigator's hand on his bony shoulder.

'To know yourself is also to know each victim. And each murderer.'

It was advice that he had never taken. He wished that he had. Hindsight, indigestion to life's rich meal. Sour in the belly, worse in the toilet pan.

'I need to ask her more questions. She's a key that could use a little turning.'

With purpose, Piao moved back into the room. The Doctor stepped forward, his palm raised, but, seeing the expression upon the Senior Investigator's face he moved aside.

'Comrade Lan Li, where did you work? Perhaps this PLA princeling knew you from there?'

The girl's wounds were in the process of being

cleaned, re-dressed. Medicated padding, festoons of clean bandaging and a kidney bowl full of water whose hue was slowly changing to a dull brown.

'The Ming Ren.'

'The Famous People Club on the Beijing Road, Boss. Smart place. Expensive. Exclusive. Just high *cadre* and *tai zi*.'

Piao moved to the bed, watching her face transformed.

'You have an arrangement with the club, the owner?'

So dark her eyes, but no acknowledgement of his words.

'Lan Li I need to know these things. I know that it must be painful for you, but such details could help us in our investigation. Who was your pimp, Lan Li? We will not prosecute him. I just wish to talk with him. Perhaps he has knowledge of this PLA princeling.'

The reply reluctant, whispered.

'You are, Senior Investigator. You are my pimp.'

'I do not understand, Lan Li. What is it that you mean?'

'You do not know how vice works, do you, Senior Investigator?'

'We are new to the department, very new.'

Words, darker. Redder.

'Then learn, Senior Investigator. Learn fast. The Ming Ren, it is owned by the Public Security Bureau. I am owned by the Public Security Bureau ...'

Words, darker.

'So you are my pimp, Comrade PSB.'

15

Ku-hai yu-sheng . . . *'Alive in the bitter sea'*

You hoe the field until your hands bleed. Blister upon blister, as numerous as the Western Mountains. You work in the heat of the foundry, each crucible's pour as hot as the sun. Your skin cracking, as the arid river bed. Eyes as dehydrated as apricots, split and left to August middays. You plant the rice seedlings until your back is as set as concrete. Lying in your bed bent, like a human question mark, unable to straighten yourself.

And then the next day comes, and the next day, and the next . . . *Ku-hai yu-sheng*. 'Alive in the bitter sea'.

And what of the high *cadres*, and the *tai zis*, their 'princeling' sons, how bitter is their sea?

The shops that are guarded by middle-aged women attendants in horn-rimmed glasses and short hair trimmed in pudding bowl shapes, you will not be allowed to enter. It is not a place for you because it is a place for the high *cadres*. They will show their Special Purchase card. They will buy what you cannot.

At number 53 Dong Hua Men Street, foreign food-

stuffs, fine chocolate, wines, Scotch whisky, hams from Italy, cheeses from France.

Number 83 Chao Yang Men Street. Western videos, books, and magazines. And for those in very special favour, those whose *yuan* is plentiful and whose power throws long shadows, western pornography.

The Friendship Stores. Perfumes, luxury items, designer clothing, soft leather footwear, jewellery.

They will have their hair cut in salons that you cannot enter. They will educate their children in countries that you see the silver-winged planes flying to in reflection, in the waters of your paddy fields. America, Britain, Switzerland. Special places held for them on their return, at Fudan University, Beijing University. Special positions held for them within the Party structure. Within the People's Liberation Army.

And in the neon bright clubs in Dainty Delicacies Street that the *cadres* and their princeling sons play in, opium served in silver pipes. A bottle of wine for $200. Whisky for $500. A private room for $1,000. And a whore to comfort them for beween $1,000 and $15,000, depending on what they wish her to do.

Such is the bitterness of their sea.

16

The Ming Ren, 'Famous People' Club, 240 Beijinglu

'Is this a good fucking idea, Boss?'

Late. Two a.m. Moving up the stairs. Street-night colours swapped for the hues that secret night places have. Sharp, rich colours, frosting *yuan*-grabbing hands. Gilding dollar-stuffed wallets.

Yaobang, at the top of the stairs, feeling out of place. A queue with suits, sharply creased, hand-stitched. The Senior Investigator, documents of authority already in hand, roughly pushing forward to the queue's head. Thin, worn linen rubbing past the finest cotton. Polyester bruising against the most expensive silk.

A whisper answering the Big Man's question.

'In reviling, it is not necessary to prepare a preliminary draft.'

Treading on pristine polished shoes. Yaobang, a string of apologies as his boss passed through. A hostess standing at a desk. Either side of her, two guards wearing pith helmets with feathers in the khaki bands, already eyeing him. Already pumping themselves up like tractor tyres.

The Senior Investigator turning, a wink to the Big Man, words few, but understood.

'Do not worry, Deputy, you will live to eat once more. We are just the weasels coming to say happy New Year to the chickens.'

Piao's hand already in the faces of the guards. Red star in fragmented reflection across heavy brows. His gaze turning to meet theirs.

'I am Senior Investigator Sun Piao of the PSB Homicide Squad. I know that I am many months late, but please tell your manager that I would like to wish him a very happy New Year.'

*

The manager immaculately attired, wearing a suit as expensive as a second-hand Shanghai Sedan and with shoes the cost of which could have fed a family for six months. But a snake in a lion's skin. Nothing that was noble or attractive about him; only things of the gutter.

'Who the fuck are you?'

'PSB . . .'

And against his shiny, smooth cheek.

'Vice Squad.'

Laughing.

'Vice? The PSB don't have a fucking Vice Squad.'

Yaobang, against his other cheek.

'They fucking do now.'

Smiling, the manager.

'You can't just walk in here. I don't care who you

fucking are. Unless the whores in the back are your fuck-ing sisters.'

A mouth as foul as a sewer, the manager. Anger rising within Piao, a bitter saline wave. Already feeling a personal hatred for him.

Preened, perfumed high *cadres* in conspiratorial groups. The manager watching as they moved through plush, padded doors and into private rooms. A splinter of gold and red light ... a teasing female laugh as the door closed. Other silk-suited high *cadres*, hiding their faces with soft, white palms, hurriedly walking out of the club, ignoring the hostesses' polite goodnights.

The manager confronting Piao.

'You're ruining my fucking business. My clientele, they do not expect such fucking treatment. They were given fucking assurances.'

Turning to Yaobang.

'What do you fucking pigs earn a month? Two hun-dred? Three hundred?'

Laughing. Gold-capped teeth. Grey-coated tongue.

'You know what it costs to come in here? What a fucking door pass costs? Of course you don't know, because you've got shit between your ears. It costs between five and ten thousand, depending on how good your *guan-xi* is. And your *guan-xi* wouldn't get you into our fucking toilet. Now fuck off.'

His hand pushing at Yaobang's chest.

'Go. Go now or I'll call your *danwei* chairman. He

will not appreciate his favourite club being ruined by interfering flat-footed arseholes like you.'

A nod to the guards. Moving forward, shadows chasing in front of them. The Big Man pushing the manager away and producing his pistol. Sharp into the manager's ribcage. Doubling over, like a kick to a sack full of rotten apples.

'No one pushes a serving officer in the Public Security Bureau. Have I made myself fucking clear?'

An ingratiating smile, but laced with fear. The manager pulling in a breath, sharply painful.

'Comrade Officer, come, come. We're all on the same side.'

Piao into his ear.

'No, Comrade Manager, you have been misinformed. I am not on your side. Now let us keep everything nice and normal. Tell your men to back off, or my Deputy will spread you over the expensive wallpaper of your club.'

'What do you fucking PSB want?'

'A rare commodity. Information.'

'I don't do information.'

'Yes, Comrade Manager. Yes, you do provide information.'

A nod. The Big Man's stubby thumb releasing the safety.

'Now order them back,' Piao pointing at the guards.

'Go fucking back. It's OK. Nothing I can't fucking

handle. Go back to work. What do you think I'm fucking pay you for, you children of whores?'

The guards' shadows receding as they moved back to the main door. The heavy door closed. Prying glances eclipsed by studded leather.

'Thank you, Comrade. Very cooperative. That is what we need in the situation that I wish to talk to you about. Cooperation and team work.'

'Fuck off, whore for a mother. I cooperate with no one.'

A long-legged, red gash-lipped hostess moving from one of the private rooms with a small tray of foreign cigarettes, brightly packaged condoms, pastel-shaded pills. Piao's mouth filled with an imagined sugar-candied sweetness. His tongue clawed by bitter medication.

The manager, his confidence returned, winking at the Big Man.

'You like, yes? Of course you like.'

Laughing.

The hostess walking to a door beside a sheet-copper shod bar. Every soft step, Yaobang's eyes longingly following the slit of her dress, the splinter of her pale shapely leg. A barman, tuxedo, bow tie, scuffed shoes, nodding to her as she pushed the door open. Kitchen clatter and noise, the door swinging closed. Piao walking towards the bar through the same door.

'This way.'

Yaobang, hauling the manager forward. Following

the hostess's perfume to the bar, through the door and into a kitchen. Two chefs loading delicacies onto silver trays. Feilong, hazel hen, fed on ginseng seed. Served in the most delicate of china bowls. Hundred-year-old duck's eggs preserved in clay, straw and quicklime. The egg-white and yolk blending, taking on the appearance of black watered silk.

At a sink a kitchen assistant washing crystal glasses, white ice-snap china plates. Another assistant, shoulder to shoulder, pushing vegetable peelings down a waste disposal unit with a chewed-up stick.

A door to the stinking back *long* open. City smells falling in: the Yellow Dragon's breath, the cars' cough, the dogs' cocked-legged curtsy and beside it a hostess and two others slumped against the alley's rough brickwork. Smoke slowly escaping from thick crimson lips and snaking over eyes that had seen too much for any soul to remain unbruised.

'Tell them to take a fucking break.'

'They have jobs to do. Clients to serve.'

'Tell them or I'll shoot your fucking balls off.'

The manager's gaze meeting Piao's.

'There are many *liu-mang* in our city who have a permanent limp due to my Deputy's trigger-happy finger. I suggest you do as he asks.'

Reading the truth in Piao's eyes.

'Take a break. Take a fucking break.'

Chefs, assistants, hostesses, blank eyes, slow paces

out to the cold night and the *long*. The Senior Investigator closing and bolting the door. Turning to the manager.

'Thank you, Comrade. Our conversation, and what you will need to say to us, it is best not heard by others. Loose tongues can lead to shallow graves.'

'I have nothing to say to you or your fucking dog. I have friends who are provincial leaders. Clients who are government ministers, Politburo members. I have nothing to fear from whore's children. One call from me and your fucking throats will be slit.'

Moving towards the manager, the Big Man's shadow falling across him. Piao wedging himself in between the two of them.

'Over there. Take him over there.'

Pointing to the large sink filled with vegetable stalks and amputated leaves. Yaobang's arms embracing the manager, hauling him across the kitchen. Pinning him in place, tight against the sink. Across his black suit jacket smears of saffron sauce.

'Down there.'

Piao's nod to the centre of the discoloured sink. A black hole stained with vegetable matter. The waste disposal unit. Yaobang grabbing the manager's arm in the vice of his hands and forcing it into the rubber-sheathed mouth of the hole. A stink of rotting things rising up from the sewers.

'Bastards, bastards. What are you fucking doing? You're mad. I don't even fucking know you.'

Wedging it firmly in place. Cufflink torn free. Material, silkily expensive, ripping.

'I'll pay you. That's what you want, isn't it? That is what it is always about with you PSB. *Yuan*. Or dollars. Yes?'

'Information. That is the only currency that will save your fingers.'

Piao's thumb orbiting the waste disposal unit's sunken rubber button.

'We will start with the small things, Comrade Manager, perhaps inconsequential to you but pieces in a jigsaw to me. This place, this Ming Ren Club, what is it?'

Looking up, the manager, laughing incredulously.

'Are you fucking serious? And you call yourself Vice Squad? A whorehouse, idiot policeman, that's what this is. The best, the most select whores in the city. We will need to educate you, Vice Squad.'

'So you admit to breaking the law by adhering to the "olds"?'

'The "olds"? Breaking the law? Fuck you, you motherless bastard. Go into our private rooms. A high-ranking member of the local Party committee being buggered in room five. A visiting chief of the Public Security Bureau in our jacuzzi, being pissed on by two whores. Do you know who owns this club and half a dozen others? The fucking PSB. The law, this is who gives us permission to break the law.'

Laughing again with teeth of gold.

'Big business. They own half the clubs, half the whorehouses in the city. PLA own the rest, and all controlled by the senior officers of the Shanghai Kan Shou Jingbei Si Ling Bu.'

Piao shaking his head.

'The Guard Army of Shanghai Garrison. They own this city. They own the vice, or most of it. They fucking own you. You really didn't know, did you?'

Piao avoiding his mocking gaze.

'So what are you going to do now, screw with a senior colonel in the PLA? Walk into his headquarters and fucking arrest them? They are beyond you, policeman. Beyond everyone.'

'What other business interests do the PLA have?'

'What fucking businesses don't they have an interest in. The PSB are amateurs compared to the PLA. They have big operations. Joint ventures with triads, the Sun Yee On, Taiwan's Four Seas and the Bamboo Gang. The businessmen put up the fucking capital, and the PLA runs the businesses and the clubs. Fuck, I should be paid for this educational seminar. All the clubs along the Yanan Road, all the way to Hongqiao Airport, they're all PLA as well as around the Shangri-La Hotel on the Beijing Road and on the Nanjing Road near the People's Park. All the clubs in the Siping Road in Hongkou, all fucking PLA. Do you know what their operations are worth? Thirty billion fucking dollars a year.'

Laughing, but his eyes never leaving Piao's orbiting thumb around the rubber button of the waste disposal.

'And they have the blessing of our dear leaders in Beijing. Directives that government agencies should become more financially self-sufficient. They've certainly fucking done that. But not many at the highest levels of government and the Party know just exactly how they've done it.'

'You had a girl who worked here. A very beautiful girl, until she was carved up with a cut-throat razor . . .'

The manager's attitude changing; the dark side of the moon. Struggling to pull his hand from the waste disposal's black mouth, the Big Man holding him tighter.

'I see that you recognize who it is that I talk about. Tell me about her.'

Silence. Just distant laughter from a private room.

'Lan Li. Tell me about her!'

'I don't know her. Fuck off you abortions of a whore.'

A stab at the button, as a knife into a fat-bellied pig to disembowel it. Motor, blades, a grinding noise, laced into it, a guttural scream. The kind that is at home in a farmyard, or an abattoir.

'I am sorry, Comrade Manager. I did not notice that your hand was in the waste disposal unit when I turned it on.'

'And I'm a witness, Boss. You were only trying to help them with a few fucking chores around the kitchen, and the idiot starts pushing cabbage leaves down there with his fingers.'

The manager sobbing. Snot in diamond falls from his nose.

'Terrible the accidents that happen in the fucking kitchen. But nothing that a few stitches and bandages won't sort out. Not like the girl, eh, Boss?'

Words, each edged in anger's fine serrated teeth.

'Now, tell me of Lan Li, Comrade Manager.'

'Fuck off.'

A nod to Yaobang.

'OK, OK. A fucking whore we used. Very good. Our fucking best . . .'

Pulling the paper from his pocket, the Senior Investigator. Placing it on the edge of the sink. Stars of spittle and blood. Diluted, but blooming through the cheap paper. Black biroed names. Three names, three dead girls.

'These names, do you recognize any of them?'

'Whores. Why are you bothered about fucking whores?'

'Have some respect. Women, they hold up half the fucking sky, eh, Boss? That's what Mao said.'

'Fuck Mao. I don't fucking know them . . . the truth . . . the fucking truth. Over there. There. The menu . . .'

On a shelf a dozen leather-bound A4 books.

'See, see for your fucking self.'

The Senior Investigator taking one of the menus, brushing half-prepared vegetables out of the way, laying it on top of one of the work surfaces. Quickly moving through the pages. The menu, glossy and detailed. The

menu of prostitutes. Of girls sold on and sold on again. *Mei ming* ... girls stolen, abducted. Girls from the Republic's legion of orphanages. *Mei ming* ... girls with 'no names'. The menu ... their specialities, their special 'tricks'. The most beautiful women that he had ever seen, bright eyes and faces, and shimmering bodies, but as fat sows at market to be sold to the butcher, soft stroke across neck, awaiting the bleed. At the bottom of each page a name. At the bottom of each photograph a number that they could be paged with and the cost of an evening's hire. Lan Li, the menu's most expensive whore by far.

Closing the menu and moving back to the sink.

'We have a description of the man who assaulted Lan Li. A *tai zi*.'

'Everyone, everyone who comes here is a *tai zi* ... everyone's a princeling. Who else could afford a fucking bottle of whisky for a thousand dollars?'

Piao holding up a photograph. A man, his mouth, as a gash, sutures un-picked. Laughing.

'This *tai zi*, he has a scarred face. A bad photograph, but this is the one who we wish to interview.'

Pulling the manager's face up.

'This *tai zi*, he is also a serial murderer. That gives us permission to get any information any way that we can. To those who life no longer possesses, we owe it. Who is this comrade? Who is this princeling?'

'I don't fucking know him.'

Yaobang, taking the manager's bleeding hand in his.

'You know him, Comrade Manager. You know him as well as you know your prostitutes.'

The Big Man crushing the torn fingers. Waiting for the scream to die.

'PLA. He's fucking PLA. High ranking. His father, a big-shot PLA. Very big. That's all I know. That's all I needed to fucking know. This *tai zi*'s men enforcing protection. Money, always after money.'

Piao now reading truth as well as fear in the manager's eyes.

'Used to be easy, so easy. We had our business, PLA theirs. Now he wants it all, this princeling. I know no more than this.'

The Big Man, swathing the Comrade Manager's hand in a tea towel. Piao unbolting the door. An instant smell of stolen foreign cigarettes and pisses onto the *long*'s crumbling brick wall. Chefs, assistants, hostesses, shuffling back in. The Senior Investigator handing the first a clean tea towel.

'Your manager, he really should be more careful with kitchen appliances.'

Walking into the night, instantly chilled, with the Big Man lumbering behind, stealing two dumplings from a tray beside a pouting hostess.

'I don't suppose you'd offer discounts to PSB employees?'

'Fuck off,' she said.

Never had he heard a swearword said with such meaning.

'Your loss.'

Walking a little faster after the Senior Investigator, the second dumpling already rolling around the inside of his mouth.

All the way to the Shanghai Sedan, the manager's shouted abuse and obscenities spilling like shit from an open sewer. But Piao thinking of only one thing, as if it were a shield to hold all else at bay: a five-pointed star carved into a young woman's stomach. The same five-pointed crimson star that sits at the heart of the PLA's uniform badge.

★

The rain that had stopped had started again, the air alive with electricity. By the time that they had reached the sanctuary of the Sedan they were drenched. Rain everywhere, down their necks, cuffs, soaking through the cheap material of their jackets and trousers to their skin. Washing the sickness aside, cleansing the pestilence. And still in his eyes, the girl, Lan Li, once so perfect.

Piao's palms thudding onto the steering wheel. The Big Man lighting a China Brand, tossing the pack onto Piao's lap. Tobacco, not as honey-sweet as the foreign cigarettes that they had smelt, but free of the pimp's gutter touch.

'The girl was right, Boss. A fucking PLA *tai zi* . . .'

Shaking his head.

'A whore knows her clients better than a farmer

147

knows his swine. Now we know why the *fen-chu* moth-balled its vice department. They own half of the fucking whores.'

Windscreen wipers stuttering into reluctant action.

'A fucking worry, and a PLA princeling who will know every *cadre* in every high place.'

Sucking in the oxygen of smoke, the Big Man's gaze distant, beyond cracked buildings and broken *longs*.

'They could put you back in *Ankang* again if, as before, you go up against high-ranking PLA with their fucking Politburo friends. They protect their own, even if they are murderers.'

Smiling, Piao. Reminded of a joke heard in *Ankang*. A good joke. A very old joke.

Two comrade prisoners are against a wall facing a firing squad. They are offered blindfolds. One refuses, cursing loudly. The other comrade prisoner whispers, 'Ssh! Be a good comrade, don't make trouble.'

But Piao's smile only lasting a few seconds, the memory of *Ankang* more powerful than any joke.

'Perhaps do it differently this time, eh, Boss? Play their games and not be so fucking blunt?'

Wiping the sweat from his brow with his cuff, the Senior Investigator. *Ankang*'s taste fading with the China Brand's jaded drags. They were on Jinlinglu before he could find the words to answer the Big Man's question, and then only with wise words borrowed from another.

'"When walking through a melon patch, do not adjust your sandals."'

17

'To be unhappy over a relationship is worthless. You should plunge yourself into the struggle for production, and gradually your wounds will be healed'

The editor's advice page, *China Youth News*

Within the vast forest of the Chinese language, there is no term for the love between a man and a woman. Romantic love, within the People's Republic, has always been viewed as not respectable.

Within China there is no accepted polite expression for the term 'making love'.

A relationship, marriage, seen only as a careful arrangement between two families. Ensuring prosperity and providing children. A business too important to be left to young people themselves. Love coming second to the business of the day. And sex? Sex is something that occurs. Like eating, sleeping, or bowel movements. Sex occurs, like relationships occur. But both, by order, by expectation, taking second place to the Party. To the needs of the People's Republic. The result, a rigid puritanism with Beijing shaping the sex lives of millions of Chinese comrades. Romance, marriage, procreation,

the number of children that a comrade can have, divorce, intercourse, all subject to Party dictates.

An established code of behaviour, simple, but effective.

Shirts on men should always be buttoned to the top. Even more the case for women. Even one button undone is considered lewd, a sign that the wearer must be a prostitute.

In the winter women are always expected to wear jackets in public. Even within the home a jacket should be worn if opening the front door.

In high school girls are to sit separately from boys.

Women should avoid the use of make-up.

To kiss a woman is to propose marriage.

Jokes with sexual innuendo are never to be told in public.

By government edict marriage should not occur until the age of twenty-eight.

To get married one must seek permission from the *danwei*. If there is a 'political blemish' on your records, permission may be denied.

18

'Though death befalls all men alike, it may be weightier than Mount Tai or lighter than a feather'
The ancient Chinese writer Szuma Chien

Imitation Italian cologne, Southern Comfort and a fine reek of sweat; the flat smelling of all of these, in a complex blend.

Rentang. The living space, an office, a warehouse. The Wizard sitting in front of a large computer screen with his crab fingers moving in leisurely choreography across the keyboard and a glass within reach.

His question addressed to the Big Man, but his eyes still fixed on the screen.

'Where have you been? Out all day yesterday. I didn't go to bed until around three this morning and you still weren't home.'

'Fuck me, it's like having a wife, but with none of the sex.'

Piao pulling on his shirt and jacket while checking the mail. Always checking mail, but brown envelopes, only ever brown envelopes. Letters from the *danwei*, the street committee, a letter from the *fen-chu*; the only

letter that he didn't crumple up and throw towards the fire grate. Three days from now, an appointment with Zoul, and the psychiatrist, Tu. There was a real possibility of suspension on medical grounds.

Folding the letter, once, twice. Pushing it into an already crowded back pocket of his trousers.

'So, Comrade Wizard, stun me. What have you got?'

'You don't get miracles in Shanghai, especially in this area. So don't expect any.'

White characters crawled across the screen of the monitor and across his spectacle lenses.

Click. A secure file. Its opening page a crest of gold and red. Stars as burning indented coals. Harsh entrenched characters.

SHANGHAI KAN SHOU JINGBEI SI LING BU

'Fuck. The Guard Army of Shanghai Garrison Headquarters.'

'That's right, fat man, the People's Liberation Army. I got your boss's note.'

A glance at the Senior Investigator.

'I hope that you have the appetite for this, Piao. It gets even better. I've hacked into the central PLA computer database. Used a code-breaker program and then put in a backdoor. Spent a whole morning getting in here. All morning and half a bottle of Southern Comfort. That's what we're doing now. Through the backdoor and straight up their unprotected arse.'

Personnel files, names, ranks, pages upon pages of

characters, like black meat hooks holding up to view the career of every PLA officer assigned to the Shanghai garrison.

'I've been in here all day. Like a fairground. *Ta ma de*. A whole new career for me here. I even had time to hack into the PSB database. Your own *fen-chu* and your own file, Sun Piao. Sad, Senior Investigator, very sad, your file, it almost made me want to cry. So much promise. So many fuck-ups.'

Piao's hand, across his; pages scrolling as the pressure increased.

'You forget how tightly I have you by the balls, Comrade Rentang. Perhaps we should send some of the pictures to Comrade Bai of the Supreme People's Procurate, or to *tong zhi*, Lu Shiying, Head of the Institute for Legal Sociological and Juvenile Delinquency?'

'I get the point, Senior Investigator.'

'No. No, I do not think that you do. But you will if you piss on my head and tell me that it is raining.'

Piao, removing his hand and pouring himself a drink.

'Now show me what you have. The PLA with the harelip. Any luck?'

'Fuck all, until I hacked into the PLA medical files. Looking for patterns. I'm good at looking for patterns. It's called lateral thinking.'

Click. A new domain. A new file. A request for a password. Fingers over keyboard in a practised choreography. Fingers to keys, summoning up a password cracker ... 'PQWAK'.

'Definitely not fucking tricky enough.'

Virtual doors opening. Virtual pages flowing. Names. List after list.

'Medical records, confidential medical records.'

'Shit, Boss, we could be shot for this.'

The bottle in the Senior Investigator's hand, its candle neck fitting so neatly between thumb and palm. So precisely. Too precisely. Pouring deeply into Yao-bang's glass.

'Drink, Deputy. Isn't being shot more preferable to being crucified and kissed by the oxy-acetylene torch's flame?'

Against the Wizard's face, words misting one lens of his spectacles.

'Show me more.'

'More. Your Boss wants more, fat man. Which, of course, is my pleasure. We're lucky, the file is so big and contains so much data that they installed it with its own search engine.'

Typing, carefully, precisely.

HARELIP . . . CLEFT PALATE.

Twenty-two names. Rentang's finger tapping on the screen.

'All PLA, all male, all with harelips and cleft palates. You wanted the top of the pyramid. I just hope that you don't have a fear of heights, Senior Investigator.'

Finger tapping the monitor.

'Not him. Studying in England, Sandhurst. Not him, died a month ago. A boating accident. Not him, or him.

One in hospital, testicular surgery. One in the New Territories. Not him either. Now a factory manager in Chengdu, producing toilet seats . . .'

Tap.

'Not him either. Or him. Definitely not him. In Virtue Forest awaiting execution for fraud . . .'

Six names remaining.

'One of these is your princeling. You recognize some of these family names, Senior Investigator? Yes, I'm sure that you do. It doesn't take an investigator to recognize some of these names. Bao, a long standing PLA family. One of Mao's contemporaries, the grandfather, Pi, a senior colonel in the PLA, Western Territory, currently in Tibet. Niu, from a very high-ranking PLA family, all senior colonels. His father has political ambitions and is seeking election to the Politburo.'

Pages turning as more Southern Comfort was poured.

'Qi, son of a senior colonel in the PLA, head of the Guard Army of Shanghai Garrison Headquarters. Xiong you will of course recognize. Didn't you have run-in with his nephew a few years ago?'

'I arrested him for his involvement in the killing of a child, a girl, four years ago. She had been sexually abused and murdered.'

'Throat slit. I remember it, Boss, from ear to ear. Yes, I remember it. Couldn't sleep for a week.'

Shaking his head. Drinking his drink.

'And what happens? The case gets buried in a deep

filing cabinet. Important evidence goes missing. Always the same. Always the same when it comes to *cadre* like this. What's another dead girl. Just spilt fucking water.'

The Wizard carefully adjusting his spectacles.

'I take it that we will keep this one on our list then? This sort of thing runs in families. I read an article on it in Gongdelin Prison. Something to do with genes, bad genes.'

Piao nodded his head.

'And the last one, Senior Investigator. You'll know this name as well. Zhui. A PLA who was head of the Beijing Garrison Headquarters until last year. He left in difficult circumstances but now sits on the Politburo.'

'Not a happy picture, any of them.'

'You can fucking say that again. Any one of them could get this case buried. And us with it, probably in the foundations of the Shanghai Stadium.'

Piao's fingernail moving down the names. Perhaps some kind of understanding, straddling the gaps between characters, of what kind of man could crucify two PSB comrade officers and murder prostitutes, ripping them up as if they were just betting slips?

'Print off everything available on each of them. Focus on Xiong and Qi.'

Much in the records, the said, the unsaid, the bloodline ... parentage. *Cadre* or peasant and how many generations ago? Party history: volunteers to the Party or conscripts? And in the struggle to establish

the shining path, the Great Helmsman's course, what part the bloodline that now led to this *cadre*'s existence had played. Such detail, even so many decades on, could determine a *cadre*'s grading. His level of favour, his very character.

'The other names that I gave you, the three dead whores and the girl in the Number 1 Hospital . . .'

'Yang, Deming Da, Tsang, and the girl in the hospital, Lan Li, no records on any of them. Officially they were never born. And so, officially, they never lived or died.'

Shaking his head, Piao. The Wizard smiling, his finger moving back and forth across the screen, traversing the area of records that would have held a girl's life from the cradle to the grave.

'Cleaner than your conscience, yes, Senior Investigator?'

Eyes meeting in mercury light. The Wizard withdrawing from the lock of the gaze first.

'And the number that I gave to you . . .'

The Wizard holding up his hand, faint across his palm in red ink.

473309169972

'The hard part was finding the site, so I tried close to home. *Ta ma de.* Too close to home.'

A ballet of the Wizard's fingers. Pixels sprinting. The deep roots of another PLA database. The three of them staring at the monitor.

MINISTRY OF SECURITY

473309169972

This encrypted file contains critically secret State
information.

Entrance to this file is on a purely need-to-know
basis.

Permission to enter this file can only be
obtained by written request to the Minister of
Security in Beijing.

'What the fuck is this?'

'An important number, an important file. *Ta ma de.*
I tried to crack it. No luck. A forty-bit encryption.
Impossible. If they bothered to put a forty-bit encryp-
tion on it, it's important.'

Piao moved to the window, his fingers prising a gap
in the blind. The sun was rising reluctantly through
cracked *longs.* Turning, the blind falling back into place.
Yaobang, holding out his glass.

'This isn't just about killing fucking *yeh-jis*, Boss.'

But Piao's mind already onto the next problem.

'A number that is a dam. A dam that an ant might
well destroy. We find out what the number that binds
them means and we find out what their death means.
Wizard, find me someone who understands numbers.
Someone who can read their mystery.'

Rentang was already turning to the monitor. Fingers
already seeking knowledge.

'I'm on a few hacking networks. Every kind of strange fruit is in there. Don't worry, you'll get what you want, Piao. Doesn't the Wizard always deliver?'

The Shanghai Communist Party Records Annexe, Warehouse 4, Bansongyuanlu

The warehouse lay slumped between river water and new-development concrete. Even from beyond its thick walls, and with the retch of the river's stink filling your nostrils, you could smell other subtle things. The odour that a blocked career path has, because of a neighbour's insinuation. The reek that a life forced into a cul-de-sac has, because of a grandparent's bloodline, or a billion citizens have, when they are forced to be silent with words welded to tongues and their sentences nailed to their lips.

A closed door guarded by two Party faithful, an old mama whose breasts had long since dried of milk and a middle-aged man with conjunctivitis and a degree in political thought from Beijing University. Investigator Yaobang nodded to them, they nodded to him. The door opened, he stepped through it, the door closed.

The request was typed on official PSB paper. A list of female names and the dates that they had been born in the People's Republic of China. It took the clerk, one of several in identical jackets reinforced with leather elbow patches, fully forty minutes to return from the

dark bowels of a warehouse that consisted only of
long runs of shelves. Upon each, piled high and deep,
a generation of Shanghainese lives. In their dust-edged
pages a record of every event in a citizen's life and a
measure of its worth to the state, to the Party, from
birth to death, and beyond.

'I am sorry, Detective Yaobang, there must be a
mistake. The names that you gave me, Yang, Deming
Da, Tsang and Lan Li, these people do not exist. They
are non-citizens. We have neither Party nor *danwei*
records on these individuals.'

The Big Man moved forward, his elbows braced on
the rough wooden counter and his voice lowered.

'These non-citizens' records will be in your back
room, Comrade.'

A wink of an eye, a nod in the direction of darkness.

'I do not understand what you mean, Detective
Yaobang.'

Closer, his face to the clerk's. The man's smell, of
paper, dust, and a life dealing with others' shit.

'Your back room, Comrade. The three walk-in safes
that are permanently open because the fucking keys to
them were lost during the Cultural Revolution.'

A wink. A nod. The clerk backing away a pace.
Yaobang's breath a bushfire of chilli, garlic, stale beer
and words that he did not wish to hear.

'You are mistaken, Detective. The Communist Party
Records Annexe has no room such as this.'

'But, Comrade Clerk, it does. It has several rooms

such as this. This is not the first time that I have been here. I, as you, am no ordinary comrade. I, as you, know of these rooms.'

'There are no such . . .'

'Shhh. Shhh, Comrade Clerk. Even in here you do not know who might be listening.'

His eyes furtively looking around, his words whispered in a low tone.

'Now go and get me the records of the names that I have given you. They will be in one of the walk-in safes, along with those many other comrades who do not exist officially.'

The clerk looking over his shoulder.

'I, I do not have the authority to furnish you with these records.'

'This letter gives you the fucking authority, Comrade Clerk. This letter insists, Comrade Clerk.'

'But I cannot furnish these records to you. These are non-comrades. They do not exist.'

Yaobang's fingers travelling over the top of a dusty desk tidy. His eyes meeting the clerk's.

'If they are non-comrades, then their files will not be missed, will they, Comrade Clerk?'

Shaking his head.

'I cannot do it, Detective Yaobang. Such a request could lead to me losing my position, or worse.'

'Is this an indelible marker, Comrade Clerk?'

The Big Man pulling a black-capped marker pen from the desk tidy.

'Yes. Yes it is, why do you ask? Please, that is the only marker pen that we have. Could you replace it in . . .'

In a lightning-fast grab, snaring the clerk's wrist. Holding it in a vice-like grip, before slamming his hand onto the counter. In two defined black slashes, marking the top of his hand with a thick 'x'.

'What are you doing? What is this?'

Yaobang allowing him to pull away. Replacing the top on the marker pen and placing it neatly in the desk tidy as he spoke.

'It is to mark you apart from your colleagues, Comrade Clerk. So that when I return with more PSB officers and the official papers for your arrest on a charge of attempting to subvert a Public Security Bureau investigation carried out on behalf of the People's Republic of China, I can tell who you fucking are.'

The little colour that remained in the clerk's face, draining away. Yaobang turning towards the door, and in a whisper that he knew that the clerk would just be able to hear.

'A serious charge, Comrade Clerk. Very serious. Perhaps your own files will rest in one of the rooms with no key.'

A hand on the Big Man's shoulder. A whisper deep into his ear.

'I will see, I will see what I can do, Comrade Yaobang.'

And in a whisper of a whisper.

'There is a back door in the *long*, at the far end of the warehouse. I will be there in thirty minutes. Will you be able to find it, Investigator?'

The door opening.

'It is a door that I know well, Comrade Clerk. Too fucking well.'

The door closing.

*

It was closer to forty minutes than thirty. Finally, a series of bolts shunted on the other side of weathered, reinforced timber. Slowly the door opening. The clerk, his arms piled high and spilling with thick folders. His words hurried and whispered. Only just audible above the water's ebb and flow.

'Sorry, Comrade Yaobang, it took time to find three sets of the files. The women named, life no longer possesses them. They are in the city morgue on Zaoyanglu and have been assigned numbers. 35774324, 35774341, 35774352. We put the files of dead non-comrades in a different place to living non-comrades.'

Taking the files from the clerk's arms. The door already starting to close.

'Comrade Yaobang, you will say nothing of this, of me, yes?'

'And you will say nothing of this, or me, yes, Comrade Clerk?'

A nod greeting a nod. The door closed. The bolts slipping back into place.

19

The City Morgue, Zaoyanglu

The first time that Piao had watched the dissection of a human brain, the pathologist holding it as a trophy in his hands, he had wondered what might get trapped beneath the clinician's fingernails. Perhaps a memory, ripped and isolated? Or perhaps the bit that makes the rules? Keeps the rules . . . breaks the rules?

*

'Do you know what the time is?'

The door, steel and reclaimed wood; Yaobang's hand between it and the doorframe. White-knuckle clench around documents of authority. Red star burning in his palm.

'My feet are killing me. I've got a gut ache and need a shit. And I've got a hole in my fucking shoe and a wet sock, because it's pissing down with rain out here.'

'Do you know what the time is?'

Pushing at the door, but the mortuary attendant, a picked wishbone of a man, wobbling, but still resolute.

'I know what the fucking time is, it's time I went home. Now open this door or I'll . . .'

'Just checking your document of authority, Investigator, and your letter of authority to examine the bodies. I need to check, you know. We get all sorts of perverts wanting to enter a place like this.'

The attendant wiping the snot from his nose onto his glistening cuff. Staring through the gap at Piao and the Big Man and then returning the documentation.

The door opening. The attendant, almost luminescent in his paleness, already walking away.

'Come on, then. Come on. Do you not know what time it is? And watch my floors with those wet feet of yours, Investigator. People have been killed by slipping on a wet marble floor. In fact we had one brought in two days ago. An old daddy, eighty-five, if he was a day. Skull wall as thin as a quail's eggshell. I'll show you if you wish.'

Piao leaving the limping Deputy behind.

'That will not be necessary, Comrade. Three cadavers in one night is quite sufficient. But thank you for the generous offer.'

The wishbone smiling a crooked smile. Never, not in fifteen years, had a senior investigator ever said thank you to him.

'Pity. It's quite a sight. A brain like a pickled walnut.'

Double doors pulled open in an asthmatic wheeze.

'No matter, Senior Investigator. No matter. But

while you check those who life no longer possesses, I will make tea.'

A hand down the front of his threadbare trousers, the attendant adjusting his balls.

'Yes, *xunhuacha*. It is never the same seeing the dead without a good strong mug of tea in your hand.'

★

Three mortuary drawers. Three huffs of air. Three girls who had appeared on Detectives Di's files. Yang, Deming Da, Tsang, now numbers: 35774324. 35774341, 35774352. Three daughters. 'Spilt water'.

'Here, Senior Investigator, *xunhuacha*, the likes of which you have never tasted before,' handing him a mug, black with gold emblazoned characters on a thin pitted glaze that would soon wear through:

THE PEOPLE'S OLYMPICS 2008

Jasmine driving the smell of death from his nostrils and purging the taste of it from his tongue. As he sipped it glancing down at the three open drawers. Three girls razor-carved. Not a three-inch expanse of skin that was not afflicted by the crazy paving of ugly wounds. And through the sanguine chaotic slashes, the careful, methodical scalpel lines of the pathologist's autopsy. Clumsily thick, workman-like stitches.

Xunhuacha in a deep gulp. The mortuary assistant eager to inform.

'An average of fifty-five cuts on each body. The exact figure is in the pathologist's full reports.'

'Just like the *yeh-ji* in the fucking hospital, Boss.'

The mortuary assistant, his finger tracing one of the young women's deeper wounds.

'There's another dead one in the hospital?'

Walking swiftly away, the Big Man, his garbled words.

'Not dead, *dao-mei*. Just left her. Left her in the Number 1 Hospital.'

The sound of coughing in the hallway.

More *xunhuacha* running down the Comrade Assistants chin in his eagerness to speak.

'Some of the cuts are so deep that they penetrate muscle. Here, here, and here, they even score bone. And these, a bit special. The cuts are up to seven millimetres deep, approximately fifteen millimetres wide. The design was cut and then the flesh between the cuts sliced away.'

Tea stirred with a discoloured spoon. Stirred more times than was necessary. A cracked bell of a sound, a spike entering into the Senior Investigator's concentration.

'Whoever did it took his time. An artist. A perfectionist. The pathologist estimated at least six minutes a girl.'

'A sadist, yes. A perfectionist, I am not so sure. A perfectionist would have left no evidence for a pathologist

to examine. The bodies would have been hidden or cremated, lost forever . . .'

Piao's fingers through the hair of one of the dead girls.

'Or perhaps we have one who likes games, who relishes the chase. A robber of lives who has the false confidence that he can escape the consequences of such actions. Or a comrade who believes that he is beyond our laws . . .'

More coughing from the hallway.

'Actually, perhaps you should concern yourself with my Deputy, Comrade. A glass of water might help.'

'Yes. Yes, I will get one right away.'

Piao kneeling, as if praying, looking into the drawers. The smells that death demands when life has vacated, filling him. His eyes, full and focused on the carved designs. A red bloom of a sanguine fashioned five-pointed star between the navel and vagina, drawing the eye as the needle draws the thread. Perhaps the one who murdered wanted exactly that, to draw the focus, taint the scent. Or perhaps he just enjoyed using a razor like a paintbrush.

The Senior Investigator taking each girl's hand into his. So small and so pale. Fingernails bitten and unpainted. Unlike the *yeh-ji* Lan Li's wriggling crimson fishes of long painted nails. Each girl's feet, toenails, the same pink, set in death's blue, no ripe cherries of scarlet. Their teeth amalgam-valleyed, uneven, uncapped, ordinary teeth, not perfect at all, not like the *yeh-ji* Lan Li's.

Stepping back and for the first time really looking at them. Past the pallid shroud that death bestows, young women that you would see in any street market, any laundry, or any tea shop. If anything, marked out by their very ordinariness. No *yeh-jis*, not these three. Receptionists, waitresses, perhaps, but not prostitutes.

The pathologist's reports were long and lovingly written in the secret language insisted upon by those who interpret death's choreography. Yet the unsaid as important as the said.

Piao shook his head. Bad mistakes, elementary mistakes. Detective Di . . . other things on his mind? Di, he had not read the pathologist's reports, or had at least not read them with an investigator's eye. That and the files of all four young women coming to him bundled together in thick elastic bands all at once. Lan Li, a prostitute, her file at the very top of the bundle. He had judged them all by her. Lan Li a *yeh-ji*, so all four *yeh-jis*.

Rereading the pathologist's reports. Lives, and how they had been lived, laid bare by the scalpel's silver glide. Not one of the dead girls showing evidence of ever having had a sexually transmitted disease; unusual amongst *yeh-jis*. Not one of the dead girls showing evidence of ever having had an abortion; again, unusual amongst *yeh-jis*.

One of the dead girls had still been intact, a virgin. The other two, there was evidence of fresh semen within their vaginas, but too contaminated by river water for

definitive DNA testing. Evidence too that they had also been virgins prior to being raped and their deaths.

Carefully closing the reports, the Senior Investigator. Death lost in anonymity. Three dead girls, now numbers laid to black printed rest.

★

'You are going, Senior Investigator? Already?'

Piao, reports under arm, already walking from the mortuary.

'It was a help seeing those whom life no longer possesses? You have got what you wanted?'

Piao, walking towards the Big Man, a half wink.

'It was a great help, thank you. I now want the bodies of the girls released to their families for burial.'

Heavy doors, triple locked, opening onto Zaoyanglu and the sounds of the night.

'Got what you wanted, Boss? So what now, call the *fen-chu*, talk to Zoul, surveillance, back-up?'

'No, not Zoul. A few trusted officers, no uniforms.'

'You sure, Boss?'

'I am sure.'

'Mortuaries, more fucking leaks than drunks at a urinal. You think that the message will get through?'

'It will get through.'

'"*Cao-mu jie-bing*", eh Boss?'

'Yes, "the dead cat turned".'

★

The number, long, complicated. No ordinary number this. Only on the third attempt, getting it right. The number connecting. Even at this hour the telephone being answered within two rings. The voice of a PLA receptionist. A voice, each syllable separate and cut from ice. From the crumpled slip of paper, saying the rank, the name. Instantly the call being switched, reswitched, to a limbo of electronic white noise. A million callers, voices synthesized down to a tinnitus of surfing breeze. A ringing tone, the sort that he had never heard before. Ringing. Ringing. Just about to put down the receiver when the call was answered. A voice. A rasp.

'*Ni nar.*'

'Comrade Officer Sir, you asked me to call you, to let you know if anyone requested to view the slashed whores.'

Silence. But in the background western music, voices, giggling females.

'Me, the mortuary assistant, Comrade Officer Sir. You recall, you asked me to . . .'

'Yes, I know what I asked.'

'Of course, Comrade Officer Sir. I did not wish to suggest that you had a poor memory.'

Silence. Except for a girl's whisper. A cigarette being lit. Glasses, clinking.

'A PSB investigator was just here. A senior investigator. Homicide.'

'Name?'

'Yes, I got his name, Comrade Officer Sir. His name was Piao. Senior Investigator Sun Piao.'

Silence.

'He saw each victim. Examined them very carefully. Said that his seeing them had been "a great help". His Deputy said that they had just come from the Number 1 Hospital. There was another victim there. Another victim. A *yeh-ji*. But this one is alive, Comrade Officer Sir. Yes, he definitely said alive.'

Silence. Whispered words. Perfumed breaths against perfumed cheek.

'Thank you for listening, Comrade Officer Sir. I do not wish to appear greedy, Comrade Officer Sir, but when we met, you said that I would receive a reward. For information, a large reward, Comrade Officer Sir.'

Some seconds before the mortuary assistant realized that the telephone call had been ended. Many more seconds of listening to the void's heartbeat before he accepted the silence. Even more seconds before he had the courage to say, angrily, down the telephone receiver.

'Arsehole, fucking PLA arsehole. Your mother was a whore for whores.'

But with each word, making sure that his hand was tight across the telephone mouthpiece.

20

'Cao-mu jie-bing' . . . '*The dead cat turned*'

Four men, stepping from a glossy-sided *Hong-qi*. Silver people moving through greyness. Their posture confident; everything about them seeming to relegate all to just a backdrop.

Gates flung back. Through rubber doors. More rubber doors. A nurse making the bed; arse as big as a full moon over the Huangpu Park. A nurse experienced enough to know danger's signature. Her smile, blossom honey sweet.

'*Ni nar.*'

His voice quiet, brutal.

'I will ask you once, and only once. There was a girl here, in this room. Where is she now?'

'She has gone, discharged from the hospital, but I don't know where. The doctor who was treating her will be able to tell you.'

'His name?'

'Foong, Doctor Foong.'

She checked her watch. The strap, too tight, biting into her milk-fat wrist.

'He will be in the ICT ward. Second floor.'

For many seconds still, looking deeply into her eyes, hunting something at their very horizon. But no other words. Turning on his heel. Moving from the room. Black phalanx closing around him. Only when they were out of sight, she moving to the Bakelite telephone. Slippery in her sweaty palm. Two digits dialled. Noticing that her legs were shaking and her inner thighs damp with urine. Her call answered within two rings. Silence at its other end.

'Doctor Foong. Doctor Foong. Tell him there is a problem. Tell him to get out of the hospital immediately.'

*

They caught Foong between floors. Eyes wide with anxiety, the sheen of oily sweat – all giving him away. That and the name badge, white deeply engraved into black, above the row of pens in his top pocket. No words, strong hands only, pulling him down the stairs. Through the large plate-glass windows, city streets, *longs* life; thinking that it might be the very last images that his eyes would hold. Life bursting, staggering with its vibrancy. That and their faces.

An empty examination room, on the floor torn sterile wrappers. On one of the work surfaces, a bowl of used cotton balls, a half-full cup of tea. Pulling him across the black and chrome couch. Palms' sweaty squeal across its plastic sheathing. Tethered in sinew strong hands. A joke, its words lost to him. A laugh, and then a man stepping

forward. His appearance, one that would not be forgotten. And only now noticing between manicured fingers, a hypodermic. Still no words, just its glass cold touch to the side of the doctor's face. Perfumed fingers rolling the syringe gently across Foong's cheek, crossing, recrossing his eye line. Only when the man with the holed-face spoke, realizing that lips existed in this face. From cracked granite sentences as dull-edged as a stream over pebbles, but the tone cultured, educated.

'Where is the girl, Lan Li?'

'I do not know.'

Silver signature of the hypodermic's needle across his eye line.

'She was taken in the night. I do not know where to.'

'Where is she?'

'I do not know. I am telling the truth, I do not know.'

The man with the holed-face moving to the work top, to the cup of old tea. Needle up to its thigh in black-leafed *lucha*. A deep thirst, drinking until the syringe was dark with its hue. Measured footsteps back to Foong. An order whispered.

'Hold him.'

Vice hands, clasping his face, head. Needle tip, like a bright star piercing, just millimetres from Foong's eye. Again the tone of the words belying their content.

'One last time. The whore, Lan Li, where is she?'

'I do not know. Please believe me. Please. The Senior

Investigator, Piao, he took her. The Homicide Senior Investigator . . .'

The needle moving through the few millimetres towards his pupil. Thumbnail already whitening to the pressure upon the syringe's plunger.

A sudden cacophony crammed into a split second. A door flung back on its hinges. Bodies piling through. Feet over a rubber floor. Pistols, snub-nosed and darkly obscene, wedged bloodily into the bony cleft between back of ear and skull.

'Take the hypodermic away from his eye.'

Moving closer.

'Take the hypodermic away from his eye, or I will shoot you where you stand. It will save our comrade judges their valuable time. Do it now. I will not ask again, Comrade Princeling.'

Pressure to the trigger. So close, both hearing the strain of tensed steel. Both sensing the bullet's slumber in the chamber about to end. Eye meeting eye. Slowly the silver needle lowered to the table. Arms bent behind backs. Handcuffs biting into wrists. Personal belongings, mobile telephones, confiscated from the *tai zi*. Prodded down stairs. Pushed through corridors and into the street. The only sound an ambulance siren screaming from a head-on collision at the junction of Xietulu and Tianyajiaolu, and the Big Man's words.

'*Cao-mu jie-bing*, Boss. We've got the fuckers.'

★

Four men, four cars. Piao sitting beside the PLA with the scarred face. Avenues, *longs*, sprinting past. Watching the light shred across his face. Only when they had travelled for fully ten minutes, a movement. Side window being wound down. Cologne, its monied stench falling on an investigator's empty stomach, too much to bear. Only when they had travelled for fully fifteen minutes, words.

'Your name, Comrade PLA?'

His voice as a breeze dulled by travel through thick bough branches.

'Soon you will know it, Senior Investigator.'

Piao, sharply pulling the PLA's face around.

'Your name, PLA?'

Fingers tighter.

'Your name?'

His eyes across the PLA's.

'Bao? Your grandfather, a comrade who stood in Mao's shadow. No, perhaps not. What about Pi? A high *cadre* father who is a senior colonel, doing our will in Tibet. Or perhaps you are Comrade Niu, whose father wishes to take a seat in our Politburo. Or is it Qi? Princeling son of the Senior Colonel whose Guard Army protects our city . . .'

In the blackness of his pupil, a flexing. A flicker of surprise, lightning on a distant horizon.

'Yes, it is Comrade Qi, isn't it?'

Pulling his face away, the PLA, shutters of control falling back into place.

'I am Senior Investigator Sun Piao of the Public Security Bureau Homicide Squad.'

In one hand his pistol, in the other hand his documents of authority held to the face of the *tai zi*.

'I arrest you on suspicion of involvement in the murder of Comrade Yang, Comrade Deming Da, and Comrade Tsang. Also of a fourth as yet unknown female at the site of the Shanghai Stadium. In addition, on suspicion of involvement in the murder of Comrade Detective Di and Deputy Detective Tan at the Shanghai Yu Yuan Import Export warehouse and of the attempted murder of the woman Comrade Lan Li.'

Qi impassive. The silence spiked only by a sharp alarm calling from his wristwatch.

'You cannot hold me. By tonight I will be released.'

With difficulty from the handcuffs constricting grip, pushing a button, the alarm silenced.

<div align="center">*</div>

On the corner of Beijingdonglu and Sichuanlu, an ambulance parked. Windows blacked out, blind eyes to a world in reflection. From inside, through bandages' slit, alert eyes watching, seeing. The PSB patrol car pulling up beside the ambulance, traffic lights' procession of reds, ambers, greens, ignored. Piao moving through the traffic's swell from the patrol car to the ambulance, as pre-arranged.

Thickly chromium plated cot bars grasped by sutured fingers. The Senior Investigator stroking the

hand behind those fingers. Each stroke, a word. Pointing to the face pressed by the Big Man's firm hand, hard against the glass of the PSB patrol car's side window.

'Is that him?'

Without hesitation.

'Yes.'

'You are sure? Positive?'

'I am positive.'

Silent tears. Piao's hand on hers, caressing her fingers.

'His name, I wish to know his name.'

Several seconds before the Senior Investigator answered.

'You were right, he is a PLA. He is a *tai zi*. Colonel Zhong Qi. But you will be safe now. This I promise with my own life. He will never hurt you again.'

A full minute before Piao jumped out of the ambulance and nodded to the driver. A nod also to the PSB patrol car. The Sedan moving off at speed, piercing a red light and turning to the north away from the Huangpu and towards the *fen-chu*.

<p style="text-align:center">*</p>

An hour and a half, letting the PLA rabbits stew in their own juices. Yaobang, even in a PSB patrol car, taking that long to get back to the flat, collecting the report. And from the flat, back to the *fen-chu*.

Over *lucha*, the Senior Investigator reading the

report. Across his shoulders, the tea's sour steam, and the face of the Big Man.

Zhong Qi, born 21st April 1971. A 'Celestial Dragon'. Place of birth, Nanchang, birthplace of the People's Liberation Army. Built on the uprising, on the massacre of the supporters of the Communist Party. Now a city of factories, chemicals, a cannery, tractors, diesel engines. Moved to Shanghai on the death of his mother, when just two years old. His father, Gu Qi, then just a colonel, taking up a new commission with the Shanghai Garrison Army.

Education record: Top marks from the PLA Cadet College in Shanghai. Sword of Honour. First in his class. A People's Liberation Army scholarship to England, Oxford University. Followed by officer training at Sandhurst. Top of his class. A further posting to London. Two years at the People's Republic's Embassy. Returning to China, to Beijing University. A first-class degree in Political Studies. A posting to the USSR sponsored by the Shanghai Communist Party. Another degree from Kiev University in Philosophy and Military History. Returning to Shanghai, a commission with the Shanghai Kan Shou Jingbei Si Ling Bu, with the rank of colonel. A high flyer if there ever was one. The highest of flyers.

Danwei: purchase slips. A house in Beijing. A dacha near Hangzhou Bay. Six months ago promoted to a

grade eleven *cadre*. Shooting up through the *cadre* levels. Copies of permission and purchase slips for a Red Flag, a washing machine, a television. Granted, a privilege card for the Friendship Store. Travel permits, internal and external. England, USSR, Pakistan.

Blood line: grandchild of a comrade who had known the Great Helmsman himself. His grandfather and Mao student friends together in Changsha, the birthplace of the Chairman. Grandmother, an esteemed comrade who had played her part in the Long March. Impeccable the blood line, from peasantry to high-ranking cadre.

Communist Party record: the path of a Communist Party faithful. Attending meetings, rallies, with his father from the age of four. A prominent member of the local Youth Party. Chairman by the age of fifteen. Rising through the ranks like a bright-tailed comet.

Medical record: inoculations, whooping cough at eight years old, appendectomy at fifteen, but, highly unusual on the subject of his harelip, just four words. No supportive material. No mention of the corrective surgery that he had obviously received.

Draining the cup, Yaobang.

'Shit, Boss. Why do some have it all? Brains, privilege. A perfect fucking record.'

'Too perfect, like writing your own reference. No one could be such a fine comrade, Mao himself included.'

ANDY OAKES

Remembering the Great Helmsman's spit-drenching anger. His fondness, especially in later life, for the company of much younger women comrades.

Pouring more tea, the Senior Investigator.

'To fashion a report such as this is easy for such a powerful princeling. Especially for one with a father such as Senior Colonel Gu Qi.'

Pacing, the Big Man.

'A senior colonel, this princeling's father. An army billeted in his back garden. What can we fucking do against that?'

'What we can do is what we can. We start off by asking our Wizard to find us something out of the ordinary. This princeling, I want to know him intimately. Financial details, relationships, his comings and goings, strengths and weaknesses. Especially weaknesses. Everything.'

'But investigating comrades like this will get us killed, Boss. We will be found in the Huangpu, and I can't swim.'

Slapping him on the back, the Senior Investigator.

'Swimming will not help when you are wrapped in chains.'

'Thanks Boss, very comforting.'

But Piao's thoughts elsewhere.

'Tell the Wizard that if he cannot find what we are looking for in the PLA's files, to find it somewhere else.'

'Where, Boss?'

'*Danwei* files. Party files. Hospital medical records.

University records. He was educated abroad in England. They would have required many details about him before they offered to train him as an officer.'

'And when we find whatever it is, Boss, will it be an eye for an eye?'

Piao moving towards the door. Timber, once worn smooth by ten thousand urgent palms, now painted over in brown, drip-proof gloss. Pushing the door open. The corridor beyond smelling of newly fashioned plastic and sweaty groins.

'An eye for an eye will make us all blind, Deputy.'

*

'Well?'

Yun squirming a familiar squirm. Trying to hide it with activity. Reports and arrest forms in triplicate.

'I couldn't get hold of him.'

Pen in pale, nail-bitten fingered strokes.

'Zoul's been at a *danwei* conference, yesterday and today. On no account can he be disturbed.'

'On no account?'

Eyes averted. A shake of the head.

'Not even for this?'

A glance toward the desk. A circle of PSB uniforms, at the centre of its olive ring, the four PLA *tai zis*.

'I don't know, I couldn't get that far. But I left him a note.'

The Senior Investigator's fingers finding a paperclip. Tracing its trapped steel loop.

'To be blunt, Piao, I'm surprised. Well, perhaps not surprised, after all it is you that we are talking about . . .'

His face, as if he had bought a dumpling for fifty *fen*, and had then seen them being sold in the shop next door for twenty-five *fen*.

'But not to tell us the identity and rank of these *tai zi* comrades, especially the PLA colonel, well, to be frank, it's, it's . . .'

'It is what, Detective Yun?'

'It is very worrying. Yes, very worrying indeed. This is a *tai zi* with a very powerful father. He could, he could . . .'

'He could what, fellow Comrade Officer? Transfer us? Wreck our careers? Perhaps crucify us and play with his oxy-acetylene torch over us?'

'Keep your voice down, Piao. Walls have ears, even newly constructed walls.'

A concerned look over his shoulder.

'With a PLA *cadre* like this, Piao, all is possible.'

'Yes, you are correct, my good friend, Detective Yun. You are, as always, correct.'

'Then perhaps we should, should . . .'

'Should what, Yun? Perhaps apologize to him profusely? Tell him that his arrest was a mistake, human error, or mistaken identity? Offer him tea and then escort him back to the Shanghai Garrison that his "very powerful father" commands?'

'Exactly my thinking, Senior Investigator. Exactly my thinking.'

'Let me get this exactly right, Yun. What you propose is to release a *tai zi* who has murdered three young comrades and mutilated a fourth. A *tai zi* who crucified our fellow comrade officers, Detective Di and his Deputy. Who used an oxy-acetylene torch on them as a means of torture. And who then had them murdered by driving spikes through their foreheads. Is this an accurate account of what you wish?'

'No, no, no, Sun Piao. You have confused the matter, as always.'

Bubbles of spit across his bottom lip.

'This princeling, this Zhong Qi, how do you know that he has done these things? There was no evidence.'

'But there is, Yun. Evidence that will link him inextricably to both crimes.'

'What about, what about . . .'

'Witnesses?'

'Witnesses, yes. There are no witnesses to what you say that this PLA colonel has done. The heinous crimes that you say that he has committed.'

'But there are, Detective Yun.'

'*Ta ma de. Ta ma de.*'

'This is a serial killer, Detective. Even though in the People's Republic, we do not "officially" possess such a unique creature. A serial killer. But an arrogant one. And arrogance, as you know, Yun, is a meal unsalted.'

Yun leaving his chair. A worried orbit of the custody desk, his eyes avoiding the PLA as they were led down to the interview rooms. Returning to his seat. A minute or two before he felt able to speak.

'You are a hurricane, Sun Piao. You leave no house with a roof.'

'The three PLA, I want them in interview room one. The PLA *tai zi* colonel by himself in interview room four.'

Shaking his head, Yun.

'They will be ready for you in five minutes, Sun Piao.'

'Good. I will be there in thirty. They can wait for me. There is no hurry.'

A smile.

'"You do not help shoots grow faster by pulling them up with your fingers".'

*

Twenty minutes, Piao washing, rewashing his face, hands. As if trying to cleanse himself and disengage from something that tainted. A stain on the soul. Between each cold water baptism studying his reflection in the mirror. Seeking something that was no longer there. But worst of all not knowing what it was that he was looking for. Only his finger tracing the pink track of his scar through his eyebrow, drawing threads of something that he sought, and with that a hard pinch of recollection. Just days out of *Ankang*, still in the

harsh vice of detoxification, standing in a bath, moving with the sway of some anonymous internal melody. The water as cold, in a bitter baptism over his head. In a sheet, down his body. Yaobang balancing on a chair, a reluctant gymnast, stepping gingerly to the flooded floor, refilling the metal bucket, taking his place, with a moan of stressed timber. The chair in a violent wobble and spill of water. Six buckets, six violent wobbles, six spills. Piao, arms by his sides, riding the zinc-coated wave. Nothing else. Just the water. Just the sensation of it across his hair, skin. Across his eyes in a deluge of clarity. More water, colder than the last. Achingly cold. And through its ache, across his tongue, a taste, burnt almonds and iron. And then the world in a satin-sheathed shunt. Tipping, the walls, the ceiling, and the Big Man. So slow, at first . . . but accelerating. The taps, brass and angular, rearing up, sprinting to greet him. But not caring. Even as they collided, not caring. Unable to care. Just darkness and a taste of blood in the very corner of his mouth. Honey and pepper. Down his chin in a frothy warm flow. Sensing, even in this purdah of shadows, a panic of activity around him. Disembodied voices shouting. But words lost in the seizure's insistent embrace. Nothing within it for him. Only one thing constant within the darkness, the Big Man's hand clenched around his. Tight, dependably tight. An anchor to the other side of the epileptic storm. His only anchor.

Only when another officer came into the toilet, Piao able to rip himself away. Turning the taps off. Drying

his face and hands. Banishing the memories; moving fast, too fast for them to latch back onto him. Just the corridor, the stairs, another corridor, and then the interview room . . .

Interview room one

Three PLA officers in one corner of the room. Animated talk. Dart-eyed, fat, milk-fed faces.

Silence as Piao confidently entered. Beside the door a large reel-to-reel tape recorder. Flicking the burnished switch. Mirror heads shifting into place. One tape reel in leisurely arcs, tape flicking out its life. The other reel in urgent catch-up sprint. From an envelope, three prints enhanced with great skill from VHS tape by the scientist, Comrade Nie. Placing them meticulously, equidistant on the table top. From a folder three charge sheets. Comparing and then matching faces with electronically enhanced prints.

'You, here. Come here. This is you? Yes?'

Tapping the first print with his knuckles.

'Yes.'

'Louder please, for the record.'

'I said, yes, that is me. But what is this picture? Where did . . .'

'Your name?'

Thick red marker to hand.

'Name?'

'Ang.'

Red marker writing the name at the bottom of the page.

'Sit.'

No noise in the PLA officer's footfall.

'You, here. This is you, yes? I said that this looks like you, Comrade PLA. Is it?'

Silence. Just the flick-flick of recording tape in slow orbits.

'I am not sure. Not sure . . .'

A glance over his shoulder, the *tai zi*, with nervous eyes.

'Is this you, or do I have to find your mama to identify the subject of this photograph?'

'It looks like me. It is me. Yes.'

'Louder. Our tape recorder is old.'

'It looks like me.'

Words shouted. Almost an order.

'I said louder. Much louder, PLA.'

'Me, it's me, Comrade Officer.'

A more gentle voice. A coaxing command.

'And who is me, Comrade Officer? What is your name?'

'Tsung.'

'Sit, Officer Tsung. Sit.'

Walking back to the other side of the room, avoiding eye contact with his brother officers.

'You. Here.'

No movement.

'I said here. Now.'

No movement. Pao, moving to the door. A whispered word. Thirty seconds later two large PSB officers lumbering into the room. Tunics too tight over stomachs which were too big. The Senior Investigator pointing.

'That one. I want him here.'

Only as the two were almost upon him the PLA officer standing, smoothing down a perfectly tailored jacket and walking to the table.

'Thank you, Comrade PLA.'

The third print. The clearest print. Piao's knuckle tapping upon it, as if to open some long-frozen lock in memory's door.

'I believe that this is you, Officer.'

Manicured fingers delicately turning the print around.

'Where did this picture come from?'

'What does it matter? A face is a face. Whether that face is in a Friendship Store buying fine French wines or in a whorehouse on the Beijing Road drinking them. Or perhaps an officer like you, who undoubtedly comes from an esteemed family, has so many faces that he now cannot remember the face that he was born with?'

Just the flick of the recording tape and the tick of the clock.

'Let us see. One, a face to greet your wealthy parents with. Two, a face to woo the daughters of senior *cadre* friends of the family. Three, a face to order the services

of a whore at the Shanghai Moon Club on the Zhaujia-bang Road.'

Anger welling.

'Four, a face to hold down a woman as her throat is slit like a vanilla pod as you rape her. A special feeling is it, Comrade PLA, raping a young woman who is in the very act of dying? Surely you remember that face, Officer?'

Hot, spicy anger spilling over.

'I have no idea what you are talking about, but it is me in that photograph. Officer Huan of the People's Liberation Army. Are you satisfied?'

'No, Officer Huan, I am not completely satisfied. But I soon will be. Now sit. Sit before I break your fucking legs.'

Into a manila file, prints, charge sheets.

'I am formally charging the three of you with involvement in the murder of an as yet unknown female perpetrated at the site of the Shanghai Stadium from where these images were obtained. Also on suspicion of involvement in the murders of Comrade Deming Da, Comrade Yang and Comrade Tsang, and the attempted murder of Comrade Lan Li . . .'

Moving to the reel-to-reel tape recorder, the Senior Investigator.

'I am also investigating your possible involvement in the murders of PSB Comrade Detective Di and Deputy Detective Tan at the Shanghai Yu Yuan Import Export warehouse.'

Piao looking at each officer in turn.

'In due course a state defence advocate will be assigned to your case.'

Three steps and Piao had left the interview room. Stopping only once, briefly. Looking back into the room through the small section of two-way glass. Between the three of them an argument starting. Recriminations. Threats. But not listening to words, the Senior Investigator, just noting the body language. The second of the three, Officer Tsung, nervous eyes, always a good sign. Years of experience can pick out the most rosy, the most juicy red apple from when it is just mere apple blossom, Piao had been told as a child.

Yes, he would watch Officer Tsung.

*

Five minutes later

A hurriedly drunk mug of tea tasting of the tin pot that it was brewed in. As Piao drank, watching the old *tong zhi*, Ow-Yang, busy himself. Fingers buried in amongst the intestinal wiring of a critically sick computer.

Dialling the number etched in biro onto his palm. The telephone number that the Big Man had given him. A cousin of a cousin's cousin. The telephone answered within a few rings.

'*Ni nar.*'

'Detective Yaobang, I wish to . . .'

With a clatter, the receiver thrown down. At the

other end of the line, amputated shouts, a shout back. Footsteps, heavy and slow.

'Boss, everything OK?'

'How did you know it was me telephoning?'

A laugh, mouth full. Almost smelling the drizzled garlic on the Big Man's lips and tasting the burn of chilli on his tongue.

'I've got a good secretary, Boss. Didn't you notice. So, what do you want?'

'Checking that you got there without incident, that it went well.'

Piao finding the next words strangely difficult. Their shape not seeming to fit his mouth.

'Checking if she is safe, the girl. Lan Li.'

'Sure, Boss. Sure. She is well and she is safe.'

'Good, good. I just wanted to check. I will go now.'

'Boss?'

Playfulness in the words spilling from a mouth full of half-masticated noodles.

'Boss, why is it you never call to check if I'm fucking safe? What is it about this girl?'

A whisper, as the handset fell to its cradle.

'We share the same scars.'

Interview room four

A great deal in a face, but not in this one.

Comrade Colonel Zhong Qi of the People's

Liberation Army sat in the far corner of the large inter-view room, his eyes fixed upon the stained white wall.

Piao entered the room. Six strides to the table. Reaching for the worn chrome switch of the reel-to-reel and flicking it on. A full minute before he spoke. Just the sound of the tape revolving onto tape.

'Senior Investigator Sun Piao of the Public Security Bureau Homicide Squad interviewing Comrade Colonel Zhong Qi of the Shanghai Kan Shou Jingbei Si Ling Bu. The date is the 21st of February. The time is . . .'

Checking his watch.

'Around 11.30 a.m.'

'The time is exactly 11.42 a.m.'

Piao pulling his cuff across his watch. Snub-nosed base metal rudely staring from the thin yellow metal masquerading as gold.

'Thank you, Comrade Qi. At least you PLA are useful for something.'

A slight smile from the comrade, but his eyes fixed to a distant agenda. Reading from the charge sheets, the Senior Investigator.

'Comrade Colonel Zhong Qi, of the People's Liber-ation Army, I am obliged to repeat the charges against you. Comrade Colonel you are charged with involve-ment in the murders of Comrade Detective Di and Deputy Detective Tan of the PSB at the Shanghai Yu Yuan Import Export warehouse.'

A bored gaze at his watch on his wrist, the *tai zi*.

'You are also charged with involvement in the mur-

der of an unnamed female comrade at the construction site of the Shanghai Stadium and of involvement in the murder of Comrade Yang, Comrade Deming Da, Comrade Tsang, and the attempted murder of Comrade Lan Li. There may well be additional charges added once our investigations are complete.'

Silence as oppressive as a premature winter.

'I must also inform you that your fellow officers, Tsung, Ang and Huan, have already confessed.'

Qi laughing.

'Have confessed their name, rank and number, no doubt. I will not fall for that old trick. Now shall we just get this farce over.'

'Your status, Comrade Colonel, is such that the Party will feel obliged to make an example of you. A warning to other *cadre* who would commit such crimes. It will be a short trial. They always are. Few words, swift justice. The journey will be short also to the mound of sandbags. A low mound of sandbags, of course. The public must be allowed to see you kneeling. They will want to see the moment that the bullet leaves the rifle. The swirl of blue-grey smoke. And, of course, the blood running into the sawdust.'

Laughter from the *tai zi* Colonel. The kind of laughter that you would remember, but wish to forget. Tapping his watch.

'Trial. There will be no trial, Senior Investigator. I will be leaving your *fen-chu* shortly, very shortly.'

From a bulky file, pictures, copies of notes, a witness

statement, a copy of a CCTV recording. Piao placing them precisely on the table.

'Yes, Comrade Colonel, there will be a trial. Such compelling evidence demands it. The murder of citizens of the People's Republic demands it. You are not beyond the law.'

The *tai zi*'s eyes turning upon him.

'Your evidence will not be enough, Senior Investigator Sun Piao.'

His voice a low whisper, surely too soft for the reel-to-reel to have picked up. Piao craning forward. Even at some distance the princeling's sweet breath sickening him.

'I do not understand, Comrade PLA. Do you care to elaborate? Do you care to speak up?'

Across the *tai zi*'s face a shadow of a smile.

'Your evidence will never be enough.'

Piao, anger in a hot flood, on his feet, circling the princeling. Only the thought that his fist would leave a mark preventing him from giving his anger physical form.

'The Comrade PLA has said, "Your evidence will never be enough". Comrade PLA, let me remind you that the laws of the People's Republic of China govern all of its citizens.'

'Fine words, good communist words, but you are out of your depth, Senior Investigator.'

Close to the *tai zi*'s cheek, Piao, but loud enough for the tape machine to pick-up.

'"Our point of departure is to serve the people wholeheartedly and never for a moment divorce ourselves from the masses, to proceed in all cases from the interests of the people and not from one's self-interest or from the interests of a small group, and to identify our responsibility to the people with our responsibility to the leading organs of the Party."'

'Your knowledge of Mao will not help you, Senior Investigator. The old ways are dead. I, and others like me, we are the new way. We work to a higher purpose.'

Piao sitting once more, his anger now cold, focused and tactical.

'You are a very unattractive comrade, Zhong Qi. Every time you look in the mirror, the mirror confirms it. Confirms it to the point that you now avoid any reflective surface, which is why you have turned your back to our window.'

For the first time the princeling showing signs of discomfort.

'You are a freak of nature. No amount of plastic surgery can disguise the ugliness of your face, or your soul.'

Through the cologne, his smell, the PLA ... animal, feral.

'That is why you kill so freely. Your anger at your own ugliness is a a self-loathing that spills from within you. We have an excellent psychiatrist at our *fen-chu*, Comrade PLA. I will recommend you to him. He will make you more at ease with your ugliness, although he

cannot take it away from you. He is only a psychiatrist, he is not a god. Your ugliness will still remain, but your anger about it may not.'

Violence, sudden and without warning. The *tai zi* exploding from his chair, throwing it at the wall in thunderous concussion, then grabbing the table, heaving it onto its side. The reel-to-reel tape recorder crashing to the floor. The princeling picking it up and hurling it against the door.

Turning, his face clammy, his breath laboured, words fractured.

'How dare you insult me, you *Ankang* scum! I work for a higher purpose, for a new and better People's Republic. If other scum like those whores or your interfering detectives get in the way of such progress, then they are casualties of war. I make no apologies for serving the interests of our great nation.'

Kicking the reel-to-reel recorder.

'Casualties of war, and there will be many more before this progress has been completed.'

Calming himself, then wiping his face with a pristine white monogrammed handkerchief.

'You need a sign to show you the path, the new shining path, Senior Investigator Sun Piao. Have you checked your post lately?'

Footsteps approaching. Straightening his jacket, the *tai zi*. Smoothing back his hair.

'Your time, it is up, Senior Investigator.'

Already walking to the door, the *tai zi*. Footsteps

closer. The interview-room door thrown back on its hinges. Detective Yun handing Piao the release papers. The PLA smiling, as he moved into the corridor, toward his freedom. Piao kicking the door closed. On the floor the shattered remnants of the reel-to-reel still emitting a deep guttural buzz. Pulling the electric plug from the socket, the noise fading, dying. Only the sound of distant footsteps left, keeping company with the beat of his heart. Piao on his knees gathering up papers, photographs, the faces of murderers and the murdered. Throwing a broken leg of the chair heavily against the wall.

I should have taken you to a dark, high bridge over the Huangpu River, Comrade Princeling. Not the *fen-chu*. Never to the *fen-chu*.

★

Zoul pacing, shouting. Featureless eyes glaring at Piao.

'Stupid. Stupid. You were to carry out an unofficial investigation. Unofficial. To arrest such a *cadre*, such a *tai zi*. Do you have a death wish, Senior Investigator? Do you?'

Not waiting for an answer.

'And the possible impact on the *fen-chu*. Your comrade officers. Me, your Comrade Chief Officer. A man like Qi, he will have long arms. He will know others, many others who have even longer arms.'

'He is guilty, Comrade Chief Officer. Here is the evidence.'

File, envelope, held out at arm's length. Zoul ignoring them.

'Evidence, evidence.'

Words spat with disdain.

'This is what matters. This is what matters, Senior Investigator, not evidence.'

The desk, oak with leather and gold tracery, on it a pile of papers, faxes, emails, telephone messages, couriered letters. The Comrade Chief Officer's hands scooping them up. Zoul reading as he walked.

'This email from the Ministry of Security insisting that Colonel Qi be released. Immediately released. Two telephone messages. Two chairmen of *danweis* both ordering that the questioning of Colonel Qi be halted immediately.'

Papers in a fluttered fall to the desktop.

'Ten, twenty faxes: the Central Political Bureau, the Central Secretariat, the All-China Federation of Trade Unions, the Guard Army of Shanghai Garrison Headquarters, the People's Liberation Army Central Command.'

Picking up another pile.

'Telephone messages. These from the local Party. These from Beijing, the Central Committee, the Political Bureau. These from the All China Youth Federation and the Communist Youth League Central Committee.'

Zoul shaking his head.

'Why here? Why bring these PLA here? You were to

do this away from the *fen-chu*, undercover. We are all tainted by this act.'

Circling the Senior Investigator twice before he replied.

'*Cao-mu jie-bing.*'

Zoul laughing. No more than a sparse grunt.

'"The dead cat turned." Naive, Investigator. With men such as these, you will be that cat, that dead cat that they turn.'

Another grunt. His face creased with it.

'You used the power of the *fen-chu* to treat these men as common criminals. You humiliated them by arresting them, photographing and fingerprinting them. Worst of all, you subjected them to a DNA test. And in return for all of this shit . . .'

Faxes, emails, telephone messages, falling through his fingers.

'What did you get out of them? Three names, ranks and numbers. As for Qi, even his words are lost to us with the smashing of our reel-to-reel recorder. You have nothing, Piao. Nothing. Just words said to you only, and to the walls of interview room four. Bricks, Senior Investigator, they do not speak.'

From Piao's tunic pocket, a small silver tape recorder.

'I took an additional precaution, Comrade Chief Officer.'

Zoul surprised.

Piao placing the tape recorder on the desk. The tape rewound. Words . . . spurting, compressed, inverted. A button pushed, words fast forwarded. A shunt of sound, another button, the sound of a chair colliding with a wall, followed by that of a table thrown to the floor. Plastic splintering as the reel-to-reel violently met the concrete of the wall. And then a voice, breathy and angry.

'How dare you insult me, you *Ankang* scum! I work for a higher purpose, for a new and better People's Republic. If other scum like those whores or your interfering detectives get in the way of such progress, then they are casualties of war. I make no apologies for serving the interests of our great nation.'

The sound of Qi kicking the reel-to-reel recorder. More words loaded with anger.

'Casualties of war, and there will be many more before this progress has been completed.'

The voice calmer now. Words less fractured.

'You need a sign to show you the path, the new shining path, Senior Investigator Sun Piao. Have you checked your post lately?'

Piao switched off the recorder.

'Good evidence, Senior Investigator, but you will need more, much more than this to pin a *cadre* like Qi in place.'

But the Senior Investigator was only half listening to Zoul as he replayed the tape in his mind. Concentrating

on Qi's words, every one of them. Not just the answers that he wanted to hear.

'It is an unfortunate reality of life in our People's Republic that these *tai zis*' excesses go unchecked and unpunished. We must all learn to play a game, Piao. A very precise and careful game, or suffer the dire consequences.'

Listening. The tape slowly revolving. Qi's words, dull-edged.

'You need a sign to show you the path, the new shining path, Senior Investigator Sun Piao. Have you checked your post lately?'

The Comrade Chief Officer with his back to Piao, staring out of the window.

'What is it, Senior Investigator?'

A button stabbed. Another. Another.

'What's wrong, Piao?'

'Have you checked your post lately?'

Again.

'Have you checked your post lately?'

'Is there a problem, Senior Investigator Piao? '

Zoul turning, but his office door already open. In the corridor outside, just the sound of a cleaner going about her business and the sound of feet. Running feet.

*

A box, perhaps eighteen inches square, heavily wrapped in brown paper and white string. Carefully, as if holding

a baby, Piao carrying it into the bathroom. His instincts
and the PLA's words leading him to the bath, where he
set the parcel at its very heart.

'When did it arrive?'

'About two hours ago by courier. I signed for you.'

Only now Rentang noticing the sheen of sweat
across the Senior Investigator's face. The heavy rise, the
plummeting fall of his chest.

'What's wrong, Piao?'

String untied and falling. Fingers under tape sealed
seams. Brown paper, slipping away like onion skins.

'Leave the bathroom. Call the PSB. I want a forensic
officer here. Now.'

'What is it? A fucking bomb?'

'Just call them. Now. Go now.'

Piao already knowing, the worst part of it all.

Rentang leaving the bathroom, almost running. the
Senior Investigator pushing the door to. A sudden urge,
almost uncontrollable, to run. To escape.

Pulling the tape from the plastic and from the tight
bubble-wrap. Suddenly aware of the hue that blood has,
seeping onto the chipped enamel of the bath, pooling
in puddles of old tap water. And, through a gap in the
bubble-wrap, a shock of hair, matted, bloodied. And
smells ... smells of a butcher's stall, of meat past its
sell-by date.

Gently setting the severed head in the bath. Smooth-
ing down the wild tumble of hair. Windows to the
soul, his fingers across the old papa's eyes. Slipping to

the floor, Piao. But his gaze never away from the old vagrant's face. The forensic team would be on their way. Latex and powder, self-sealing evidence bags and professional detachment. On their way, but at least thirty minutes to sit, wait, watch.

His fist, twice in violent concussion with the bath's rolled cast-iron top.

'Fuck. Fuck.'

Pain, the purge of righteous pain, partly assuaging the guilt of realizing that he was not mourning the death of a good comrade, but regretting the loss of a witness, the only witness to Detective Di's murder. Fuck the life that his job had foisted upon him. Always the job. He would have cried, cried for the old comrade, cried for himself. But he wasn't sure how to. The job, a robber of even his tears.

21

Crows everywhere are equally black

Do not leave your daughter alone. Out of your sight. Out of your reach. Out of your influence. Even though a girl might be 'spilt water', she has her value.

Dusk to dawn, work her hard in the rock-strewn fields. And then there is the housework to finish, and laundry.

Your daughter, she could bring a dowry. Perhaps become a concubine of a Party official if she is pretty enough.

Or perhaps a *yeh-ji*? There are many tourists, much money in their perfumed pockets.

As you can see a daughter can have much value. Watch her, guard her, or a shadow might peel from a shadow and steal your daughter into the night.

★

Go to the poor areas. Not a street or *long* in them that does not know of a girl being stolen. Taken as she made her way to the market, to the next town or to the house of a grandparent. Transported beyond the mountains

that seem to obstruct every exit from Guizhou. Taken to be a bride for 8,000 *yuan*, a slave for 10,000 *yuan*. A prostitute, now that comes a little more expensive. HIV and AIDS? Do not worry yourself over such things. In the People's Republic, they do not exist. In the People's Republic they cannot exist.

★

Do not leave your daughter alone . . . so many incentives to steal her away from you.

In one year alone 110,000 women were found by the authorities and returned home. In the small town of Zunyi, where Mao established his vice-like grip on the Communist Party in the 1930s, eighty-four women were freed from a gang that had abducted them. The gang leaders executed. How many, you think, would have known the Great Helmsman's words about the equality of women on the new shining path of the People's Republic?

'Women hold up half the sky . . .'

In one year alone, 1999, 1,800 stolen children returned to their families.

In one year alone, 2003, 13,000 rescued children, and this, from a central government reluctant to even acknowledge the problem. The poverty-stricken province of Guizhou, never known for exporting anything of note, now known as the centre of the kidnapping industry.

Do not leave your daughter alone. 'Spilt water', hard

to find once they are in the hostess bars of Hong Kong, the brothels of Shanghai. Hard to find. One whore looks like another. Ask any PSB Chief. They will be unanimous in what they say and how they say it.

'Crows everywhere are equally black.'

22

Four reports. One tape

Xunhuacha, rose petal tea, tasting of plums fallen to ground and late afternoon rains. Another cup, then another. Spread out before him, four reports, four young women, three dead, one still living. But all mapped by the *tai zi*'s cut-throat glide.

Piao looking for what things have in common. Sometimes small things, but big in consequence.

One prostitute, Lan Li, and three other girls anything but. Expensive, private educations. Good students, good girls with nothing in their lives of the alley's shadow. Nothing that should have drawn the attention of the PLA *tai zis* to them.

Dates and places of birth, different. No shared schools, neighbourhoods, friends or colleagues. No shared interests or political history. All had been members of the Party's Youth League, but in different cities or neighbourhoods. All good communist girls who would have made Mao's red lips smile.

Shaking his head.

Another cup of *xunhuacha*, another China Brand. Reading until his eyes bled with the need of sleep.

Danwei files: cradle to the grave files, each examined and re-examined. Similarities, but nothing that bound them to each other in life or in death, except for death itself.

Neighbourhood street committee files, Party files, personal files.

The back of his hand over his weary eyes hunting for the ordinary, which would point to the extraordinary. Last files, inconsequential files, files not about the young women at all, files on bloodline, parents, details, dates. Four reports. In turn viewing them all, one after the other. Knowing that it would be there, the thing that they have in common.

Spilling the tea as he bent to pick up Lan Li's parents' file, different from the others who had been killed, but not only in that she still possessed life, while they did not. Lan Li, a girl, 'spilt water', given up by her rich and well-connected parents who desired a son . . . 'ten thousand ounces of gold'. Lan Li, now a *mei ming*, a 'no name'. Handed over to the Shanghai Number 2 Welfare Institute on Chongming Island, a conveyor belt leading straight to death or to the whorehouse. While the other three, also from politically good stock and relatively privileged lifestyles, had led cosseted, demure lives, all that Lan Li had known had been rejection and abuse. To never see your parents again – for them to never see you again. Piao shaking his head. A cup that he had drunk from.

Exhausted, all of his attention just to focus his

vision. Father's name. Date of birth. Age. Lineage. Education. Profession ... profession. Cup to floor. Cigarette stubbed out. Eyes frantically seeking files. Fingers racing, hunting through pages for one detail within the twenty thousand that he had read. Reread. Knowing that it would be there. Knowing.

The three girls whom life no longer possessed. Their fathers, each of their fathers, a scientist. Lan Li, her birth father, long lost, but now reminded of blood's bind, also a scientist.

Piao, eyes closed, weighing-up actions, leading to consequences and other actions.

The *tai zi* surely using the daughters to manipulate their fathers. And not to yield, while the crop of your seed is scythed down long before it has reached harvest time. To be the one who has brought death to her side. You. The taste of death now present in everything that you do. Ingrained even at a genetic level. Haunting your very shadow. And was it worth it, such service to save face, such service to your masters, to state, to Party ... worth your daughter?

23

Two funerals

> *May all beings be filled with joy and peace . . .*

Mud and rain. White mourners over scarred ground, following the monk's sandalled footfall. Half of his words falling to heavy hearts, half stolen by the driving wind.

Near the summit of the round hill, the plot. *Feng shui* demanding such, as long as the *yuan* will stretch, or *guan-xi* barter. Mourners huddling behind the barriers of buffeted umbrellas. Tearful faces turned away as the coffin was lowered into the grave. Bad fortune to follow if not.

Spade by spade, the mourners filling the grave with earth. Only the sound of mud falling onto wood, and prayers, and meditative supplications. At the back of the group, under a black brooding cloud of an umbrella, a gaunt man and a plump woman, the parents of the girl now known by the mortuary tag tied to her toe, as 35774341.

'Forgive me, Comrade. I am Senior Investigator Sun

Piao, and this is my Deputy. We are from the Homicide Squad and we are working on your daughter Xia's case.'

Water across Piao's cheeks, lips, in a chatteringly cold baptism. He and the Big Man beyond the saving grace of the umbrella's span.

'We have come to pay our respects. We have also come to ask you some questions.'

Looks of astonishment. The mother's hand moving to her face. Tears pushing from her eyes and falling silently down thickly applied make-up.

'Now? You wish to ask your questions now, while our daughter is being laid to rest?'

'I appreciate that this is unusual, but so was the nature of her death, Comrade.'

The word death bringing a sob from the mother. Yaobang pulling a surprisingly clean handkerchief from his trouser pocket and offering it to her. A plump-handed rejection.

'Come, mama . . .'

The Big Man's arm around her waist, guiding her and the umbrella towards an oasis of other umbrellas.

'Let the big boys talk for a while. I am a good listener, tell me of how beautiful your daughter, Xia, was as a baby. Yes, mama?'

The husband watching his wife's waddle through the mud towards the graveside. Thinking of how slim she had been when he had first married her.

'Do I have a choice about answering your questions, Senior Investigator?'

ANDY OAKES

'There are always choices, Comrade Scientist. Even the prisoner in *lao gai* has the choice of being beaten either by the stick or with the leather strap. Is that not an example of good communist principles in action?'

Already wary as all are when they see the shining brass buttons of the PSB tunic, and aware that the investigator had called him Comrade Scientist.

'What is it exactly that you want, Senior Investigator?'

'Exactly. An excellent word. That is what I like about comrades who have undergone the rigours of a science degree at university. Exactness. But let me be exact with you, Comrade Scientist. At least as exact as I can be, in a case where we are like frogs at the bottom of the well looking up at the sky. Four daughters of scientist fathers, attacked, mutilated. Three whom life no longer possesses. Scientist fathers whose files are full of data, crammed with detail, except about the project that they are currently working on. What was required of you, or from you, Comrade Scientist?'

Silence. Only the rain and the monk's chants.

'Threats were made to you by a *tai zi*, a PLA princeling. His name, Qi. Your daughter would be harmed. Such a beautiful daughter. You go to your superior, he makes assurances to you. He tells you firmly, you are to do nothing, say nothing. Do not fear, he reassures you. Your daughter will be safe. She will be protected. But in the innermost chamber of your heart, you did not believe him, did you, Comrade Scientist? You were

right not to believe. Your daughter, she was not pro-
tected. This *tai zi*, I have his words on tape. You know
how he described your daughter's callous murder? He
called her "a casualty of war".'

Silence, words spent, mourners moving from the
graveside, following the monk down the hill. A ques-
tioning glance from his wife's black eyes to her husband.

'She does not know, does she? Comrade Scientist,
your wife, she does not know that your daughter died
because you would not give this princeling what he
wanted, does she?'

'No, she does not know.'

'A heavy cost, Comrade. A heavy secret to bear.
But I can lighten this burden for you. These men,
the princeling, the *tai zi*, they will not escape justice.
By the ancestors, I promise this.'

The comrade turned, his wife's lingering glance cut
adrift.

'The service that you have given to your profession
and our masters in the Ministry of Security, the secrets
that you have honoured, and the high cost that you
have paid in doing so, I cannot promise you that it will
ever be recognized. But it will be avenged.'

Silence.

'But for this to come to fruition, you must aid me.
I must know what it is that was worth the life of
your daughter. I must know what it is that was worth
the lives of three other young women. What can be
so important? Comrade, we are standing at the side of

your only daughter's grave. She was an innocent. Please help me. You must help me.'

Silence.

'I am here to help you.'

'That is what he said, my *tong zhi* superior. And now I am no more than a *guang guan*.'

'Comrade, "bare branches" do not have the information at their disposal to hurt men such as these PLA. Tell me the secret that you and your comrade Scientists hold, and I will be your fist in an iron glove.'

Silence. Only the rain and its cyclic journey. The Senior Investigator unbuttoning his coat, rifling through the deep inner pockets, pulling out a small diary.

'This number. Do you know this number?'

Silence. Nervous, the Comrade Scientist's eyes. Seeking escape. Everything about him balancing on a precipice.

'One of our comrade officers may have died because of this number.'

'I cannot speak of this.'

'You know this number. The fact that you cannot speak of it tells me that you know what it is, Comrade Scientist.'

The Comrade Scientist already moving aside. The pull of the hill drawing his feet back to the older area of the graveyard. Headstone banked against headstone, as dominoes about to tumble. Names now eroded. Pulling him back to the lithe country girl that he had courted; thirty years passed and now a plump wife with expensive tastes.

Piao, soaked through and blinded by the rain, shaking his head. One last appeal shouted against the wind's rage.

'For the memory of your daughter, give me something. Anything. Anything, Comrade.'

Turning from his plump wife's darkly questioning gaze, the Comrade Scientist. Looking back through rain, through tears, his lips moving. His words, in the strong wind, a breath within a roar.

'Mao Zedong, Southern Kiangsi, 20th August 1933.'

*

Two funerals

The Gui Ji Li Bai Tang, the Shanghai Community Church, sat on the Henshang Road. A splinter of Christianity, into the soft thigh of foreign gods and their eastern prophets.

A difficult thing to enter a church, for a faithful member of the Party that describes itself as 'more important than God'. Almost an impossibility. The rule still on the Party's statute books, that citizens who have a religious belief are not permitted to join the Party.

*

A small ante-room, tucked away in the bowels of the church. A small, nervous congregation. Eyes turning as they entered. An instant smell of incense, covered tracks and secret gods. The priest's words faltering, stalling.

Eyes falling on the stars burning on epaulettes, brass-buttoned tunic. Piao sitting, nodding, the Liturgy of the Eucharist, continuing. Words veined with unease across a makeshift altar; a white embroidered cloth covering the splintered table.

'This isn't right, Boss.'

'Try to reshape your foot to fit into a new shoe. It is religion, nothing more than religion.'

A woman dressed completely in black at the very front of the congregation leaving her seat. A hurried walk toward the rear of the room, towards the Senior Investigator and the Big Man. Only raising her face as she was almost upon them; the features of a bird caught up in an almost invisible net. A recognition in each other's eyes, need and duty, drawing them as opposite poles of magnets. Automatically Piao opening the door. The woman passing between them. Her smell of dried tears and mothballs. Following her. The woman waiting until the doors had swung fully closed before she spat. From the back of her throat with heart and soul. Hot, bitter spittle, across the Senior Investigator's face in ginger and garlic venom. Yaobang thrusting himself forward between them. Paw of a hand on the woman's shoulder, breaching the bounds of familiarity.

'Enough.'

The Senior Investigator stepping forward, cuff wiping warm spit from his face.

'She does not spit at me. She does not know me. She spits at the uniform, the Party, the star of the

People's Republic. She spits at the murderer of her daughter. And these things deserve to be spat at. Is that not so, Madam? You and your husband, the Comrade Scientist, you have been ill-treated, forgotten. No messages of sympathy, no support. Your daughter's death and now your husband's ill-health, an embarrassment to those in authority.'

Tears down her wasted cheeks.

'No explanation of why life no longer possesses your beloved daughter. Twenty-one years of caring for her, loving her. It is a lifetime, a lifetime. No explanation of why your husband, the Comrade Scientist, was not protected from the threats that he received regarding your daughter's wellbeing. And now he also falters, struck down by loss and ill-health.'

The woman, once a mother, falling forward, hands on each of Piao's shoulders.

'A letter of condolence from his superior officer. But nothing about finding her murderer.'

Her eyes looking up to Piao's, tears and questions brimming.

'A mother, a wife, she needs to know such things. My husband, he fulfilled his duty and now we have no daughter.'

Her hot tears through his shirt to his skin. So many tears, so many sadnesses. How many more before they diluted him completely?

'A Mass for my daughter. Prayers for my poor, ill husband. Can this be right?'

'No, mama, this is not right. But we are here to investigate her death. To avenge her.'

'No, no.'

Her face from the Senior Investigator's chest.

'I do not wish her death to be avenged. "Vengeance is mine, I will repay, sayeth the Lord."'

Soothing strokes, Piao's hand across her hair. As her husband would have done, if he had been present, and not in medication's soporific halfway house.

'But what about justice? Surely even your religion recognizes justice?'

Bitter tears flowing as if they would never stop.

'Madam, I make a solemn promise to bring to justice those who perpetrated this crime upon your daughter and your family.'

So many questions written across her lips. Piao's cuff wiping away her tears.

'The questions in your eyes, Madam. Do not ask them now. Do not ask me to cause you pain in the answers that I might give to you. Only ask me when I have found your daughter's murderers. When there is that balm to heal the wounds. For now, Madam, it is I who need your help. Your husband, he was involved in a special project of some kind. There are no notes, no folders that we have access to. Unusual, very unusual. We do not know what this project was. But we need to know. It is perhaps the nature of this project that brought this sorrow to you. The pressures upon your husband, the threats to your daughter's life.'

'But there is nothing that I know. Nothing at all. Such a quiet man, my poor husband. Such a conscientious man. He would not speak of such matters. Never did he talk of his work. Never.'

'We would like to see him, Madam. Talk to him. Perhaps he will . . .'

'No. No. My husband is too ill. He talks of nothing now, nothing. The silence, it came slowly. The doctors say that he has lost his words and with them his sanity. Our daughter, she was his heaven. With her gone there is only hell.'

'He was a biologist?'

A nod of her head.

'Did you meet his colleagues? The others who were involved in his work?'

'A quiet man, a conscientious man. He kept his work and colleagues separate from his life at home.'

The Big Man taking up the questioning.

'Is there anything else that you can tell us, mama?'

A shake of her head.

'Madam, it is important. Please try, even in your deep grief, to think of something that the Comrade Scientist said.'

'But I have already told you there is nothing. There is, is . . .'

A stumble. Words collapsing to silence. Piao's hand across her hair. Once black, now grey.

'He would be away for days. Sometimes weeks. I worried about him. I gave him food to take. A fussy

eater, my husband. So fussy. But always he would re-
fuse. Always. "Why take sand to a desert", he would say.
"That's all they do there, grow food. The best soil in
the People's Republic . . ."'

'Where, Madam? Where was he talking about?'

'Shuihuzhuan.'

'"The Water Margin", yes, Madam?'

'It was his favourite book. And now . . .'

Piao to the Big Man.

'The 108 heroes of the "Water Margin" lived in the
marshy areas around the great lakes, Dongting and
Poyang . . .'

'The "two rice bowls", Boss. They call it that because
the plains around the lakes are so fertile.'

The mother's tears easing with the giving of some-
thing of value.

'Your husband was correct, Madam. There would
be no need to take food to such a place as that. Thirty
per cent of the Republic's rice comes from there. But
the question is, why would such a place as that take a
comrade scientist to its bosom for weeks at a time?'

Piao pushed open the ante-room doors. The woman,
the mother, escorted to her seat either side by servants
of a Party 'more powerful than God'. Eyes of the small
congregation turning from the priest to the gold but-
toned tunic, to the red starred epaulettes.

'Sit, Madam, gain comfort. There is much comfort
in a son of God's blood. Much in a son of God's body.'

'You are a Christian, Investigator?'

Piao and the Big Man, already turning back to the half-open door. Sounds of the world beyond at full thrash already in their ears.

'No, Madam, I am a communist. Whatever that might be.'

*

The People's Square, an hour just watching the first rehearsals for the Festival of the People's Army of Liberation. Comrades from the collective farms bussed in. Pigs, tractors set aside for a day. Women in leotards which were too small or too big. Knickers, white, pink, blue, poking from weathered elastic. Marching, turning left to calls of right – right to orders of left. On the podium an artistic crisis; the choreographer's frustrated shout.

'Listen. Listen to my words. Or are you only used to the snort of your pigs?'

The Big Man turning, flicking cigarette ash from his tie.

'Perhaps this is what being a fucking communist is all about, eh Boss?'

Piao lighting a new cigarette from the butt of the one he had just finished. Life, death, its cycle in every-thing. Pulling deeply on the China Brand. As if his first. His last. But sure that the Great Helmsman had not spoken of leotards which were too small or too big in

his thoughts on the 'fragrant flower' that was Marxist
ideology.

*

The note taped to the Vice Squad telephone in the
basement of the *fen-chu* was brief. Two names in
uncompromising black-barbed type. The last two scien-
tists, biologists, whose lives had fallen from heaven to
hell with their daughters passing beyond life.

The Big Man pulling the note from the handset. In
a single scan knowing, and with it, the sound of doors
slamming shut. Two doors. The father of the body now
in the morgue and known as 3577434, life no longer
possessing him. Taken by his own hand as the ink was
still drying on the file that would open an investigation
into his child's death. And the father of one of the other
girls in the morgue, now known only as 35774352,
missing. Lost to the eyes of his family, friends, col-
leagues. Lost to their love. Why fear the black night
when the light of your world has been extinguished?

Crumpling the note into a tight ball, the Big Man,
and launching it towards the nearest bin. Missing it.
Two lives lost in paper rolling across the floor to join
so many other balls of crumpled paper.

24

The waitress was perhaps nineteen years old. Pink
panties that blushed into view every time that she served
a table. Every time that her micro-mini moved slightly
off the horizontal plane. Ten tables to serve, and as
many languages pouring from her crimson-glossed lips.
French, English, German, Japanese, Italian, Russian; not
a language in which she couldn't say, with the correct
accent and with feeling, 'Service is not included.'

Not a table that she didn't serve before theirs. The
one in the far corner, the *dahu*, two mobile phones, one
mouth. The eau de cologned brace of *cadres* nearest
the bar, organizers in palms, comparing megabytes. The
Party officials' wives, doctrines on tongues, Dolce and
Gabbana on their bodies.

'Three Tsingtao.'

The waitress's eyes heavy with mascara, raising them
to the spotlit ceiling.

'We don't serve Tsingtao.'

'Three Suntory.'

'We don't serve Suntory.'

'Reeb?'

A shake of her head, lacquer-spiked hair unmoving.

Yaobang's eyes seeking the aid of his Senior Investigator. Or if all else failed, Rentang, the 'Wizard'. Piao in a whisper,

'Try Heineken.'

The Big Man, timidly.

'Heineken?'

The waitress thrusting a black and gold drinks list into his hot pepper-sauce-stained fingers.

'We are a tequila bar. We only serve tequila.'

Yaobang's face as blank as the page on her drinks order receipt pad.

'What's tequila?'

The Wizard taking control and pulling the drinks menu from his hand.

'Tequila is a drink that they have in Mexico.'

'They also have dysentery in Mexico. Doesn't mean that I want that either.'

The waitress starting to put her pencil away. Rentang's finger hovering over gold.

'I will have a Tequila Cuervo Especial with salt and lemon. A double.'

Piao's eyes meeting the waitress's mascara strokes.

'Do you have Perrier or Evian?'

'Yes.'

'I will have whatever is the cheapest.'

The waitress looking at Piao as if he had been wiped from the sole of someone's designer leather shoe.

'And I will have one as well.'

The Big Man, confidence bouncing back.

'In fact, you can make mine a fucking double.'

She walked away with haste, the Big Man watching for a blush of underwear that never came.

'Nice bar. We're moving up-market, eh, Boss?'

'What he means, is why bring us here, unless it is bad news. And knowing you, Sun Piao, dangerous news,' cut in the Wizard.

The drinks arriving. Rentang, grey tongue licking white salt from the pallid top of his hand. Slinging back the tequila. Biting into the lemon. His voice several notes higher.

'So, shock us, Senior Investigator. We only have six who life no longer possesses. Surely you can do better than that?'

'Seven.'

Choking the Wizard. Tequila, lemon, salt, across the tabletop.

'What? '

'Seven. In the bathroom, the parcel that you accepted from the courier. It was the head of the old father, the vagrant. Our only witness.'

'*Dao-mei. Dao-mei.*'

Pouring the Evian onto ice, the Senior Investigator. Onto lemon. Slowly sipping. Yaobang following his every move then violently spitting the Evian onto the table top.

'Shit, it's fucking water. I haven't drunk water since I was twelve years old.'

Piao holding the glass to his forehead. Its chill

bringing some clarity, some sanity from the madness racing in his head. Yaobang pushing the glass away.

'So, Boss, what the fuck's going on?'

'We are in a vice, one with powerful jaws.'

Piao sipped at the water.

'We have a serial murderer, Colonel Zhong Qi, the *tai zi* son of the Commanding Officer of the Shanghai Kan Shou Jingbei Si Ling Bu. The probable murderer of two PSB comrade officers. A mutilator of one and the possible murderer of at least three other young women. Who also probably arranged the murder of the vagrant who was our prime witness to the killing and torture of Di and his Deputy.'

Piao's finger making tracings through the condensation on his glass.

'His father, the Senior Colonel, would not be proud of such a son.'

'Or perhaps he would, Boss? This *tai zi*'s son, a drink from the same bottle from what I've heard.'

'This is the evidence we have on this *tai zi*. The old vagrant's statement, Lan Li's statement, video evidence from the construction site at the Shanghai Stadium. DNA evidence that matches that from the cigarette butt found at the crime scene. Also, during my brief interview with him, this *tai zi* admitted to the murders of the young women, and of our comrade officers. He called them "casualties of war".'

'Then you have him, Sun Piao. You have this arrogant *tai zi* bastard. What more evidence could you need?'

Rentang raised his glass in a toast.

'Good work, Senior Investigator. Now we can all go home.'

Piao gently lowering the Wizard's arm.

'It is not as simple as that. It is never as simple as that. At least not in the People's Republic.'

'*Ta ma de.* Not as simple! It couldn't be more simple!'

The Big Man throwing an arm around the Wizard's scrawny neck.

'My friend, the Boss is right, it's not as fucking simple as that. Evidence is not enough, you have also to be a student of politics.'

Shaking his head. With each shake, a whispered incantation of bad luck.

'*Dao-mei. Dao-mei.*'

Finishing his drink.

'What is it that's going on? Evidence was enough for you to ensnare me. For you to blackmail me into helping you.'

'This serial killer has friends in high places, many friends in very high places.'

Rentang once more beckoning over the waitress. Yaobang placing the spent glasses at the far end of the table. A blush of baby pink as she retrieved them. Ignoring the Big Man's smile, wink. Ordering more tequila.

The Wizard's palm to the Senior Investigator's face. Words fended off.

'I told you, I don't want to hear another word. Six dead . . .'

'Seven,' the Big Man correcting.

'Seven dead. I will not be the fucking eighth.'

Ignoring him, Piao.

'We also know that the three girls and Lan Li, all of their fathers are, or were, scientists. All biologists.'

'It's got to be drugs, Boss. Easy *yuan*. Especially for these fucking *tai zi*. They travel where they want. They don't need travel permits from the *danwei*. Makes distribution a dream.'

A nod from the Senior Investigator.

'Perhaps.'

Words to himself, Piao. Barely a whisper. Words, the skeleton on which to hang a thought process.

'"Casualties of war". But casualties of what war, Boss?'

'Perhaps. Anyway, Zoul wants all that we have. He wants us to hand it all in. Photographs, video, any forensic evidence, files, the location of the girl, Lan Li.'

The Wizard's words dulled by tequila's bite.

'Either hand the case over or destroy the evidence Sun Piao. Just get rid of it.'

Shaking his head, the Wizard.

'But you're not going to give up this case, are you, you're going to get us fucking killed and for what? For what? '

Yaobang not needing to think before replying.

'For Di and his Deputy. For all those young women

who were fucking carved up. For the old comrade whose head was sent by courier. That's what for.'

The Senior Investigator's arm coming down across Yaobang's shoulders.

'I will not give up this case. These comrades, they murder as freely as we breathe. They rip humanity as if it were toilet paper. They see themselves as beyond our laws, because they are *tai zi*.'

Slapping the Big Man on his back.

'I represent the law. Whether they are *cadre* or peasant, I draw no distinction. I will demonstrate to them that they are not out of the reach of our long arm. But I will not force either of you to come down this road with me. If you do not wish to be a part of what I am doing, go now.'

From his inside pocket a rolled manila envelope. Slapping it down on the table.

'The photographs and the negatives that I have on you are in this envelope. All of them. You can walk away, now. Take them with you. There will be no recriminations.'

Rentang standing, pushing his chair hard against table.

'It's all right, I'm just going to the toilet. What has our People's Republic come to when an honest comrade can't even take a piss?'

Watching the Wizard disappear from view.

Fifteen minutes, watching the waitress's pink panties occasionally wink into view. Yaobang was the first to speak.

'He's taking his time, Boss. He won't come back. Probably squirming out of a back window.'

'This is the People's Republic. We allow our citizens a choice, or at least a choice of sorts, unlike some countries.'

'So, what do we do now, Boss?'

Piao ignored the question.

'We are being followed.'

'I know, Boss, saw them on our tail on the way here. A black Beijing, a BJ 750.'

Piao nodded.

'Could be anyone, except someone wanting to wish us long life. On which subject I will need some help with the PLA Officer, Tsung. I watched him. He is an egg with flies around it.'

Yaobang grinning.

'And flies never visit an egg that has no fucking crack, eh, Boss?'

A door opening, a door closing. Rentang in a measured, dignified walk returning to the table.

'I am an idiot, I will continue to help you. What do you want me to do?'

'Do what you do best, Wizard. Find us things on your computer that will tell us of our Colonel Qi. Things that have barbs and will stick in his throat, and in the throats of others. Also find a way into that file that has a lock on it.'

'The forty-bit encryption. I already have someone for you to see, Sun Piao. A hacker, the best.'

232

'And . . .'

Even the thought of saying the name bringing bitterness to his tongue, as if a pill were melting its soporific spell across it.

'*Ankang*. I need to know who it was that got me released. Who it was that placed me in its grip.'

'It will be difficult. *Ta ma de*. Very difficult.'

'But that is what you are good at, Wizard. Difficult things.'

A paper pulled from his pocket. Piao laying it on the table.

'This also . . .'

Mao Zedong, southern Kiangsi, 20th August 1933

'I need to know everything about it.'

*

A grandstand view from the Sedan. Brief, and interrupted by traffic flow. Five thousand young women in leotards, more rehearsals for the Festival of the People's Army of Liberation. A bag of chilli hot dumplings on his lap, haemorrhaging grease on to his trousers. A little piece of heaven set down to Nanjingxilu, but Yao-bang, a taste for neither. Concrete in the pit of his stomach.

'Lingling, Boss, it was Lingling who wanted you out of *Ankang*.'

'My wife?'

Just the words, a switch thrown to a hundred tape

loops. Memories of memories. Still, her perfume in his nostrils, on his fingertips the silk of her skin.

'Lingling wanted you out of *Ankang*. She telephoned me. Told me to look after you. As if I fucking needed telling. It was her *guan-xi* that got you out. But Zoul, he must have fucking known as well.'

No response from the Senior Investigator.

'I asked her the cost. "There is no cost for a husband," she said . . .'

'Why not tell me earlier?'

'I'm sorry, Boss. I know that I should have told you. But you were so weak when you were released from *Ankang*. And . . .'

'And?'

'And she said that telling you would put your, our, lives at risk.'

'Where Lingling is involved there is always risk.'

In the rear-view mirror, a tableau of the Great Helmsman with one eye, and a clench of confused faces looking out from his sweet mouth.

'Sorry, Boss. I should have fucking known better.'

Fuxingdonglu, before the Senior Investigator was able to speak once more. And then only by using a cyclic breathing exercise that a psychologist had demonstrated to him in *Ankang*. Three seconds inhaling through the nose. Three seconds holding the breath. Three seconds exhaling through the mouth.

'You should have told me. Words between friends are diamonds and not difficult to trade.'

A deep exhalation as a full stop. As an exorcism. Piao's hand into the dark greased bag of dumplings sluggishly rolling on top of the dashboard.

'Mama Lau's, or the stall in the Jinling Road?'

Smiling, the Big Man, and holding a fat, greased pearl of dumpling toward the windscreen, as if he was looking for a flaw in a rare diamond.

'Mama Lau's of course, Boss. What do you think I am, tight, someone that would skin a fucking flea?'

25

You do not know how a violin sounds before you
* play it.*
You do not know how deep a river is before you
* go across it.*
You do not know if a new bottle leaks before you
* put water in it.*
You do not know if your lover loves you or not,
* but how to test it?*

<div align="right">Hakka Chinese mountain song</div>

Over the next few days they counted four BJ 750s that were following them; identically sprayed, plated and liveried. But to the trained eye, four different Beijings, each with its own distinctive marks and features.

Through the corner of the curtain, one of them, a street away, in shadow. In its velour interior strained eyes watching through high-powered binoculars. The smell of long-ago smoked cigarettes, sticky armpits, sweat-groined pants and talk of jobs well done, perhaps of a girl's hot cry to the razor's hot track.

Walking to the Sedan, starting it up, driving. Acting normal.

A constant speed, shadow Beijing in tow, no sudden moves. foot on accelerator. Across the Wusongjiang, eight ribcage bridges, veins into the artery, traffic building. Ahead, staggers of red lights, traffic in awkward jerks and pulls. The traffic freed and Piao easing ahead. Behind, a Friendship taxi and an old and beaten Fiat, one of the Beijings; tethered like a black dog on a metal-linked chain. Passing on green, the last lights on the very edge of the junction, the traffic ahead slipping through. Piao touching the brake. The car ahead slipping through amber. Piao pulling the Sedan up gently by the lights.

From Beijingxilu, a truck moving swiftly, through the death of amber lights.

Piao easing the Sedan forward, turning as the light changed to green. Only the Sedan and the Friendship taxi, making the turn. The Liberation truck just missing them both, its back wheels sliding, front wheels locked. A mask of concentration the driver's face, frantic hands. The aged truck jerking violently to a halt blocking the flow of traffic from the Hongkou end of Xizanglu. A chorus of horns leant on by a host of elbows. Hands out of wound-down windows in wild gesticulations. Behind the old Fiat, fierce eyes watching from a black Beijing 750, as a Shanghai Sedan drove leisurely out of sight down Beijingdonglu towards Huangpu Park.

Eyes watching as the driver of a Liberation truck jumped from his cab. Holding his head in his hands. Examining the damage to a load which had been spilt

and crushed. At least twenty minutes to exchange arguments and then to sweep the mess to the side of the road. Twenty minutes, if he had a broom. The splintered pallets, broken trays, the crush of 5,000 mooncakes, the best in the old French Concession. Yes, at least twenty minutes if he had a broom, which, of course, he did not.

Only when past the Huangpu Park the Big Man commenting.

'A lot of *yuan* that many mooncakes, Boss. The cousins will need paying.'

Piao nodding, the mathematics of the situation already orbiting his brain. Mooncakes at ten *fen* a cake, translated into bottles of whisky. A lot of whisky for a lot of crumbs and no tail.

Beidaihe, the Sea of Bohai

Piao looked to the heavens, to the ritual of the ages. A 'wave day', the confluence of flyways over Beidaihe and its theme-park hotels. Over its Twinkle Night City palaces and its razor-wire-bangled *zhau-dai-suos*. Seasonal rivers of birds linking north-east Asia, south China, Indo-China, Australia, Africa. Black ribbon strands, interlocking chevrons. Grey cranes, white Siberian cranes, red crowned cranes, far from home and flying further. A whisper, unwhispered, calling them to a place that they know only in the helix of their DNA.

No language to its voice. No words, just a calling of triggered actions and responses.

A longing. A longing that you didn't even know that you had longed for.

The Senior Investigator only moving towards the *zhau-dai-suo* with Yaobang's insistent nudges.

'We're here, Boss.'

'Here', a kind of home. 'Here', a longing answered?

*

'Fuck me. Some place, Boss.'

Whispered even though at least thirty metres away. Observing the house from the dark olive lace shadows of chestnuts. An *a-yi*, wishbone bent. A security officer, built like a Party headquarters, thick bricked and with a sense of permanence. A studded outer door set into the fifteen-foot-high razor-wire-topped wall that shielded the *zhau-dai-suo* from the outer world. A bell, an intercom system and, perched above the door, a CCTV camera. Through the old East German binoculars Piao searching each brightly lit window.

'The higher the wall the more powerful the *cadre*.'

'Or those that they are fucking sleeping with Boss.'

Shadow to shadow, moving through trees, lush grass, they skirted the western wall, fleetingly around the front of the *zhau-dai-suo* and the eastern wall, looking for a weakness that was not there.

Approaching the corner and hearing before seeing it, the sea and the beach; pressed as one in the uncertain

minutes of a day moving into night. The *zhau-dai-suo*, its private access to the beach might prove its weak point. Moving down the paved path, a steady stream of people passing. On the sand now, the light fading, and suddenly they were there, as if waves that had reared from the belly of the sea were now shifting from liquid and into solid form. Two figures trailed by a darker figure. A woman in silhouette, slim, so slim. Her long graceful arm trailing, her hand gently resting on a very small child's head. Fingers moving in and out of his fine hair. Even from many metres away, the sensual delight of the simple act, obvious, and for Piao a moment of almost unbearable pain. *Nemma bai nemma pang.* He should be my child, my son.

Just beyond them, a third figure. Black hair, suit, shoes, the kind of shoes that are worn to funerals.

Closer. The woman animated, talking to the child, but the words lost in the slip of metal waves running to the metal beach. Staring directly at Piao as they approached each other. She not knowing him, but he knowing her as you would know your own reflection in a mirror.

Recognition dawning in her eyes, a question forming on her lips. He, the Senior Investigator, looking past her to the Security Officer walking in her footfall. Eyes widening. He too feeling the adrenalin and rush. Its taste, of perhaps years to be cut prematurely short. A pension never to be realized.

Her hand from the child's head to her face. Sweep

of Security Officer's jacket as his fingers fumbled for steel. Pistol facing pistol. Piao, hand over hand, and pointing. An obscene, anodized finger in uncompromising stance. Screaming.

'Drop it.'

Yaobang in a slow move to the flank, but not daring to pull his pistol. Piao conscious that he was crouching ball-like, making himself a smaller target. Already shrinking from the bullet. Shouting at the top of his voice.

'Drop it.'

And she all of the time, silent, paralysed. Her child held protectively to her. Her body wrapped around him, a damp cotton, maternal shield.

'Drop it.'

A wild gaze to the woman. The Security Officer seeking a signal. To spill blood or acquiesce. A cheap-suited gladiator waiting for the thumbs up or down.

Then her voice.

'Do as he says.'

A sound, at that instant the best sound in the world, the pistol dropping onto the sand. Yaobang moving to retrieve it. Pulling his own pistol, its black snout grating on the back of bony skull. No words necessary.

For some seconds Piao looking seaward. Gathering himself, torn by divergent thoughts. Holstering his pistol. Moving to the woman, his words unrehearsed and sounding stupid.

'There is no need to look surprised, Lingling. Why

would a wife look so surprised when she sees her husband?'

★

Dark now, hardly able to see her face. The words that he spoke, in the darkness, seeming detached from everything.

'You will go to the entryphone. You will ask the other Security Officer to come out of the house. Say that you are concerned about a hole in the fence at the back entrance to the beach. Say nothing that alarms him. Do nothing that alarms him.'

The entryphone buzzer pushed. Somewhere in the *zhau-dai-suo* a monitor filled by a woman's face.

'*Ni nar?*'

'There is a hole in the fence. I need to show it to the Security Officer, send him out to me.'

'Certainly, Madam.'

The voice tinny and old. Fifteen seconds later a door opening, closing. Heavy feet on a pebble path. Closer. The outer door, opening. An instant reek of fake Tabac, mixed with vinegary sweat. An arm out of darkness around his throat. Another with a pistol bruising against his temple.

'Breathe too loud and it will be the last breath that you fucking take.'

The Senior Investigator into his other ear.

'I would listen to what he is saying. He has been very stressed lately.'

Sweat across the Security Officer's fat pork face.

'Where is the *a-yi*?'

'In the kitchen.'

Searching him. A knife. A pistol, its butt well worn with violent use.

'Anyone else in the residence?'

'No.'

Moving to the woman in shadow. Blind to the CCTV.

'We need to talk, in private, off the record . . .'

'Off the record? Is anything ever "off the record" with the PSB, with you, Sun Piao?'

'You have a basement or a lockable room without windows for these and the *a-yi*.'

'And if I do not tell you, Sun, what will you do, break my arm? Treat me as you have treated him?'

Her eyes, just an instant, moving to the fat Security Officer. Blood across his ear and the collar of his shirt. The barb of her words hitting home. That she should even think of him in that way. But perhaps such violence had always lain at the horizon of his vision? The final refuge from words.

'Just tell me and tell me now.'

In his eyes something that she had not seen before. Something of the street. Some ugly remnant of the *Ankang*.

'There's a basement at the bottom of the main staircase.'

Yaobang prodding the Security Officers down the

243

double flight of stairs to the windowless basement. A jangle of large keys against thickly painted wood. The woman and the child with Piao moving down the red-carpeted hallway to the kitchen. Everywhere boxes, packing cases. Negotiating them in silence. Into the kitchen, a scream, muffled, calmed. The woman leading the *a-yi* by her elbow to the Big Man in the basement. For some minutes the child left with Piao in the kitchen. A boy, small, pale, but with his mother's cold beauty. Not an endearing look, but one that snared the eyes with its perfection. The child regarding the Senior Investigator with a serious unblinking and unsettling gaze, making Piao think of his dirty shoes, the hole in his sock, the black moon crescents of dirt underneath his fingernails. That a child could do this was disconcerting. With haste the woman who was still his wife, returning. A protective arm thrown around the child's shoulders as if to save him from some unnamed but terrible threat. For the Senior Investigator, the pain not diminished. *Nemma bai nemma pang.* He should be my baby, my child. The same thought perhaps striking her?

'We need to talk. I think that you should put the child to bed.'

'His name is Kang, the same name that his father had.'

Piss and pressed suits. The septuagenarian Politburo member whose bed she had warmed. Whose shrivelled cock she had hardened to sculpt a better life for herself, far removed from poverty. Away from a Senior Investi-

gator who could only offer the fickle notions and impracticalities of love.

'I know his father's name when I hear it. Put the child to bed. Now.'

Stairs of solid hardwood, as dark as bitter chocolate. Silk-hung walls studded with paintings, originals. Flowers by the 'Jading Intimists', Wang Shimin and Wang Yuanqi. A landscape by Yun Shouping. On the landings ornate alcoves with treasured items of porcelain. But mainly noticing boxes everywhere, as if someone were moving away. Not a panicked move, but a planned, organized withdrawal.

On the first floor, the child's bedroom. Watching as she cared for him, prepared him for night's voyage. A kiss. The child watching her shadow decrease as they moved from the room. His universe, and she the only thing within it.

Her bedroom was large. A woman's room, softly vulnerable. On an antique dressing-table, a cluster of silver- and gold-framed photographs. Each photograph of her, Lingling, arm-linked with a man. Each man, arm-linked with power: a member of the Politburo, a captain of industry, a provincial leader, a government minister.

Double doors led onto a balcony. The night alive with the sound of sea, invisible waves breaking themselves onto an invisible beach. Curtains billowing in a night-breeze tinged with camphor wood fires and the perfume of jasmine. On the large satin-sheathed bed,

beaded Indian pillows, Thai silk pillows. On the wall above the bed, another Yun Shouping original. It was worth enough to keep Piao and the whole of the *fen-chu* in Tsingtaos for the next ten years. But the only thing truly catching his attention, against the far wall, more boxes. More tissue paper waiting to wrap memories in their soft folds. On the top layer of the box, half-wrapped, a small solid antique silver frame containing a photograph of Lingling and the child ... the family that could, should have been his. Between them, a striking-looking man, pristine in every way. One arm around Lingling's shoulders, his other hand on the boy's head. The long, soft, gold-ringed fingers of a *cadre* through the child's hair. Even after so long surprised by the deep brand of pain. Pushing it down, as he had always done. Pushing it down.

When he looked up, she had sat on the edge of the bed, her beach sarong falling open showing her legs. Honey-hued grains of sand in static waves across her calves. Hardly able now to remember the times that he had run his hands up the silky smoothness of her legs, his lips following in an eager breathlessness, to where inner thigh met inner thigh in a salt sweet kiss. Hardly able to remember anything about how they had been together, except pain. Yes, pain. Remembering that. The first memory, the last memory.

'*Ankang.*'

She smiled, reaching for a bowl of lychees. Scarlet manicured talons plucking from gold, rose, tan. Her

other hand fending off the word as if it were disgusting to her.

'I will talk of no such thing.'

'I need to know, and you should tell me because . . .'

'Why, because I am still your wife?'

'Yes, my wife.'

The lychees soft flesh to her lips.

'In name only, Sun. And marriage is more than just a shared name, or had you not realized that?'

From the inner sanctum of her mouth, the lychee's stone.

'You will get no answers here. Am I am supposed to thank you, Sun, for scaring me, my child? Waving your pistol around in front of us. To thank you for entering my house on the pretext of asking me questions?'

Dropping the lychee stone to the carpet, knowing that it would anger him. Sun Piao, a man who would always think of those who would have to labour and clean up the mess of others.

'I thought that you had come to kill us.'

Piao, moving to the window. In pale reflection, his face, a creation of darkness.

'You can think such things of me?'

She did not answer.

'Why I am here, it is not about who we once were. That is in the past . . .'

'In the past, Sun? You are sure of this, in the past?'

The intense darkness of her gaze piercing him.

'There are many questions that I need answered. I

will ask you these here. If you do not answer them, I will ask you them again in Shanghai, in the *fen-chu*.'

'If only you had been so strong when you were truly my husband, Piao. But you overestimate your authority in such a place as this. In Beidaihe you are one investigator in a sea of those who do whatever they wish. You may pass for clever amongst those who you normally investigate, who live in the *longs* and who smell of the gutter, but in my world, with the kind of people with whom I associate and call my friends, you are merely naive.'

Smiling, but not her eyes. Never her eyes.

'In the *zhau-dai-suo* next door, beyond the trees, is a member of the Central Committee. He walks on the beach with me and talks about how little his wife enjoys sex. Beyond that, the *zhau-dai-suo* near the headland. That belongs to an esteemed government minister. They have three Red Flags and four *a-yis*. I play *mah-jongg* with his wife and she talks with tears running down her face of the young boys that he likes to play more intimate games with. The two *zhau-dai-suo* beyond the hill. The Provincial Head and the home of his Deputy. I shop with their wives and their mistresses. I have influential friends, Sun. You would not get me within 100 miles of a *fen-chu*.'

Piao standing, not knowing what to do with his arms, with his feet. Feeling put in a place stinking of piss and vomit and knowing that he belonged and would never leave there. Not a life of silks, of views that

caress the senses, of painted originals, of the smells that come in gold-topped bottles. No, not a life like this one.

'I will answer only what I want to answer.'

Thinking even as she spoke that 'those who sacrifice their conscience for ambition, burn a picture to obtain the ashes'.

'*Ankang*: you had me released?'

Silence.

'The questions that I am asking you are a part of my investigation into murders. Many murders. Friends in important places can provide powerful *guan-xi*. But friends in high places do not wish to be associated with murder.'

A step closer.

'My release from *Ankang* coincided with this investigation. It all dovetailed too neatly for it to be a coincidence. You had me released from *Ankang*, which tells me that you are somehow linked to these murders.'

She still smiling, but in her eyes calculations, balances, a weighing-up.

'*Ankang*. Yes, I was influential in your release.'

'Why?'

Silence. Just the sea. Just his heart.

'There was no reason. It was just something that I did.'

'No, Lingling. You are a person who always has an agenda.'

She shrugged.

'It is not like that, Sun.'

'It is not? Look at the facts. Two comrade officers crucified and tortured. An old comrade, a vagrant, decapitated. Three young women slashed to death by cut-throat razors. A fourth, cut and left for dead in the Wusong. Another young woman murdered and buried in a hole in the Shanghai Stadium under the banner for the Olympics. And into this I am released from *Ankang* . . .'

A step closer, his shadow falling over her.

'Why was I released from that place? The timing, it is too perfect. My first case, a tangle of PLA, state involvement, hidden agendas and so many who life no longer possesses.'

'I thought that was how you liked your cases, Sun?'

'Do you have knowledge of the *tai zi* Colonel Zhong Qi?'

Silence.

'Do you know this *cadre*?'

'Be careful my husband. It will not be so easy to resurrect you from *Ankang* next time.'

'What do you mean? Is this a threat, wife?'

Standing, pushing past him to the balcony. Moving with her, Piao into her ear, his whisper mixed with the sea's voice. As if wanting nobody else in the universe to share it. Just her, just the breezes from far-pitched continents.

'Your dangerous games will bring about dangerous situations wife. This *tai zi*, this PLA, what do you know of him?'

Trying to move away, but his arms braced either side of her, snaring her hard against the balcony and his body. Feeling her ragged, torn breaths against his chest, at odds with the rhythmic exhalations of the sea.

'Just his name and that he is dangerous. Sun, he is very dangerous.'

Struggling against the wall of his body.

'All of these PLA are very dangerous. They care for nothing except their wealth, their power.'

'The same could be said of your wife.'

'No, they are different. They create another country within the People's Republic. These are difficult times, very difficult times.'

'What do you mean? All of our times are difficult in this People's Republic. Alive in the bitter sea, that is the fate of most of our comrades.'

Exhausted by the struggle, falling limp against him. Her words as a breeze too weak to hold the kite's long-tailed flight.

'The Ministry of Security, it is . . . it is attempting to cut back on the PLA's power. And also on the influence of the *tai zis*, on levels of corruption, drug trafficking, prostitution, the abduction of children.'

A fleeting, dark-eyed glance towards the bedroom next door. A child, her child, so safe.

'But the Ministry is meeting strong resistance. To challenge the PLA in any fashion. To bring into question any actions of a *tai zi* at present. These are dangerous things, Sun.'

'So, I am to turn my back on my investigations and let sadistic serial killers go free?'

Her finger across his lips, so cool and soft, so perfumed. An urge, bottomless, to take it into his mouth.

'That I know is not in your nature. You are the storm that rains on every roof. I know this. So do your superiors. That is what frightens them so much, especially in the extraordinary circumstances that prevail at present.'

Not removing her finger. His words sealed in crimson by its presence.

'You just need to be very careful. If I can assist you I will.'

His lips, shaping to speak. But a second finger silencing them.

'You have had your say, Sun. Now is the time to listen to the sound that your rain makes on others' rooftops. Yes, I had you released from *Ankang* and returned to the PSB, in what I thought would be a safe place for you. I spoke to Zoul and he promised me that he would keep you safe. He failed.'

Her eyes on his.

'But how can you stop the wind from blowing.'

Her eyes on his and ten thousand memories brought back to life.

'You have enemies, Sun, from past investigations. Many enemies in high places. Not all appreciate the storm's rain falling on their rooftops. It loosens tiles,

floods basements. Your enemies, they were almost upon you. They were so close that you did not see them.'

Across his lips her fingers, but not able to still the question, like the seventh wave, rearing up from deep within him.

'It was you, Lingling. You were the one who put me in *Ankang* in the first place?'

In her eyes, reluctance, secrets in dark-cornered hiding places.

'*Ankang* was hard, I know. But it offered you a sanctuary, a place where not even their arms could reach, and people within it to keep you safe from *Ankang*'s worst horrors. I have no other involvement, Sun. I know nothing of these deaths or of this *tai zi*.'

Still her fingers, calming the fever of his lips, holding back the questions.

'Shh. There is no agenda here, Sun. There has never been an agenda.'

Slowly her fingers leaving his lips. An instant sense of loss. Wondering if she would ever touch his lips again. About to speak, but she interrupting.

'I will allow you one more question, Sun, and I will answer it truthfully.'

And he, realizing that he was no longer an investigator, but a husband asking the simplest, yet most complex of all questions.

'Why?'

She smiling, and in his eyes seeing all that was to be seen, and that which was hidden. Half turning her face,

eyes hidden by the night. Looking out to the blackness of the sea and sky. No witness as to where they kissed. Some minutes before she spoke. The one question, answered truthfully.

'A relationship is not like signing off a report. Or did you not know that, Senior Investigator Sun Piao?'

26

In the People's Republic of China three overlapping components provide the Party, the state, with radar that can pick any comrade up wherever they decide to go.

The *danwei*, cradle to the grave, providing the housing where you live, the school where you are educated, the clinic for when you are sick. The purchase cards for rice, cooking oil, soap. You will need their written permission to get married, divorced, to have a child. A travel permit to go beyond the city limits. A docket to purchase, if you are well off, a car, a refrigerator, a washing machine. A docket to bury your dead. A docket to register the living.

The *xiao-xu*, the 'small groups'. These, based on the techniques developed in the communists' cave headquarters of Yanan in the 1940s, to indoctrinate the thousands of disparate new adherents flocking to the cause. Thousands split into groups of no more than ten, undergoing months of what the communists called 'thought reform'. Stage 1, specific Party documents to study. Stage 2, mutual criticism of past attitudes and activities. Stage 3, a time for submission and rebirth. Not unlike a religious conversion. Each individual

writing, rewriting a personal confession. Over and over again, until the Party accepted it. And now? The 'small group' will meet in your school, your university, your neighbourhood, once or twice a week. Central Committee documents and dictates will be read out and studied. Each member of the *xiao-xu*, at designated times, will write a report on themselves to the Party. It should contain the 'three levels' of consciousness. The first, what you think about yourself. The second, the things that you tell only your closest friends. The third level, the feelings that you hide even from yourself.

The third component of control, the 'Street Committee', providing a mechanism to watch each comrade at home. Their members a cross between building inspector, police informer, social worker and spy. In each *long*, in each tenement building, they will sit. They will note each coming, each going. They will keep a strict eye on their residence's neatness, reprimanding you if your shoes are dirty, if you do not sweep your hallway. Entering and searching your flat wherever they wish. They will count the members of your family, searching for relatives from the countryside who you might be trying to smuggle into the city. They will berate you if you do not wash your dishes and plates after a meal. A written report to the Party, if you do not have a photograph of the Party Chairman in a prominent position in your living room.

Street Committee members decide which family should have a child and which family should not. A

person from the Street Committee assigned to monitor each woman's menstrual cycle. If a period is missed by a comrade who has not been given permission to have a baby, an abortion is ordered.

27

Dark, darker, moving through the Yanan East road tunnel. A black Beijing, six cars back. At the exit, north river side, traffic lights on red. Cars backing up. Everything the colour of sun-dried tomatoes. Piao squeezing through the narrow gap of door and pressed steel. Keeping low, rolling behind the concrete parapet. In its faded khaki slip the handprints, boot marks, of the workers who had toiled to build it. The lights to green and the car passing in a belch of diesel fumes. Eyes watering, moving out of the tunnel, the Big Man would keep them running west, Piao running east. A Friendship taxi picked up on the Bund, its dead-eyed driver moaning incessantly about the weather and the wait for his wife's hysterectomy operation. Piao tossing a crumpled ten-*yuan* note and jumping out north of Daminglu. Moving into the *longs* around Haininglu. River mist skirting the confluence of the Wusongjiang with the Huangpu, smoothing cracked walls, dulling every sound. Following the Big Man's instructions; biro drawn onto palm. The People's Stadium, a bowl of light, a crucible of sound, not executions tonight, just football. A goal, 60,000 voices in joyous unison. Moving

through the rabbit warrens, away from the stadium's leggy shadow. Single sounds now, a mosaic of identifiably tenement life. Fretful babies, playful lovers, ill drunks. *Mah-jongg* tiles snapping down. *Renao*, life, hot and spicy.

On the fourth floor, the apartment. Moving silently. Noodles simmering, dumplings steaming, cheap cuts of fatty pork roasting. Climbing the steps, mouth watering. Tsingtaos, China Brands, but not able to remember the last full meal he had eaten. Knocking lightly, the far door on the left. Three locks, a spy hole and an insistent voice.

'*Ni nar.*'

An old woman's voice. Piao whispering his name, rank.

'*Ni nar.*'

Another two times before the Senior Investigator took out his badge and slipped it, grating, under the door. Seconds of silence and then one, two, three locks being released. Through the narrow gap smells of food, fresh and Sichuan spiced, and the creases of an old mama's crumpled velvet face. A finger to her lips, words whispered.

'Quickly, the Street Committee.'

A hand pulling him in.

'My grandson told me to expect you. He says that you are a good man.'

Silently closing the door. Her arm, thinly veiled bone, already through his arm, guiding him into a lounge.

259

Rich fabrics, hand-woven rugs. Plump, upholstered armchairs, lace antimacassars, fine appliqué cushions. And smells: lavender and tea tree, *xunhuacha* and carbolic soap. The room, a mother's room, a grandmother's room.

'A good boss also, he says.'

Pointing a crooked finger toward the kitchen. The sound of bowls being washed. Faintly, a song being sung.

> *After peach flowers are bloomed,*
> *chrysanthemum blooms.*
> *My lover wants something that belongs to me.*

'I was a good nurse, a very good nurse. The old ways are the best. You shall see.'

With his assistance, lowering herself into an armchair. Cushions already sculpted to her form by hours of sitting.

'Go to her. See for yourself.'

A knot of concern and anticipation, nagging at Piao like the August bite of the mosquito. Moving to the half-open door. A view of her from behind. A floral dress, tight to her bust, waist and hips. Her figure perfect, that of the summer wave listlessly tumbling to the shore. Moving to the slow samba rhythm of washing up. For some time just watching her. Listening to the words tumble from her lips in whispered and glorious off-key.

First he wants my pillow,
and then he wants my bed,
and then he thinks that I am his medicine.

Sensing his presence, Lan Li slowly turning. For the first time, Piao feeling that he was really seeing her as she had been, as she now was. Sutures unpicked and drawn out like the bee stings. Bandages, gauzes, fallen away. The change from when he had last seen her almost choking him. Scars still visible, but as the imagined lines drawn between the stars that make up the constellations. But now only seeing the brushstroke curve of eyebrow, sweep of mouth, glint of hazel eyes and the purse of her lips.

She smiled, her face alive. Summer breeze across a field of golden corn. Drying her hands. Still that smile. Lips to slumber on and to dream about. Her gaze lowered.

'I want to thank you for placing me here with your Deputy's grandmother. It has felt like the home that I have never had. When all you've known is orphanages, clubs and . . .'

Words trailing away as bathwater down the waste pipe.

'It has been so good being here, being safe. And look . . .'

Hands held to her face.

'Look at how she has helped. So many secret potions, the mama. Always something bubbling away on the stove.'

No words. Just a look and silence from Piao.

Her smile fading. Suddenly a chill to the room.

'There is something wrong. I know it.'

Her hand on his shoulder, porcelain cool.

'What is it? You must tell me.'

Perception, the whore's most essential talent. Seeing the ghost at the back of Piao's eyes.

Guilt that he was not more powerful, not a *cadre* strong and in a high place, and able to assure her, protect her.

'The man that did this to you, we arrested him, charged him. You were correct, he was a PLA *tai zi*. Powerful with *guan-xi* and friends in high places . . .'

Piao looking away, words that he knew would hurt.

'We had to release him.'

Her hand leaving his shoulder. Instantly mourning the loss of her touch. Walking away, turning her back on him.

'After what he did to me and to the others?'

Her back as soft as the arcing bow of the willow. An urge to touch her, hold her.

'It is wrong, but he is powerful. Murder is not enough, apparently, to hold such a princeling as this.'

Her arms folded, holding herself.

'We need to make sure that you are safe. In the next few days you will be moved again out of the city. One of Deputy Yaobang's cousins will take you there. You will be safe, I promise you. They are good people, fine people.'

'I am just a witness, nothing more to you. Of course you will keep me safe, until I have served my purpose.'

Turning with tears down her cheeks. He had seen so many women cry in his life, but never so generously. His hand gently across her cheek, hoping that it would say more than his words, mean more than his words. Words, the palest ink.

'I want you to be well. I want you to be safe. Yaobang's cousin will make sure of that.'

'Where will I be taken?'

'I am not to know, neither is my Deputy.'

Their eyes meeting. A passing of so many things between them.

'You are afraid of knowing, aren't you?'

'It is best that we do not know for the time being.'

'You are afraid that this *tai zi* will use you to get this information. To find out where I am. To hurt me.'

'Such a princeling has long arms and methods that could be persuasive. I do not wish you to be hurt again, ever.'

Silent, her footsteps. A shock down his spine as her hands found his shoulders. So warm her body against him.

'Ever again? Ever is a very long time, Senior Investigator.'

Gently pulling him around. Her hands back to his shoulders. Electricity arcing. Her body firmer, hotter against his.

'Are you to be my own personal PSB protector?'

Suddenly her lips on his. Her taste unexpected. Not of paged 'greenbacks' by the thousand, not of other men's fantasies embodied in a bound menu and realized in the curves of her flesh. But their taste uncomplicated, freely given. Kissing her back, so soft, so hard. The taste of a woman, how he had missed it.

'We have much in common, Senior Investigator. When this is over we will compare scars.'

Her fingers to the missing button on his collar.

'I see a complication in your life, Senior Investigator.'

'Sun.'

Her finger orbiting the amputated thread where the button had been.

'A complication, Sun. When one who has no one to sew buttons onto his shirt meets someone who has never had someone who they can sew buttons on for . . .'

His fingertips tracing the curve of her face in a premature farewell. She reading the signs.

'You have to go.'

'Yes, I have to go.'

Kissing him once more. A second kiss. A last kiss? Not of neon late nights and salt-bruised lipsticked lips, but of future hopes married to present concerns. Watching him walk away, a glance back across his shoulder, stunned by her beauty. But already Lan Li turning away. Words of a sweet song sung out of key, braided through the water's scalding fall.

After peach flowers are bloomed,
chrysanthemum blooms.
My lover wants something that belongs to me.

The old mama catching him as he reached the short hallway.

'You tell my grandson to wear a vest. The nights are cold. He will listen to you as he admires you. The girl, she's a good girl. Do not worry yourself, Senior Investigator. She will be safe. You just make sure that you are as safe.'

For several seconds studying Piao's eyes.

'You have much in common with her. I see that.'

Into the small of his back, the mama's hand, pushing him out of the door and towards the stairs. Door closing, but not before he could hear the last words of her song. Lan Li's off-key lament, slowly fading as he left.

First he wants my pillow,
and then he wants my bed,
and then he thinks that I am his medicine.

28

A favour for a favour.
Guan-xi, *the oil that lubricates the wheels.*
Teacher's whisky, *the oil that lubricates the throat*

The launch was small. Insignificant in the river's grasp, cutting through the storm's premature midnight. Conscious, even in the sanctuary of the tiny wheelhouse, of the Huangpu's waters. Water that should be sweet, but tasting of everything except water: diesel spills, factory breath and humanity's picked bones.

Cuff dripping riverwater, Yaobang pointed. The launch's crew, a flint-faced Mongol grunting as he adjusted the wheel.

'Do you know where you are going?'

'Of course, Boss. There. Traced it all the way down the fucking river.'

Lightning, his face chromium dipped.

'Tried to do it the proper way: paperwork, Harbour Master. Fuck all, invisible. So I tried it the realistic way: witnesses, office workers, boatmen, dockers. The Happy Sow Import Export Company. An old warehouse storing pork bellies, until the bottom fell out of the market.'

A roll of thunder. Distant drums.

'A warehouse attendant a few blocks down saw it all. Well, saw the activity and a mountain of tarpaulin. He has a set of keys for the Happy Sow Import Export Company.'

Tapping the Mongol on the shoulder, shouting, pointing in fierce stabs.

'There, there. Turn for fuck sake. Turn in or we'll be in Taiwan.'

A fierce correction. Heads swimming with nausea. Waves in thunderous applause against the side of the launch.

'He was left a spare set of keys years ago. Safety precaution, but no paperwork.'

'Nobody knows?'

'Exactly, Boss.'

'Has he been in the warehouse? Has he taken a look?'

'Too fucking scared, Boss.'

'PLA uniforms. When seen, people always heading in the opposite direction.'

'He'll meet us on the riverside, by his warehouse.'

Looming up, concrete strung with old tyres, massaged by strong sable fingers of the river. A nauseous vomit of spent diesel as the prop was thrown into reverse. A rich reek as the Huangpu's waters churned to the hue of mould on cheese.

'Told you I knew where I was going, Boss.'

Rope in hand, the Mongol bounding onto the concrete apron. Hand over hand in frantic binding.

The Senior Investigator stepping ashore, with solid ground the nausea backing away.

From the shadow came another shadow, a man waving, Yaobang waving back.

Following the figure into the cracked brick alley between the warehouse walls. Danger. Suddenly aware of the vulnerability of soft flesh and the cold heat of a pistol in slumber against a polyester shirt. Breathless, the man, his words ragged through slit of lips.

'A thousand *yuan* to get you in. No *yuan*, no deal.'

The Big Man laughing. Turning away, farting.

'Take the change out of that, you arsehole. That's all you're getting out of me.'

Walking back towards the Mongol and the river. Piao whispering into the warehouseman's ear.

'He means it, Comrade. My Deputy, not a man to give you the drippings from his nose. If I were you, I would come down in price. Maybe a bottle of whisky? Teacher's? I would ask him while he is in a good mood. I would not recommend asking him when he is in a bad mood.'

Shouting into the wind.

'Whisky, and I will get you in. Whisky.'

Yaobang stopping, turning.

'One bottle, no fucking more.'

Shaking his head.

'A thousand fucking *yuan*. Who do you think I am? You'd have to make me Party Chairman for me to pay you a thousand *yuan*. Now, which way?'

'Here. Here. It's safe. No one around. No one.'

Keys fumbled, jangled, and then into lock. A black rectangle of space opening. Squeezing through it, an immediate sense of a vast area opening up. Their eyes straining to see in a darkness in which nothing could be seen.

'In here they unloaded. In here. We need light.'

A thump of arc light. The vast area, illuminated but showing nothing but scarred floor.

'I saw them load from the barge. Here. I saw them. Two loads.'

Piao following a slug's path, grey, almost silver in the light. Crushed, powdered concrete from the centre of the warehouse floor to where steel shutters fell. A deeply recessed green button, the Senior Investigator pushing it. A wail of motor and a squeal of a shutter torturously rolling upwards.

'What are you doing? What are you doing?'

The warehouseman running towards the rising wall of steel.

'Don't be stupid, they will see us.'

Palm seeking the large, red mushroom button. Piao grabbing his wrist.

'They are long gone, Comrade, long gone.'

Across the loading bay apron and to where apron met the quay and the river ... a stop-start trail of crushed concrete.

'Last night, that's when they moved the loads. *Wangba dan*. I wasn't here last night.'

The green button, an agonized squeal. The steel wall falling back into place.

'Who would have been here last night?'

'No one.'

'Who would have seen them?'

'Maybe Yap. Old man Yap.'

'What does he do?'

'He combs the riverfront. Scrap metals, plastics, anything he can find, or steal . . .'

The warehouseman walking to the light switch, the door. Already tasting the fire of the whisky. Japanese whisky, Yamazaki, only ever tasted occasionally. But many years since he had felt the fire of proper whisky across his thirsty tongue.

'Would old man Yap have seen?'

Laughing, coughing, the warehouseman.

'Was Mao Zedong a fucking communist?'

★

'What's it fucking worth?'

Yap, the old comrade, warmed his hands in front of a brazier. A one-roomed shack, old bits of wood, corrugated iron, tacked onto the side of a desolate warehouse; a single, rotting tooth in a black mouth. Barely room for them. Bundles of newspapers, boxes of scrap metal, plastics, in static falls around them.

'Worth? Worth?'

Outraged the warehouseman, his eyes glowing as he knelt.

'It is our civic duty, our social responsibility to assist our PSB comrades.'

Yap throwing another piece of driftwood onto the brazier. Sparks in yellow flight to a corrugated steel heaven.

'What's it fucking worth?'

Head in hands, the warehouseman reassessing.

'Half a bottle of whisky. Good stuff mind. Not Japanese shit.'

'Deal.'

Yap, spitting on a palm as tough as leather and extending it. The warehouseman grasping it reluctantly. Mourning that half a bottle of his whisky was now poured into it.

'So, old papa. What did you see?'

The beachcomber warming his hands, regarding Yaobang through bored eyes.

'*Ta ma de.* You're a big boy. Bet your mama had a tough job squeezing you out.'

'Less of me, old papa. Think of your fucking whisky and tell us what you saw.'

'Not Japanese the whisky, eh? You're sure?'

'Sure. Now get on with it.'

His eyes filled with the white and yellow fire of the embers.

'Late last night I was having a shit out the back. There was a boat, big bastard, tying up beside the warehouse, the Happy Sow Import Export Company. Unusual, very unusual. Lots of activity. Men jumping

about. Civilian crew. Others in uniform ... People's Liberation Army.'

'You sure it was PLA, old papa?'

'As sure as you're a fat bastard. Of course I'm sure, what do you take me for? Anyway, all in a hurry and jumping around like monkeys. The shutter goes up in the warehouse. Ropes, pulleys, and they're hauling these cargoes across the concrete floor. Across and over the loading bay apron and across the cobbles. A right fucking noise.'

Piao staring across river, rubbing his hands and moving closer to the brazier, its fierce heat tightening the skin of his face.

'Comrade Yap, the river is wide at this point, and you saw all of this with your naked eyes?'

'Good eyes. Good eyes ...'

Pointing fiercely at the bloodshot orbs, before rifling in a large box directly behind him.

'Good eyes and these.'

A heavy pair of East German binoculars, not unlike the Senior Investigator's. Yap polishing the lenses with his dirty sleeve.

'Carl Zeiss lenses, found them on the foreshore, six years ago this August. The best, the very best. You can see Clavius with these. You can even pick out Copernicus in detail.'

'What the fuck are Clavius and Copernicus?'

Piao, a hand on the Big Man's shoulder, a whisper in his ear.

'They are craters on the moon.'

Yap smiling.

'"When the finger points to the moon the idiot studies the finger".'

'So, Comrade Yap, through your Carl Zeiss eyes what else were you able to see?'

'Fucking everything.'

Piao warming his hands once more. A chill, a coldness, that would not leave him.

'From the quay they hoisted the cargoes onto the flat deck with the use of the derrick. The first one, there was no problems. The second . . .'

Looking deeper into the brazier.

'There was a stiff wind as now. One of the ropes tying down the heavy tarpaulin got fouled up on the derrick's cable. They lowered the cargo back onto the quay. Then the funny business started.'

'What "funny business"?'

'He ordered all of the crew and uniformed PLA off the deck and downstairs. Then he and a few others untangled the mess, tied the tarpaulin back in place. Then the uniformed lot were called back on deck. They lifted the cargo and swung it onto the boat.'

'"He", Comrade Yap. You said, "he".'

'Their *ganbu* boss. Top *cadre*. Well dressed, elegant.'

'Anything else about him that you would remember. Anything at all?'

'Elegant, but an ugly bastard. His face full of craters like the moon. His face, Clavius and Copernicus.'

'You fucking sure, old papa?'

'Of course. Of course.'

Watching the comrade's face, the firelight marbling his eyes.

' "Fucking everything", you said, Comrade Yap.'

A hesitant glance at Piao.

'I understand your reluctance, but tell me of what you saw through your Carl Zeiss eyes, old comrade.'

The old man turning back to the fire.

'On the quayside when the crew were below deck, the tarpaulin, it was a right mess. Caught up, ripped, blowing in the wind. They had to untie it, pull it off completely. Start again. Took about fifteen minutes. I saw what was under that tarpaulin for at least five, six of those minutes. Bodies. A large chunk of concrete with bodies within it. *Wangba dan.* The bodies of girls, several of them or bits of them.'

Cursing the day he had ever looked through the binoculars, spitting into the fire.

'Soon as everything was secured they got up a head of steam and cast off. Moving down river to the sea.'

'That's the end of the trail, Boss. They'll have headed out to sea and dumped the loads overboard. Wouldn't be so bad if we knew what boat it was. Must be fucking hundreds that pass this point every day.'

'True,' interrupted the comrade.

'Hundreds and hundreds. But not all are ex-People's Liberation Army Navy boats, with the PLAN identifica-

tion marks painted out. And not all have had a name repainted on their bow.'

Eyes that had seen the craters of the moon filled with fire.

'*MAO'S SMILE*, that's what was painted on its bow. *MAO'S* fucking *SMILE*.'

From his jacket, Piao holding another bottle of whisky as gold as a *cadre*'s back teeth. Yap and the warehouseman, their features gilded by the brazier's orange light.

'A bonus, Comrades, if you will talk of what you have seen to the judges in the People's Court.'

Yap, hard hands extended.

'For such a bottle, Comrade Investigator, I would fucking marry the judges in the People's Court.'

29

The Wizard, spectacles alive, a billion pixels flowing, surging, cascading. An electronic sea rising up, tamed and rippling to the commands of his fingertips on the keyboard.

'When you can't get what you want legally. Hack. Hack. Hack.'

'What are you doing?'

'Hacking. An organization or company can be a bit more difficult, but not unduly so for a genius such as I.'

A smile as wide as the nineteen-inch monitor screen.

'A personal computer is easier. Most users are unsophisticated and do not value the files that their computers hold. Our Comrade Qi may drive a Red Flag, and wear gold cufflinks, but I will bet my collection of Internet pornography that he runs his computer as a *liu-mang* does with her legs. Open all hours.'

Gold glass tipped to dry lips.

'Even you, Senior Investigator, could use this hacking method. NetBios. The easiest way to hack remotely. All you need is the victim's IP address.'

Piao already lost, shaking his head. The Wizard smiling.

'As for our dear PLA Comrade Qi, I already have his computer's IP address.'

From his pocket, a carefully folded piece of paper. Sharp-edged, sharp-cornered, which he precisely unfolded.

'A little backdoor help, Senior Investigator. An associate in a major Internet service provider. *Guan-xi* makes the world go round, yes?'

'And what am I paying your "associate" for this backdoor information, if I did not already know?'

'No, no, no, Investigator. Not Marlboro, not Southern Comfort for such a man as this . . .'

Fingers stroking the monitor.

'Something much, much sweeter.'

Smiling.

'Now we start, yes? NetBios hacking. We will see how sophisticated our comrade is, shall we?'

Fingers, in precise movements. Mouse, in swirling choreography. White on black, headings. Name. Type. Status. The Wizard's fingers down the second column . . . digits in brackets. His finger tapping the monitor. A Morse of excitement.

'Tut, tut, Comrade Qi. Not so clever our Red Flag driving comrade.'

Drinking deeply, swilling it around his mouth like a boxer between rounds. But not spitting, swallowing the brushfire's burn. Over keys, confident fingers. White onto black. Share name resources coming up.

'What we are now going to do is to connect our

computer to the victim computer's hard disk. After we have connected successfully, a drive will be created on our computer and we will be able to view the contents of that drive. Our drive will have the same contents as his.'

No security. No password being requested. Candy from a very unsophisticated baby. Confirmation.

COMMAND COMPLETED SUCCESSFULLY

'We're in, Senior Investigator. Painless, yes?'
A click . . . My Computer.
'Fucking brilliant . . .'
The contents of Comrade Qi's computer's hard drive. Skin, flayed, flesh striped away. Bones, bare and bleached. Files. Folders.

'Now tell me, my friend of a homicide investigator, where is it that you wanted to go today?'

Part Two

Part Two

30

There is no exact equivalent in the Chinese language for the word, 'conformity'. Why should there be? In the People's Republic there is nothing else.

In the People's Republic you will be educated to hide your talents, not to be an individual, nor to stand out in a crowd. Not to mention your accomplishments. You will be told:

> *A tall tree will be crushed by the wind;*
> *A rock that sticks out of the riverbank will be washed*
> *by the current.*

Even in your facial expressions you should not stand out. You will be told to learn the 'eight faces polished like jade'. And in time, you will learn how to master the technique. Who you are, what you feel, lost behind its stony, polished stare.

31

The couriered note, on official PSB headed paper, was brief. Unmistakably Comrade Chief Officer Zoul's hand.

Jing Xuan Blind Man Healing Massage Centre.
670–674 Yi Shan Road,
Today. 6.30.

Piao checked the time on the bottom right-hand corner of the monitor screen. 5.25. Yi Shan Road, across the city. It meant a drive against a tide of vehicles turning for home at the sound of ten thousand factory sirens. Piao took a last look back as he slipped the CD Rom into his coat pocket.

'Thank you.'

Rentang nodding. Southern Comfort smile, reflected gold across his mouth as he lifted the glass in salute.

'No, really, thank you.'

The Wizard, slightly puzzled and disturbed. A PSB Investigator who says thank you twice within one's lifetime: surely the birds would fall from the branches of the trees?

★

CITIZEN ONE

Jing Xuan Blind Man Healing Massage Centre, Yi Shan Road, Pu Xi District

Through steam, glimpses of ornate tiling, the high-bowl arch of the ceiling, the columns and pillars. Everything in gradations of white and pale grey. Naked figures moving through gauze mist, in and out of the water. On altars of marble, flesh pinched, kneaded, pummelled. The masseur's strong fingers in rhythmic dance.

Comrade Chief Officer Zoul raised his head from the bed of marble. His cheek white with its cold kiss.

'Jing Xuan, the Blind Man Healing Centre. You have not been here before, Piao?'

'No, Comrade Chief Officer.'

'A good place to meet, Piao. Very good to talk, to make arrangements and agreements. To come to understandings.'

Zoul grimacing at the masseur's ballet. Flesh, mottled skin, as a plump wave running to shore.

'And such a place has its advantages. The masseurs being blind from childhood, they see no face, know no face.'

Ghosts of white, fading into white. And whispers wrapped in *guan-xi*. Debts, deals, favours, sealed with the briefest of handshakes.

'Comrade Chief Officer Zoul, you wish something from me.'

'Always in a rush, Piao. Relax, enjoy this luxury. A glimpse of the future perhaps.'

A flick of his head in the direction of the far wall. Degrees of mist, inlaid in mist; figures robed and disrobed.

'See, the Chairman of the local Party. And there, the Secretary of our *danwei*. Those, the *tai zi* of our masters in industry, our masters in Beijing. Power and money. It can almost be smelt, Piao. Yes? Take a deep breath. A deep, deep inhalation.'

But in Piao's inhalations only the smells that corrupted old men have. Rotting fruit breath and spent sperm, sweet cologne and the musky sweat of banknotes.

'What is it that you want, Comrade Chief Officer?'

'You misinterpret me, Piao. It is not what I want. Me, I am easily satisfied. I seek only a quiet life, but with an officer such as you under my command, Sun Piao, this is not easy to achieve. A storm that rains on all rooftops, Senior Investigator. That is what you are.'

'Words that another has said,' thought Piao.

'You are not a cobblestone that has allowed itself to become worn, Sun Piao, smoothed. A trait that can make enemies. There are those that do not wish stones thrown into the stillness of the lakes in which they swim.'

Zoul, wiping his brow.

'No. It is not about what I want, Sun Piao. It is about one who swims in a lake that you have been throwing stones into. Large rocks into . . .'

A finger pointing into mist.

'It is about what he wants.'

Through the mist, a figure firming, hardening.

'You look surprised, Piao. I am disappointed that you should be surprised, an investigator of your reputation.'

'Then you are very easily disappointed, Colonel Qi.'

The *tai zi* pristine even when half-naked, a towel wrapped around his waist. Everything toned, gold, flexed and in place. A glossy magazine photograph in the flesh.

Zoul calling over another masseur.

'Colonel, lie on the marble. Let the masseur relieve you of the strains of the day.'

'Too far Zoul. You go too far. I will not have a blind man touch me. Get away from me.'

An aside designed only for the Comrade Chief Officer to hear.

'Don't get above yourself, Zoul. We are not comrades-in-arms. We are not old friends. You serve a purpose, nothing more.'

A shrill alarm sounding out from a heavy watch on his wrist. Without even looking down, switching it off. Resetting it for two hours later. Smiling at Piao.

'You will want to know why I am here. Why I have arranged this, this meeting of minds.'

'I will not disappoint again, Comrade Qi. But I might surprise you. I know why you wish me here.'

'You do, do you? Then tell me, Senior Investigator. Tell me.'

'The higher the *cadre*, Comrade *Tai Zi*, the further down for you and your sponsor, your father, to tumble. You wish to bribe. If that does not achieve the result that you seek, you wish to threaten.'

Hands clasped in a manicured steeple of gold rings.

'You are an irritant, Senior Investigator. Nothing more. But I have, as they say, bigger pork bellies to carve than you. Business that I need to conduct that has the full blessing of the People's Liberation Army. To put it bluntly, what I do raises much needed funds to increase the potency of an army that is massively under-funded by our government. I am serving a great national interest. Sometimes in this process irritants may need to be soothed. Bumps on the road to where I need to get to, smoothed out.'

'Young women, bumps in the road? Two of my comrade officers, bumps in the road, Comrade *Tai Zi*?'

'You talk of these human lives as if they were inconsequential. Mere inconveniences. I doubt that their parents, lovers, children, would agree, Comrade *Tai Zi*.'

'You fail to understand how important my work is.'

'More important than these lives, Colonel?'

Silence.

'No, Colonel Qi, you fail to understand how important these lives are.'

Silence.

'I cannot walk away from this, PLA. Not this. Too many things I have walked away from in my life. And

my soul is holed by those acts. But I will not walk away from this, or from you, Comrade PLA.'

Qi's breath smelling of peppermint and putrid meat.

'Not even with 500,000 *yuan* in your pocket, Senior Investigator? Or perhaps you have no need for money, Comrade PSB?'

'No, Comrade *Tai Zi*, even though money thinks that I am dead I cannot walk away with your *yuan* in my pocket. Not when I have seen the faces of those who you have murdered and those who mourn them.'

'Such a waste, Piao. You have nothing in your hands but, but . . .'

Manicured fingers raking the air.

'Mist.'

'I have much more than you think. The ligature tightens, Comrade Colonel. Can you not feel it?'

Qi, pulling loose the heavy gold necklace.

'No, Piao.'

Eyes meeting through the mist.

'You have nothing. Nothing.'

Cao-mu jie-bing. 'The dead cat turned.'

'Mao Zedong. August 20th 1933. Southern Kiangsi.'

The Comrade Colonel, like a boxer rolling with the punch.

'Perhaps even I underestimated you, Senior Investigator. There is nothing more dangerous than an honest man.'

Getting to his feet and standing over Piao. A fierce whisper across his cheek.

'You know that you and those who you protect, they will not survive Senior Investigator?'

'A threat of murder to an officer in the service of the People's Republic of China. An employee of the Ministry of Security. A serious charge, Comrade PLA.'

Laughing as he moved back into the mist.

'No, Piao, not murder. There are many ways to skin a cat . . .'

*

The Big Man, China Brand embraced between his lips, was sitting in the Shanghai on the Yi Shan road. As a stepping stone in a river of bright water, streams of Forever bicycles smoothing their way around the Sedan's dented bumpers.

'So how was it mixing with the fucking rich and powerful, Boss?'

The sound of a cigarette lighter. Of a long, lingering inhalation of cheap smoke.

'That fucking bad, Boss?'

Flicking his cigarette butt out of the quarter window.

'Then let's hope that the Wizard has had a better day than you.'

*

Home. Flat 402, the December 10th 1949
apartment block

A door's creak and open. Electric light, as yellow as sixty-a-day nicotine fingers, spilling into the hallway.

'Comrade Piao, I really must complain. The stranger in your flat, really. The noises that he has been making. And the comings and goings. I have to notify you that I will be writing a letter to the Party. Your attendance at the small group's meetings has been pitiful. You really must . . .'

Piao turning, facing the Street Committee Chairwoman.

'I am sorry, Comrade, I do not understand what you mean. Noises?'

'You know exactly what I mean, Comrade Piao. Noises like I have never heard before. As if a pig was being castrated in your living room.'

Eyes catching eyes, a message passed between them. Immediately turning, Piao, the Big Man, moving silently up the staircase. Hands to the inside of their jackets, fingertips to diamond-cut steel. Silhouette pistols moving ahead of them. Senses alive, seeking a shift in the unlabelled nuances that marked this place as home. Nothing in the deeply cornered folds of blackness, nearing the landing . . . nothing.

Behind them, the Comrade Street Committee Chairwoman following, her voice rising, reverberating.

'How dare you walk away from me, Comrade. This is official business, Party business. Have some respect.'

Piao spinning around, the Street Committee Chairwoman's eyes widening. Hands moving to her baby-bird face. Her toothless mouth, a tunnel of screaming words.

'A gun. A gun.'

For an instance, Piao also glancing down at the pistol. Always shocking him to see his hand wrapped around its steel. A doubt, but then swiftly moving back up the steps that he had retreated from. The Big Man passing him, moving towards the Street Committee Chairwoman. His hand, dinner-plate huge, clamping around her mouth.

The alarm now sounded. Each step, knowing that they would know. And only the one entrance into his flat. Rimless rounds' sightlines already chosen? A head-shot? Shot to mid-chest?

Piao, two steps at a time now. A violent charge. Deep guttural yell in his throat. Slamming the half-open door into the wall. A splinter of wood, a yelp of metal hinges twisting. Senses reaching out for the signals that danger emanates. Nothing. Slowly, with effort, his posture relaxing, adrenalin's tide receding. Moving down the short hallway. Slowly rounding the door. The Wizard, static, facing the computer, his back to the door, a half-full bottle of Southern Comfort within reach.

Moving further into the room. And then it was upon him, like the heat of a dog's breath before its teeth

puncture your skin. Only one smell, as clearly defined as your own signature on your own cheque, a monsoon of blood. The Senior Investigator holstering his pistol.

Slowly moving around the side of the Wizard. Eyes alive to all. Horror at the gradations and depths that the colour red can possess. From the Wizard's mouth, down his chin, neck and chest, pooling in his lap ... blood. From his lap, down his legs, into his shoes, onto the carpet. So much blood, it would have to be a large wound to cause such a tide. Piao's eyes searching, but finding nothing obvious. Reaching for Rentang's wrist, no perceptible pulse.

'Yaobang, here. Quick.'

Footfalls in the hallway. The Street Committee Chairwoman's face married to the palm of his hand. As the Big Man breached the living-room door his hand falling from the old woman's face. Piao answering the question unasked.

'A pulse, but very faint. An ambulance, call one immediately.'

Blood spattered over the telephone. The Big Man using a loose sheet of paper to pick up the handset, so as not to leave his own fingerprints. Not noticing as the Street Committee Chairwoman ran for the stairs, both hands to her face in witness to a silent scream. Not noticing unconsciousness chasing her down with faster feet, her legs folding as if they were deck chairs. Not hearing her body meet the floor in a violent embrace.

The Senior Investigator's attention drawn to a tumbler, deeply filled, near the far right corner of the computer monitor. The tumbler, its red contents almost overflowing. Southern Comfort, tainted to the hue of tinned tomatoes. Piao, with reluctance, already guessing what he would find, taking a pair of tweezers from his inside pocket, forcing them wide open. Fishing. Something solid in liquid. Bobbed squirms, away from the tweezers pinch, but steel snaring its quarry. Through the liquid, a deeper red moving through red. Slowly, carefully, withdrawing a tongue, root and branch. The Wizard's tongue.

The Number 1 Hospital

A drip. A blip. And his eyes open. Two commas on a blank sheet of white paper. Focusing on Piao, a gurgling deep at the back of Rentang's throat, expanding into a pattern, rough and phlegmy. Falling chaotically into a coughing fit. His whole body, the bed, rattling with its fury.

The Senior Investigator, adrenalin fighting two days without sleep, yanking the string of the buzzer to summon a stout-legged nurse. A hand, Rentang's, reaching out to his, loosely pulling it down towards the side cupboard. A clip-board. A pen. The cough easing to a gagging, guttural Morse of breaths. Their eyes fixed on each others'. An understanding passed. Folding the Wizard's hand

around the biro. Painfully slow and precise. Looking away as the words formed. Seeing a flush of red move down plastic tubing. Florid poppy fields of spittle, blood flecked, in full bloom across the bedding.

Only looking at the paper once the pen had halted its trace. Once the arm had fallen back to aertex ocean and Rentang was at the very centre of the doctor and nurse's universe.

Two words.

FILE TWENTY

*

'How is he, Boss?'

A look.

'That fucking bad, eh?'

Scrubbing as he talked. The carpet foaming a candy-floss pink.

'And the Street Committee Chairwoman?'

The Senior Investigator moving to the computer. A screen saver flowing with oscillating hoops and colours. As he took the mouse, their hues across his knuckles.

'A broken jaw.'

A laugh from the Big Man.

'I suppose it will be some time before she can speak. There's always a silver lining, Boss.'

Pink rubber gloves across the glass. Gagging, the Big Man, as he carefully picked up the tumbler of Southern Comfort.

'I'll never fucking drink this shit again, Boss.'

The toilet flushing.

'Scene of crimes, been and gone, Boss. Thirty minutes, that was all. Didn't even look at the computer. Either they've got hot dates, or they don't want to know.'

A tap running.

'What I don't understand is why Qi's thugs didn't smash the fucking computer.'

'Maybe they were having so much fun that they forgot.'

'Yeah, maybe.'

Yaobang watching the Senior Investigator's fingers on the keyboard.

'Thought you didn't know how to use a computer, Boss.'

'I don't. But I am good at watching.'

In a blink, the screen saver's oscillations swept aside to be replaced by pages of numbers. The computer, where Rentang had left it. Strings of data crashing like a waterfall as Piao scrolled. Pages in frantic dashes. Stopping, then scrolling slowly back. A page, two pages. Slowly, a file title moving into mid-frame. Caps indented.

FILE TWENTY

'It is from Qi's computer. The Wizard had hacked into it.'

On the right-hand side of the screen, a fine misting of specks. The Wizard's blood. A few hours ago a man's

tongue had been cut out as he sat on this seat looking at this screen. Every word plucked from his mouth forever. File Twenty. Its significance unknown. But important it must be for a man gagged in blood and sutures to summon the energy to write words that he could no longer speak. To write 'File Twenty' instead of, 'Fuck off'. To write 'File Twenty' instead of 'See how you have ruined me'. Yes, File Twenty must be important.

Lines. Columns. Banded characters. Numbers. Code labelled. Code edged. Not a code to conceal – Qi confident that nobody would ever see this file. But a code of convenience. A short-hand to save space, to save typing and time. Patterns emerging the more that Piao looked at it. A record, an accounts book, a diary and an inventory. Monies out and monies in. Cream scooped from the top. At various accounting intersections the same characters coming into play. A code? A company? A nickname? A name? And *yuan*, trailing so many noughts behind it, like a locomotive pulling carriages. *Yuan*, by the hundreds of thousands, by the millions, sent by courier, the same day of the month, the same time of day. Sent to Citizen One.

'Who or what the fuck is Citizen One?'

Pointing to figures, running totals.

'Shit, and are these *yuan*, Boss?'

A nod.

'That many *yuan*, it's got to be drugs, Boss. Only drugs would generate such income. That's what our *tai*

zi's up to. Some war with another drugs cartel. What do you think, Boss?'

'Perhaps. Such a PLA would have access to a network that covered the whole of the People's Republic. Transport. Distribution.'

Tapping the monitor screen with his nail.

'This also . . .'

The only other complete name. The only other junction where substantial amounts of *yuan* were being absorbed. Page after virtual page, the same name repeating. Drawing the eye, as the needle to the spittle spiked end of the thread.

'Kanatjan Pasechnik. A Russian comrade, I would imagine.'

'Perhaps he likes the particular cocaine that our PLA is fucking providing, Boss?'

Piao, tapping the monitor screen.

'Citizen One and this Russian comrade, I want to know them as intimately as you know the inside of one of Mama Lau's dumplings.'

'Sure, Boss.'

'This file, it is important. I think that this is a bridge that Colonel Qi has failed to dismantle shortly after crossing it. We cannot afford a mistake. Ring Ow-Yang, he will talk me through saving it.'

'Anything else, Boss?'

'Yes, I want you to get me lists. Lists of every one of the highest *cadre* who make up the following bodies:

foreign legations, the Central Political Bureau, the Central Secretariat, the All-China Federation of Trade Unions. I want lists of all the most powerful committees in the Republic. Like the bastards that telexed for our comrade PLA's release from the *fen-chu.*'

Writing notes on the meat of his palm, the Big Man. Tucking the biro into the pocket of his stained shirt.

'It's going to fucking cost.'

'I know. "At least two bottles of Teacher's whisky. Maybe even a few packs of Marlboro thrown in." And then, somehow, we are going to dismantle this equipment and tomorrow set it up in the hospital. In the Wizard's room.'

'Shit, Boss. We're really going to take this computer all apart and put it fucking back together again . . .'

A nod.

'And then you can help me pack a box. You said that your cousins would provide transport for us? And a place for us to operate from and to sleep?'

'Sure, Boss. Next week.'

'Can they be persuaded to bring this forward?'

'Probably, Boss. But why?'

'I have noticed that my cut-throat razor has gone missing. I believe that this was what was used on the Wizard. When you go to the *fen-chu* submit a report about it being missing, so that it is on record.'

The Senior Investigator's eyes drifting to the sodden dull brown carpet at his feet.

'Your cousins, I would like to go there tonight, late. This flat has suddenly lost its place in my heart.'

*

Late. Too late to sleep. Too early not to sleep

Piao walking from the bathroom, drips of cold water with every footfall. Pulling on a fresh, clean shirt, identical to the last. Noticing that the inside of the cuffs and his shirt collar were still grey. No matter how he scrubbed them, they were never clean. As if his soul, soiled, was bleeding dirt through the pores of his skin in an attempt to purge itself.

Picking up a cardboard box. On its scuffed, stained sides, huge yellow-inked Spanish suns blazing over green inked hills, trees bent with orange-inked satsumas.

Packing the box, and something about the slow parade of this process honing his thoughts, sharpening his perceptions about his life. Clothes, precisely folding them and placing them into the box still smelling of satsumas. Sparse toiletries. A razor. A book, the *Shijing*, 'The Book of Songs'. On top of these, a spare pistol, an old Soviet Makarov PM. Two clips and a worn holster. His documents of authority. A diary. A pen. But still only half full, the box, like his life. Finally placing the carefully wrapped frame in amongst the fold of his clothes; a press of grey-crescent-collared and cuffed shirts. Within the frame, a photograph. A woman, sable fan of fine hair. A wife lost in time, a lover lost in a cold *cadre*'s embrace.

For a while, longer than he imagined, standing at the window viewing the lives that others lead. From the *long*, through the gap between window and worn frame, steam carrying the aroma of noodles, anointed with garlic and ginger ... a marriage arranged in heaven. Only pulled from his trance by a tired footfall from the kitchen.

'Ready to go, Boss. The cousins will be waiting.'

Sealing the box quickly, feeling pain that his life was so meagre, that it could be sealed in a small box that had once held satsumas from Spain.

'Yes. I am ready.'

Piao picked up the box and walked out of the room without looking back.

32

The Happy Smile Bakery, Longhualu

From the river, warehouse skirted, the scars of commerce. A million ships that had berthed, delivering cargoes, loading cargoes: pork bellies, spices, iron, herbs, silk, the products from ten thousand factories. But the warehouses now empty. Where dockers once laboured, now an Internet café and a cluster of chromed 'birds of a feather' retail outlets. Where the People's Republic's wealth hung on the crane's jib, the pallet's load . . . now a Coffee Republic; fifty different versions of the frothy brew. On their pastel walls, mezzotints and sepia prints, of what work once looked like and how lives were once lived in this place.

And behind the cracked brick walls and windows too dirty to see through, where the river lapped exhausted and stinking, the Happy Smile Bakery. Day and night, the aroma of mooncakes baking, cutting through the smell of Latin beans roasting and the cologned dabs of western dreams. Fifteen thousand mooncakes.

<p style="text-align:center">★</p>

The same hybrid dream for three nights. Each dream, a little clearer, night by night.

In one of the main wards of *Ankang*, a horseshoe of parchment pale faces. Rolled, marble white eyes and dribbled-down shirt fronts. A doctor and a nurse also standing in the space; beside them, a large electrical appliance with switches, a numbered dial, and heavy wires in umbilical snakings across the floor. Beside them a stainless-steel cot, a patient with a paper-white face strapped to its quicksilver framework. Fine acupuncture needles removed from delicate paper sheathes and carefully affixed to rubber holders at the ends of the wires. Applied with deep twists into the patient's temples, the *taiyang* points. The doctor, wire rim spectacled, black rubber gloved, between rubber forefinger and thumb, the heavily engraved knob; twisting it to its first point, until it met resistance. A hum of electricity, and even in REM's grip, a taste, a smell of burning. Instantly, a place beyond pain. The patient bucking with the electricity's razored jolt. His spine arching, legs kicking, arms bracing beyond limits, and a scream, as a scream was never heard before. As sharp, as seamless as an oxy-acetylene torch's flame. The doctor turning, and shouting at the inmates. Slapping his hands at them. Pointing at them. The other hand, the knob, twisting . . . past the first level of resistance. And the patient screaming, and the inmates backing away, some crying, others throwing up.

And in the darkness of a place that he didn't know, Piao waking, the torture within him. The 'electric ant's'

crawl across him. Screaming with the victim, into a perfumed night, until sleep claimed him once more.

<div align="center">*</div>

The early hours of the morning were cold. Colder than Piao had known for a long time. A sleeping bag with a half-full sack of rice flour used as a pillow and only the distant ovens, with their whispers of hot breath, keeping him from freezing.

Finally rising, the dream's residue still haunting his memory. Taking the crisp report from the cardboard box of his belongings that the Wizard had handed to him before.

Moving through the rear door of the bakery and onto the pier. A mooncake in his other hand. The sun struggling to rise through cracked windows, to a sky still regretting that night had slipped its mooring. Sitting on the pier's very edge. Against the backdrop of the sable chiselled river, the shock of the report's pristine papered whiteness.

PEKING UNIVERSITY – Central Offices

Medical report – No. 634437893
Student Name – Zhong Qi

Page one and two, general details. Family blood line, family medical details, record of inoculations. Childhood, details of height, weight progression, illnesses.

Only on page three were there references to his birth deformity: cleft palate, harelip. On page four, detailed hospital notes from his birth to the present and as the years progressed, the notes becoming more frequent, more alarming.

> The patient is suffering from a form of sleep
> apnoea. An apnoea index in excess of 100 events
> an hour has been recorded, and it is strongly
> recommended that the child be monitored
> throughout the entire night. The child must be
> considered to be at severe risk of Sudden Infant
> Death Syndrome. Oxygen in the bloodstream has
> fallen to critical levels due to prolonged periods of
> not breathing during sleeping hours. Pulse
> oximetry has shown readings at these times of only
> 55 per cent oxygen saturation. This has led to
> irregular heartbeats and heart failure. On four
> occasions to date, the child has needed to be
> manually resuscitated.

A letter from the People's Number 1 Hospital, after years of study, medicines, countless doctor's appointments and specialist consultations.

> A diagnosis of sleep apnoea has been arrived at.
> Whether this is central or obstructive sleep apnoea
> remains a mystery. However, corrective surgery
> must be seen as the best way forward.
> Uvuolpalatopharyngoplasty is suggested. Excess

tissue will be removed from the back of the throat.
Tonsils and adenoids will also be removed.

The operation, a failure, more extreme surgery con-
sidered.

The patient, a healthy young comrade in every
other regard, continues to suffer an extreme form
of apnoea. This is causing major desaturations, and
cardiac arrhythmias. Previous surgery to both nose
and throat must be regarded to have failed. It is
now suggested, with reluctance, that a more
extreme surgical procedure be considered to
counter this life-threatening problem.

Diagrams of what the surgeon's hands would perform.

Anxiety of family members and hospital staff
personnel, and threat to the patient's life, can be
eliminated through a tracheostomy. A tube,
temporary at first, to be inserted through an
opening in the trachea. It is recommended that the
tube be closed, plugged, during waking hours, and
only open during sleep so that air bypasses the
throat and flows directly into the lungs.

A letter from the specialist, two months later, in
response to one from Qi's father, the Senior Colonel.

Comrade, I regret your decision to veto the
proposed surgical procedure planned for your son,
Zhong. I understand your concerns, but feel that it

is my duty to stress, in the strongest terms
possible, the risk to him in not allowing this
surgery. He has severe sleep apnoea. This is not a
condition that will correct itself. Indeed, Comrade
Senior Colonel Qi, the risk to him might well
increase with age. I must emphasize that his is the
most critical case that I and my colleagues have
ever recorded.

A distant moan from a tug struggling against the
turn of the tide. Piao reading the final words of the
specialist's letter. A shiver running through him.

The patient, your son, must be considered to be at
such risk that if he sleeps for two hours or more
unmonitored, death will surely follow. I pray to the
ancestors, Comrade Senior Colonel, that you have
made the correct decision.

Walking back into the bakery, the Senior Investiga-
tor, exhaustion, a heavy yoke upon him. Pulling his bed
against the oven wall, zipping the sleeping bag around
himself. An hour's sleep might drive the chill of the
night from him, still harboured in the marrow of his
bones. An hour's sleep might drive the sound of a still
remembered scream from his inner ear.

An hour's sleep, but it would not still the alarm that
he remembered shrieking from the large watch perma-
nently strapped to the *tai zi*, Zhong Qi's wrist. Every
two hours, its voice calling . . .

'Awaken Comrade, your life waits – awaken, or it will pass you by.'

*

'What do you think, Boss?'

Half a dozen wrenches of the key to resuscitate the Liberation truck into half-life. Pulling out of the depot of the Happy Smile Bakery amidst a pall of silver-grey smoke. A half-cousin of the Big Man heaving the gate open. A smile of broken teeth that would make any dentist weep. Traffic horn blaring as the truck forced itself into Longhualu, skirting the pagoda and shaving the swerve of the Huangpu.

'Thought we could do with a little anonymity, Boss.'

'And this is anonymous, a truck with "The Happy Smile Bakery" scrawled across its sides? Anonymous is a battered Shanghai Sedan which we already had. It might have been better just changing the Sedan's plates.'

Moving onto the junction with Zhongshannanlu and Ruijinglu, travelling north. Braking, accelerating, clutch slipping, a yelp of gears not meshing, the Liberation truck jolting violently. Yaobang wrestling with the stick. Pumping the gas. The sound of wooden trays jostling for position in the back. Piao lighting a Panda Brand, staring over his shoulder into the gloom of the Liberation truck's interior.

'What is in all the pallets and trays in the rear?'

The Big Man stretching behind him, pushing the

cotton sheeting aside and reaching into one of the wooden trays.

'Fucking mooncakes. Best in the old French Concession. The cousins make 15,000 a night.'

'Yes, I did notice.'

Tossing one onto the Senior Investigator's lap. Biting into another. A hole in the moon.

'But what are they doing in the back of a truck that we are using as our only transport?'

A bite across Clavius, another bite transecting Copernicus.

'That's the deal, Boss. We get the truck for the job. My half-cousin gets his cakes delivered. Everybody fucking wins.'

Piao nibbling around the moon.

'Yes, everybody wins.'

Watching the traffic scrape into Shimenlu. Through gaps in the metal river, glimpses of the People's Square. Soldiers in precise marches readying themselves for the Festival of the People's Army of Liberation. Waves of olive green, breaking on a stone shore.

'Better a diamond with a flaw than a pebble without one.'

*

Cobblestones, web-ripped shadows, buildings frayed with age and neglect, as if this desolate part of the city was no longer possessed of life and was fading away by the second.

Neon tainting mist up ahead. A fluorescent sign buzzing with the fury of a wasp imprisoned in a bottle.

'This is it.'

SPARKICE

Parking out of view on a wharf dock cracked by ten thousand cargo loads. In mist, lighting cigarettes, Yao-bang pushing open the scraped and dented doors, and the musics blunted decibels, hitting them mid-chest and seeming to reverberate through their bodies. Aware only of the raw rock music, of black leather, lank hair over the eyes of rows of emaciated youthful bodies in sway to indecipherable lyrics, strapped to a machine riff.

Two doormen slumped bored in China Brand smoke. The Big Man discreetly flashing his badge. As ever the usual effect, their posture straightening and fear in their eyes.

'Relax, it's not fucking official.'

A hand up, calming them.

'We are here to see, to see . . .'

A name scrawled in biro to the back of the hand.

'Comrade Cypherpunk.'

Feeling stupid. The next words, even more stupid, as if whispering the dialogue from a cheap, well thumbed and trashy detective paperback.

'Tell him that the Wizard sent us.'

Then following the doorman. A lumbering walk into the darkness, opening up into the vast space of the

Internet café. A thousand personal computers flooding the cigarette-indented floor of the aisle with multi-hued weaves. Shifting chameleon fingers over a thousand keyboard keys. Heads bowed in homage at the altar of the web.

Spray-can graffiti set into the rear wall in fluorescent shrieking hues, the star of the People's Republic in crudely invasive and hard-edged paint runs, now yellowed by nicotine. At its very centre, as if blight had affected this bloom, a black door. The doorman knocking twice and slipping through the gap. The door closing. A muffled conversation. Two, three minutes, the door opening.

'He is expecting you.'

The door pushed open. Piao, the Big Man, breaching a bank of smoke. Across the stained floor, trailing wires, piles of books, dissected electronic equipment, spilt floppy disks and CDs. The door closed.

Behind a large monitor, smoke was rising in a constant plume which wormed its way across the discoloured ceiling tiles.

'Friends of the Wizard are friends of mine.'

Talking in English. Clever. If picked up on a wire tap, so much more difficult to transcribe, and so much more time-consuming.

Smells of the human animal encased in a fine silk suit. A comrade of porcelain paleness and pristine neatness greeting them.

'I was nervous about dealing with PSB, but the

Wizard has assured me that you are, how should I put this . . .'

'Tame.'

'Tame'. Perhaps the most insulting word that Piao had ever heard used to describe him. Almost as bad in its mediocrity as 'nice'.

'You are tame, aren't you?'

English, answering back in English. The language of kings, Coward, Shakespeare, the Beatles. The Senior Investigator using it at any excuse, as most Chinese.

'Some would not agree, Comrade. In fact, many would not agree. Including myself.'

Across the hacker's face, uncertainty. Oxygen to an investigator.

'You are Comrade Cypherpunk? You are not what I expected.'

Soft fingers on the computer mouse, clicking out of a program. A victim's computer stripped to the bone. A corporate server sliced and diced.

'I take that as a compliment. To surprise an officer in the PSB is not a regular occurrence. My life, it has schizophrenic qualities to it. By day an eminent university professor of mathematics, by night, *voilà*, Cypherpunk. A mutually and financially beneficial relationship with the owner of this fine establishment. Hacking, it supplements a poor professor of mathematics' pay. Without it I would be smoking China Brands like you, Senior Investigator.'

Blowing foreign cigarette smoke in Piao's direction.

'So, you've come about the file. The encryption?'

'The Wizard felt that it would be impossible to break a, a . . .'

'A forty-bit encryption? Not for me, Investigator. Every encryption is breakable, although they would like to make you think that they are not. An encryption is just an envelope of data that only people with a key can close and open. And a key, in its simplest form, is just a string of ones and zeroes randomly generated by a computer. I was one of the first to break one in the late nineties. RSA Data Security Incorporated put out a challenge to break a forty-bit encryption product.'

Beside the computer a bowl of brightly coloured sweets. His fingers, with great delicacy, picking from it. Yaobang, picking one up, examining it in detail. Pills? Narcotics? The hacker smiling with rainbow teeth.

'Smarties. English confectionery. A hacker friend sends me some boxes every month. Good and, I am pleased to say, legal. '

Licking his fingertips. Red. Yellow. Green. Static traffic lights.

'Anyway, the forty-bit encryption provided to me by the Wizard, it took me three hours.'

The Senior Investigator moved closer.

'You have done it? You have unlocked the file?'

'Of course. This conclusion was never in doubt.'

His fingers across the keyboard. Data slowing. Pausing. Stopping.

MINISTRY OF SECURITY
473309169972

Carefully hunting through a topple of floppy disks next to the computer. Precise writing on perfectly placed labels.

'The advantage of having a mutually symbiotic relationship with a businessman who owns a thousand-computer Internet café.'

Clicking the floppy disk into place in its drive. A whir of activity.

'It took 250 powerful workstations trying 100 billion possible keys each hour to break this encryption.'

PASSWORD ACCEPTED

Removing the floppy disk.

Yaobang helping himself to a Smartie. Gingerly licking it. Smiling. Throwing it into his mouth. Helping himself to a fistful of rainbow colours. The professor, giving him a sideways glance.

'Not the red Smarties, Investigator. The red ones are my favourite.'

Using his hand as a plate, the Big Man sorting the colours out. Throwing the red ones back into the bowl. The rest, he crunched open-mouthed.

The professor inserting a CD-Rom.

'What the fuck is it?'

'Images from a remote sensing satellite, Ziyuan-2, ZY-2. It was delivered by a Long March-4B rocket from

the Taiyuan Satellite Launching Centre in the northern Shanxi Province on October 27th.'

The image rising up. Cloud to misty ribbons. Land. Paddies. Roads.

'ZY-2 orbits the earth every 94.3 minutes at an altitude of between 294 and 305 miles. It produces, as you can see, high-definition digital images comparable to the sharpest images produced by American and European commercial satellites. ZY-2 can focus down on objects less than half a metre in diameter.'

The hacker's hand back into the sweet bowl.

'In other words, from 300 miles up in orbit, in the right conditions, it could read the headline from a newspaper that you were holding. The ZY-2 was launched as a civilian earth-monitoring system, in fact it has a secret military designation of Jianbing-3. It can be used for planning combat missions, targeting missiles at American forces in Japan, or for preparing aircraft strikes on Taiwan. The images on this file, however, are of our People's Republic.'

Yaobang's eyes nervous. Tapping the monitor with walnut knuckles.

'Spying, we're spying on our own country, our own fucking comrades?'

'No, not spying, remote sensing. Satellites, used for analysing environmental changes. Natural resources, minerals, ore, crop planning. It is used a great deal nowadays. The file you gave me holds several hundred satellite images and other associated data.'

A click on a virtual button and the frame rising towards them. Shifting left. Cloud, rearing up. Lakes. A splintered bed of forests. Orchards. Tossed seas of corn field. The hacker watching their eyes widen as he spoke.

'This is what I believe you are looking for.'

A new image filling the screen. An ocean of wheat, old gold. A single track road dissecting it. Gated at its beginning and its end. At the very centre of the fields, a verdant oasis. With an emerald nail, Piao pointing. Around the oasis, bordered onto the wheat fields, a double black hairline. Cursor pulling a box around the area of interest. Cursor over a virtual magnifying glass.

25% ... 50% ... 75% ... 100% ... 125% ... 150% ...

The double hairline, now double tram lines and concrete postings. Razor-wire fencing, electronic surveillance topped.

'Take the picture out again. Take the frame out. This area. Yes, show me this area.'

Rectangle pulled from nothing. At its centre, smudges of grey brown. A mosaic of flat rooftops.

'Can you scan along?'

'Of course, anything for the PSB.'

Scanning west. Accommodation blocks? Recreational facilities? Scanning east. Long buildings, low buildings ... strings of pipes and electric cabling. A factory? A laboratory?

'What are they, Boss?'

The hacker replying.

'It's called Facility-4. A *lao gai* that has a history that goes back before the Long March. Very secret. Very forgotten about. It also has another name, Righteous Mountain.'

Looking at the Senior Investigator.

'I cross-referenced in Ministry of Security sites. Righteous Mountain is barely mentioned, and no one ever leaves it. An estimated 5,000 inmates, but I can find no traces of anyone that has been released from Facility-4 in five years.'

'I would like a tour.'

'But just a virtual tour. Righteous Mountain does not seem the kind of place that you would wish to visit in person.'

Scanning north. A generator plant? A water purification processor? Scanning south. Workshops? Storage facilities? A warehouse fed by heavy piping. Refrigeration? Air-conditioning? A garage, several cars parked at its rear. Four-wheel drive. Two Sedans. And unmistakably, the long stretch of gloss black of a Red Flag. On the edge of the monitor a small rectangle of lush viridian foliage.

'Pan along a bit more. A bit more. That is fine.'

Lines of exuberant flora, scratched between them, runs of silver water.

'Must be drugs, Boss. Must be. It all fucking fits.'

'Not what the remote sensing data says. Just rice, no cannabis or poppy. And as far as I know growing rice in our People's Republic is not yet against the law.'

Yaobang's finger tapping the screen.

'It's a small paddy though, Boss. Not enough to feed me and my cousins, let alone the inmates of a *lao gai*.'

The Senior Investigator nodding.

'Show me this section again, this time in more detail. More. A little more.'

Filling the screen, details so fine. The red and white alternating paintwork on the drop-barrier. Acute angled wording on a stop sign. A guard's olive-hued moon of peeked hat. Heavy black rifle slung over his shoulder.

'A little more.'

At the very furthest range of the satellite's capabilities. Geometric lines, expanding around, blurred but recognizable, red stars.

'Fuck me, Boss. PLA.'

'These images, Comrade Hacker, you know their precise location?'

'Of course, it was a part of the data on the file.'

'Good. Then we shall have a little competition between technology and detective work. I shall write on this piece of paper the area that I think that we are looking at. And you, Comrade Hacker, can tell me if I am correct.'

The professor smiling.

'Technology every time, Investigator. Every time.'

On the paper:

*The plains around Lake Dongting and Lake Poyang,
the 'two rice bowls'. Jiangxi Province.*

On the screen:

Poyang Lake, Jiangxi Province

'Shuihuzhuan. Lands of "The Water Margin".'

Carefully folding the paper, the Senior Investigator and placing it in his pocket. Making himself more comfortable. Stretching out his legs.

'I think, Comrade Cypherpunk, that you have much printing to do. The file on Righteous Mountain looks very large.'

Removing his jacket, loosening his tie. Helping himself to a handful of Smarties. Smiling. From the hacker, a less certain smile.

'Anything else that I can help you comrades with?'

Piao, Smarties in traffic lights across his palm.

'The Wizard, there was something else that he was exploring for us, something that was given reluctantly to me . . .'

Writing, Piao, handing over the slip of paper. As the professor accessed a search engine, typing in the words, reading them out aloud.

'Mao Zedong, Southern Kiangsi, 20th August 1933.'

A flight of websites blinking to screen.

'Here, my PSB Comrade. Technology at its very best. It a speech that was made by Mao Zedong in Southern Kiangsi on 20th August 1933. A speech made at an economic construction conference. I will print it off for you.'

Through the chatter of the printer, Piao dredging his memory.

'I know this speech. It was made during the period when Chiang Kai-shek was launching five large-scale onslaughts against the Red area, centred on Juichin and Kiangsi. Encirclement and suppression campaigns they were called. The Great Helmsman at their very centre like the calm eye of the hurricane.'

The last of nine pages falling into the hacker's fingers. Dropping them onto the Senior Investigator's lap.

'The speech is entitled, "Pay Attention to Economic Work".'

*

Reading as the Big Man drove. An obscure route that would shake off all but the best tails.

> The growing intensity of the revolutionary war makes it imperative for us to mobilize the masses in order to launch an immediate campaign on the economic front and undertake all possible and necessary tasks of economic construction . . .

Across the sheets, beats of mustard street lights, glare and feints of headlights.

> Only by extending the work on the economic front and building the economy of the Red areas can we provide an adequate material basis for the revolutionary war, proceed smoothly with our military offensives and strike . . .

A puddled track between factories stacked back to back.

... and set up public granaries and storehouses for
famine relief everywhere. Each county must
establish a sub-department for the regulation of
food supplies, with branch offices in important
districts and market centres.

For some minutes parked beneath the tree line of
the Huangpu park, lights switched off. Yaobang's eyes
alert to any car that might be following them. Satisfied,
lighting a China Brand before driving off.

'We must do our best to develop agriculture and
handicrafts and increase the output of farm
implements and lime in order to ensure a bigger
crop next year . . .'

Reading, rereading the speech three, four times. And
with it, trying to pull threads together. Threads that
were separated by over seventy years. What did a
scientist's father, his daughter's body interred into the
cloying soil of a cemetery, share with Mao Zedong as
he planned and, with his Red Army, fought his way out
of the enemy's fifth 'encirclement and suppression'
campaign? What did this grieving scientist father have
in common with the Great Helmsman, who in 1933
had spoken these words while in the violent throes of
constructing a nation's revolutionary and economic
pathway?

As they pulled into the yard of the Happy Smile Bakery, headlights fading, the Senior Investigator fumbling through his pockets. Dropping a pencil in the dim light, hunting it down with eager fingertips. Frantically underlining a tract of the speech's text with a blunt lead.

> ... that without building up the economy it is impossible to secure the material prerequisites for the revolutionary war, and the people will become exhausted in the course of a long war. Just consider!

'You got something, Boss?'

> Rice is cheap in the autumn and the winter, but it becomes terribly dear in spring and summer. All this directly affects the life of the workers and peasants and prevents any improvement.

'Boss?'

> And does it not affect our basic line – the alliance of workers and peasants? If the workers and peasants become dissatisfied with their living conditions will it not affect the expansion of our Red Army and the mobilization of the masses for the revolutionary war?

Neatly folding Mao's speech and placing it deep into an inside pocket.

'You've got a link, Boss?'

The Senior Investigator smiling as he jumped down from the Liberation truck, walking towards the bakery and 15,000 mooncakes, the best in the old French Concession. As the door banged shut and the smell of sweaty cousins and molasses assailed them, two words, both of them lost to the Big Man's ears.

'Oryza sativa.'

33

Nanjing Road, 'China's number 1 street', 350 stores, 1 million shoppers a day. With the traffic running blind from the Bund in the east to the 1,000-year-old Buddhist Jingan Temple in the west.

The start of Nanjing Road East ... the architecture of old Shanghai. North and south of the street, the atmosphere of the 1920s. On the right, at Number 422, Duoyunxuan, opened in the Qing Dynasty and famous for its calligraphy and stone rubbings. On the left, nineteen storeys of what used to be Tian Yun Luo, the first amusement arcade in Shanghai, now the Overseas Chinese Store and the Shanghai Number 2 Television Station. At 490 Nanjing Road East the Zhang Xiaoquan Scissors Store: 1,000 different designs of scissor – right-handed, left-handed, no-handed. The Maochang Spectacles Store with 1,000 different designs of spectacles: reading glasses, bi-focals, monocles. On the opposite side of Nanjing, the Shanghai Number 1 Foodstuffs Store. Locals still calling it the Sun Sun Company, as it was before the liberation: 250 different types of tea. Further west, on the left-hand side, the Yunan Road Night Bazaar open from dusk till ten p.m. for *fen*, *hundun*

tang, ravioli soup, *shaomian*, fried noodles. The haunt of dry-mouthed taxi drivers, noodle-craving PSB. At Number 830, the cream-coloured building, the Number 1 Department Store, the largest store in China, which has 3,000 salesmen selling over 30,000 different items to over 250,000 customers every day.

Crossing Xixang Road, People's Square, onto Nanjing Road West. People's Park. The Overseas Chinese Hotel catering mainly for Chinese expatriates from Hong Kong, Macao, Taiwan. Next door, the Park Hotel, overlooking the People's Square. Twenty-four storeys, once the tallest building in Shanghai. Famous for its Art Deco interior and its Beijing roast duck. Further along the road, typical Yangzhou cuisine, restaurants noted for the food's freshness, lightness, clarity, sweetness. Stewed crab ovum with pork patties. Their famous pastries, eight treasure *shaomai* and lightly fried dumplings stuffed with scallion-flavoured pork. At 580, the Peiluomen Garment Store specializing in western-tailored suits. Novel designs, exquisite hand-sewn quality. Favourite of the high *cadres*. On the left, the building with a clock topping it, the Old Shanghai Library, formerly the Jockey Club. On the right the Shanghai Flower and Bird Shop. Cages of yellow-gold songbirds. Tanks of goldfish. 1081 Nanjing Road West, the Meilongzhen Restaurant, with egg plant in fermented bean sauce and ginkgo nuts cooked with shrimp meat.

And within sight, through traffic, the Chinese Medicine Store. Five thousand different medicines. A dusty

banner in its window, proclaiming to sell 'Ten Best Brands', 'Zaizao Pill', 'Huoluo Pill'. A pill for every condition, every mood. *Pa ma-fan*, 'to fear trouble' . . . paranoia. *Shen-jing shuai-ro*, 'weakness of the nerves' . . . anxiety.

On their wall, as long as a Red Flag automobile, is a list. Some of the more extreme conditions that can be treated underlined in red. As if every personal file of every homicide investigator in the *fen-chu* had been read and transcribed.

Depression
Violent Anger
Bereavement
Trauma
Impotency

34

Two tigers, two tigers.
They run fast, they run fast.
One has no eyes, one has no tail.
How strange, how strange.
<div align="right">Chinese children's song</div>

Flies never visit an egg that has no crack

A finger pointing through the windscreen.

'There, Boss. The "cracked egg".'

A man's reflection in the glass.

'He'll go into the bar and then back onto the Nanjing Road.'

Picking at his teeth, the Big Man. A reluctant shred of pork dumpling levered from a dark crevice.

'Tsung calls into every bar on Nanjing. Every stop, a bigger bulge in his trouser pockets. And we're not talking about a "glad to fucking see you" bulge, if you know what I mean, Boss. The same routine, our PLA little friend. Four days in a row.'

Tight against mirrored glass, a thousand reflections with Tsung at the centre of its maze. The PLA officer

nervous, shooting a gaze over his shoulder, a hand to the pistol that lay slumbering under his expensively tailored jacket. Another look around before disappearing into the bar's interior.

'I will stay this side in the Zhang Xiaoquan Scissors Store. You follow him, cross with him, and as he steps on the kerb we will take him.'

A nod. The Big Man jumping out of the Liberation truck, a laboured run through a gap in the traffic and taking up position four doors down from the bar. Already drenched in the incessant rain.

Piao slamming the Liberation truck's door and running for the Zhang Xiaoquan Scissors Store. Soaked by the time he reached it. Standing just inside of the door, in the Xiaoquan's front window, a display of specialist scissors for the disabled, for those with no thumbs, fingers, or no hands or sight. Looking past honed scissor blades as he watched the other side of Nanjinglu through the stutter of traffic. The entrance to the bar, people coming and going. A couple draped around each other, a drunk, and suddenly there he was, the *tai zi*, patting the fat, packed pockets of his trousers stuffed with *yuan*. Protection money, pimping money, by the tens of thousands. Standing directly under the buzzing neon light's drop, at one with the wet, glossed jigsaw cars. Pulling up his collar, walking fast and keeping tight to the shop windows.

The Big Man picking him up, fifteen, twenty metres

behind. Following through the knots of pedestrians. The princeling avoiding the worst of the puddles, suddenly turning his back into the slanting rain as he lit a long, gold-banded-filter cigarette. As he did so, catching sight of Yaobang pressed against the glass. A recognition set in red neon. The PLA dropping his expensive cigarette, starting to run with the Big Man matching his every move as if joined by an umbilical cord. Frantic, the PLA's eyes, seeking a gap. Seeing one. Readying himself, hand to the railings of the traffic barrier. Sprinting between bumpers, making it to the concrete island splitting the traffic's frantic race. A glance at the sanctuary offered by the other side of the lane of traffic. From there so many other roads to choose, so many other escapes and then protection, the arm of the People's Liberation Army, so long and so comforting. Cradle to the grave comfort. A second glance, and then seeing him. A face he knew, but could not name, only remembering as he saw the pistol's ugly snout slowly moving from the cover of his sodden jacket.

'Still. Stand still.'

The rain pissing down on Piao's head. Cuff across his eyes.

'Don't move.'

The PLA welded to the spot, but the Senior Investigator's view of him was suddenly lost as a snorting beast of an articulated lorry pulled up. Piao, in spray and dampened exhaust fumes, running around its

belching arse. Crouching, hand over hand, his pistol dripping rain and jigsaw shadow, but Tsung, the cracked egg, gone.

'Where the fuck, Boss?'

Traffic breaking into separate links while the Senior Investigator's eyes frantically hunted for a running figure. A face amongst other faces, or a wet arm being pulled back through a side window, or a window being wound back up, but nothing. Again the Senior Investigator scanning the ebb of traffic, through the rain the sound of horns and the anger of engines over-revved. And in it all a little thing, such a little thing. Piao on his knees in a puddle, watching the water's soft escaping dance.

'The drain's grate has been moved. He is using the sewers. Get a torch.'

Yaobang, pistol in hand, halting the traffic. Heaved breaths, running back to the Liberation Truck. Grabbing the torch and the batteries from under the driver's seat and juggling them as he ran back. Fiddling the cells into the cracked body of the torch, as the Senior Investigator wrenched up the grating with bleeding fingers. Water falling into darkness. An instant reek of dead and expelled things. Feeling a damp wall, then an iron ladder before swinging his legs over, twisting and moving down. The Big Man following, rung after rung, with the torch in his mouth. The yellow beam blinking, cutting out, blinking back to life. Piao moving its beam onto

the rough walkways just above the trough and shadowing the wall, moving past Yaobang.

'This way.'

'How the fuck do you know, Boss?'

'On the walkway wet footprints. No magic. Now keep your voice down. Listen.'

Twenty feet above, the blood flow of the city's carotid artery. Liberation trucks on tarmac, swarms of Forever bicycles, fleets of Friendship taxis, a million hurrying pedestrians. But behind it, scrabbling, scraping against the white traffic noise, feet on stone, in water, running, slipping, falling.

A corner of broken brickwork, rounding it in a sickening skid. Pulling an arm out across the Big Man. Stopping. Their quarry now aware of somebody else in the tunnel. A new urgency. Piao half running and slipping. The Big Man labouring behind him. Thrusting legs through the deeper sluggish tide. Side tunnels feeding the overflowing trough.

Ahead, a man fighting against exhaustion. A dull echo, a fall, a moan. Piao and the Big Man stopping. Ahead, nothing, no sound, except the night city spiralling above them. Then a luminescent glow of light submerged in water. Starting a run towards it, halving the distance, seeing him, directly beneath a rectangular barred grill set deep into damp mortar, spilling distant electric neon hues from the street. Seeing him as his arms moved up. A pistol's dark shadow before a dull

gold flame. Piao pushing the Big Man into the water, diving on top of him. A roar, then a crack of splintered brick. Ears ringing. Another shot. The Senior Investigator, fingers seeking the pistol butt, moving through water to where it met the stinking air. Pistol gripped double-handed, sights aligned, through weeping vision, aiming low, a round loosed off.

Half cough. Half words.

'Did, you get him, Boss?'

'No. But better to light a candle than to curse the darkness.'

Tsung turning, running. Banishing all else from his consciousness, Piao, finger in a gentle squeeze, as his weapon's trainer had said so many years ago, so many holed bodies ago.

Instantly with the recoil, a body punched, spinning, falling. Yaobang already running towards it. Standing above a dark shape, hauling it from the trough, his pistol wedged rudely into the corner of its eye. The PLA, Tsung.

'Look at it, you've ruined my best uniform. Any more shit from you and I'll take your fucking head off.'

Piao, an exhausted whisper into the PLA's other ear.

'I would listen, Comrade Tsung. He means it. He is a proud man, with a keen dress sense.'

'Not a good start, is it? I think that you had better try to impress us. Answer a few questions. That would be a better fucking starting point, wouldn't it?'

'*Wangba dan*, you fat bastard . . .'

Hard against bone, anodized steel. The Senior Investigator pushing the pistol aside, noticing the slow seep of blood from the PLA's lower stomach. A shake of his head.

'Talk to us, Comrade Princeling. But be quick, you need a hospital.'

With each word the PLA wincing with the pain.

'I have nothing to say. Just take me in, I will tell them you brutalized me, manhandled me, attacked me, dragged me into the sewers and then shot me. I will sign a statement saying this and provide witnesses.'

Witnesses. There are always witnesses. A crate of beer to find an old woman who will swear on her labour pains that she is your mother. A carton of cigarettes to purchase an old man who will testify on the grey hairs on his head that he is your long-lost loving father.

'Take me in, I need medical attention. I need to call my Colonel. He'll have me out of your interview room within an hour.'

'I'm afraid that we don't tend to do things quite that way, Comrade. We are what you call unconventional in our approach. Aren't we, Boss?'

'Just take me in. I will answer nothing.'

Piao, a whisper into Tsung's ear. Its quietness, its preciseness, as chilling as a winter in Harbin.

'This is a dangerous place to be, Officer Tsung. A comrade could die in such a place as this.'

'I don't fucking care if I die. If I do, you will follow. My Colonel will make sure.'

Pulling Tsung closer, his breath over the PLA's.

'You do not care if you die, Comrade Princeling?'

A smile.

'Neither do I, so let us do it.'

The Comrade's heart dropping, as an elevator freed from its constraining cables. In the Senior Investigator's eyes, only the edge that real truths have.

'Who ordered the murder of the girls?'

'Fuck off. Take me in. I need attention, medical attention.'

A nod. Yaobang hauling the PLA by his jacket back into the trough. Violently his hand over Tsung's face, pushing him deeply into the sour water. The PLA rising, gasping, coughing.

'Qi. Qi, fucking Qi.'

'Good. Now are getting somewhere, Comrade Cracked Egg.'

Gently wiping the water from the PLA's face.

'The girls, why were they murdered?'

'Fun. Just fun. He likes to watch. Watch us as we fuck them.'

'And he likes to watch you slash them and rape them as they die, yes, Comrade?'

The Big Man's hand upon his face.

'Yes, yes. He likes to watch.'

'But there was another agenda for four of them, was there not, Comrade PLA?'

Shaking his head away from Yaobang's hand.

'Fuck off. Fuck off. Take me in.'

A nod. The Big Man's hand grasping the princeling's neck, forcing the head back, open mouthed gasping for breath, into the black water. Mouth, nostrils, in a deep gagging fill. Bubbles, at first furious, now just in gentle measures of the many seconds. A nod. The PLA's face breaching the surface. Water pouring from the interior of his mouth and nostrils.

'Comrade, there was another agenda. Talk to me, *Tai Zi*. Talk to me of other agendas.'

Gasped, tattered breaths.

'Fathers, their fathers. He wanted something from them. Their fathers. Scientists. Important, something important . . .'

Violent coughs racking his whole body.

'Money, big money, for the benefit of the PLA, he said. The girls, casualties of war, he said.'

Piao, with his cuff, wiping the water and the snot from Tsung's face. And deeply into his ear.

'But Comrade Cracked Egg, the PLA is not at war.'

'This, this is all I know. All I know. Take me, take me in.'

'But I do not think so, Comrade. I think that you know much more. What of the name Citizen One? What of the name Kanatjan Pasechnik?'

A shake of the head.

'Facility-4? Righteous Mountain?'

A shake of the head.

'Please. Please. These names, I don't know them.'

A darker plume moving through black water. The loss of blood from the PLA's stomach increasing.

'Your time, as with your blood, is running out, Comrade Tsung. Talk to me. Persuade me that you know no more. What is Qi after? What is this about? Drugs? The scientists were biologists.'

Shaking his head. Coughing.

'Qi, what was he wanting from the fathers?'

Shaking his head violently. A nod. Yaobang's hand across the PLA's face forcing it deep, deeper into the trough. At first a struggle, but after many tens of seconds it abating into a stillness of dark water disturbed only by the occasional bubble limply seeking its surface. A nod. Tsung's paper-white face rising through the water to its surface.

Kneeling in shit, the Senior Investigator's face against the Cracked Egg's face. Watching Tsung's eyes. Squeezes of unconsciousness. Pinpoint irises, turning in on themselves.

'I need more from you, and you need urgent medical attention, Comrade PLA. A sewer is not a place to die in. Tell me, before I forget where the nearest hospital is. A hospital, *Tai Zi*, more than you gave those who you call casualties of war.'

The warm breath of the words against the PLA's cheek calling him back.

'Be quick, yes, Comrade? Time is a butterfly. Tell me more. Now.'

Coughs. Breaths, torn and pulled in through blue lips.

'Two days . . . two . . .'

'More. I need to know more to stop the killing. For the dead girls, tell me for the sake of the dead girls.'

A slight shake of the head, unconsciousness banished.

'Maglev. Maglev train station, Longyang Road . . .'

His vision blurring, his eyes swimming.

'Around two a.m. Two a.m . . .'

'What will I see, Comrade PLA? What will I see at the Maglev train station?'

Unconsciousness beckoning. Eyes, falling matt.

'Dollars. Millions. And . . . power. Great, great power . . .'

35

The sailor, the look of a man who was constantly regretting his mother's fertility, was easily recognizable. A glass eye, grey-blue, to his natural eye, which was the colour of day-old black coffee. A mesmerizingly schizophrenic effect, making you feel that you were talking to two people at the same time.

'Information?'

Yaobang sitting. The Reeb beer in front of the sailor, as blond-headed as an American movie starlet, making his throat feel band-saw dry.

'I'm not going to screw with that tai zi . . .'

'Qi?'

'That's what they called the bastard. He was the *cadre* in charge. He was the one that gave me the coordinates.'

'Coordinates?'

'Deep water for that area.'

Glass set down. Foam in slow slide. Yaobang beckoning over a sad-eyed waitress. Another Reeb ordered.

'Tell me more, Comrade. To speak is good for the fucking soul.'

'But not good for my health. I'm not going to fuck with that princeling. The look of a man who could hasten a death in the family.'

The Big Man extravagantly reaching into an inside pocket. Purposely, a glimpse of his shoulder holster and a pistol's dark arse. In his hand a fresh harvest of US dollars, letting them fall from his hand and onto the worn Formica table top.

'You look like the kind of man would recognize a good business opportunity, Comrade. You look like the sort of comrade that I can make an offer to that will free his fear of a death in the family. You must understand that I'm making you an offer, Comrade, that must be fucking accepted.'

Calloused fingertips across Abraham Lincoln, Andrew Jackson, Alexander Hamilton.

'Fuck it. I sail at high tide. I'm away for three months . . .'

Draining the glass of Reeb.

'What's one death in a family of hundreds?'

The *Celestial Right* Archaeological Research Vessel, Big and Little Yangshan Islands, Hangzhou Bay, twenty-seven kilometres off Shanghai's southern coast

Piao's head, an internal blackboard. Adding things to his list, changing things, crossing things off. The release of crossing things off. Rising from the bunk and the

comforting discomfort of rough blankets to an iron floor shivering with vibration. In the Big Man's hand a chipped steaming enamel mug of *lucha*. The Senior Investigator refusing it with a limp wave of the hand. Rising, thinking that fresh air would help up on deck.

A sky of rain which was reluctant to fall. A chill breeze and clouds the colour of amalgam. Shivering, sweat across his forehead. Pulling his collar up and sitting on an oil drum, his arms crossed, slumped on rust-blistered rails. Yaobang hauling an oil-stained tarpaulin across the deck, wrapping it around his Boss, Piao nodding his thanks. Looking out to sea across Hangzou Bay, Xiao Yangshan and Da Yangshan Islands, a deeper grey set in grey, biting into the horizon.

A hand on his shoulder. Bone, thinly veiled with liver-spotted skin.

'Not a good sailor, young Piao. Like your dear mother.'

Recognizing the voice. Chieh, Director of the Bureau for the Preservation of Cultural Relics, massaging the Senior Investigator's shoulder.

'I took her sailing on the lake, years ago. So many years ago. As sick as a pregnant sow.'

Laughing.

'Did I ever tell you, Sun Piao, your mother, the most beautiful girl in Songjiang? How I loved her. But it was not to be.'

Piao, his head raised just long enough to expel the words, as few as possible.

'I did not expect you here, Director Chieh.'

'This is my ship, my responsibility. I loan it to you only because I owe you *guan-xi* for favours that you have performed for my bureau.'

'I loaned my bureau's research vessel to you also because of your dear mother's friendship.'

Spreading a handkerchief, then sitting on an oil drum beside the Senior Investigator.

'And because there is little reason to leave my office nowadays. My work, busy, busy, busy. And, of course, there is my secretary, Miss Lau. Old, but good breasts, firm thighs.'

Laughing.

'And there is so much that is new to see, young Piao. You see where the foundations spike? The longest trans-oceanic bridge in the world will be built there, an eight-lane highway spanning these waters. Twelve billion *yuan* creating a 36-kilometre-long bridge, shortening the journey between the two Yangtze River Delta cities by 120 kilometres. Can you imagine?'

Pointing towards Big and Little Yangshan Islands.

'And there, the Yangshan port development. The largest port project under construction in the world. Built to deal with our city's growth rate of 29 per cent a year and to handle the third and fourth generation of cargo ships. It will include a deep-water port, where there will be a fifty-two-berth container terminal. Eighteen billion dollars of investment. Amazing. Amazing . . .'

Shaking his head.

'Progress, progress, progress. As long as we do not lose the values of the past. But that is the reason why I exist, Sun Piao. And you. The past . . .'

His voice lower.

'Tell me, young Piao, I have come here to see the sights, but you?'

Screws reversing. Grey waters blooming with a brown blush. The anchor pinning them firmly to GSP data provided by a sailor for US dollars that would not even buy the comfort of a decent whore for the night.

'Why are you here?'

The Senior Investigator looking up and squinting into the wizened monkey face.

'Like you, the past. To give honour to that past, Director Chieh, and to give honour to those who lost their future to it.'

*

Ritual . . . of rubber, steel. Rites . . . of buckles, dials, pipes

Dive Marshal's keen-eyed patrol. Three divers, pre-dive safety checks. The buoyancy-control device, weights, releases. Compressed air, 232 Bar. Twelve litre tanks at around 25 metres giving around thirty minutes at depth. Air on. Turning the knob all the way, then half a turn back.

Two divers already in the water with a rope attached to a buoy, their forms melting, deeper, bubbles escorting a rope into darkness. Twenty-seven metres, securing

the rope in place. A small crane swung over the side, its steel cable securing a weighted, holed plastic tray containing a live-feed video camera in an underwater housing and arc lighting. Torches, basic tools and rope. The third diver entering the water, one hand to the rope, the other to a fiercely beamed torch, following the tray into darkness.

Piao concentrating on the buoy, on the eruption of bubbles, slowing, slowing. Concentrating until there was a shout from the bridge.

'Live feed's started.'

Grey steel bathed in green radar light. Broken monochrome splinters from the small monitor. Oscillations across faces; noses shunted sideways, mouths twisting, untwisting. A face, mask encased. A hand, thumb extended.

Hongcha laced with *maotai* in chipped enamel mugs as Piao watched the divers' precise ballet. One, in static position, feeding out a rope to a second tethered diver circling around him. Each revolution, a metre fed out in sharp-eyed arc search. The third diver observing, filming. Thirty minutes passing, Piao counting them out. Links in a chain.

Thirty minutes . . . nothing. The monitor fading to black, at its centre, a bright star slowly imploding. Piao, limping badly, the first out of the bridge and to the rails as the divers returned for fresh tanks. The Dive Marshal, rituals re-enacted: replacing tanks, double checking regulators, gauges.

By the time that Piao had made it back across the deck and up the ladder to the bridge, the monitor had sparked back into life. Sitting at the back of the bridge closest to the door, his eyes glued to every movement as the minutes ticked by. Nothing.

Lighting another cigarette, and in its cadmium strike a blur of movement across the monitor.

'They've fucking found something, Boss.'

The third diver moving forward. The video camera their eyes. Shapes, ill-defined ... two divers, rope-tethered. A larger shape looming, beyond that, another. The video camera's zoom lens following the diver's pointing finger. The shape filling the lens and the monitor. Chieh, the Captain and some of the crew moving closer, pulling the detail into focus. Something, the briefest shaving of a second, familiar, but unfamiliar, out of context with the bottom of a sea.

'What was that?'

Chieh's spectacles removed, gaze riveted to the Senior Investigator's eyes. Back to monitor, but the video camera already in swirling freefall. Snatches of stone, flippers, the rippled sea bottom and the diamond diffused sky. A diver's manic sprint for the surface. Other hands already picking up the camera, following his frantic bubbled flight. The Dive Marshal running for the door, shouting.

'Call for a helicopter, we need an immediate transfer. There is a Dayang-class support and rescue ship in the port. It has a decompression chamber.'

Sliding down the steps, followed by crew. Running to the rails; a broil of bubbles breaking to the sea's surface. The diver puncturing the waves like a black leaping dolphin. Life-jacketed bodies in water, hauling him from weightlessness to iron.

The Captain turning to Piao, his breath, still of *hongcha*, *maotai* laced.

'The diver, he came up too quickly. He should know better. His lungs could be ruptured. He'll almost certainly have the bends.'

His gaze diverted across the Senior Investigator's shoulder to the monitor. His irises widening.

'What is this? *Ta ma de*, what the fuck is this?'

Piao already knowing, and not needing to see the eyeless face, the curve of a decomposing cheek, or the black hole of a mouth . . . a fish emerging from its torn lipped darkness.

Turning away, only the sound of the sea against their iron oasis and Yaobang's scorching words on the back of his neck.

'I think we've found what we were fucking looking for, Boss.'

<p style="text-align:center">*</p>

Dark. Just the glow of the distant city, stars banished. And the running lights from distant freighters, coldly blue, tipping over the edge of the East China Sea. The Pacific and the Sea of Japan with a beckoning perfumed finger. So many silver places never to visit.

Only seeing him by the play of cigarette tip's light, at the bow of the *Celestial Right*, black against sea of darkness. Yaobang helping Director Chieh negotiate the deck, the cables, hatchways and tethered cargoes.

'How are you feeling, Boss?'

No answer. Piao, eyes to the lost horizon, counting the deep trenched ride of freighters. Only the Director's bony hand on his shoulder pulling him back to the undulating iron deck.

'Sun Piao, you should have told us.'

'How is the diver?'

The Big Man moving forward, constellations of ships' running lights, eclipsed. Lighting his cigarette from the Senior Investigator's.

'He's all right, Boss. No permanent damage. Nothing that will get in the way of living a normal life. He was lucky. Maybe just a few nightmares.'

'A normal life, whatever that might be.'

'Yes, he was very lucky.'

Director Chieh, moving around to confront him.

'You should have told us what to expect, Sun Piao. You should have explained the situation when you asked for my support. A diver nearly died and we who have witnessed what is on the bottom of Hang-zhou Bay are compromised. You should have been honest with me, Sun Piao. Honesty is the mark of a virtuous man.'

'Do not talk to me of virtuous men, Director, as yet, beside my Deputy, I have met none.'

Piao flicking the cigarette butt into the air over the ship's railing.

'And as a virtuous man yourself, Director, what would you have done? I would have told my story, given my reasons, talked of those who life no longer possesses, of girls slashed to death and abandoned in the Wusongjiang, of girls murdered and entombed in concrete and of comrades crucified, tortured . . .'

Lighting another cigarette.

'And you, Director Chieh, you would have apologized. You would have said how busy you were. Your ship, this ship, out of commission, or involved in a major archaeological research project. Our meeting, it would have been erased from your diary. Files, with my contact details, lost in a very deep cabinet. Your secretary briefed, with a watertight alibi, as to where you were at the time of our supposed meeting.'

Silence. A deep drag on the China brand.

'There is no need for embarrassment in this, Director. I, more than anyone, know the game and know how it is to be played. It is a game that we all know and play in this People's Republic of ours.'

A hand on the old man's shoulder.

'You are a good man, Director Chieh. A good man and a good comrade. But sometimes the two do not go together well. To my personal cost, I know this also to be a truth.'

'You are right, very right. I am sorry, Sun Piao. We should think of those who life no longer possess. What

have we come to? A shadow, and we stay at home peeking out of the corner of our curtains. A stranger looking at us, and we come back to our office and shred documents. What do we do now?'

Silence. Just the night. Just the sea. No shadows. No strangers.

'We will play the game that we all play, Director. And we will play it well. Your crew, your divers, they were never here. You will support them in developing solid alibis. You will change all the paperwork relating to this voyage. You have a long arm, Director Chieh. *Guan-xi* will buy the harbour master's memory. *Guan-xi* will erase the details that relate to the diver's transport to the decompression unit and his brief stay in hospital.'

Piao standing and walking to the rails. The ship's life flowing in vibration up his legs and centring in his chest.

'The only copy of the video film that was taken after the diver panicked you will give it to me. The Global Satellite Positioning data of the bodies in the concrete you will also give to me.'

Chieh, following the Senior Investigator, their eyes staring out to the sea and the sky, where they met in an invisible weld.

'You are a magnet that attracts what all other magnets would repel, Sun Piao, but I will support you in any other way that I can. But tell me, what will you do with this information that is as a bullet in a pistol's chamber aimed at you?'

Intense pain, achingly hot, firing the sutured wound to his calf. A reminder of life and the living of it, and with it, proof that he still craved its continuance, when at other times he had not.

'"If you have never done anything evil, you should not be worrying about devils coming to knock on your door".'

Refusing to place a hand on the ache in his calf, celebrating its torment.

'I will knock on their secret doors, Director. And on the doors of those who sponsor them and see how they greet that knock.'

36

*The smell of mooncakes. The smell of night.
The smell of nightmares queuing*

Sitting on the pier. The taste of tea, crow black, and
Azuki bean-filling over his tongue. Still night, but a pale
lemon rip at the base of the sky, as if the spiked horizon
were slowly being gilded.

'He looked like a ghost, poor bastard. Never thought
I'd be fucking sorry for the Wizard, Boss.'

A silence as long as the night. Just the water's
sluggish lap against pitted stone and wooden pier posts
that had no memory of the forests that they had been
born to.

'You asked him?'

'Sure, Boss. Barely conscious, but I asked him all the
same. Made a sort of "no" grunt to each question.'

'Anything from Qi's time in England? Data from his
time at university there? Officer training school? No.
His general life there? Women in his life?'

The Senior Investigator looking away.

'Fuck all, Boss. There is nothing else. We have
everything that the Wizard could get before, before . . .

We have enough to try and stitch together. But nothing makes any sense in this case.'

The Big Man unzipping his trousers and pissing into the river.

'I've got to get some sleep, Boss. Every night its getting more like trying to catch a flea with a knotted rope.'

Rezipping his flies. Walking to the door. A warmth of ovens and the smell of sweat and baking.

'Shit, nearly forgot . . .'

A thick sheath of papers from his inside pocket. Handing them to Piao.

'Got the telephone records that you wanted. Qi's mobile and his prefix 39 number. And Boss, do yourself a favour and don't ask what they fucking cost.'

<p style="text-align:center">*</p>

Under the light of a torch's amber beam, Piao reading. Reading until his eyes burnt with lack of sleep, his head racing to dates, numbers, names, call durations. Qi's prefix 39 number, well used, but carefully used. Nothing that snagged or drew recognition. Calls to and from his garrison and from his father, the Senior Colonel, his comrade officers, an aunt in Beijing and a cousin in Shenyang. Calls to and from his specialist at the People's Number 1 Hospital.

Mosaic of data over data. Qi's mobile telephone records. So many pages of calls, at one point Piao toying with them, and himself; poking them through the gap

between the pier's timbers. A dare in his head. Let them fall ... let them drift on the night tide, through the Yellow Sea, to the East China Sea, to Taiwan. Let Taiwan have them.

Walking back into the bakery. His room, a corner of a storage space, his unrolled sleeping bag, bordered by boxes. His life now contained in corrugated cardboard. Without wanting it, at least consciously, her photo still dust covered, in his hand. Why include it in the elements that now made up the time span that was called his life? A finger across sable-fanned hair and the soft curve of cheek bone. Dust grey, into colour. Shaking his head ... the very worst bits to be left with, the confusion. Wondering if it had ever happened at all. A life, a wife, a marriage.

Shaking his head again, and moving back to the mosaic of papers. Page by page, reading them. If nothing else, at least he was a comrade of habit. Blunt pencil to tongue and to the paper underlining and circling. Over and over again, the same destinations, numbers, names. All of the names, to Piao's eyes, reading as Arabic. And amongst them, distinguished by difference and indenting every page, the Russian name, Kanatjan Pasechnik.

37

Little brother, where are your little hands?
My hands are here.
They can grasp guns.
They can fire.
Pow. Pow. Pow.

<div align="right">Chinese nursery song</div>

The People's Liberation Army, the world's largest armed force. Two million troops. At times of crisis, a further 1.5 million from the reserve militia. Another 1 million from the PAP, the People's Armed Police. These consist of combat, combat support and combat support service units. Over 70 brigades, 100 independent regiments, 11 armoured units, 10 mechanized infantry divisions and 7 regiment-level special force units.

<div align="center">*</div>

In 1999 the World Bank made a loan of $200 million to the People's Republic of China. It was granted to support the Chinese government's continuing reforms. The Chinese government, through its State Planning Commission, used the Golden China Corporation as its

financial agent to disperse the World Bank's funds. However, the Golden China Corporation is owned and operated by the People's Liberation Army.

Money granted for 'continuing reforms' going towards weapons.

$5 million given to the Northwest Institute for Nonferrous Metal research. Part of the China National Nuclear Corporation, providing the Chinese Army with its nuclear weapons.

$5 million given to the Harbin Research Unit. A PLA front used to purchase turbo-fan engines for the People's Liberation Army Air Force.

$4 million to the Nanjing Radio Factory. Owned by the PLA, and providing satellite equipment and secure military radios.

$4 million to the Marine Design and Research Institute of China. A PLA primary design facility for all Chinese warships, including nuclear-powered submarines.

$3 million to Xi'an Jiatong University. A major PLA research centre, with shared facilities with a PLA chemical and biological weapons unit.

$5.5 million to the China Textile Company. A front, known to be used as a money making venture by the PLA generals.

38

A private room, courtesy of *guan-xi*. The Wizard untethered from his tubes, his mouth unjacked and a colour in his face and an anger in his eyes. Watching the Senior Investigator, his Deputy, on their knees, checking for electronic listening devices underneath the bed, behind the electrical points. On tiptoes, in clumsy pirouettes, checking in lighting roses, behind curtain pelmets. A nod. A thumbs up.

Watching as the various elements of the computer system were brought into the room on trolleys. A sheet of paper in the Big Man's hand; complex biroed drawings. Seeming so easy. Foolproof. But now with the reality of myriad wires and orifices to plug them into, the sense of powerlessness that only the computer can engender. For thirty minutes going through the motions. Only when helplessly lost, throwing arms into the air, cables onto the floor, the nurse, with stouter legs than the others, summoning help. A doctor rewiring the main's plug. An anaesthetist plugging the printer to port and the monitor to connector. A senior consultant switching the system on and rebooting. Hospital staff ushered out of the room. Curtains closed with a

swish. Piao, CD taken proudly from pocket and inserted into the drive.

Click. Click. FILE TWENTY.

The soft, exposed underbelly of Comrade Qi's computer spread out like a filleted carp. Columns in coded runs. Characters, figures, in chained links. Piao's finger in dust strokes and points to the monitor screen. Rentang, in nods, shakes of the head to questions. All against a soundtrack of air passing through a tongueless mouth.

'Dates. Monies in?'

A nod.

'This figure, *yuan*?'

A shake.

'Dollars?'

A nod. A long, low whistle from the Big Man. Whatever they were selling, the PLA was making big, big, dollars.

'This short-hand, I do not understand it.'

A pen clutched weakly in the Wizard's spider fingers, walking slowly over the paper. His voice, black ink.

Bars ... profits ... kickbacks.

Characters forming abbreviations. Seeing them now. Finger chasing down column after column.

SMC: Shanghai Moon Club.

DC: Dedo Club.

TFGB: Tom's Famous Grouse Bar.

FPC: Famous People Club.

Bars. Karaoke clubs. So many dollars.

At the end of every month, figures totalled, large numbers. Dollars, by the million. Beside the total, another figure, a far smaller figure. Tapping the screen with his finger.

'This is incomings? Prostitution, extortion, profits from PLA-owned establishments . . .'

A nod.

'This figure. Same day, same time every month. Money couriered to a central point.'

Citizen One.

'Show me the balances for the next six months.'

Scrolling through the pages, month after month, checking the gridlocked intersection of totalled digits. Every month a major discrepancy between income and what Qi was couriering out. A discrepancy of hundreds of thousands of dollars. Yaobang shaking his head.

'He's fucking skimming, the stupid bastard. Swindling the PLA. He must have a death wish.'

'Not if nobody knows.'

Not noticing the Wizard's spider scrawl onto paper, until the cough raked him. Yaobang, with a tissue, wiping away Rentang's spittle. Piao taking the paper from his limp hand, slowly turning it around.

Citizen One. Mao . . . Long March.

'There is a link between these. What link?'

Turning back the paper.

PLA.

'I do not understand.'

Money man. Mao's.

Pen dropping as Rentang was pinned back in the bed in a fit of exhaustion. Breaths through the black tunnel of his mouth in stuttered rasps.

Slowly scrolling through pages before stopping. A different look. A different form of coding to the pages of the file. Figures with more zeroes. The Big Man whistling long and low.

'What is this, Boss? This isn't prostitution or extortion. Look at the figures. Fucking millions. Only drugs can generate dollars like this.'

A phlegmy, hacking cough, blood in a fine mist. But Rentang flapping his hand for a pen, demanding a pen.

Focus ... first, second column. Abbreviations. Initials.

Piao's finger tracing across columns one and two. Hard-edged characters bordering figures by the million. Hard-edged characters in a form of abbreviations.

'The lists that I asked for – political committees, unions – you have them?'

'Sure, Boss. Three trayfuls of them in the back of the Liberation truck.'

Watching the Senior Investigator's eyes.

'Fuck me, Boss. We're not going to go through that lot, are we?'

The Wizard, with great effort, sitting higher in the bed, frenzied hand over paper.

Yes.

'There's too much fucking data, Boss. I can't see that

it would be worth it. You're sure we should go through it all?'

Writing fast, so fast, the Wizard. The same word repeated. But then, like a tree felled by a single blow, falling back onto the bed. His eyes bulging. Blood, in a generous rivulet down chin and onto bed linen in an angry budding. The Big Man's hand already finding the alarm button, as the Senior Investigator cradled the Wizard in his arms. Yaobang running to the door, bellowing down the corridor. Distant, echoing, the sound of feet not used to running. A doctor and two nurses. An instantaneous diagnosis. Rolling Rentang onto his side and into the recovery position. The Big Man catching his spectacles as they started to fall towards the floor.

'He's haemorrhaging.'

Drips reinserted. A wad of gauze damming the river. The doctor, seventy hours a week under strip lighting, his face as pale as the bed linen answering the question in the Big Man's eyes.

'It is serious. I have to get him to the operating table,' as he ran pushing the trolley from the room. Nurses either side, drips held high as paper lanterns at New Year. Disappearing down the corridor in degrees of lightness and shadow, and a rattle of chromium-plated steel.

Only when steel's urgent song had passed, the Senior Investigator taking the paper in hands stained by the Wizard's blood. The same word repeated.

Yes . . . yes . . . yes . . . yes.

Looking into the Big Man's eyes.

'He is telling us with his blood. We check every line of data that we have.'

39

The list of contacts in the shaky hand of Director Chieh had been long; esteemed names thrown as leaves into the wind in the hope that one would fall on its back.

Twenty-three telephone calls later, twenty-three identical conversations before the right leaf, amongst so many others, was found . . .

The new Shanghai Museum, Henannanlu

Opposite City Hall, a layered sprawl, consisting of five vast circular discs sheathed in pink marble imported from Spain, set on top of a rectangular block. From the roof, four handle arches, reminiscent of an ancient Chinese bronze; the reference underlined by the large glyph above the rounded wall of the main entrance.

But when asked to describe the building, the only image to come to mind would be that of a wedding cake. A vast, multi-tiered, pink, 70 million dollar wedding cake.

The Director was not a man who lived up to the splendour of the Shanghai Museum's marble-paved

central atrium, surrounded by its fourteen carpeted galleries. A maze of bronzes, ceramics, paintings, calligraphies, coins, jades, statues, lacquers and seals. A pasty-suited comrade, the Director, who was surely still suckling on the breast, and whose face you would have difficulty in remembering within two minutes of leaving him.

'Citizen One . . .'

Three galleries passed through, and these the only words exchanged after the formal introductions.

'We have 120,000 objects at present in the museum, Senior Investigator. There is just one that has a reference to such a name.'

A busy man, hard to keep up with his pace. Following him through gallery after gallery. Entering through a nondescript door, behind the marble cladding and rich timbered walls, a web of beige, scuffed corridors leading into more beige, scuffed corridors. At the very soul of the building, vast storage rooms with huge packing cases. Behind mesh wire, mummy-wrapped bronzes, statues, multi-storey cabinets of porcelain, and the smells that only the millennia old possess, of lives by the generations, fallen to ground, of armies of people come and gone, little known, or forgotten.

Beside a huge metal wall, the Director stopped. The pasty man searching for one key amongst fifty on a huge chain. Piao taking time to study one of the vases in the display cabinet, fifth century BC. On its exterior a representation of slaves given as a gift to Li

Wang, the King of the Western Zhou. An inscription written boldly on its exterior, celebrating the gift of 1,726 lives.

Into his ear a whisper that anyone within fifty feet would have clearly heard.

'History, it's just one thing after another, Boss, but nothing changes. Nothing ever changes.'

Finally, a key into a lock, then the sound of steel sliding on steel runners. Air in a faint huff. A vast floor to ceiling drawer extending. Its interior cotton hung. The Director gathering the white festoons and dramatically pulling the sheer curtain aside. Slowly a vast oil painted canvas spreading into view, which was at least twenty-five feet long and fifteen feet high. Eclipsing them in shadow, the heroes of the Long March, depicted in epic Soviet style. 16th October 1934, 100,000 men of the Red Army, auxiliary groups, and those most closely involved with the Revolutionary Council, embarking on a journey of 6,000 miles. At their front, the Great Helmsman, Mao Zedong. Red Banners enveloping him. Eyes star-bright. Set upon his face the smile of a known triumph to come.

'Fuck me, Boss. It's big.'

The Director, dwarfed by the giants of the revolution.

'Yes, Deputy, it is big. Too big to warrant us displaying it.'

Staring up into the face of a ten-foot-tall Mao Zedong.

'It was painted some years after the Long March, as you can see in epic proportions.'

The Senior Investigator moving back almost to the far wall, to get a better view.

> *From the Red East rises the sun,*
> *There appears a Mao Zedong.*

'Citizen One?'

'It's got to be the Great Helmsman, Boss. Who else?'

The Big Man striding from left of the tableau, past Mao, to the far right, pointing at a soldier with a rifle hung from his shoulder. His hand, huge and rough, and at its calloused heart, the pale hand of a child.

'The soldier?'

'No, not the soldier, the child. Citizen One is the child, Director?'

A nod. Piao stood within two feet of the oil painting's surface. A child's soft face filling his sight. Oil paint eyes brimming with the promise of years of progress and advancement. Three score and ten, in Mao's promised land.

'Comrade Director, what is the story here?'

Already walking to a telephone. An extension number dialled. In a distant office, ringing.

'I do not know, Senior Investigator. But I know a comrade that does.'

★

Miss Lai crossed her shapely legs and sipped the *xun-huacha* with over rouged lips. She did not make a movement that the Big Man did not dwell upon. The only question in his thoughts: stockings or tights?

'I completed a thesis for my degree at Beijing on the evolution of the People's Liberation Army. That is the only reason that I have knowledge of Citizen One. But I am afraid that this knowledge is limited.'

'And your thesis, Miss Lai, how was it received?'

She smiled with lips that should be kissed.

'Top of my year, Senior Investigator.'

'Of course. I would have expected no less. What a wonderful thing education is.'

Yaobang leaning across the table, pouring more tea. Her perfume and the *xunhuacha* reminding him of every girl that he had failed to tempt to go out with him.

'So tell us, who is this Citizen One?'

She smiled, a shred of rose petal across her front teeth, but he could forgive her even that.

'The child's name is unknown. He was three years old at the time of the Long March. His parents had been Party activists, but murdered by Kuomintang Nationalists. He had survived alone, beside their bodies, for many days. Mao himself was taken by the child's resilience and bravery. He took an interest in the boy and named him Citizen One.'

Stirring the tea.

'That became his name and all that he was ever known by. The child was practically raised by the Red Army. They were his parents, his playmates, his educators. He was a bright child, a bright young man. They even paid for him to be educated abroad, the Sorbonne. He was one of the very first, the original *tai zi*.'

Recrossing her legs. Blush of pink, in slow fade, caressed by the Big Man's smile.

'But always a Party faithful who was strong in doctrine, pure in principle and true to the Great Helmsman's ideals. He rose through the ranks, with Mao's sponsorship, influencing thought and policy. Very creative, especially in the field of economics. Highly entrepreneurial, he became the architect of the PLA's financial structure. They called him Mao's banker. In the 1980s, when he would have been in his sixties, his role changed. It is not known exactly what to, but it would seem that he became effectively their accountant.'

'Accountant?'

'Of course. Even the PLA needs an accountant. An economic guiding light. They were under-funded by government, year after year. They were unable to update with the latest technology and weaponry and were constantly losing ground to the west. Morale was low: a dangerous situation amongst so many egos with tanks parked in their garages. Economists in Hong Kong have estimated that, in 1993 for instance, Citizen One added some $27 billion to the PLA budget of $57 billion. A massive achievement by any standards.'

More tea, with Yaobang pouring. His eyes unable to leave the print of her lipstick on the iced white of the china.

'It was also in the 1980s that Citizen One disappeared from view. He had always been extremely reclusive. So reclusive that not one photograph of him exists.'

'Perhaps he retired?'

'No, a *tong zhi* such as this would not retire. A *tong zhi* such as this would have to have his fingers prised and broken on his death bed before he would give up the reins of power.'

Piao walking to the window. Views to Huangpu Park. The sun caught in razor wire branches.

'He did not retire. He is still active, is he not?'

'But he'd be in his seventies, Boss.'

'So are most of our Politburo members.'

To the girl.

'Veteran revolutionaries only end up as monsters and ghosts. He is still active.'

'Yes, Senior Investigator. Citizen One is still active. He is still the PLA's accountant, heading a team of hundreds. But he is very "hands-on", active on the big projects and the entrepreneurial schemes. But also one who would still get his hands dirty. One who would still want to be involved in the small print.'

'Where is this Citizen One to be found? Beijing? At the Guard Army Garrison Headquarters?'

She smiled the smile of secret knowledge, the power and confidence that it brings.

'When I was researching for my thesis, I talked to an economist friend in Korea. He had visited a hotel here in Shanghai. A conference on fraud intelligence. He briefly saw a man during one session, sitting at the very back of the conference hall. An elderly *tong zhi*. To this day he is certain that it was Citizen One.'

Her tongue across her lips. Across rose petals.

'He talked to some of the hotel staff. It appears that this *tong zhi* was a permanent resident in the hotel's penthouse. He had been living there since the 1980s.'

'He was reclusive. There is not a single photograph of him that exists. This you said yourself. So how can your economist have known him?'

'Difficult years the fifties, sixties, seventies. Purges, political upheavals, rivalries, the unity of the Long March unravelled. The trauma of the Gang of Four. But those at the Party top table had recognized that there would be difficult times ahead. They had also recognized their trusted protégé's talents. They wanted him protected.'

Miss Lai joined the Senior Investigator at the window, the Big Man following her legs. Stockings, yes, he was sure she was wearing stockings.

'When he was fifteen years old he was taken to a whore, his first, and a tattooist in the old French Concession, the first of many through the years. On Mao's direct order his right arm was tattooed from his shoulder to his hand . . .'

She anticipated the question.

'A pledge given by the Red Army, by Mao himself,

and containing the characters of his own name, that Citizen One on pain of death, should never be harmed. He was offered protection for the entire span of his natural life, with that promise tattooed onto his very skin.'

Pausing briefly for added effect.

'The man at the back of the conference hall, he had a tattoo on his hand, extending beyond his cuff and up his arm. My economist friend saw it.'

'The hotel, Miss Lai, where Citizen One controls his empire from, it's name?'

'I trust that you do not wish him any harm. Not that you could do anything, he is guarded around the clock.'

'The name of the hotel please, Miss Lai.'

'The hotel, it is the Heping, Senior Investigator. The Hotel of Peace.'

40

Exhaustion like steel shutters across his eyes. Only a brace of warm Tsingtaos and China Brand after China Brand, holding sleep at bay.

FILE TWENTY. Fingers down the columns, characters, forming abbreviations. Names, organiztions, committees? Hunting a grain of rice in a barn of wheat without success.

'Fuck this, Boss. It's hopeless. Let's call it a day.'

Just Piao's sideways glance enough.

'OK, Boss. Perhaps not.'

Turning pages and more pages before moving to the banks of official directories. The dizzy, misted heights of *cadre* rankings below Grade Ten. All with their own offices, a padded velour office chair and with windows overlooking the city. And a secretary, always young with large breasts and available for such a highly graded *cadre*.

Toppling the pile with his palm, taking a sad joy in watching pages slip over pages and *cadre* falling to a bare timber floor.

FILE TWENTY. Once more immersed in the code of abbreviations and trailing zeroes, but still the key missing. Suddenly a snag of recognition.

'I need data focusing on Party structure, committees, ministries, also the directories on foreign legations, foreign governments.'

'Still in the truck, Boss. Why, you got something?'

Stumbling back through the bakery.

Easing the large tomes to floor beside Piao. Column one, his fingernail underlining a run of characters: DPRK. The Democratic People's Republic of North Korea. A directory, under twenty more. Government structure. Ministries. Party and government committees. Foreign legations, embassy structures, personnel. Column two: YHS. Under the heading Supreme People's Assembly, a sub-heading, Standing Committee. Under that, a name, YHS: Chairman, Yang Hysong-Sop. In the third column a sum of ten million US dollars, donated by Comrade Hysong-Sop, in the name of the DPRK. Ten million dollars into the *tai zi*'s account.

Three lines down, T-RK. Taiwan – Republic of China. Piao hunting through the wall of directories. A hard covered folder embossed with a busy flag and snagging characters. Piao's finger travelling along, ministry by ministry. Stopping at the Ministry of Foreign Affairs, under the Vice Minister's name. OH: Ouyang Hwang. Eyes back to third column. Another ten million US dollars.

The process repeated. RPS, the Republic of South Korea. *CKM:* Cho Ki-Moon. A high ranking *cadre* from the Ministry of State Security. Recognizing more abbreviations. V, Vietnam. S, Singapore. Recognizing more initials. THD, Trinh Hong Duong. SR, Ser Retnam.

High *cadre*, each entry beside them carrying a ten-million-dollar price ticket.

The Big Man grinning.

'Told you, Boss. Fucking drugs. An international auction.'

Pages turning.

'No, not an auction, dollars for something else and none of it going to the PLA.'

Pages turning.

A page hidden in pages. Beside the regular payments couriered to Citizen One, irregular payments to the Russian, Kanatjan Pasechnik. Below this a series of characters whittled into more abbreviations. Yaobang shrugging his shoulders; just letters, with no hook of recognition.

The Senior Investigator, eyes caught by the abbreviations, GSCS, on the final page of the printout. Feeling his pulse rate rise. A sheen of sweat push through the pores of his forehead.

'GSCS, what country is that, Boss?'

'It is the country of our birth. GSCS stands for the General Secretary of the Central Secretariat.'

'Fuck, and ST, Boss?'

'Su-Tu. Comrade General Secretary Su-Tu. The top of the pyramid.'

*

'How are you, Wizard?'

No move to grasp his pen or to establish eye contact.

'How are you, really?'

Shy fish eyes behind aquarium lenses ... a glance. Fingers toying with the pen. Finally, picking it up. Finally, words onto paper.

They've taken my voice. Who I am. They've killed me with silence.

Piao, a hand carefully raising the lowered chin.

'I am sorry.'

Tears, in complete silence. Piao holding the Wizard to his chest. And then the noise, a cry from the stomach, from the throat, a tongueless cry that filled the room with its distress, resonating through the Senior Investigator. A raw, primal sound, so shocking in its honesty.

Piao nodding, the Big Man knowing. Leaving the room, pacing the corridor beyond the steel-wire-reinforced glass and admiring the nurse's legs. How he loved sturdy legs.

The Senior Investigator drying Rentang's face and his spectacles. Holding the tissue to the Wizard's nose. Blowing. Falling back onto the stained pillow. His face, misery and fear. Waiting for words, Piao's words. A sense of them tucked under his tongue, ready. But the Senior Investigator raising a finger to his lips. With his other hand, fast words written onto white paper.

A day is a lifetime in our People's Republic.

Kneeling, exploring the area under the bed, the same areas that he had searched just twenty-four hours earlier. The power sockets, behind the cupboards. On his tiptoes, exploring the light fitting. Behind a picture

frame. Some seconds, his hand obscured by canvas and roughly traded brush strokes. Coarse trees reaching up to an impossibly blue sky. When he withdrew his hand, it came with fingers pinched around brightly coloured wires and a minute circuit board. The paraphernalia that makes up a UHF transmitter: a bug.

Slow, deliberately written words. As Rentang read them, hearing the Senior Investigator's tone within each character . . . as he was meant to.

Perhaps, in the People's Republic, Wizard, it is better not to have a tongue.

The second note already sitting beside the first.

Those who have taken your voice . . . it is now time to kill them with the loudness that words have.

The Wizard, fingers eager to take possession of the pen. Of words, of vengeful actions.

How?

It was a long note that Piao wrote. A long series of notes. A death. An assassination. Surely such sentences deserve long notes? Rentang smiling, his mouth a dark cave of silence.

When?

Written fast. Eagerness driving Piao's fingers.

When you hear from me. If you do not hear from me, exactly sixty days from now.

From a tongueless mouth, a smile. From pen, words. Will it work?

For the first time his eyes averted, the Senior Investigator. Pen over paper, slower. More uncertain.

I know how they think. I can live in their heads.

And if it doesn't work?

Sometimes a few trees survive the most destructive of hurricanes, and live long enough to bear blossom and fruit.

Eyes rising. A nod, followed by another nod, hand shaking hand.

The Senior Investigator gathering up the pieces of paper and putting them into an ashtray. The flare of a match. Paper curling, burning. Grinding the ashes to powder just to be safe.

*

Two hours, the gathering of virtual documents into virtual files. Stills, monochrome, grey frayed-edged. Images of loosely knit reticulation. Video, starts and stutters. File after file. Data, as black-garbed troops gathered, awaiting the order.

Into the Senior Investigator's palm, a CD-Rom, still warm from the laser's invisible etch.

Only as Piao was leaving did the Wizard reach for the pack of freshly printed papers wedged between the bedside cupboard and the discoloured wall. Fanning the pages of the report with his fingers . . . their breeze of laser printed ink seeming to revive him. A report of precise, trenched characters. Handing it to the Senior Investigator. And to accompany the note he was writing, silent mouthings in unison with the pen's scratch.

This, the front of FILE TWENTY. The only section

on his hard drive that was password protected. Important. Yes?

One glance enough to recognize the slashed and boxed characters that made up the names of the authors of the report. Each a scientist, a biologist . . . each with a daughter whom life no longer possessed.

Smiling, the Wizard, as he watched the Senior Investigator read the words that his pen could form, but that his mouth could not.

I know, was Mao a communist?

41

The Maglev train station, Longyang Road

2.45 a.m.

'There. There, Boss.'

Pointing through the back of the mirror glass to a pale man standing on the platform amongst the commuters. Unmistakably him, the father of a dead girl. The scientist who they had watched bury her.

Over an announcer's clipped phrases and the onrush of air smelling of burnt electricity, the Senior Investigator's words.

'No dead heroes, yes?'

The Big Man buckling his shoulder holster. A nod as they walked out onto the central platform, moving through the commuters. Air, noise, building with every footstep. Litter dancing skyward, falling back to the platform as the Maglev train slowed, coming to a gentle halt. The scientist moving forward. The Maglev train's doors opening, but the scientist just standing there, arms by his sides as people moved to and fro. An announcement over the crisp PA system, and only just

before the Maglev train's doors closed, a last body breaching the gap to the platform. His shadow cast over the scientist. Smoothing down his expensive jacket, the PLA Officer Huan, the hard-boiled egg compared to Tsung, the egg with the crack.

The Maglev train visibly rising higher on its magnetic cushion, before accelerating swiftly through the platform and into the night. And with it, the Senior Investigator moving forward, the Big Man flanking him. A fraction of a second of recognition, the *tai zi*'s hand snatching something from the scientists and running. Commuters barged violently aside as he raced back down the platform to where the tracks entered the station through rectangular concrete portholes. A scream from a knot of tourists as Yaobang raising his pistol, double handed. The sprinting PLA in the Big Man's sights, but Piao pushing his Deputy's pistol down.

'Not in here, there are too many people and there is nowhere that the princeling can go. He's trapped.'

Passing the pale scientist, his hands extended as if ready to embrace arrest.

'I . . . I am sorry . . .'

A nod from the Senior Investigator.

'Go home, father. Go home to your wife and to the memories of your daughter.'

A few seconds' hesitation before he moved, with the wave of commuters, down the platform and into the neon-lit night. Not once looking back.

Ahead, the *tai zi* moving from platform to the tunnel

and out onto the single track, braced by columns thirty feet above street level. His speed slowing, to a half-running, half-balancing scurry. Yaobang following him out onto the track, but the Senior Investigator's arm across his chest, stopping him.

'A train's coming. He will have to come back.'

Backtracking, Piao and the Big Man, into the fluorescent sanctuary of the station. Watching as the PLA, Huan, continued to negotiate the single concrete track oblivious of the Maglev train bearing down on him. Only as the track started its fine oscillating hum, transmitted to his calves and knees, did he look up; his shadow thrown against the station's superstructure in blue-yellow transfixing beam. A siren from the Maglev train cutting through the night. Panic in the PLA's stride as he glanced over his shoulder back to the station, judging the distance. Too far, too late. Shielding his eyes from the arc headlights of the Maglev train as fear reached deeply inside of him, seizing him in its icy talons. Another blast from the rapidly advancing train as the PLA reached a narrow rat run beside the track. Panicking as the Maglev train, its track in thunderous tremble, bore down upon him. Clambering over the waist-high balustrade as the train shot past; slicing through the air. Fingers wrenched from steel, his grip lost, leaving him scrabbling for purchase, a handhold to anything solid. But already falling.

*

Although after three in the morning, a small group had surrounded the broken figure of the PLA, each wondering how such a large amount of blood could ever have been contained within such a compact body. It was not necessary to feel for a pulse. Such an injury to the head communicated to the Senior Investigator that life no longer resided within the PLA.

'He's got an important father, this *tai zi*, with fucking important friends. More shadows to avoid.'

A nod, affirming a truth.

'When the ambulance arrives, go with it, direct it to the First People's Hospital. We have a doctor there who owes us a favour. They have a small refrigerated unit in the basement that they used to use for their own dead before the new mortuary opened. They rarely use it now. A body could be "lost" for days. Weeks. It will buy us time.'

'If the doctor allows it, Boss.'

'Use all of your considerable persuasive charms on him. If that does not work ask him if he would like a tour of Virtue Forest. That normally has the desired effect.'

'Hope it's all worth it, Boss.'

Piao knelt beside the princeling, carefully unwrapping torn fingers from what lay at the heart of the PLA's palm. A small plastic container, the Senior Investigator wiping the blood from it, holding it up to the streetlight and rolling the contents of it around and around, before

pulling out the stopper and pouring the seeding onto his palm.

'It is from the plains around Lake Dongting and Lake Poyang. Facility-4. Righteous Mountain. Where the girls' scientist fathers worked.'

'Told you, Boss, cannabis seed.'

'It is what was for sale in file twenty. What Vietnam, Korea, Taiwan, were all wanting to purchase.'

A seeding worth more US dollars than could fill the back of the cousin's Liberation truck. The Senior Investigator's nose to hand, smelling the seeds. No drugs these, just the smell that every village in the People's Republic would know with backbreaking certainty.

'It is not drugs.'

'Then what is it, Boss?'

'Oryza sativa, that is what this harvest is called.'

Carefully pouring the seeds back into the container. And remembering a question . . .

'What will I see at the Maglev train station, *Tai Zi*?'

Sealing the container, with its stopper, and remembering the answer.

'Dollars. Millions. And . . . power. Great, great power . . .'

Stepping fully into the light.

'So what is this stuff, Boss?'

Placing the container into his pocket.

'Oryza sativa is rice. The scientists' daughters were murdered for unmilled rice seed.'

42

The sun is in the east,
and that lovely girl is in my chamber.
She is in my chamber.
She treads in my footstep,
and comes to me.

The ode 'Dong Fang Zhi Ri', from
the Shijing *The Book of Songs*

'Not a good idea, Boss. You know that. It was arranged so neither of us would know. Security. Fucking security.'

'I need to see her.'

'Why?'

'I have a bad feeling about the future.'

'A bad feeling? How bad, Boss?'

No words. Just his eyes, beachball blue. But something gnawing, at depth.

'That bad, eh? OK, Boss. Bad feelings are to be trusted. I'll arrange a fucking meeting.'

★

The street market, Jiankanglu, Nanking

Early, forty-five minutes to whittle away. Walking in the 'Capital of Heaven', in the lands where 'the owl and the phoenix do not sing together'. Inside the Ming Gate, Lake Xuanwu's willow-shaded banks with views to the Changjiang, the Yangtze, the Blue River, with its slumbering meander under the Great Bridge.

'Thirty minutes, Boss. No more. It will be in a public place, a street market. Safe. Don't fucking worry, I'll make sure no one is trailing us. There are many stalls in Jiankanglu selling local fabrics. The last sells silks, thousands of them. She will be at the rear of the stall, you at the front. Silks between you. You will not see each other. But you will hear each other's words. If you see her, and she sees you, then someone else could see the both of you together. We can't take the risk.'

Entering the market and its chequerboard pattern of stalls, with pottery, as glazed red as hot coals, brushwork paintings of bold black slash washing into grey-blue, calligraphy, with the words of Confucius, brushing against the lyrics of the Beatles, cages of chickens, canaries and runt pigs, calling out their lives and their deaths. And at the very heart of Jiankanglu, a dog squashed dead in the centre of the road, caught in a sideways chase and run; still in its eye, the darting cats leer. At the very far frayed edge of the market, the silk stall. Tumbles of kite tails living out the breeze's life, as it sighed across the river and over the canaries' bones of rust.

Each heartbeat of wind, carrying a fish's soul on its humped back.

Just standing there, the soft embrace and flick of the billowing silks across his face, hair. Their gentle rasp against his stubble. And then her voice.

'I am here.'

Breeze through gossamer weaves, stealing his words.

'I am here.'

So close to him. Able to smell the lemon and almond oil that she had used on her hair. Her hand across silk. His hand meeting its span. Each finger met in equal caress. Her heat against his. His against hers. At that instant the universe in balance, perfect and just.

'It is how it should be . . .'

'Yes. It is how it should be.'

His fingers travelling down her fingers. Encircling her wrist in a turquoise bangle, as the sea embraces the island. Feeling her life, her pulse. Her past, present, but only the ancestors able to know her future. Pulling her closer to him and him to her. Vague glimpses through lavender, corn yellow, ruby. Her eyes, vermilion softened. Lips, cadmium kissed.

'I needed to see you. To tell you. I have an uneasy feeling about the future. I have no one else in my life, not any more. No one else to tell who will listen. Just you . . .'

Pulling her closer, into the breeze's soft ballet.

'Just you. I feel a link between us . . .'

Falling into her, body and soul. Lips meeting, tasting her, and the famine fed.

'I know . . .'

Her fingers running down the insides of his. Soft wing flutters matching his heartbeat. And with it a knowing; but not daring to name it.

'*Ni-ai* . . . *ni-ai* . . . *ni-ai*.'

And then a voice that he did not recognize, calling her to sanctuary. A voice that he knew, the Big Man, calling him back away from such sanctuary. Watching the hue of the silks lighten as she withdrew from them.

'*Ni-ai*', the only words on his lips.

'To drown with love.'

43

CAAS Chinese Academy of Agricultural Sciences, Anyang, Henan Province

Always the backdoor . . .

The comrade who met them was joss-stick thin. More meat on the Big Man's tie than on the geneticist's bones.

'The money. You have the money?'

Greenback dollars from Piao's inside pocket. Counting them out onto the pallid outstretched palm, as the geneticist smiled apologetically.

'I have a wife who demands the better things in life.'

'The better things in life, Comrade, might not include a wife such as this.'

An acidic smile from the geneticist.

'You have what you wish to be tested?'

A small cotton pouch from his pocket to the scientist's hand.

'Two days. You come back in two days and I will have the results.'

Already closing the door, but Yaobang's foot blocking its arc.

'We fucking need it done tonight, Comrade.'

'No, no, no. This is delicate work. Precise work. Impossible.'

Piao reaching roughly into the man's jacket pocket. His fingers to the dollars.

'OK. OK, I will go to work on it immediately.'

Looking up to the heavens, as if for divine intervention from the ancestors, but none coming. Shaking a matchstick head.

'Two a.m. Come back at two a.m. Not a minute before, not a minute after, and you shall have preliminary results.'

The Big Man removing his foot. The door closing.

<div align="center">*</div>

Two a.m. . . . not a minute before, not a minute after

The office of the geneticist, with its occupant smiling at them broadly.

'Who put you up to this? Cuan? Liao? No. No. I will wager that it was, Su. Yes, Su, the old bastard.'

'I am sorry, Comrade Scientist, I do not know what you are talking about. Are these the results of your test?'

'Yes. The results. But you are joking. This sample is from America. I heard that they were working on it, but that they were many years away from a result such as this. This is stolen, or purchased? Then you must have very wealthy backers. Very wealthy indeed. Perhaps I should ask for more American dollars?'

The Senior Investigator fanning through the report.

Folding it and stuffing it into a deep inside pocket, and then tipping the contents of the cotton pouch onto his palm. Black husked seeds, now milled, polished. Seeds, strangely gold in hue. Counting each of them.

'Oryza sativa. I gave you fifteen seeds. There should be fourteen seeds returned to me, Comrade Scientist. You only used one for DNA and gene analysis.'

Holding his hand out, moving towards the geneticist, Yaobang, whispering embarrassedly into the Senior Investigator's ear.

'Boss, it's only rice!'

The geneticist falling back into his black leather chair.

'This is not a joke, nor American? And your Deputy, he doesn't know, does he?'

'Know what, Boss?'

'Three seeds, Comrade Scientist.'

'But you do know, don't you, Senior Investigator?'

Opening a drawer of his desk he produced a small plastic phial.

'What you have here is incredible, billions of years of evolution turned on its head . . .'

Unscrewing the lid and reluctantly pouring the contents onto the Senior Investigator's palm.

'An answer to many millions of prayers. What you have here, Senior Investigator, is ten years in the making. Very special, and worth about two billion US dollars in investment costs I would wager. *Ta ma de.* And what billions you could harvest in licensing this seed's secrets. Billions, enough to buy heaven itself . . .'

Piao, walking to the door, the Big Man trailing behind him.

'To buy heaven, and to paint it any colour that you wish.'

*

A different route back to Shanghai, the path of the snake, taking no obvious or major roads. Any eyes which were seeking, lost in the mazes of orchards and the paddies hemmed in by dykes.

Piao engrossed in reading the report and soon lost in its technicalities, but understanding enough to chill him even in the stifling heat of the Sedan; goose pimples running down his spine.

'I will get a copy and once I have fully deciphered the report I will make some notes. You take it to the Wizard, along with the other data. He will know what to do.'

'Sure, Boss, and what is he going to do?'

'He is preparing a hammer, a very large hammer to come down upon a very large egg.'

'Sounds messy, Boss.'

'Be vigilant, as walls have ...'

'Ears. I know, Boss.'

'Anything that you have to communicate to the Wizard, write it down, and then burn and scatter the evidence. We take no chances. We take no risks. In the meantime I want you to set up surveillance at the Hotel of Peace. Use a little *guan-xi*, a little persuasion

and your innate charm. Citizen One, I want to know his movements.'

'Sure, Boss. I know. When he eats, when he sleeps, when he shits, the usual. Planning to pay the comrade a visit?'

'We throw our harvest of rice into the air and see where the wind blows it.'

'With the storm that's been blowing on us, it could be swept all the way to fucking Taiwan.'

Piao, his eyes fixed to rear-view mirror, far behind them, a diamond glare of full-beam headlights making him wince.

'Pull over. Quick.'

Yaobang wheeling the Sedan off the road, turning off their lights and the engine. The car passing playing American rock and roll music through its open side windows. Minutes before the Senior Investigator gave the nod. Greasy fingers turning the ignition key, the Sedan coughing into life.

'What's up, Boss? I've never seen you so jumpy.'

'We have "a dam to an ant".'

'You mean a big fucking problem, Boss. But perhaps this Citizen One can get us out of it?'

Piao, with a deep exhalation, winding the side window down and watching the cigarette smoke sweep into the night.

'If he has a will to. If, as we have been told, the shining path still gleams as brightly in this *tong zhi*'s eyes.'

44

Oryza sativa.

Rice, the staple diet of the population: of many populations.

Rice straw used for roofing and packing materials, for feed, fertilizer and fuel.

Rice seed used to treat breast cancer, stomach and abdominal ailments, diarrhoea, dysentery, fever, jaundice, psoriasis.

Rice stems for treating nausea.

Rice stem ash for infections and wounds and for use as a shampoo.

Rice flowers dried for cosmetics and toothpaste.

Rice water for ulcers and applied externally for gout.

Rice, boiled, used in a poultice for sores.

Rice root used as an astringent.

The most populated country on the planet, the People's Republic of China with its 1.3 billion people; 1.3 billion 'mouths with stomachs attached', 20 per cent of the world's population, to be fed using only 7 per cent of the world's arable land, a constant challenge for food production.

For this reason the highest concern of the Party

hierarchy: food security, crop yields. Essential, the staple diet of rice, its consistent and continued flow central to law and order and to the pyramid power structure of the People's Republic. Central to the Party's hold on every element of daily life and its routines. That sense that the sun will still rise tomorrow, that the moon will still sail in the night sky, and that the Great Helmsman's words will still order the steps that are trodden.

45

The Bridge of Nine Turns, Yu Gardens

Piao stood at the exact epicentre of the Bridge of Nine Turns, at the apex of the fifth turn. From either end, safe from hostile spirits, queuing and unable to negotiate the zigzag structure of the bridge. Standing there motionless as if he had always been in this place, just waiting for her, as he had done, before, and even after all this time still able to taste the soft fruit of her earlobes.

With effort moving from the bridge and into the penumbra of risk. On the bank of the lake, allowing reports and books to fall to the grass. The geneticist's report still with the faint acidic odour of fresh printout. Sheets of remote sensing data. The report that the Wizard had unlocked from FILE TWENTY.

Reading and cross referencing with a highlighter pen marking passages of special interest. Rereading the various highlighted passages as if unable to free himself from their implications. Rice, oryza sativa, equalling so many torn from their lives.

This is a highly developed cultivar of rice. It is a transgenic crop, formed by isolating genes that

control specific characteristics in one kind of organism, and transferring these genes into other quite different organisms, which will then inherit those characteristics.

On the lake's edge, in black silhouette over dull silver, an old man, a small boy. Moving through shadow, out of shadow.

Artificially inserted genes give this cultivar improved characteristics. Better tolerance levels to heat, cold, drought. Better yield: its seed bearing head is 50 per cent larger than other cultivars. Better growth rates. It will provide two more harvests in a one yearly cycle than any other known cultivar.

From wooden boxes, preened and pampered cooing pigeons taken to hand. Feathers of every grey graduation smoothed by caring fingers. Attached to the pigeons' feet, small bundles of tiny reeds. Whistles fashioned from miniature water bottles ... held, tail end to string by a full stop of carved ivory ornament.

Transgenic techniques enable us not only to insert genes from unrelated plants into another but, in the case of this particular cultivar, to cross the divide between species: between plant life and bacterial life. This cultivar is a Bt insect-resistant crop (Bacillus Thuringiensis – a soil bacterium). If an insect such as a yellow stem borer consumes

these spores, a delta-endotoxin is released into the insect's gut. Within a few days that insect will die. Recovery of just 5 per cent of our crop yield that would normally be lost to yellow stem borer or striped stem borer larvae will be able to provide food, for one year, for around 140 million of our fellow comrades; that makes this cultivar priceless throughout the rice-growing regions of the world.

A boy's whisper, an old man's whisper, to warm pigeon's head against cheek. In open-handed prayer to heaven, pigeon's flight to sky. Traced patterns of circles, ovals, figures of eight. Reeds catching the breeze. Whistles singing their songs. Harmonized ... flight, rushing air under pigeons' wings.

Normal rice, our staple diet and that of our neighbours, contains no beta-carotene, the precursor of vitamin A, thus creating high levels of vitamin A deficiency amongst our population and causing an alarming set of costs to our healthcare institutions. It should be noted in this context that worldwide 400 million people are at risk from vitamin A deficiency. In addition, it is the world's major cause of blindness, with 500,000 children alone becoming blind because of it, and 1.5 million children a year dying from vitamin A deficiency. This new cultivar, which contains a total of four new enzymes which have been engineered into it, can put an end to this major problem.

The wind keener. Whistles, reeds, shriller. The old man, calling into the wind, into the reeded music. Pigeons, grey arrows, falling to earth, to hands. Gentle fingers, releasing reeds, whistles, ivory tethered ornaments.

The transgenic engineering has resulted in a rice variety that can produce its own vitamin A. It also gives the rice its unique coloration; hence its name: Golden Rice.

Pigeons, from hands, to cages. Gentle words as lids, closed. Partitions slid into place. Seed, for the birds. Supper calling the old man, the boy, home. Home.

The implications of this rice for our population, for our economy, for the harmony and political stability of our nation are beyond measure.'

Piao, starting to gather up the books and only now seeing it at the bottom of the report released from FILE TWENTY: the names of the scientists who had worked on the Golden Rice project. One name, two names, three names, but there were four such scientists. One had not signed the report, not wishing to own it or its findings. It had it cost him his daughter's life. But then, signing the report had not saved the other daughters of the other fathers.

Walking, pausing by the bridge, staring into the lotus waters.

Maybe even after they killed his daughter the fourth scientist still refused to sign. So they had killed his

colleague's daughters to put yet more pressure on him. But why would he wish to disassociate himself from a miracle? And at such a cost?

Moving back across the Bridge of Nine Turns, Piao, not afraid of the queue of evil spirits, but increasing his pace none the less.

There was a sign to be read in the actions of this brave comrade. A trail of breadcrumbs left in a vain hope that they would not be eaten by birds. He would visit the fourth scientist, the fourth father whose name was missing from the report. He would visit him, if only to share his grief.

46

Beyond Jixi the land falls as a stone dropped from heaven with soil as brown as a Lisu girl's eyes. The house stood on a rocky headland, overlooking an ocean of corn; a crop more golden than the sun that beckoned it from the warm soil. But the house looking apart from its surroundings, its posture that of the prospective swimmer, too scared to brave the cold salt water.

From the path you could see him, the Comrade Scientist, sitting in the heart of the garden on a bench, as if he had always been in that place, the comrade.

Few callers to such a house; the knock on the door was answered quickly.

'You remember me, Madam?'

'Yes, I remember you and your Deputy, in the church, the communists. What do you want?'

Her meagre body guarding the gap between door and doorframe.

'You know what we are here for, mama.'

Mama, a label that she thought cremated with her baby, her daughter. Instantly to her eyes, tears as bright as lead crystal.

'I have been expecting you, but I had hoped that

you would not come. He is too ill to see you. He has no words.'

'But he does, mama. I see them in the things that he has already done.'

The file clasped tightly in Piao's other hand. The report from FILE TWENTY. Three signatures and a gap of smooth paper where a fourth signature had been omitted.

'The things that he has refused to do, these are his words.'

Her eyes falling to the report. Its contents lost to her, but not its significance.

'Then you have what you want, Senior Investigator. Or do the PSB never have completely what they want?'

'You know us too well, mama.'

An understanding smile.

'He is a brave man, your husband. Foolishly brave, some would say. But not me. But there are now words that he must put to actions. Words that he must use to fill the trail of gaps that he has left, and that he knew would lead us here.'

Something in the Senior Investigator's eyes that would not be denied. Standing back from the door, the mama, allowing Piao and the Big Man to pass through it.

*

The sun lower, the shadows in the garden longer, the perfume of the flowers more gentle.

The old comrade sat in a mash of dappled light, Piao knelt, his hand upon the scientist's. Eyes to the corn field, but seeing only the paper-pale face of a girl in the chill of a mortuary drawer.

'Comrade Biologist, you had hoped that we would come. Your signature being missing from this report on the blessing that is Golden Rice, Comrade.'

Placing the file gently on his lap.

'By not signing it, although you do not talk, you shout at the top of your voice.'

The biologist's hand moving to the report. Gently, like breeze over the heavy heads of corn, his fingers over the ink.

'A brave thing to do, Comrade. The PLA are harsh, but the *tai zi*, Qi, more than harsh. Help us on our way. We want those who took your daughter from you.'

'He cannot speak. He has no words. Leave him alone. Can you not see, he has been through enough.'

Her hand on his wasted shoulder, not in comfort but in a persuasive grip.

'Go. Go. He has no words. They have dried up. All, dried up . . .'

In the breeze through the uppermost branches of the trees, a rasp. A sound not unlike the first breath after a resuscitation.

'I have, I have words.'

To the comrade's mouth, Yaobang's ear.

'Speak up, papa. The wind is high, your words will be lost.'

His hand moving to his wife's, removing it from his shoulder. For many seconds cradling it in his lap.

'I have words. I have, I have words, wife.'

Breathless. Calming himself. Regulating his breaths, in unison with the breeze.

'Get it. Get it for him. Now.'

'No. No. Have we not been through enough?'

'Get it for him, wife. For, for her sake.'

Moving through the garden, the mama, until she was lost in the dark interior of the house. For the first time, Piao and the old scientist's eyes meeting.

'Why now Comrade Scientist? Why now letting your words flow?'

Looking past the Senior Investigator's gaze, across his shoulder, to the field of corn.

'Because you bothered to look and ask.'

Shaking his head, the Comrade Scientist, as if attempting to shake a devil from his shoulder.

'I, I still see her in the field playing. But now her feet do not bruise the corn nor her footfall disturb the dew.'

Across the old papa's lips, a breeze smelling of over-farmed land and of sacrifice.

'Senior Investigator, this *tai zi*, you will make him pay for what he did to my child and the other daughters whom life no longer possesses?'

Holding the old papa's hand more tightly.

'Yes, papa. But what can ever pay you back for a daughter's hand that can never be held again in your own?'

Moving from the house and onto the sunlit lawn, the mama. In her hand paper, as brightly reflective as a shard of glass. A sideways look from the comrade as she placed the papers into Piao's hand. Turning her back and walking to the garden's very edge, her form broken by a sway of trellis shadows.

Across the front page of the papers, Yaobang's hand.

'It's just a copy of the report we already have, Boss.'

'No, not a copy . . .'

In between each word, struggled, breathless breaths from the scientist.

'The original. There are important, very important differences. Read. Read. See.'

Pointing to the house.

'Go. Read.'

*

The kitchen smelt of old people: of food kept for too long, of floors only rarely cleaned, of dreams long fallen from the vine. On a table stained by tea cups' rings and crescent moons, the reports spread side by side, page by page, turned by the Big Man's soy-stained fingers. Every page identical, every word in each report shadowing every word. Only as the pages of the first report, gathered by the Wizard's skills, came to an end, the differences evident. The Comrade Scientist's report two pages longer. Two pages phrased in a more confrontational style. Two pages speaking, screaming with a very different voice.

It would be negligent of us not to point out some of the problems that could arise from this technology that has been used in creating Golden Rice and the highly complex constructs that are at its heart. The gene constructs are new. In billions of years of evolution, they have never existed before. In essence, we do not know what we are creating. We do not know what the repercussions will be.'

Whistling, the Big Man. Long, low.

All cells, including those of human beings, are now known to take up genetic material. Invasive pieces of genetic material may jump into the genome to mutate genes. Some insertions of foreign genetic material may be associated with cancer. This is particularly significant in this case as the genetic material used is associated with diseases in plants that have many of the characteristics of cancer.

Turning the page, figures, a graph and a summing up of the project of Golden Rice and its promise of liberation from malnutrition, blindness, and premature death.

We must point out urgently that the development of Golden Rice will do little to ameliorate Vitamin A deficiency within the population. We must further point out that, to generate sufficient Vitamin A from Golden Rice, a woman of average height and weight would need to consume more

than 16 lb of cooked rice every day, a child 12 lb of
rice every day. An impossibility. Vitamin A
deficiency within the population should be
approached through a programme of oral delivery.
Vitamin A pills are affordable and immediately
available. In the long term, the problem should be
addressed with the reintroduction of agricultural
bio-diversity in a sustainable fashion.

The Senior Investigator reading the last lines out
aloud.

In essence, Golden Rice does not perform the task
that it was developed for. It must also be
considered to be based on a hazardous technology.
We would suggest an immediate cessation of the
project.

At the bottom of the page four signatures.
'This is the original report before the PLA doctored
it. The papa refused to sign the edited version of the re-
port. It cost him his daughter. This project cost too many
comrade scientists their daughters.'
Yaobang incredulous.
'Fuck me, Boss, the PLA knows Golden Rice doesn't
work, it's just a scam. He's hiding the evidence. Golden
Rice is a confidence trick. Millions of dollars he's taken
foreign governments for.'
Reports folded, refolded, deeply into the Big Man's
inside pocket.

'Pity this Golden Rice doesn't fucking work; Mao, if he were still alive, would have pinned a medal on these comrade scientists' chests if it had. Maybe even Qi would have got a medal.'

'Yes, perhaps.'

'I'll get a copy of the report to the Wizard, Boss, and when he's finished with it, destroy it.'

'Yes. And perhaps some of the Great Helmsman's words to act as wrapping paper. Seventy-year-old wrapping paper.'

47

'He leaves the penthouse just twice a week. Same day and at the same time. A comrade of habit, eh, Boss?'

'Where to?'

'The hotel's second floor, room 168, to see a woman. He leaves his minders in the penthouse and makes the journey alone.'

'Who is she?'

'Another old *tong zhi*. He's known her forty years. They drink tea and *dukang*, look at old photographs of dead comrades and play *mah-jongg*.'

'A good way to die, drinking and playing *mah-jongg* with an old comrade.'

'Sure Boss, better than the *liu-mang*'s blade that we'll get.'

'This *guan-xi*, the cost?'

'Two bottles and a permit for the Friendship Store.'

A little inebriation. A little camouflaged capitalism. Guaranteed to loosen any comrade's lips.

'When is the next time that they meet?'

'Tomorrow, as usual. Four p.m. sharp, Boss.'

'Enough time to do what I need to do.'

Absent-mindedly his fingers feeling for the CD-Rom tucked deeply into his pocket.

'It is a long time since I played *mah-jongg*. Many other games, but not *mah-jongg*.'

The Heping, Hotel of Peace

Four p.m.

Like an old maiden aunt, the Heping, the Hotel of Peace, on Nanjingxilu. Aged now, standing back from the avenue as if too afraid to cross it. Beyond the gaudy lobby, her beauty now in retreat. Features worn: fondant-icing plasterwork, nicotine-stained; statuesque Art Deco forms, cornices of frozen roses, ivy climbs, chipped, cracked and hurriedly repaired with harsh albino filler; the once rich-hued silk wallpapers, fading . . . faded.

And in the lobby bar, cracked antique leather and worn brass, where Coward would tell his whispered tales, the Sassoons would hasten their deals, a trio of sixty-year-old musicians playing to a background noise of *dahus'* mobile phone mutterings. Denture mouthed lyrics such as 'I'd like to get you on a slow boat to China' sung in warbled unison.

*

The same room, the same time and the same hostess, an esteemed comrade that he had known through fat

times, but mostly thin times. A good woman, but a bad *mah-jongg* player. On the table the same board and worn ivory tiles that had been their battlefield for over a quarter of a century now. On the table the same brand of *dukang* waiting to be poured into the same crystal glasses, and in the corner a television, a video recorder and a toppling stack of illicit American films.

But something had changed. As she had opened the hotel room door to his familiar knock, seeing it across her eyes, as fleeting as the crane's flight across the face of a full moon. During the struggle he had seen men executed for less. A downcast eye to a question, or a nervous shuffle during a political tirade. He was a man who had always acted on instinct. A true friend of that small voice within, now whispering, 'Turn, walk away to the sanctuary of the penthouse, Comrade'. But the *mah-jongg* board with a louder voice, combined with the gold glint of *dukang* and a fellow *tong zhi* who knew of times before mobile telephones, Armani-suited politicians and 'sound bites'. Ignoring the voice, he entered the room. She closed the door. And regret upon him, as fast-running as a dog after a Liberation truck. The hungry mouth of a pistol tight behind ear and skull. And with it, uttering the most stupid words that had ever passed his cautious lips.

'Do you know who I am?'

Yes, to come this far, to go to such lengths, such

men as these would know exactly who he was. The man standing in front of him, half-blood eyes of turquoise, his words disarming. Breached, the old comrade's defences, by their cheap tobacco-perfumed taint.

'*Tong Zhi* Citizen One. You are a hero of the People's Republic, one of the last who knew how it was before.'

Piao taking a photograph from his inside pocket. A bright-eyed child with the sense of a victory yet to be won shining through his eyes in evangelical certainty. A few paces in front, the swirl and lick of red banner, the Great Helmsman.

Citizen One scanning the photograph with *dukang*-fuelled tears.

'It has been many years since I have seen this painting, many, many years. My uncles, I called them. Mao, Zhou Enlai, Deng Xiaoping, and so many others. By day they could kill a thousand, ten thousand Kuomintang, but by night they would make me safe, tuck me into a bed, tell stories now forgotten and explain to me the shining path of communist reasoning.'

Shaking his head.

'Men such as these are as gemstones amongst cliffs of mud and shale. The politicians of today are just interested in "shoving the shit back up the horse's arse".'

The Senior Investigator taking back the photograph and returning it to his pocket.

'Yes, *Tong Zhi*, that is why we are here. We wish to show you what has grown from the earth that was watered by your fellow comrades' blood.'

*

Tong zhi Citizen One was quite correct, the woman comrade was a poor *mah-jongg* player. Piao winning game after game as the Big Man supplied them with *dukang*. And through it all, the old comrade reading, with the single-minded focus that only an accountant can muster. FILE TWENTY in its pristine inked entirety. A hand that had once been shaped around a rifle butt, child's finger to trigger, now armed with something more dangerous, a pen, in copious barbed scrawl and a calculator trailing strings of noughts.

Four hours before he stopped to take a drink, rejecting the offer of food.

'I am used to much, but also very little. I was a child during the Long March. It was sometimes days between a drink, or a meal.'

Carefully placing FILE TWENTY on the floor.

'Such an experience fashions a man. Even now I find a dough stick or a crust of bread that I have secreted under my pillow, or in some other safe place. Now I can afford the best things in life, but still I hide food.'

Picking up the papers once again.

'And this is why you have come to me? This PLA princeling, this trusted officer, he is dirt under the

fingernails of the peasantry. He is a robber of the proletariat.'

Shaking his head vigorously.

'Millions of *yuan* obtained in the foulest of fashions. Prostitution, thuggery, the "olds" that Mao struggled to free us from, resurrected by my own PLA. I swear by my fallen comrades' blood that I knew nothing of this outrage. If I had, I would have . . .'

Angrily tapping the papers on the table.

'A curse on these princelings and their excesses. How is it possible that the heroes of the People's Republic have spawned such a plague as these?'

Anger now replaced by sadness and determination.

'I have been in my penthouse for too long. Communism has died, and I did not even hear its whimper. This PLA, there is no need to extract money in such obscene ways. No need. The guiding policy for the PLA has been the "16 Character Policy". *Junmin jiehe, pingzhan jiehe, junpin youaizn, yinmin yangjun . . .* '

Whispering the words, Piao.

'Integrate the military with the civilian; integrate war with peace; give priority to weaponry; make goods for civilians use and use the profits generated to maintain the military.'

Nodding, the *tong zhi*.

'Exactly. The fact that President Jiang Zemin has issued regulations on economic accountability and is pressuring the generals to disclose their interests,

indicates that all is not well. But, for my part, we follow the "16 Character Policy" to the letter. As a result we now have around 30,000 commercial units that I have developed for the PLA. Good, honest, solid businesses . . .'

Fingers running down a column of trenched figures.

'Poly Investment Holdings, Continental Mariner, these are listed on the Hong Kong Stock Exchange and are owned by the People's Liberation Army General Staff Department. Hong Kong Macau International Holdings, HMH China Investments, these are owned by the GPD, the PLA's General Political Department.'

Turning the page.

'China Poly, owned by the GSD, this alone has more than 100 subsidiaries, with assets totalling over 10 billion *yuan*. Last year it earned more that 500 million US dollars.'

Unable, at first, to find the relevant entry.

'The PLA runs over 500 hospitals. The Xinxing Group, owned by the PLA, employs 200,000 workers. Songliao Automobile is 53 per cent controlled by the Shenyang Military Region. We have a majority interest in the stockbrokers J&A. Last year it reported a profit of 711 million *yuan*. The PLA now controls China United Airlines, and Beijing's five-star Palace Hotel. PLA businesses have joint profit-making ventures with the Canadian company Shooting Star Technologies. With American companies Baxter Healthcare, Exten Indus-

tries, SC & M International, General Electric Medical Systems and many more.'

Fist banging the desk.

'Good businesses, legitimate businesses, which receive my blessing and full support. But whoring! "The olds"! The People's Liberation Army does not want profits from such things. This princeling steals from the weakest, for his own pocket. Millions of *yuan* taken from the defence of our People's Republic. It is here in his own records, in black and white.'

Finger stabbing down on data.

'Money that should go to our PLA for the defence of our people, falling into this *tai zhi*'s pocket as rain from heaven. I know his father, this princeling. A good comrade. A good servant of the people. I weep. I weep . . .'

Unable to speak. Leafing through to the last pages of FILE TWENTY. Filling his glass, the Big Man.

'This! What is this about, Senior Investigator? You have the face of the clock, Senior Investigator, but not the hands to indicate the time. There is a major conspiracy afoot here. Millions of dollars changing hands. But for what? I believe that you know, but you are not prepared to tell me, Senior Investigator. Or you, Deputy?'

No reply.

'You should be in the Peking Opera, Comrade Piao. You have a sense of the dramatic.'

'I work in the Homicide Squad, *Tong Zhi*. Only the dramatic reside in that continent.'

'True words. True words. I have seen much of death also. Too much. Far too much. It taints the soul. Poisons the tree of life.'

'"Thousands upon thousands of martyrs have heroically laid down their lives for the people; let us hold their banner high and march ahead along the path crimson with their blood."'

'Very good, the glorious words of the Great Helmsman, from his *Selected Works*, Volume Three. You understand the path and are a remarkable man, for a PSB, Senior Investigator Piao.'

Suddenly standing, Citizen One, removing his jacket, unbuttoning the cuff of his shirt, and almost as a solemn rite, slowly rolling up his sleeve. Colours, some age-dulled, some with the vibrancy of newly inked additions. A tattoo from wrist to shoulder, a glorious tapestry of the smudged and the defined. A contract of guaranteed safety, in carefully crafted characters. At its primary-hued heart, the characters for Mao himself, and every leader of the People's Republic since. But the contract equally binding in the opposite direction?

'You need not fear. I will keep my half of the bargain. I will keep to the shining path and do my duty.'

Suddenly, once more under the red banner. Once more side by side with the heroes of the revolution.

'Show me all that there is to show me, Comrade Investigator. You need not fear. You have come to the right citizen. I am Citizen One.'

*

Thirty minutes later

Tears traversing wrinkles. The Big Man handing the woman comrade a tissue. A nod of her head and a look toward Citizen One.

'For what, these terrible deaths of such young women and these brutal murders of your fellow comrade officers in the PSB?'

Piao, at the window, staring into the night.

'And these dollars, millions of dollars? What do they buy?'

Turning, the Senior Investigator, and dropping a cotton pouch into the old comrade's hand.

'Oryza sativa. Rice, Comrade Citizen One. The promise of a very special rice.'

'Rice! No, no, Senior Investigator, this cannot be. Rice may cause indigestion, but nothing such as this. Never such as this.'

A nod. The Big Man pulling several reports from an envelope. Dropping them onto the table in front of the *tong zhi*.

'Comrade Citizen One, it is called Golden Rice. Something that held so much promise, like the Great Leap Forward, but in reality was an empty vessel.

Although the initial results were promising, when the scientists working on the project informed Comrade Qi of their negative findings, he at first attempted to suppress their report. Then he insisted that they doctor it and put their signature to it. They refused. He offered them money. When that did not work he made threats against their daughters. When that did not work he murdered their daughters.'

'And this rice, this Golden Rice; you can produce evidence that Qi suppressed their reports? Doctored their reports?'

'The evidence is in front of you, Citizen Comrade One.'

'And still Qi continued to take millions of dollars from countries that are our neighbours on the false promise of this rice?'

'The evidence of that is in his own accounts, *Tong Zhi*.'

'Yes. Yes, the figures that I saw with my own eyes. Of course. Then you have completed the circle of evidence, Senior Investigator Piao.'

His knuckles tapping the reports in front of him.

'That I should grow so old as to see such as this. Me, one who survived the perils of the Long March!'

Shaking his head again. Minutes before he spoke.

'To bring into the light that which you have shown me is our clear duty, but it would be naive and irresponsible not first to consider the consequences.'

'I do not care about . . .'

'Consequence, Senior Investigator? You should. I can see that I may need to save you from yourself.'

Through the window an aeroplane scraping the sable sky. A flight leaving Pudong International. Leaving for somewhere new, silver, shiny bright.

'What you have discovered could cause enormous damage to China's reputation within the international community, should it be released. We are no longer an island, our fortune is bound to others, and others to ours. As well as economic consequences there could be political fall-out from these revelations, Senior Investigator. Such revelations could, among other things, jeopardize our hosting the Olympics.'

Piao sensing that the words he wished to say would be inappropriate.

'There is an art in this, Senior Investigator. One has to weigh issues against issues, and consequences against consequences. So much to lose in revealing what it is that you have discovered. But on the other hand so much to lose in allowing these princelings free rein.'

And almost under his breath.

'A plague on us, these *tai zis*. A plague that will eventually destroy our People's Republic.'

A deep inhalation, a decision made.

'Sometimes, even when in the deepest of fevers and with the patient at his weakest, it is necessary to take drastic action, to take a knife and bleed the patient. And in that painful bleeding, a life saved. That was what our Cultural Revolution was, a curative blood-letting.'

Citizen One's hand pointing to the electric horizon of the city.

'But see, the patient survived. Perhaps we will have our own Cultural Revolution, Senior Investigator. On a much smaller scale, you understand.'

Laughing, the *tong zhi*.

'And you, Senior Investigator? What of you?'

'I am a solution that became a problem.'

'A dangerous role to achieve, Senior Investigator.'

'I excel at achieving such dangerous roles, Comrade Citizen One.'

The *tong zhi*, his hand on Piao's shoulder.

'You have done well, Senior Investigator. You have done well and you will be rewarded. This will earn you and your Deputy medals.'

'We already have medals, *Tong Zhi*.'

'Then what would you wish of me, Senior Investigator? An old *tong zhi* who has obviously lived for too long.'

'Information, Citizen One. Information . . .'

'Ah, Senior Investigator. Politician's gold, yes? What information?'

'Colonel Qi, I wish knowledge of his time as a student while in London. Something occurred there that has sculpted his life to its will. As the Long March sculpted your honourable decades.'

A nod.

'I have names taken from the princeling's mobile telephone data that need to be examined. Names that

Qi is sending large amounts of money to, as you saw, Citizen One. Names that span the world. We need intelligence on these, *Tong Zhi*.'

'I have well-established contacts. This information will be yours.'

'Thank you, *Tong Zhi*. There is also a Russian by the name of Kanatjan Pasechnik. I wish information about him also. Our own contacts, our own *guan-xi* have failed us.'

'Never to be trusted, Russians. Wolves in a bear's clothing. We shall see what business Colonel Qi has with a Russian. You shall get what you require, Comrade Senior Investigator.'

'Thank you, Citizen One. I had almost despaired of . . .'

A hand raised, stilling Piao's words.

'What, Comrade Senior Investigator? The lack of integrity on the part of your superiors and amongst the high *cadres*? A loss of the shining path from the eyes of the politicians that command you?'

A nod and a single word from Piao that could beckon for any citizen, *lao gai*'s embrace.

'Yes.'

'I still follow the Great Helmsman's shining path, Senior Investigator, although such a journey is now not fashionable.'

The Big Man helping the woman comrade to her feet.

'Perhaps you should have more faith, PSB. Yes, more

faith. There are still some left who do not bow to the contents of a wallet.'

The *tong zhi*, papers, reports, into a folder.

Smiling at the septuagenarian female comrade linked to his arm; in his eyes, still a pretty twenty-year-old.

'We will apologize to our security officers for causing so much concern. We will say that we went for a walk. A long walk. It was a beautiful night. So many bright stars. How we both love to look at the stars. You are, of course, aware, Senior Investigator, that there is not another country in the world that has such a canopy of bright stars. Surely, if there is a God then he must be a good communist comrade.'

Moving into the corridor smelling of foreign cigarettes and red rose soap.

'One day from now, Senior Investigator. The Hongqiao bird market. Madam Lee's Songbird Emporium, midday.'

Smiling, as his arm slipped around the female comrade's waist.

'One day from now and you will have your politician's gold.'

48

The Hongqiao Bird and Flower Market,
the Hongqiao Road

As if heaven had fallen to earth, the market wound like a garland through the Hongqiao Road. One end tethered to 200 stalls of birds that once flew, but were now caged: hummingbirds, canaries, finches and the more exotic songbirds. The other end of the market, as a rainbow pinned to earth at 1778 Hongqiao Road by the Gubei flower market, with its 20,000 square metres of blooms. Every colour to soothe the soul and paint the mood.

And in amongst the songbirds' sad laments, the children's animated chatter, the tourists' whoops and hollers, harsher things, as the hard stone set at the heart of each lychee's soft, giving flesh. A spit, a slap of hands to black-market deals. A canary pecking the feathers from another canary's head. Harsher things. Flight feathers pulled with tweezers from a hummingbird's glistening wings. An argument, fierce and hot, over a price set, a deal broken. Harsher things. A squeal cutting through the midday, as a Mandarin duck is parted from

its life. Over age-trodden cobblestones, as dull as old *fen* coins, flower petals and a generous spatter of blood.

*

Madam Lee, an old broiler chicken that thought that she was still a songbird, advanced on Citizen One with lips triple-coated in scarlet lipstick to give him a kiss. A tale told of a life sadder than this current existence, as she plucked flight feathers from a lovebird's wings. Another tale told, to much laughter, as she bound with tape the beaks of two unhappy-eyed parrots. Only when the laughter had died and her attentions turned to a toucan cowering in the corner of its rusty cage, did she point the way with a scarlet triple-coated fingernail. Citizen One leading through a double glass-beaded curtain and into a small room beyond . . . its smell of menopausal women, over-brewed *xunhuacha* and bird feathers. At the centre of the dark room, candle lit, a large samovar of Russian origin, ornately fluted, original nickel plate worn back to its brass body. Around the samovar, a circle of leather, gold-embossed cushions. Citizen One seating himself, pulling a candle closer and pouring himself tea, his every action speaking of him having been in this place many times before. Piao and the Big Man following him. Their actions more stilted, as they juggled cups that would not hold even enough liquid to wash out an eye, let alone quench the thirst of a mouth that tasted of bird's feathers.

From a file Citizen One pulling a sheath of precisely

folded papers and spreading them out on a cushion with his hand.

'I am a comrade who keeps his promises.'

His hand moving over the pages until they were perfectly smooth.

'In this, and in what you have shown me, Investigators, we will all need to have complete trust in each other.'

Noisily drinking his tea.

'First, data from foreign intelligence services: the SIS. BND, German Intelligence, the CIA, Centro Nacional De Intelligencia of Spain, the French, DRM, Direction du Renseignement Militaire . . .'

The distaste showing as he spoke.

'Your Qi, he has many contacts with very unsavoury characters. Muslim extremists, suspected terrorists. Some he met at university while in England. All were members of Al-Muhajiroun, a radical Muslim faction. Fanatics. Many of them, it is known, have been to Afghanistan and have trained at terrorist training camps, or have studied under radical clerics in the madrasas of Pakistan. Such people are a great concern to our friends in the west, a great concern.'

Only now that Piao's eyes were growing accustomed to the candlelight, aware that they were being watched. From high shelves on three of the room's walls, birds of every description, stuffed and mounted. Dead eyes of yellow-aged glass beads looking down.

'Nazeer Ahmed Hanjour. Nazeer apparently means

"the one who warns". He became close to Qi at university and is credited with introducing him to Islam. Hanjour passed him on to a radical cleric at a mosque in London. He took a special interest in Qi. Educated him. Abdul Waddani, another cleric. The Americans are seeking his extradition on charges relating to terrorism. Saadat Al-Sharif, our Colonel's closest friend while in London. He is being tracked by the British SIS. Sa'd Al-Qadi. The German authorities have him under constant surveillance. Implicated in funding terrorist acts.'

Citizen One placing the papers on Piao's lap.

'And another twenty-seven of them. A great concern that a Chinese national should have such "friends". Especially one as well connected as Qi, who has access to military hardware and specialist resources.'

More papers from the file.

'As for the other name that you gave to me, the Russian dog. Kanatjan Pasechnik, a nasty piece of work. A thick file on him within every intelligence agency in Europe. A bio-weapons scientist who was a leading light with the Russian company BIOPREPARAT, a civilian "front" organization for their biological weapons programme. He was developing new strains of smallpox, as well as genetically splicing one virus into another. A not dissimilar technique to the one which would have been used on your transgenic crop, Golden Rice, Senior Investigator.'

A concerned nod of the head as he turned more pages.

'Since the break-up of the Soviet Union and the programme ending, he has been unemployed. But it is believed that some regimes in the Middle East were courting him. Unfortunately, I think that our princeling has beaten them to it.'

'I do not like the sound of this, *Tong Zhi*.'

Two notes in the file, both saying the same thing. One from Qi's *danwei*. Another from the *Luxingshe*. Personal requests from the princeling, on behalf of the People's Liberation Army, for a Russian national to be allowed into the People's Republic on a special visa, for the purpose of 'scientific research for the benefit of the PLA and the Chinese people'. The Russian national's name: Sergei Popov.

'Alias, Kanatjan Pasechnik, yes, *Tong Zhi*?'

'Yes, I believe so. Our princeling must have brought him in to our People's Republic to work on the Golden Rice programme.'

'Do you mind if my Deputy and I look at these papers, Comrade?'

'Look, yes. But take away, no. Sensitive material. If it got into the wrong hands it could be tracked back to my source. A very important source. You must read them here, now. I will busy myself with Madam Lee.'

A glint in his eyes.

'Take your time, Comrades. Please, take your time.'

*

Records Office, KGB Central . . .

Personal data. Place of birth: Kiev. Date of birth: 4/7/1955. Communist Party membership no. 3678425639753465/ 6564A. Work location: Koltsovo, Siberia. Work position: Lead Scientist / Project Manager.

Page after page. Pasechnik regarded as one of the most brilliant Soviet scientists of his generation. Devising, running his own projects from the age of twenty-five. Funding, seemingly limitless. Starting within mainstream medical research. Then during the late eighties, Pasechnik's focus altering. A more shadowy area, researching viruses, genetic engineering. Field trips to Venezuela, Zaire, India, the Congo. A list of countries, the common denominator being that death had passed that way, had ravaged those lands with the most deadly viruses known to man.

Two brief reports each stamped in red ink: CLASSI-FICATION ONE STATE SECRET.

A BIOPREPARAT project, 'Hunter'. Its aim to produce new micro-organisms. Combining two viruses together to produce a 'chimaera'. Focusing on ebola, Venezuelan equine encephalomyelitis, smallpox . . . the particularly virulent strains INDIA-67 and INDIA-1. Focusing on unleashing their maximum potential as a part of a weapons system.

Reading the second report. Another BIOPREPARAT project, 'Factor'. Its main focus to develop viruses and bacteria that were more pathogenic, better able to cause

disease and fatality within the human being. With special attention paid to the degrading of the immune response. Experimentation to focus on the IL4 gene, and its insertion into the smallpox virus, with the aim of creating a vaccine-resistant strain of smallpox.

'Does this make sense to you, Boss?'

'There will be something here that speaks with a clearer voice. Something in the small print. Something that we are missing.'

Kanatjan Pasechnik. Not his projects, his exotic travels, his myriad qualifications; every step of his career noted in triplicate. Something more basic would snag their attention.

And there, a hand-written insert in the original document.

Chosen religion: *Muslim.*

*

'*Cao-mu jie-bing . . .*'

'"The dead cat turned". A risky strategy, Comrade Senior Investigator.'

Piao walking over petals as red as the People's Republic's star.

'Risky, Comrade Citizen One? Surely, as the Americans say, "a walk in the park" for someone such as you?'

'Senior Investigator, when it comes to dealing with the Politburo, there is no such thing as a "walk in the

ANDY OAKES

park". You forget, Sun Piao, I know how the Politburo thinks and reacts. It does not respond well to being placed in a position of pressure.'

Last canaries being loaded into vans. Blankets thrown over the cages, their last songs coming to an end.

'They will gather as a crowd of angry old women do. Age might have robbed them of their teeth, Senior Investigator, but you would not wish to face their gums.'

Yaobang taking from his pocket a CD-Rom and pressing it into the *tong zhi*'s hand.

'If I am correct about what I think is on here and how you intend to use it, there will be many consequences. A tidal wave of consequences.'

Pulling Piao to the side, the old *tong zhi*. A fierce whisper over traffic's roar.

'A tidal wave that I might not be able to protect you from, Senior Investigator. Do you understand what I say?'

A nod.

'This is where our paths diverge, *Tong Zhi*. You must go east. Us, we go west. Our paths home go in different directions, but not in this, yes? One other has a copy of this CD-Rom. It has already been determined how and when he should use it.'

His hand on the *tong zhi*'s in farewell.

'To trap a bird such as our Colonel Qi, a net will not be sufficient, Citizen One. What you need to do is to turn the flock that he is a part of against one of its own.'

49

Waiting for him for several hours, in silence in the dark.

Glass from a broken window at the rear of the house catching the moonlight in splinters. Drawers and cupboards ransacked. It would look exactly what it was meant to look like: a robbery. The owner of the house stumbling, unknowing, into panicking, violent *liu-mang*.

An arc of cold headlight through windows, casting listing shadows in the large hallway. A key into a lock, front door in creaking swing, a hand going to a light switch, but no light. A curse in the darkness about a light bulb only replaced a week ago. The door closing, a controlled stumbling down the hallway. Within finger's touch of the light switch to the living room, when they fell upon him. Through the leather of his coat, jacket, shirt, popping through their brief resistance, the stiletto blades. A sickening floodtide of warmth. Again, again, bruising knuckles crimson. Each plunge, a fractured breath. A quiver of lips, bubbling spit.

The victim still standing, braced by the wall, as they wiped their bloodied hands upon his shirt. Still standing but already dead, his killers made their way

through the darkness of the hall and into the indifferent night.

<div align="center">*</div>

Moving, a dark wedge cutting the morning's early hours. The door, as ordered, left ajar. Moving through the communal hallway, past the Street Committee member's door, conspicuously locked. Moving up the stairs. On the third landing a dark finger pointing.

'There.'

Silent footfall down the corridor. Outside a heavy door, two silver keys in unison, inserted into locks. Levers moving, releasing. The door opened, blackness moving through it, the door closed.

Muffled sounds, a man's voice, a deep thud and then a groan. Feet over floorboards, a young woman, her scream cut short with the palm of a sweaty hand. For several minutes, the muffled screams continuing as they went about their work with the freshly stropped cut-throat razor. The screams weaker as blood was lost with honesty generosity. Weaker, until falling silent.

The door opening. In silence moving down the stairs, through the hallway, briefly pausing outside of the Street Committee member's room. Two keys slipped through the gap beneath the door and silently out into a morning still unbreathing.

50

The *Hong-qi* that drew-up at the steps of the *fen-chu* was an official chauffeur-driven PLA Red Flag, one of a fleet of gloss-black stretched automotive perfection, that only the highest-ranking People's Liberation Army officers had access to. The documentation that the passenger in the *Hong-qi* had borne through the cauldron of a Shanghai noon was also official. More ink-bled stamps upon it than polished boots at a May Day parade in the People's Square. Documents of authority, identification, orders of office, standing orders. Detective Yun fastidiously checking each paper. Thirty-six all told. The power, the authority, issued in Beijing itself, by the General Secretary of the Central Secretariat, to take full command of the Shanghai Public Security Bureau.

Yun refolded the papers precisely as they had been folded, and returned them to the hand of the new Comrade Chief Officer. A man, every inch of him, who would wish to lead from the front, as long as the 'enemy' was already bowed and defeated. Detective Yun stood to attention and saluted crisply.

'Welcome to Shanghai, Comrade Chief Officer Xin. Welcome to the *fen-chu*.'

The old *tong zhi* smiled and leisurely lit a cigarette, looking at Yun for several seconds before he spoke. When he did so it was as if each word had been hewn from rock, long ago quarried.

'I trust that my being a serving PLA Officer will not cause you a problem? Or my being a close comrade of Senior Colonel Qi?'

'Of course not, Comrade Chief Officer Xin. But if I may be so bold as to enquire as to why Comrade Chief Officer Zoul has lost his posting at the *fen-chu*?'

'Of course you may be so bold, Comrade Detective. But you should brace yourself for some unexpected news. Highly unfortunate news. I am afraid that your previous Comrade Chief Officer was the victim of a very violent crime in his own home. He sustained terrible injuries and, unfortunately, did not survive.'

Not waiting for Yun to respond.

'My position within the Public Security Bureau, as you have seen . . .'

Pointing to the large tranche of orders of authority, thrown on to the desk.

'. . . has the full blessing of Beijing. Zoul was a fine comrade, but now Beijing feels that a more steady hand can stop the rot that has permeated this place. It is felt that a PLA posting, however unusual this may seem, will bring some additional steel to the Shanghai Public Security Bureau. My time with you will be limited. I will stay only until my job is completed. Then I will return to the Shanghai Kan Shou Jingbei Si Ling Bu,

where I belong. Until that happy day, Detective Yun, you will note that I am not one for ceremony. Salutes do not impress me.'

No longer smiling.

'Only results will catch my favour. And you will wish to catch my favour, will you not?'

Yun catching himself about to salute.

'Yes, Comrade Chief Officer Sir.'

'Good. Good. Then we have established an understanding.'

His hand to the inside pocket of his expensively tailored tunic, a neat cornered envelope retrieved. Under nicotine-yellow fingertips, the embossed seal of the Ministry of Security.

'Your first orders from your new Comrade Chief Officer, Detective. Also approved by our superiors in Beijing. There was some reluctance in some quarters, but as I am sure that you will agree, there is little choice in this sad case.'

Tentatively opening the envelope, Yun carefully reading and rereading the warrant papers. By the time that he had finished, a sheen of sweat across his forehead.

Nothing escaping the PLA's attention.

'You have a problem, Detective Yun?'

'Comrade Chief Officer Sir, there must be a mistake.'

'A mistake, Detective? Are you insinuating that I would make such an error? That our superiors in Beijing would make a mistake of such magnitude?'

'No. No, of course not, Comrade Chief Officer Sir. It is just that this is a very trustworthy officer. An officer of the highest repute. He could not be involved in something like this . . .'

'Detective Yun. I realize that discipline and standards had drifted under the late Comrade Chief Officer Zoul's command, but I really had expected a greater professionalism from senior officers of this *fen-chu*. The evidence against this officer is indisputable. More than enough to warrant a charge of murder. I am assured that there is also reliable forensic evidence that will be made available at the trial. Fingerprints found on the murder weapon itself. A cut-throat razor.'

His voice a whisper.

'My poor, poor predecessor, Comrade Chief Officer Zoul. Better that life no longer possesses him than to witness one of his most trusted officers arrested and taken to trial for murder.'

A whisper more menacing than thunder.

'You will arrest Senior Investigator Sun Piao on the charge of murder. You will do it now, Detective Yun, without delay.'

51

A tenth of an inch's difference,
And heaven and earth are set apart;
If you wish to see it before your own eyes,
Have no fixed thoughts either for or against it

Early hours. Dangerous hours

Incorporating the noises and movements into his dream.
A dream of numbers, of mindless repetitions. Only fully
awake as he heard and processed the words.

'Boss, I've just got back from the *fen-chu*. They're
coming. They're fucking coming for you.'

Adrenalin jab, shunting Piao out of the sleeping
bag.

'Qi?'

'No, Boss. No . . .'

'Who?'

'PSB. Fucking PSB.'

Pulling on clothes as they walked then ran.

'I don't know how to say this to you, Boss.'

'Say what?'

'I'm sorry, Boss. So fucking sorry.'

433

Following the Big Man through the heat of the bakery. Sweat already coursing from his brow.

'They've murdered her, Boss. Fucking murdered her.'

'Who?'

But already knowing. Her name falling to his tongue, an unlabelled sickness seeming to flooded into him.

'Lan Li.'

'Sorry, Boss. So fucking sorry. Yun says your cutthroat razor was at the crime scene. That's why they're after you.'

Words hard to form.

'You posted a report of it being taken from my flat, after the Wizard. After . . .'

'It's gone missing, Boss. There's no report on file at the *fen-chu*.'

Piao peering through the cracked corner of the window. Rain, in grey sheets, as if the heavens had turned to ocean. As if the ancestors were pissing on them.

'I don't know how they found her. How they fucking got to her.'

'My fault. Mine. To meet her, it was wrong. What I most feared, I brought about . . . *ta ma de*.'

A glint of a cap badge, then another and another.

'A stain to the soul . . .'

But Yaobang not listening.

'Boss. Boss. We must move. They're almost upon us.'

'I need to talk to the Comrade Chief Officer, maybe he can . . .'

'Zoul's dead, Boss, knifed. They made it look like a break-in, but Yun said that they took nothing, except his fucking life.'

Two blocks away, dull and lazy revolutions of red, blue and white light.

'The new Comrade Chief Officer at the *fen-chu* is PLA. We're on our own.'

Glints of gold buttons in darkness. PSB. Packs of PSB.

'The pier, Boss.'

Slipping against the bakery wall, Piao, comfort in the stone floor's chill.

Pulling at the Senior Investigator's jacket.

'You can't let them take you. That's what they want. If you want to avenge her you have to fucking save yourself.'

Rising to feet, as if ensnared in a dream. Following the Big Man through the bakery. Wrenching open the back door and instantly they were on the pier, chilled, wet. Stars banished behind mile thick cloud. Beside them, the river running fast, as if downhill.

From the arse of the bakery to the neighbouring wharves, a thick mud inlet of river, like a black finger. A leap, perhaps seven feet or more.

'We'll jump, it's the only fucking way. And then we can . . .'

With both hands, Piao grabbing the Big Man by the shoulders.

'Just me, they are after me. You stay.'

'No, Boss. I'm coming too. You need me.'

'Yes, I do need you. I need you on the inside.'

'Boss?'

Separating, moving into darkness, Piao, toes over ragged edge of concrete apron. Just the sound of the river's dark inlet and its dead smell. A fan of torchlight, a voice, feet scrabbling over mud, over filth. Counting the steps back, a run, a leap, and the Senior Investigator lost in darkness. Just the sound of a heavy fall onto other concrete. A stuttered exhalation and his uneven footfall lost in the river's angry voice.

A minute, no more, Yaobang standing at the centre of the pier, his face to heaven. Rain, as he had never known it, falling down on him. Standing there, its cry across his mouth, his tongue. Pooling in closed eyes. A sense of freedom in its purge, but only brief.

'A serious charge can arise from protecting a murderer, Deputy Yaobang. Where is Senior Investigator Sun Piao?'

Shaking his head like a dog. Opening his eyes to the old *tong zhi*, Xin. Sodden cigarette hanging between his dark lips.

'Senior Investigator who, Comrade Chief Officer PLA?'

*

Warehouse leading to warehouse, in tattered joinings. Glimpses, through cracked brickwork and dull windows,

to the road. PSB patrol car lights. Colours so bright in the grip of pounding heart exhaustion.

Ahead, a storm's approach from the south-west. Lightning in steel shuttered cloud. A roll of thunder. Counting in seconds ... *1, 2, 3, 4, 5, 6, 7, 8.* Masked lightning. Eight ... between thunder and lightning. Eight miles away, the storm. The warehouses seeming to lift from the river with each flash. And in the tentative electric air between thunder's applause, feet over concrete. Closer and closer.

The next breach between buildings, Piao leaping into the darkness, his arms reaching forward, praying for its embrace. A sickening concussion, forearms, knees, fired with pain, but managing to haul himself up onto a ledge that fronted the next wharf. His eyes filled with the river and the rain in its speared fall as he inched his way along the ledge, his toes seeking passage ... safety.

Thunder, lightning, six miles. The Huangpu, flickering. Shouts, curses, a torch beam breezing across him. They seeing him for the first time. He seeing them. A recognition within it that went far beyond hunted and hunter. A recognition of a spit-and-polish uniform that he once used to wear with pride. A life once lived also, now swept away.

Thunder. Lightning. Three miles. The city, jolting, shivering, as if caught in the teeth of a fever. Illuminated, beyond the inlet, a high wire fence gleaming in the light. Where once rice grew from soil bathed in

sweat, in tears ... a vast building site for the new road bridge servicing the spike of Pudong's cloud-belly-scrapers.

Trying to run, the fence rearing up to meet him. Piao climbing, slipping down its other side, forcing himself to run through the deep mud. Only just making the concrete apron of the bridge.

Encased in steel, running on steel; the bridges curve taking him up, over the Huangpu's edge. Looking back in cut-throat shadow, the PSB gaining with each stride. Chasing over his blood.

Thunder. Lightning. One mile. As if running on light. Their shouts and curses, over his shoulder their faces, and on the far bank the colour of electric light through the rain. Moving onto the bridge from the opposite side, the gleaming epaulettes and shiny booted footfalls.

The storm upon him. Thunder, lightning, now directly overhead. *Pa ma-fan*. The city rising and falling like ribs over lungs. The Huangpu only defined by the bracelet streams of traffic along its smooth thighed flanks. Watching, from the corners of his eyes, as the olive uniforms pressed forward. Through them, larger epaulettes, the flamboyant crest and peaked hat of the *tong zhi*, Xin. Words from his lips, but not hearing them. Just the rain, the river, the darkness, and him. Not even seeing them press forward as he climbed the parapet. Their hands reaching, grasping for him. An

instant, just an instant, feeling the rough steel of the riveted girders under his feet. Balancing on aching heels, his toes into space. An emptiness filling him, in his whole life only experienced just a few times before, and for just a few minutes; but every second of those minutes remembered.

Eyes to the point where the sky met the river in an invisible kiss, and then without thought, tumbling. Against cityscape, against the raven river, a black scratch, accelerating. Nothing solid. Nothing with texture, and that spoke of a life that Piao knew.

They say that before you die, life passes, parades before you. It does not. All that you were, had been, could be, receding into itself. Dark water down a dark plug-hole. Imploding, into a single and solitary number. That number, *0*.

<p style="text-align:center">*</p>

Comrade Chief Officer Xin craned his neck over the parapet. Far below, black waters blushing a lighter black. Watching until the river's roll resumed its uninterrupted course. Scanning the dark Huangpu for the cork to bob to the surface. Nothing. In an act of finality, spitting to the river, watching its dribbled fall until it was lost to sable.

Yun unfurled a large black cloud of an umbrella to protect the Comrade Chief Officer's uniform.

'The height of this bridge?'

'It is 8,346 metres long, including the road entrances and cost 820 million *yuan* to build, Comrade Chief Officer Sir.'

Unable to detach his eyes from the river, the *tong zhi*.

'I asked for the height of the bridge. The fall to the river from this point?'

'Sorry, Comrade Chief Officer. It is 46 metres, Comrade Chief Officer.'

'And cold, I would imagine.'

'At this time of the year, freezing, Comrade Chief Officer. Nothing could survive in the Huangpu's waters at such a low temperature.'

Xin took the bone handle of the umbrella and marched with energy through the line of sodden olive uniforms, towards the comfort of the Red Flag.

'Let us hope so for your sake, Officer Yun. Yes, let us hope so.'

52

One week later

'An acceptable apartment for a hero, I suppose.'

The Big Man packing two cardboard boxes. One for personal belongings; clothes, photographs. Another box for the *fen-chu*; a tick list of those items that go with the position of Senior Investigator.

'He was just a good man, not a fucking hero.'

Citizen One's shadow eclipsing documents of authority, a PSB tunic, awards, medals, commendations, found in a bottom drawer along with holed socks.

'An acceptable apartment for a good man.'

Staring out of the window, the old *tong zhi*. Many years, too many, since he had watched clothes drying in a *long*.

'They have still not found his body, even after this time?'

A shake of the head. Yaobang wrapping framed photographs in worn shirts.

'The Huangpu is a powerful river, sometimes it never gives up its dead.'

Wrapping a pistol in a pair of pants. A brace of medals inside of a sock.

'Anyway, better not to have a body. To everyone else he's a murderer. Who would allow us to cremate or bury a fucking murderer? *Dao-mei.* '

'Yes, *dao-mei.* But we know better, Deputy. And so we have an obligation to continue with his work.'

The *tong zhi* kneeling with effort and helping to wrap, in shirts long past their best, certificates of merit, letters of commendation.

'Speaking of which, the CD-Rom that your Senior Investigator gave to me, I have studied it. The data upon it, you still intend to use?'

A nod.

'May I ask how, Deputy?'

A shake of the head.

'May I ask when?'

Another shake of the head.

'You are working to instructions and a timetable that your Senior Investigator gave to you?'

A nod.

'It would help to know when this tidal wave will occur, Deputy Yaobang. It would be best for me to prepare before the flood waters rise to my neck, if I am to be of help to you, and to realize the vision that your Senior Investigator and I shared.'

The Big Man sealing a box. A life now encompassed by cardboard and adhesive tape.

'Sixty days.'

'Sixty days . . .'

Watching as the Deputy folded a PSB dress uniform into the other box.

'Sixty days from now, or from when . . .'

'Sixty days from . . .'

Turning away, the Big Man, his stained cuff covering his eyes.

'From when the boss fucking died.'

'Deputy Yaobang, your Senior Investigator, he had very deep pockets, providing much that we can use against this *tai zi* and the plague that are the princelings. However, we do not wish to cut off the hand whilst manicuring the nails, do we?'

Shaking his head, Yaobang.

'I am a simple man, Comrade Citizen One . . .'

Holding up his hands to the *tong zhi*'s face.

'See, the dirt of peasantry still under my nails. Cut the words that politicians use and tell me what you fucking want.'

Smiling, the old comrade.

'I can see that I have lived amongst Politburo members for too long, Deputy. I will choose my words more carefully. There is some data that I would like removed from the CD-Rom that your Senior Investigator gave to me. It is data that is damaging to Comrade Qi, but which could damage our People's Republic even more deeply and irreversibly.'

This time holding his hands up to the Big Man's face.

'I too come from peasant stock, Comrade Deputy.

The soil of our land runs through my very veins, as does a deep love for our country and the Communist Party that I have now served for more years than I care to remember. I simply cannot be an accomplice to an action that will cause our great nation so much harm.'

Standing, pacing, his arms in passionate gesticulations.

'I do not wish to barter over this, Deputy Yaobang, and I do not wish to dishonour the memory of your fine Senior Investigator Piao by discussing this matter. But unless this data is removed from the CD-Rom, I cannot see that I can support you, protect you, and bring this *tai zi*, Qi, to the harsh justice that he so rightly deserves.'

Sealing the second box, the Big Man. A life stowed away in two neat rectangular containers.

'What is it that you want removed from the CD-Rom that is so damaging to our People's Republic, Citizen One?'

Staring out of the window, the old *tong zhi*. A woman gathering in her washing. Peasant stock; you could always tell: strong thighs and firm of buttock.

'Golden Rice.'

Helping the Big Man carry the sealed boxes into the small hallway.

'I want every reference to Golden Rice removed, and that includes the scientists' report and all formal records relating to it, Comrade Deputy.'

Smiling.

'The other evidence is quite enough to achieve the result that we all want.'

53

Article 41 of the Chinese Criminal Code states that anyone sentenced for a crime, and who is fit and able to work, 'shall undergo reform through labour', lao gai

Lao gai, country within a country. Twenty million 'criminals' filling its estimated 1,100 'reform through labour' camps, none of whom have needed to go through any judicial process. The police agencies with total power to impose a sentence upon you, without you having any right to legal representation. You may appeal against your sentence, but the very challenge against the injustice perpetrated against you is viewed in the People's Court as evidence of your lack of amenability to re-education. Such a challenge inviting a harsher sentence, and even when your sentence has been completed, the weeks, months, crossed off on the wall of your cell, there is no certainty of release.

Twenty million incarcerated citizens, larger than the workforce of Spain and almost equal to that of France. A workforce that is unpaid, that is fed the cheapest food and rudimentarily clothed, that has no holidays, healthcare, legal or political rights. But a workforce that

creates much wealth, that plays an important part in the national economy. In 1999 financial analysts estimated that just ninety-nine known *lao gai* had annual sales of over $842 million. These sales coming from a plethora of goods made for the domestic market and for export: toys, steel, cars, textiles, clothing, tea.

Lao gai is a country within a country. You will labour for twelve to sixteen hours a day, seven days a week without holidays or rest days, working day and night without sleep. You will work in hazardous conditions. Mines, where with basic tools you will rip minerals from the bedrock. Tin, coal, graphite, asbestos. You will work in foundries, brickworks, on production lines, and only if you look as if you are dying will you receive medical help. If you should die, for whatever reason, you will be cremated that same day. The reason for your death as hidden as the reason for your arrival at *lao gai*.

54

Ku-hai yu-sheng . . . *'alive in the bitter sea'*

Memories of memories, in unconsciousness, as blunt as pebbles on a beach smoothed by a thousand ebbs and flows of tides.

Rough, strong hands upon him, pulling him from water into the air. A needle, mercury bright, stabbed into an arm. Half-familiar voices speaking unremembered words. The chill of a vast concrete hanger. A judge, in a PLA uniform, mouthing rehearsed words in brief orchestrated minutes. An order shouted, rough hands once more upon him. A lopsided glance over his shoulder at the judge as he walked towards a Red Flag limousine; already sitting in its dark interior, the PLA, Colonel Qi.

Another needle into another arm. A brief car journey, then a lengthy helicopter flight, before another brief car journey.

Memories of memories, as blunt as water-smoothed pebbles on a beach.

*

'Where am I?'

In the corner, an old man, taut skin over sharp bones. Blinking.

'Where am I?'

Blinking again the old papa, before turning away from Piao. Inner sight to a more comforting horizon.

'Facility-4, boy. Where else?'

Words, barely audible above the wind, hot, sharp and spicy; blowing red dust plumes into a scarred sky.

A smile. Piao struggling to hold unconsciousness at bay. Tether it in place, until his own words, weakly fashioned, passed between his dry lips.

'I knew that our fates would cross, Righteous Mountain. I knew.'

**Lao gai Facility-4, Righteous Mountain.
The 'Two Rice Bowls', Jiangxi Province**

The day, it is dying. You witness it in the sun's blood orange fall, the shadow's leggy stance. The guards' obscenely gestured jokes as to what they intend to do to the crimson lipped *yeh-jis* in the village beyond the long road that you will never walk down.

The day is dying, and so are you. You witness it in the sickness that surrounds your heart, the fever that holds your brain in its grasp. You witness it in the fact that you cannot recall a life beyond where you now labour, that you cannot now remember the *long* that

you lived in for fifteen years, just the bright wired perimeters of this hell. And the loosely linked chains of prisoners, beaten from the fields to the potholed tarmac road, still sticky from the sun's hot breath.

Every inch of this place, now tattooed within you, and in the welt's stings across your shoulders. The names that you have given to each accommodation block. Mao, Xiaoping, Zhou Enlai. Corrugated roofed. Burning, grilling you in midday's onslaught. Chilling, freezing you in midnight's open-handed slap.

Each mark on every brick of your cell. The beetle, black silk-backed, that manoeuvres across the floor and into your waiting hand every night. The footprint of a labourer's boot who built this place, in the concrete cold floor ... your fingers tracing each free run of its ridged sole. Each as intimately known as a lover's lips. Every inch of this place known, except for the low building separated from the rest of the complex. The furthest building always in shadow, from which, without even being told, eyes are always averted.

*

'Old man. Old man ...'

Asleep. The old papa's mouth open, as a cave. His few teeth like stalactites. Asleep, but Piao, *lao gai* number F8932976886, asking anyway. Perhaps because a part of him not wanting an answer.

'The building. The low building. What is it?'

And no answer coming. The black, silky-back beetle

crawling to freedom from the bars of his fingers as sleep ensnares.

Freedom . . .

*

A morning as all others. Woken to a beating, the bamboo cane across the soles of your feet. Scrapings of rice from the bottom of the pot. Water the colour and taste of rust.

A morning as all others. A wash, naked under the stand-pipes, as the guards mock your body and your manhood. Trying to cover yourself, but all that you are and have ever been open to their scrutiny and jibes.

Duty rotas read aloud. Prisoners falling, beaten into line. Marching through dust to the paddy beyond the low building. A smile from the old man. Paddy water will have grasses growing beside it that can be eaten, and carp within its mud-clouded waters, common and mirror carp. Silver shrug as rough hands reach out to grab it, snag it from its world. Almost tasting its flesh. Piao smiling back.

A morning as all others. Hours bent, until unable to straighten yourself. The sun's merciless ride across your shoulders until sweat running from the tip of your nose and into greater body of the paddy water, until there was none left to drip.

And from a distant billet a chain of prisoners with no energy to run or to escape. No will, just marching, dead-eyed. All with the same shirt sleeve rolled up past

the elbow. From the low building in sickly shadow, double doors opening. Inside, just visible, pristine, white-coated personnel, spectacles glinting in the white sun. The chain of prisoners lost to sight. Double doors pulled shut. Locked. Red dust falling back to red dust.

From the corner of cracked, dry lips.

'What is this place, old man? What is it?'

Looking away, the papa, a life spent watching for shadows. Fearing the hand on the shoulder, the knock on midnight's door.

'It is our shame.'

'But what shame? Our People's Republic, it has many.'

Paddy water falling to olive, with the eclipsing shadows of the *lao gai* guards. And through the corner of his lips, a whisper.

'Tonight, tonight we eat carp.'

Smiling as he pointed to his open shirt. Mirror-scaled fish-tail of a carp slipping inside the front of his trousers.

'And tonight, I tell you of our greatest shame.'

*

The candle was hidden behind a hollowed-out half-brick in the wall. Matches slipped between the flaking concrete of the sleeping plinth and its steel foundations. A strip of rusty steel mesh, under a loose floor tile. Dull-eyed stare ... the carp gutted with teeth and bare fingers. What could not be eaten let loose from

the barred window. By morning the lean rats would leave no evidence.

Linen jacket wedged into the gap between floor and cell door would mask the smells of cooking. Smells to remind you of a home that you once had and of a life once lived. The old man pulling small slivers of anaemic carp flesh from the ivory bone and placing the pieces on the steel mesh over the burning candle. Across the carp fine shoots of river grass. Placed precisely, gently, as if stroking a young girl's hair.

'The art is in cooking the flesh completely through. A dirty fish the carp. It feeds on slime, shit.'

Gently prodding the fish.

'But not to cook it too much.'

Gently manoeuvring the candle.

'Things have a way of telling you that they are ready. Like a woman. See?'

Curling, the grass.

'It beckons to you.'

Pulling Piao closer.

'And it speaks to you. Hear?'

A fine sizzle and an aroma bringing tears to his eyes.

'Hear? Of course you hear. Eat me, it's saying. Eat me.'

Brown juice and a sliver of carp across the tip of the old papa's finger and onto Piao's tongue.

'Good, eh? Of course good. The best you have ever tasted.'

Eyes closed. A taste, as if never tasting before, as if life, and the countryside that fed it, had all come together in that instant. And within it, a fingerprint of the old man's sweat . . . the old man's life.

'Yes. The best that I have ever tasted.'

Smiling, the papa. Carp to his fingers, to his lips and to his tongue. Smiling again.

'Eat. We might not be on the paddy field rota for weeks, months.'

Piao, his fingers teasing the carp from the steel. Flesh, branded in mesh diamonds. For many minutes just eating. The thought of words, a violation. Their mouthing, a sacrilege. Only when the old papa burped, wiping his chin of the carp's juices, did Piao feel that he had been given licence to talk.

'Tell me of the shame, old man. Tell me of our greatest shame.'

'They come for you. Take you, four at a time. Always four.'

Moving the fish around on the mesh.

'You always know it will be you, that's the worst of it. He comes a day, two days before. He takes your measurements. Height. Weight. Callipers, checking your fat levels. Fat levels. More flesh on this carp than on any of us. Blood tests also. Rarely he rejects you. Rarely. I have been lucky so far. Thank the ancestors.'

Spitting to the floor. Coughing.

'Too old for him. Too ill. Too near meeting the ancestors, I suppose.'

Piao, taking carp from the mesh and feeding it to the old papa.

'That place, it is not a hospital. A hospital releases those that it cures. But no one that walks through those doors ever returns, do they, Comrade? No one is ever cured.'

His eyes meeting Piao's.

'Cured?'

Laughing with the gums of a baby.

'Perhaps they are cured, Young Comrade. Death after a life such as this could be seen as a cure.'

Blowing out the candle, the old man. The light, fading from his eyes.

'Such shame in that place. Our greatest shame.'

'What is this greatest shame, old papa? That it is a place in which to die? '

One by one, licking his fingers the daddy, until they glistened.

'You have much to learn, Young Comrade.'

The rough blanket pulled over his emaciated shoulders.

'Did you not know? There are worse things in life than death.'

*

They came for the old papa at night, a day later. Still in their mouths, the taste of carp and young river grass.

Piao, moving forward, but beaten back. Forward again. The bamboo cane's kiss across his cheek. A

welt from the corner of his eye crossing his mouth to
his chin, in a raw red warning of silence. With all of his
might, pushing against the guard's strength. Too weak
to help. Watching as they pulled the old papa from the
cell, his eyes wide with fear. Toes dragged over concrete
and dust. Watching his tears fall silently. The old man's
lips in a soundless chatter. In the corridor more guards,
and moving from the shadow into the light, a tall figure.
His smell of complex things, of medical things and dead
things, but flooded in an overpowering odour of red
roses. Soap of red, red roses. The old papa, resigned; no
energy, no will to fight the callipers' pinch, the measur-
ing, the weighing. The list of medical questions, answers
demanded and given in a faltering voice. The tall man,
his Chinese clumsy. A nod, and last words.

'Bring him, and the others.'

Piao, face to bars, watching them, move down the
corridor, and only as they were almost lost to the night,
Piao able to find the words, baptized in blood as sweet
as Shaoxing rice wine. Shouting, its echo rebounding.

'Pasechnik. Kanatjan Pasechnik.'

The Russian turning, moving back down the corri-
dor with a steady footfall. Eyes to eyes with Piao,
through the rusted bars of the cell door. Then the
Russian smiling. His finger pointing.

'The Senior Investigator, isn't it? Yes, Comrade Qi
told me that he had sent you here.'

Moving from the bars with purpose and back down
the corridor towards the night.

'Do not fret, Senior Investigator. I shall return for you in precisely seven days, and you shall be my guest. My very special guest, I promise. And I never break a promise.'

And at that moment, a decision made. Not to struggle in futile resistance, but, like a video camera, to record all. To label each scream, number each beating, catalogue each abuse, until one day those who perpetrated these acts stood bound in justice's harsh dock.

55

*'Communism is not love. Communism is a
hammer which we use to crush the enemy'*
The Great Helmsman

And on the seventh day

Sour, medicated air. A room, harshly white. Pegs on
one wall, hanging from them like anorexic bodies, full-
length visored suits, strung with the piping and gauges
for their own independent breathing units.

A room leading from that room. The walls and floor
tiled. Large shower cubicles, heavily rubber curtained. A
collection of large scrubbing brushes and disinfectants
in prime colours. On another wall, behind bright glass
cabinets, sharp and shiny medical instruments, beside
them a large refrigerator set into steel. Also set into
steel, a large rubber sealed door with a triple glazed
window and bordered by complex gauges and CCTV
monitor screens. Grey, protective-suited figures moving
around grey iron beds encased in thick plastic tents.

Piao, his fevered brow against the window's cold
glass in a smearing of perspiration.

'What is this place?'

Pasechnik, the Russian, beyond the broad khaki shoulders of the guards, beyond the shadows of their rifles.

'I think that you already know, but let me demonstrate. We are after all, world leaders in this area of research.'

Pale fingers to a control panel set in the wall. Above a distant bed, a CCTV camera slowly arcing into position. A stuttered panning over the leadened monitor screen. Stopping, zooming in, focusing. In the anonymity of a middle bed, polythene sheathed, in its sweating shroud, the old papa. Shackled to the steel bedstead. Across his sunken naked body, a pestilence raging. The Senior Investigator, with difficulty, remembering his vow to bear witness, at all costs.

'I have brought you here because I thought that you would like to see the progress that your friend is making.'

A smile, stalking slow across his features, as a shadow across a wall.

'Days one to three, the pre-eruption phase. A period of flu-like symptoms, punctuated by high fever. Days four to five, the first appearance of papules, "elevated bumps". The first appearance of pustules, "bumps containing liquid".'

The Russian's voice calm.

'Day six to ten, the papules and pustules phase. The eruptions covering the whole of the body area. Bursting, weeping. The infected patient now highly contagious.'

Then almost with pride.

'There is no known antidote. One in three patients dying of generalized toxaemia, or skin sloughing, or lack of immunity to further infections. This unique strain of smallpox runs its course within two weeks.'

The old papa, his heavy eyelids swollen by pustules, for an instant opening. The fingers of a tethered wrist lightly against the inside of the oxygen tent, in a faint fanning. And then his energy dissipated. Fingers slithering down the inside of the oxygen tent, falling back to discoloured sheet. His eyes rolling in upon themselves to a secret universe, known to only himself.

'Why?'

'You are an intelligent comrade, Senior Investigator. You already know why. Do you not?'

Piao, knowing that even to say the words was somehow to share the guilt. Yet not to say them was a blasphemous denial.

'Zhong Ma.'

'Very perceptive, Comrade Investigator. But in a few days from now, once I have obtained the necessary authorization, you will complete the tour of this facility and will take those words to your maker . . .'

Smiling, the Russian.

'An authorization that I very much look forward to receiving.'

56

Inarticulate grunts from an empty mouth, over *dukang* glistening lips. Spinning in the Wizard's fingers, a silver disk. A deep breath. Pushing the CD-Rom deeply into the drive. A series of clicks. Back door manoeuvres. Hacking protocols. Qi's PC, its files open, accessible.

The Wizard sucking the straw deeply, warm *dukang* swimming to his throat. Tongueless words swimming out and gagged words aimed at the monitor's scroll. A constant grunting commentary. But in his own head sparkling words, cool and beautiful words. Perfectly formed and delivered.

Gagged words of regret as he highlighted whole tracts of data, technical commentaries, field test reports. His finger hovering over the delete button. A mistake, he was sure, but the Big Man had been adamant. A shake of the head. A push of the button. All references to Golden Rice banished.

Loading the data from the disk onto the front of File Twenty. A key to the door. Codes decoded. Names where there were initials. Positions, government depart-ments, political organizations where there had been abbreviations. Also darker things. Video footage, stills,

the gape of a cut-throat's kiss. Clasp of knuckles frozen in concrete. PLA faces, smiling. And other data, a regular trickle from Piao and the Big Man, now all incorporated into a dam-busting tide.

Accessing the Internet through Qi's PC. His user name, code name, known only to the comrade himself, but broken months ago. A few useful tips picked up on the net. Hacking tutorials. A protocol snipped from a hacker's forum. Character by character, typing them in.

Compose. Downloading the email addresses that the email, with its voluminous attachment, were to be sent to. A hundred lines, more. Every name in File Twenty to get a copy. Every political organization. Every media outlet in the People's Republic. Every Internet café. Beyond the Republic's protective virtual firewalls, the free flowing World Wide Web. The outside world. Copies of File Twenty to foreign media organizations, human rights monitoring agencies.

SEND. His finger to mouse button. Virtual hand, pushing virtual button. Hundreds of emails winging their way. Black flock of characters, entering departments, crossing desks. By-passing lemon-sucking-mouthed secretaries. Vaulting committee agendas. Black flock of characters, burning through diary pages. Scalding across international boundaries. No appointments, no knocks on doors, no protocols ... no fucking manners.

The Wizard pouring himself another full glass of *dukang* and sitting back, watching the flow of emails

flying to their hosts. Data that would stick like mud. Data that would be as fish bones to high *cadre* throats. A fogged mantra in spittled trail over his lips. A quotation that he had seen on the World Wide Web a long time ago.

'You can't take something off the Internet – it's like trying to take piss out of a swimming pool.'

Thinking it, hearing it in the voice that he once had. Holding the *dukang* to the monitor, the Wizard. Glass to glass in salute, drinking.

'Sixty days. Sorry you're not here to enjoy the party. But may the ancestors guard you and be as generous with their *dukang* as I am with yours, Sun Piao.'

57

The Great Hall of the People,
Tiananmen Square, Beijing

Sixteen hours later

Tableaux of the Long March, the *Gongchandang* triumph, the period of the Hundred Flowers. Portraits of the heroes of the revolution, Mao Zedong, Zhu De, Zhou Enlai, Liu Shaoqi, Chen Yi. Blood on cheeks, fire in eyes, bodies at feet. Heroes of the revolution. Their chests puffed out in pride, rifles still smoking.

The top of the pyramid, the high *cadre*, no one below grade seven. A smell of septuagenarian breath, dark wood-panelled walls, Italian leather shoes and incontinence's yellowed weep. A smell that held the breath at bay. And in the pit of the stomach, the unease of power, the sense of something decisive, inevitable and fatal about to occur.

Polished shoes across the lacquered wood floor. Others from adjoining offices joining them in purposeful walk towards the dark oak committee rooms. The highest *cadre*, the look of a man who would never have need of the help from another man.

'A mess, a terrible mess.'

A voice like concrete being mixed. They all nodded, the comrade was the current General Secretary of the Central Secretariat, the highest-ranking *cadre* amongst them, a grade two. High enough to be in sight of the very top of the pyramid.

Yes, they nodded. With a *cadre* of such a high grading, no other action being appropriate.

The doors of the Great Hall of the People, flung open. For some seconds, the General Secretary, minions flanking him, staring into its empty vastness: 10,000 seats; 10,000 with one voice. A shiver running up his spine, every time. Every time. Eyes drifting to the illuminated red-star ceiling. A vast and glorious rubric sun. His eyes, tear misted. Even though a grade two *cadre*, a general secretary of an important organ of the Communist Party, not embarrassed to wipe the tears from his eyes with monogrammed handkerchief. Indeed, making a show of the very act. A sudden and urgent feeling of benevolence in his heart for the proletariat.

'"Know this, that it is not the tree which chooses the bird, but the bird which alights upon whichever perch he pleases."'

Dabbing his eyes once more.

'Look around you. Look at the heroes of our People's Republic gazing down upon you. Can you not feel their blood coursing through your veins?'

Words ragged with emotion.

'That bird has chosen us, Comrades. It perches upon our branches as I speak.'

Turning. Walking. A phalanx of neat Italian suits, turning, walking with him. Footfall matched, but just a few steps behind.

'Come, Comrades, we have decisions to arrive at. Difficult decisions that fall upon the shoulders of those whom the bird has chosen.'

Leading them to an ancillary room, decorated in the style of the southern lands and peoples. The Bai, the Lisu, the Yi, the Naxi, the Va. Timber from the jungle valleys between the Salween River and the Irrawaddy. Animal skin seats, still musky, still earthy, from the hills around the boundaries of Guizhou and Hunan Province.

One hundred and fifty the room could seat comfortably, but only eight behind its closed doors. A trusted and powerful eight. The meeting would be brief, but to the point. The General Secretary's eyes falling onto the comrade furthest from him. A raise of eyebrow, a prompt to him to speak, to sweat.

'We have limited the Internet exposure of the files in question, Comrade General Secretary. Several western websites had posted a full transcript of the file. The ISPs that allowed these to appear are now not accessible from the People's Republic.'

'ISPs?'

'Internet service providers, Comrade General Secretary.'

Nodding, smiling, the General Secretary. The young *cadre* basking in the approval.

'The search engines of Google, AltaVista, Yahoo cannot now be accessed from within our borders. Our Ministries of Information and Industry have already issued ISPs with a set of new regulations that they must adhere to.'

Dabbing his forehead with a handkerchief devoid of monogram, the young *cadre*.

'I have posted a full set of these new regulations to your office, Comrade General Secretary. These will make it impossible for such an occurrence to happen again.'

The same nod. The same smile.

'So the situation is contained?'

A raise of his eyebrow.

'We have contained what we can contain, Comrade General Secretary.'

'Explain?'

'Comrade General Secretary Sir, we can do little about the file and its details being out there. This information is now in the public domain.'

'It cannot be erased from the Internet? Removed?'

'It is impossible to do so, Comrade General Secretary. Once on the Internet it is as water into water. They cannot be separated.'

'"Water into water". Very poetic, Comrade. Very graphic. And what is your assessment of the situation?'

Noticing the reticence written on the young *cadre*'s face.

'Say what you need to say, Comrade. In this place, in this situation, we need to give expression free rein.'

Hand to mouth, coughing, as if the words were choking him.

'Comrade General Secretary, there will be much fallout from this episode. The files and what they contain, especially the video footage.'

Interrupting him, the General Secretary.

'In a situation such as this there is only one effective strategy. Denial.'

'Yes, of course, Comrade General Secretary. My department has already been briefed. Our news agencies will also be briefed this afternoon and will be releasing articles pouring scorn on the files. Denying that the files and what they contain are authentic. Blaming it on undesirables, enemies of the People's Republic, political extremists. Statements and press releases have already been prepared.'

'Good. Good . . .'

'But, Comrade General Secretary, this case is different. It has complications.'

'How so?'

'The released files contain details, names, facts that can be tracked stage by stage. Denial will not be enough. Human rights issues will be raised about some of the bars and other "business enterprises" named in the files.'

A nervous sip of water. Dab of linen over sweating brow.

'And there are the Olympic Games, Comrade General Secretary. You will recall that the video tape of the murder of the young woman took place underneath flags bearing the symbol of the Olympics itself. The Olympic Committee will not wish to be associated with murder. It is already under pressure from powerful nations to act and to act swiftly. An emergency meeting of the IOC has been called for tonight in Geneva.'

Clearing of his throat. Nerves getting the better of him.

'We are fortunate enough to have sympathetic friends within the Olympic Committee. These friends have already been contacted. However, we will not manage to keep the Olympics unless we make some changes, some concessions. Unless we offer something in exchange, Comrade General Secretary.'

The high *cadre* thoughtful. His silence haunting the room. Nodding his head.

'You will liaise with the Ministry of Security and put onto paper some ideas. Change with a small "c", yes? But changes all the same. At all costs, we must guarantee that the Olympics take place in the People's Republic. I will expect your thoughts on my desk by this evening.'

Smiling. The subject closed.

The high *cadre*'s eyes focusing on another comrade's

face. An older comrade, gnarled and tortured face like a bonsai tree's bark.

'Tell me, old friend, this information, these files, do we know where they emanate from?'

'Yes, Comrade General Secretary.'

'The source has been traced with certainty? With one hundred per cent certainty?'

'Yes, Comrade General Secretary. Our computer experts have checked and double-checked its path to its origin. They all agree, with one hundred per cent certainty.'

'It is the citizen that we have previously discussed?'

'Yes, it is, Comrade General Secretary. The files were traced back to the hard drive of Comrade Colonel Qi's computer.'

Sentences, rasped whispers. Like blunt bladed knife's cut through stubborn material.

'But why would Qi, a most privileged *cadre*, post notice of his own crimes on the Internet? Why would he open these files to such scrutiny?'

'It came from his computer, General Secretary. But . . .'

'But, old friend?'

'But it does not mean that it was the owner of the computer that sent the information from it.'

'But then who did?'

A shrug of the shoulders.

'It is impossible to say, Comrade General Secretary,

Sir. But it is unlikely that it was the Comrade Colonel himself. What would be the purpose of such an act?' However, what is certain is that these files and the information upon them do belong to Colonel Qi.'

The gnarled comrade, his gaze firmly on the General Secretary.

'It is my view, Comrade General Secretary, that this episode is not about money. It is about power. This PLA traitor and his cronies, they test the old ways.'

An experienced politician, looking around him, making sure that his was not the only voice.

'We must curb the power and growing financial independence of the People's Liberation Army, and of the *tai zi* who ride on the shoulders of their esteemed families' names. We cannot have a state within a state, Comrade General Secretary. Everything must start and end with the People's Republic. We must obey the will of the proletariat.'

The applause that met this statement allowing the General Secretary to gather his papers and indicate that the meeting was now concluded. He had his mandate.

'Thank you, Comrades. Thank you. Your input, as ever, is most valuable. Most valuable.'

Walking to the door.

'For now our strategy will be that of denial. A more proactive policy will be developed in time to address the other more far-reaching issues raised.'

Walking into the corridor, a wave of blue hand-tailored suits in his wake. For several minutes, the

Comrade General Secretary standing motionless in the corridor. A rock at the centre of a river's rapid flow.

Whisper of words to the gnarled comrade still at his shoulder.

'Old friend, the message that I received this morning, it needs to be answered. Not on paper, nor on a telephone. A delicate matter. I wish you to take a verbal message, my old friend.'

Pausing as he considered the appropriate level of diplomatic politeness.

'Tell the comrade that I am highly honoured by his invitation and will see him tomorrow. His esteemed views I will be pleased to listen to, although I have already decided upon a course of action.'

The Comrade General Secretary, his gaze raised to the Great Hall's crimson starred heavens.

'Yes, tell Citizen One exactly that.'

58

The Penthouse Suite, the Heping, Hotel of Peace

The room and rooms running from it, electronically scanned. Strong fingers unscrewing telephone mouthpieces, ceiling roses, electrical points. A small but powerful electronic scrambling device activated. Any mobile telephone signals jammed, listening devices silenced.

Tea poured into china cups. *Xunhuacha*, the finest tea available. Rose-perfumed. Smiles and sips. Talk of the weather, the brightness of the room, of the artwork upon its walls, its lavish plasterwork coving and the beauty of its Art Deco features.

A nod. Double doors closing. Citizen One on one side of the table, on the other, the Comrade General Secretary. Between them an expanse of walnut; rich golden grain imprisoned beneath a thick skin of varnish.

A sip of tea. Security procedures and formal pleasantries exhausted.

*

Comrade Citizen One, your timing it is impeccable. But not wholly coincidental, yes?'

The old comrade stirring the tea and taking a sip. Not replying. Sometimes it is best to still the lips for the purpose of sharpening the mind.

'I gather that you will be aware of our little problem, *Tong Zhi*?'

A curious phrase to use, "our little problem". Curious and dangerous.

'You will have seen the wild accusations that were placed on the Internet. But the situation is now all in hand, *Tong Zhi*.'

Citizen One not responding.

'There are, of course, concerns. The adverse publicity, the potential threat to the Olympic Games.'

The General Secretary's eyes cast down. Too much to be seen within them.

'However, I have ordered a concerted campaign of denial, *Tong Zhi*. As we speak, our mighty press is denying that the video footage or the photographs within these files are genuine.'

'But they are genuine, Comrade General Secretary.'

No response from the politician.

'We are also countering strongly the allegation that prostitution, at the epidemic levels that would appear to be the case from the figures seen in the reports, actually exists.'

'But it does exist, Comrade General Secretary. And our beloved People's Liberation Army is living off it. As are some of our most noteworthy high *cadres*.'

Exasperation now in the General Secretary's words.

'We have also been in close touch with the International Olympic Committee. They held an emergency meeting yesterday in Geneva to discuss the situation. I have not yet had the results of that meeting, but I am extremely confident that they will find in our favour.'

'Confident, General Secretary? Extremely confident?'

'Completely, Citizen One. A number of our more prominent supporters within the movement have accepted an invitation to visit us, once the fuss has died down a bit. They will be suitably rewarded.'

'And how will they be "suitably rewarded", Comrade General Secretary? Perhaps with under-age whores, of whom there would seem to plenty at the Dedo Club in the Bailemen Hotel? Or the Shanghai Moon Club? Clubs in which your colleagues, Comrade Peng and Comrade Lui, appear to be the majority shareholders.'

Laying his cup down. Staring deeply into the *tong zhi*'s eyes. Power, authority, anger, a cocktail not to be drunk lightly. Standing, the General Secretary, his arms braced solidly on the table.

'I have been patient in listening to you, Citizen One. Very patient. Even though your star has waned and your lineage is in its grave. Still I have listened. But I take no advice from one who lives on a charity given over half a century ago.'

His face flushed purple as he walked towards the double doors.

'And I take no orders from one who does not have

the power, the authority, or the muscle to back them up.'

Pulling the doors open. The security officers standing to attention, their cheap linen jackets tensing over slumbering pistols.

'Go back to your *mah-jongg* and your aged courtesan, Comrade Citizen One. It is safer. Die in your own bed, *Tong Zhi*, and not in some ugly place.'

The reply disconcerting in its calmness.

'I suggest, Comrade General Secretary, that you turn round and read what it is that I have in my hand. It could save you your position within the People's Republic. Perhaps even your life.'

A second when everything hung by a single thread. Out of the corner of his eye, the General Secretary recognizing the seal at the top of the sharp-cornered letter. The seal of the President's personal office. Turning, the comrade, walking back to the table. Accepting the letter from Citizen One's hand. A nod to the security officers. The double doors closing.

'I am sure that you recognize the signature and seal of authority of the President of the People's Republic of China, Hu Jintao.'

Halfway through reading the letter, sinking to the chair.

'Our new President is a personal friend. We often play *mah-jongg*. A thoughtful player, Comrade Jintao. Before every move, much, much thought. Never a

decision made without assessing every risk and taking into account every angle.'

The letter falling onto the table.

'And much, much thought in the writing of this letter, giving me total authority, in the handling of this situation. It appears that my star has not yet waned, Comrade General Secretary. But, since fate has declared that we must work together for the greater good, let us waste no more time. This is what I require of you.'

The General Secretary, survivor of the Cultural Revolution and a dozen other purges, already adjusting to the new situation. Neatly folding the letter and handing it back to the *tong zhi*.

'First you will order the immediate arrest of Comrade Qi and his princeling associates. Your instructions on how these murderers and traitors shall be dealt with will follow. Then you will order, through the PSB, an immediate purge on the "old" of prostitution. Their Vice Squad will be resurrected and afforded appropriate, no, more than appropriate funds.'

The General Secretary taking a pen and gold-cornered notebook from his inside pocket.

'You will also order an amnesty for the PLA, the PSB, and the highest *cadre* within our government and Party apparatus, to disclose and surrender any business interests that they may have in this vile "old" that causes so much misery.'

Waiting for the Comrade General Secretary to finish writing.

'You will arrange for the murdered young women's bodies, entombed in concrete, to be recovered from the waters in the vicinity of Big and Little Yangshan Island, Hangzhou Bay. The exact coordinates will be furnished to you. These young women's funeral costs and those of Qi's other victim's who are still in the mortuary will be met by the Party in full.'

Citizen One taking a letter from a file.

'A letter from the International Olympic Committee. News from the meeting in Geneva. I had it intercepted. Your confidence was ill-founded, Comrade Su-Tu. It is being recommended that, on human rights grounds, the Olympics be withdrawn from our country. It is being recommended that they be held in Athens once more. Where, and I quote from the head of the IOC, "the atmosphere is more conducive to the ideals of the Olympic movement".'

His gaze riveted on the General Secretary.

'For the sake of the People's Republic, we must work together to find a way of preventing this disaster, Su-Tu.'

'I'm flattered, Comrade Citizen One, that you should regard me as a colleague.'

'Colleague! I do not regard you as a colleague. Your role in this is simple. You will find a way to push the shit back up the horse's arse, Comrade General Secretary. Or you will find out how the will of the People's Republic can be fashioned into the shape of a bullet.'

The General Secretary nodding submissively.

'Here are some detailed orders together with all of the necessary briefing papers, and some ideas that I have fashioned that might focus your thoughts, Su-Tu.'

Handing a substantial file to the General Secretary.

'I know that you are familiar with Golden Rice, Su-Tu, because, in the name of the People's Republic, you contributed several million dollars towards its development, as did a number of other countries. What you do not know, however, is that although the official reports about Golden Rice were most favourable, that was only because dissenting voices were brutally repressed. In essence, Comrade General Secretary, Golden Rice is a myth. It does not deliver the promises that our Colonel Qi claimed, to you and to others.'

Su-Tu nervous, feeling his way, but still his mind functioning with the clarity that had got him to the top of the pyramid.

'The key question is, and please correct me if I am wrong, Comrade Citizen One, whether those nations who invested in Golden Rice still believe in it.'

'Yes, they believe in Golden Rice, but the very existence of a dissenting report makes that position untenable.'

The General Secretary waiting for the point of this exchange, but not having to wait long.

'As an experienced politician, do you see how we can extricate ourselves from this situation in which we find ourselves?'

An inner smile, but Su-Tu keeping his face of polished jade.

'Legality, the politician's first port of call. And legally whatever contract was drawn up with these countries could simply be torn up, Comrade Citizen One. They were dealing with rogue elements within our People's Republic. They had no official negotiations with the Party, and so no understanding exists. But to admit to such would be a great loss of face, and to tear up such a contract would alienate us from these countries.'

Standing.

'However, and if I might be permitted, Comrade Citizen One.'

A nod of the head.

'One could allow this agreement, this understanding, to still go ahead, but a rider could be added to it, unwritten, of course.'

'And what would this addition to the agreement between our countries consist of, Comrade General Secretary?'

Carefully stepping, ready to change the direction of his journey at the merest hint of disagreement or disapproval from the old *tong zhi*.

'They would be delivered their Golden Rice and the technical data to assist their own research programmes, and we would be delivered their vote within the International Olympic Committee.'

'And what about other rice-eating nations within

the IOC? I refer to those who are not involved in the development of Golden Rice?'

'Of course, Comrade Citizen One, how remiss of me. Such nations would, of course, be allowed to benefit from Golden Rice, but perhaps at slightly less advantageous terms. They would understand that the initial investors would expect some reward for their risk. And of course their solidarity in respect to their dealings with the IOC.'

'And the IOC members who represent non-rice-eating nations?'

'They would simply receive a substantial bonus to their consultancy fees that they received for voting for us to host the Olympics in the first place.'

The *tong zhi*'s look of disgust and reluctant admiration.

'I can see, Comrade Su-Tu, that there is some truth in the saying that the prospect of the firing squad serves to concentrate the mind.'

The General Secretary more confident now, ignoring the comment.

'However, Comrade Citizen One, if we look a few years ahead, the outcomes are even better. Either our scientists will have succeeded in solving the problems with Golden Rice – in which case we will reap the benefits of our boundless generosity, or . . .'

The Comrade General Secretary, with the experience of a thousand committee rooms.

'By then, Comrade Citizen One, we will have had

our highly successful Olympic games, this great show-case for our nation.'

Smiling.

'And what air you breathe cannot be taken back. And as we will undoubtedly be the strongest economic power in the world by then, we will simply smile and apologize. Voice our most profound regrets and refund all of the investments into Golden Rice at a handsome premium. Golden Rice, which at first had held so much promise, but which turned out to be rather a disappointment.'

'Yes, good Su-Tu. Very good.'

'But, Comrade Citizen One, America may be a different matter. They will wish to rub our noses in this unfortunate situation that we find ourselves in. They will wish to make political capital out of what was placed on the Internet.'

Rising, the *tong zhi*, leading Su-Tu to the door by his elbow, as the master leads the hound.

'America, General Secretary Su-Tu . . .'

Walking through the doorway, the comrade, and into the corridor. Security officers moving into position.

'Yes, a problem, America. Always a problem . . .'

Pushing the indented button to summon the elevator.

'But I am sure that a plan will fall into our laps. Yes, something will fall into our laps, it normally does. '

'Is there something that you know that I do not know, Citizen One?'

Elevator doors opening. Pressed steel and mirrored walls. A thousand Citizen Ones in endless ranks of reflections.

'Comrade General Secretary, there is always something that I know that you do not.'

59

In the background of the call, noises that the old *tong zhi* missed. A baby crying, a couple arguing, a drunk singing and a child playing at being a soldier. *Renao . . .* life, hot and spicy.

Shaking his head. He had grown apart from the people, with the tobacco-hued soil of the land long since scrubbed from his fingernails. A penthouse suite at the Heping, the Hotel of Peace, had its compensations, especially for an aged comrade as he. But what were the sounds of such a place? Just the music of the till registers, the repetitive melodies that sang from the elevators, gold-toothed crooners singing songs of other cultures and American tourists complaining about their arthritis and the water pressure on the fourth floor.

'*Ni nar.*'

'Deputy Investigator Yaobang, I got your message. You wish to talk to me.'

'Who the fuck is this?'

Laughing, the old comrade.

'Someone that you first met as a child within a painting, Comrade Yaobang.'

'Shit. Sorry Comrade Citizen . . .'

'Do not speak my name, Deputy. Walls, they have . . .'

'Ears. I know, Comrade. But this is too important to piss around.'

'What do you want of me, Deputy?'

'The Boss, Comrade. The Senior Investigator, he's alive.'

'What?'

'Sun Piao, he's alive.'

'You know this for sure, Deputy?'

'He's in a *lao gai*. Facility-4, near Poyang Lake in Jiangxi Province. They call it Righteous Mountain.'

'Deputy, these details, how do you know them?'

'Qi's computer, we intercepted an email sent to it two hours ago by the Russian, Kanatjan Pasechnik. I have it here. It says, "The investigator, Piao, do I have your full authority in this matter". They're going to fucking kill him.'

'Calm yourself, Deputy.'

'We have to act swiftly, *Tong Zhi*, or it will be too late.'

'Deputy, these words do not mean that they intend to kill your Senior Investigator.'

'*Tong Zhi*, the fucking PLA princeling sent an email back to Righteous Mountain. "He is yours, Pasechnik. Use your imagination with his death, but leave no evidence. Not a bone".'

60

Only now moving out of lands of unconsciousness, of soft, cloying shadow lands. Aware of shouting, but not the words that made it up, and of hands upon him, hauling, lifting. Of a lightness to his head, heart, limbs . . . as if flying.

Light over light, splintering, and a noise invading, metal rotors slicing, clapping the air. Turning his head, opening his eyes and seeing through the open door the night on fire. Sky, the colour of a *yeh-ji*'s painted lips, with fields and storage buildings on fire.

Above him the Big Man's face. Water dribbling to his lips from the tin mug in the Deputy's hand.

'Drink, Boss.'

Unable to speak, just see, in detached glimpses. Hurdle of barrack buildings shooting past. Head-lit gleam of razor-wire in quicksilver dash. Olive green, chased by black; another helicopter, unmarked, peeling away in a sharp arc. And then scrubland, wasteland, beyond Righteous Mountain's grasp, as if they had reached the very edge of the world.

Unable to speak, just hear, in chaotic snatches.

'Only just managed to get you out in time, Boss.'

Metal door hauled to. Air, sound, decapitated. A navigator shouting figures, directions as numbers.

'What happened?'

'You were snatched, Special Forces, Boss, the Immediate Action Unit. You're on one of their helicopters.'

'Where to?'

'We're heading north. It's all been fucking arranged.'

A map being unfolded, out of focus above his face.

'We cross here, Lake Xingkai, Heilongjiang Province. Refuel here and here. And end up here.'

Red line of a flight path intercepting the black mass of a major centre of population.

'Safe, Boss. An old comrade of Citizen One. A clinic and a *zhau-dai-suo* . . .'

More water, sweeter than any he had ever tasted.

'They'll get you well, Boss. Fit and fucking well.'

Answering the question in the Senior Investigator's eyes.

'And Citizen One says you must be out of Shanghai, a long way out. He says that a hundred flowers are about to bloom, and that you would know what he fucking means.'

A hundred flowers – a hundred blood-red roses. Yes, he knew.

'It's up to him now, Boss. All up to Citizen One.'

'Pasechnik?'

'IAU were supposed to snatch the Russian as well, Boss, but no sign of him. Looks like he left in a fucking hurry.'

Piao agitated. Attempting to sit. So many words queuing, half-formed, across his tongue.

'Tell. Tell him . . .'

'Who, Boss?'

'Citizen One. Tell him . . .'

Reaching for the water with blind hands. The Big Man holding the cup to his trembling lips.

'Tell him what, Boss?'

'Low building. Low building. Tell him, the low building. Shame, our greatest shame . . .'

Helicopter rotors thudding through darkness. A sickening turn. Heading latitude 45° North, longitude 132° 25' East. The snow entrenched wasteland borders.

'I don't understand, what do you mean, Boss, "our greatest shame"?'

Unconsciousness as black water swirling, reigning, pulling Piao in.

'Tell him, Zhong Ma. Another Zhong Ma.'

61

Kill one to warn a hundred.
A hundred, to warn ten thousand . . .

Nothing in writing. No words on telephones, even prefix 39 numbers. No emails. No faxes. No use of intermediaries. Just words. Mouth to ear. Whispers in dark wood-panelled committee rooms. Words as instructions, as sentences. Words as daggers to hearts.

*

Their footsteps in harsh unison, through corridors leading to corridors. Exactly knowing where to go. In a warren of committee rooms. Executive offices. Party chambers. Knowing exactly where to go.

Ten medium- to high-ranking *cadre* names on Colonel Qi's email, transferred to a neatly typed list. Ten *cadres*, their feet in the fetid waters of 'the olds'. Ten *cadres*, their sell-by dates long past.

Ten offices simultaneously entered. Ten identical sets of ink-stamped documents presented. No introductions. No need. A scenario that every citizen of the People's Republic had woken to, sweating, in

the dreams that pepper the anonymous hours of the night.

Eight of the ten accused in the dock. Justice for the other two less formal. Sixteen minutes the trial lasting. Two minutes allotted for each of the accused. Each minute carefully rehearsed. Outcomes determined at the very highest levels of the Party hierarchy.

The Judge of the Supreme People's Court standing. His words, few, a good bottle of full-bodied Cunxian rice wine from Jiang Su, and an open-legged mistress waiting.

'*Lao gai* for a period of not less than twenty-five years. May the education through labour that *lao gai* affords forge new and worthwhile comrades of you.'

At the back of the court, a comrade moving out of shadow, through the doors and down the corridor. An old comrade, the heavy double doors of the Supreme People's Court held open for him. Pulling up his collar. Chilled, although the weather was warm. A curse of old age, to be out of step with all around you.

Smiling. By this time next week, there would not be a high-ranking *cadre* within the People's Republic who did not have knowledge of the ten. Who did not fear the knock on his own door. Who did not fantasize about such a shadow falling across his own life. Although the charges were read out in secret, each word of them would be the currency of gossip. Each word of them, in travel down the *xiao-dao xiao-xi*, 'little road news'.

By this time next week there would not be a high ranking *cadre* in the People's Republic who would not be scrabbling to sell his stake in a karaoke sex bar or hostess club. Who would not be revisiting his false expenses claims, or his plans to siphon monies from a building contract cheap materials scam. By this time next week, there would not be a high-ranking *cadre* in the People's Republic whose ambitions would not have been blunted, or whose attentions had not been diverted towards the proletariat, rather than the purchase of a second *zhau-dai-suo*.

The chauffeur opened the Red Flag's door and helped Citizen One into its moody, leather interior. The *Hong-qi*'s door closing. Streets, *long*, passing by in silence. Lives reflected in a thousand shop windows.

Smiling. An old lesson once more put to the test.

'For a threat to threaten, do not shout it, whisper it.'

62

There is a belief that old fishermen have, rarely spoken and dwelt over at one's peril. They will tell you, as the smoke from cheroots casts riddles over their faces and as fingers go to scars from the fishing line's snag, burn and tear. They will tell you that in the end the plundered sea takes back, in kind, what has been stolen from it. Kilo by kilo, metre by metre, soul by soul.

That is the belief that old fishermen have.

Big and Little Yangshan Islands, Hangzhou Bay

Silence fractured. Curses. Pleadings. Bribes. Screams.

It took six officers to carry each of the PLA *tai zi* from the cargo hold to the deck. A torturous procession. Two officers, in a cradle of linked arms, supporting each body. Four officers, gloved hands, to each of the large concrete 'shoes' that encased each comrade's legs.

At the bow of the *Shining Path*, a Dayang class support and rescue ship, the handrail had already been slid back upon itself. Beyond, uncontained darkness. At the edge of the iron-scarred abyss, the comrades set

down in sharply sheared shadows. Leggy sunflowers set in black razored pots. An officer of higher rank stepping forward. Once more checking through the two comrades' pockets. Meticulously. First the PLA princeling, Ang. Promises, threats, supplications, all ignored. The officer caught in the mesh of the cold ritual. Mindset only on that. Rechecking the officer's clothing; that all identifying marks and labels had been removed. Moving on to the next *tai zi*, Tsung. The sewer's smell still upon him. The same process. The same ritual. The princeling silent, only his eyes speaking. Looking east, back to distant bracelet lit coast. Wife, children . . . loss. An unstitchable gash of sadness.

The senior officer fading into deeper shadow. Many seconds before the other officer's gloved hands moved forward. Dropping to their knees. Through cheap trouser material, skin chilled by the iron deck. Pushing, with all of their strength, the concrete blocks skidding over the bleeding rust. Then a point, a razor's edge of balance, between iron and life, and air and death. The princelings frozen in a different version of time. Still, perfectly so . . . as if their very calmness would halt violence's last shunt.

From deep shadow, a barked order. Gloved hands on the concrete. Concrete pushed over the iron deck. Falling, accelerating, weighted feet whipping torsos upright, snapping arms, head, straight. Accelerating. Blunt arrows falling into darkness and into the water. Falling silently in ink. Lost cries. Falling. Slowly, flailing arms

calmed. The concrete meeting the sand seabed at fifty metres. Gently, arms falling to sides. Heads resting, chins to their chests. And in gritty baptism the sand falling back on itself as permanent night.

63

'Virtue Forest', Gongdelin Prison, Shanghai

'Apnoea', from the Greek, meaning 'want of breath'

The mouth of the giant opening. In an arc-light blaze, smudges firming to form, an arrowhead of guards meeting the Red Flag. Many seconds before the PLA princeling, Qi, left the limousine, persuaded by the pushing of rough hands. Hands underneath his armpits propelling him from the compound and through the corridors of puddled concrete to Virtue Forest's lowest depths. Stone cell walls, bruised and bleeding like skinned knuckles, smelling of earth and of lives left to rot. Rough hands on fine material, into the small of the back, pushing the PLA, Qi, towards Gongdelin's deepest cell. Unforgiving hinges, the door wrenched open. Standing at its very centre, a rigid-backed man, a senior colonel in the People's Liberation Army, in full uniform. Qi, smiling, relieved.

'Father, it is good to see you. I knew that you would come for me. I can explain everything.'

No words. No sense of recognition.

'They have told lies about me, Father. I am your son, you know that I am not what they say.'

The Senior Colonel moving forward. One by one, and with great care, undoing the buttons of his son's tunic. Removing it. Carefully folding it.

'Comrade Senior Colonel Sir, what is this?'

A gentle father's fingers removing the PLA's belt, undoing the PLA's uniform trousers, removing them, precisely folding them, laying them on top of the jacket.

'Father. Father. I do not understand. I have done nothing.'

Taking the PLA's hand. A single tear down the old man's cheek. Letting the tear fall to his chin.

'Father, what are you doing?'

His fingers to the bulky watch encircling Qi's wrist. Resisting, the PLA. Guards holding him firm.

'No. No, Father. You cannot mean to do this. Not this. Not you . . .'

A double strap. A double catch. Slowly. Carefully undoing them.

'You know what this will do to me. Father, you know.'

The watch into the Senior Colonel's hand. A life given, a life taken back.

The Senior Colonel, his fingers, rock cold, across his child's face. Across his child's eyes in a chilled farewell.

'Father? Father?'

Across his forearm, the uniform. In his pocket, the watch. The Senior Colonel moving to the cell door.

Moving into the corridor, not hearing his child's pleading words.

The cell door slamming. Senior Colonel Gu Qi, commanding officer of the Shanghai Kan Shou Jingbei Si Ling Bu, not looking back. A lesson learnt long ago, in more difficult times. An urgent march down the corridor, putting distance, as quickly as possible, between himself and such intense sorrow. Dropping the watch to the rock floor, his booted feet trampling it in a final act of destruction.

*

Sleep well at night, citizens of the People's Republic.
Sleep well, knowing that a rough man is walking the
night, prepared to do violence in your name

The *Hong-qi* was parked in Gongdelin's compound, its engine already running. Within a second of Senior Colonel Gu Qi seating himself within its moody exterior, Virtue Forest's gates rising and the Red Flag taking silently to the night.

Citizen One forcing a heavy crystal glass of *dukang* into the Senior Colonel's hand.

'It is done, Comrade Qi?'

Drinking deeply, the PLA. Its fire cauterizing the pain.

'It is done.'

The *tong zhi*, a hand to the PLA's shoulder.

'There was no choice, Comrade. Imagine a show

trial. The loss of face for you and your family. A stain on your Party record forever and such an exemplary record, such fine communist blood stock.'

Drawing the Red Flag's curtains.

'As it is, Comrade Senior Colonel, no one will ever know. You have kept to your part of the arrangement, and I will, of course, keep to mine. As we speak, PLA and Party press releases are being circulated simultaneously.'

Refilling the PLA's glass.

'We have just received news of a terrible accident in the area of the Big and Little Yangshan Islands, Hangzhou Bay. Our esteemed People's Liberation Army was involved in complex manoeuvres in training for the defence of our glorious People's Republic. Several high-ranking officers who insisted on taking an active part in the most demanding and dangerous of these operations were lost at sea. Their bodies have not yet been recovered.'

The PLA staring ahead, a cobblestone worn smooth.

'Colonel Zhong Qi, esteemed and much-loved son and comrade of Senior Colonel Gu Qi, was unfortunately amongst those lost and is presumed dead. The Party would like to place on record its appreciation for the life and service of this esteemed comrade. A comrade who was an example to all, in terms of leadership and service to the Party and to the proletariat of the People's Republic of China . . .'

Citizen One twisted the cap tightly onto the bottle of *dukang* and stowed it away.

'A son, Comrade Senior Colonel, was it not worth having a son, if only for him to receive such a wonderful and touching epitaph?'

★

One hour later

A public telephone in the lobby of the Heping, Hotel of Peace. To the off-key strains of the septuagenarian quintet singing 'The Green, Green Grass of Home', Citizen One pulling on his spectacles and dialling a number. The telephone receiver at the other end of the line picked up within two rings.

"*Ni nar.*'

'Madam, you will forgive me if I speak in haste, but as you know I have much to do. Our internal differences have been resolved, but the international dimension still needs my full attention.'

So far away, but he would have sworn that he could hear the Sea of Bohai rolling to the beach.

'Madam, I must thank you for your invaluable assistance in contacting Comrade Ai Yu. The timely assistance of the Immediate Action Unit was invaluable in the operation to rescue the Comrade Senior Investigator.'

So far away, but he would have sworn that he could smell the camphor wood fires throwing their long shadows across the caramel hued sands.

'A very fine comrade, your husband, but I was

surprised that you assisted me in my efforts to rescue a man that you appear to have so easily discarded, Madam.'

Several seconds, just the electronic white noise that pervaded all province-to-province telephone calls.

'It was my duty, Citizen One. He is still my husband.'

'Just duty, Madam?'

Silence.

'Madam?'

'And I respect him. Is that a good enough reason, Comrade Citizen One?'

Even down the telephone line, sensing her smile.

'A good enough reason, Madam? Of course, perhaps the best reason possible.'

Removing his spectacles, the *tong zhi*, a part of the ritual of ending a call.

'Once again, Madam, thank you for your assistance. I will telephone you again next week.'

'Comrade Citizen One . . .'

Stilling the fall of handset to its cradle.

'Sun Piao, my husband, he is safe?'

'Yes, Madam, very safe and recovering well.'

'And where have you spirited him away to, Comrade Citizen One?'

'Have I not said, Madam?'

An invisible smile. Much that she could learn from a comrade such as this Citizen One.

'No, you have not said, Comrade.'

Seconds, the ocean of white noise ebbing, flowing.

'Strange, I thought that I had. Our fine Comrade Senior Investigator Piao and his Deputy are in the land of Lenin and of Stalin, in the land of dead tsars and cabbage soup, Madam.'

64

One dog barks at something, the rest bark at him

The private office of the General Secretary of the Central
Secretariat, Comrade Su-Tu, just down the corridor
from the Great Hall of the People. An office that few
saw, in case the true nature of the beast be known.

'These are the last of them, Comrade General
Secretary.'

A sheaf of papers. The words of politicians shaped
into legalistic agreements by the Central Secretariat's
legal department.

'All returned, agreed, signed?'

'Yes, Comrade General Secretary. Forty-five nations
have accepted our gift to them of Golden Rice. They are
most appreciative.'

A yoke lifted from the shoulders. A smile from Su-
Tu.

'Excellent, old friend. Excellent. And they know how
to demonstrate their appreciation in this matter?'

501

'Of course, Comrade General Secretary. When the IOC meets next week in Geneva they will vote for the games to remain in Beijing.'

Su-Tu, fingers across the spines of books neatly stacked in shelves. Golden titles etched into leather. *The Art of War*, by Sun Tzu. Shakespeare's *Macbeth*, *Dreams of the Red Chamber*, by Ts'ao Chan, Steinbeck's, *The Grapes of Wrath* and *Cannery Row*.

So many volumes, all unread.

'And these nations' votes will have the desired effect?'

'An audit has already been carried out, Comrade General Secretary. It is favourable, but we do need America and the votes that they influence to be certain.'

A nod of understanding.

'Good work, old friend, we always knew that the mathematics in regard to this difficulty would be complex. However, we have what the Americans would call "an ace card" to play. You have been fully briefed?'

'Yes, Comrade General Secretary.'

'Excellent, excellent. I will communicate our progress to Citizen One. The American negotiator has already arrived and is waiting in the Long March conference room.'

Moving to the door, Su-Tu, a weighty hand on the comrade's shoulder.

'Remember, Citizen One watches us. We have much to win, much to lose.'

'You will inform Comrade Citizen One of every

detail of what we hope will be agreed with the Americans, General Secretary?'

'Yes, of course, old friend. The *tong zhi* will be fully informed with a version of what we will have agreed. And will be furnished with a version of the papers that will be drawn up.'

Patting the comrade's shoulder.

'He deserves nothing less, yes, old friend? A version of the truth for a comrade who represents a version of our People's Republic as it was a half a century ago.'

Again, patting the comrade's shoulder.

'Now, do not let me down. I will expect a great deal from these negotiations, old friend.'

Moving to the door, the *cadre*.

'I will not let you down, Comrade General Secretary.'

Smiling broadly.

'Americans, they are predictable. Greedy. They will be as the hungry carp, happy to take the maggot, however sharp the barb of the hook.'

*

A room of perfect dimensions. Its width, a complex mathematical representation of the distance walked during the Long March, 12,000 kilometres. Its length based on the number of good comrades who started the march, 87,000. Its height, a calculation based upon the number of comrades who completed the epic journey, 10,000.

Across the full length of the conference room's longest wall, unbreached by the triple-glazed windows that took in the full expanse of Tiananmen Square, a massive tableau of the heroes of the Long March, painted in the grand Soviet style. At its epicentre, the Great Helmsman himself. Around him the swirl of a vast red banner. Across his shoulder the bloody birth of a rising sun. In his eyes the past, the future, meeting and welded together in a political ideology that would surely last until the sun had lost its fire.

At one end of the long conference table, the old comrade. At the other, the American negotiator.

Through his half-glasses the *cadre* watching her eyes, bluer than he had ever witnessed before, as they travelled across the printed lines of the report. Fully thirty minutes. Not a sentence that was not fully dissected. Not a full stop that was not examined. Finally her gaze rising.

'Everything is there, Madam Negotiator. Surely you can trust a man in my position?'

A politician's smile.

'Comrade, I am not here to trust. I am here to negotiate. The two can be completely different, and often are.'

Looking down at the papers again.

'Yes, everything is here. Except the answer to my questions and the price.'

'Questions, Madam? What questions can you have? You know what it is that you are purchasing. Your

experts will have already analysed the initial data that we provided for them.'

She, experienced, letting him talk.

'You know its worth, Madam, or you would not be sitting here. Several smallpox "chimaera". The only smallpox that now exists in our world. Your nation, mine, the only ones to have such hybrid viruses. Also weaponized anthrax. Detailed data on ebola, clostridium botulinum, pneumonic plague, HFV-Lassa virus. Each you will get samples of.'

Letting him set out his stall.

'And detailed data. More than your nation could ever achieve itself. Far more. And you have questions?'

In her hands, data charts, graphs, virulence counts, toxicity levels, infection rates.

'Yes, Comrade, I have questions. This data, these samples, where do they come from?'

'I regret, but this information is classified.'

Sensing her advantage.

'There could be human rights issues here, Comrade.'

Standing, the comrade.

'One minute. One minute . . .'

Moving to the door. Through a gap, another voice, in darkness. An animated conversation. One minute passing, then five. The American negotiator checking her watch. Watching his every step as the old comrade resumed his place at her side. Speaking reluctantly, his face turned away from her, and from the heroes of the Long March.

'Zhong Ma. You know these words, Madam?'

An ambiguous movement of the head. Neither 'yes' nor 'no'.

'Zhong Ma was a Japanese prison camp at Beiyinhe, just outside Harbin. It was there, and at Pingfang, between the years 1938 and 1945, that Unit 731 carried out human experimentation on Chinese nationals.'

She waiting for him to continue.

'One thousand autopsies, some while the patients were still alive. Three thousand deaths. Our nationals experimented on with anthrax, bubonic plague, cholera, typhoid, and many other diseases. Some refer to it as the eastern Auschwitz.'

'I am not familiar with the details, but I believe you are substantially correct.'

Close to her.

'From these experiments, anthrax used by the Japanese in specially designed fragmentation bombs. Cholera, typhoid, dropped into wells, ponds. From these experiments, plague-infected fleas dropped over Ningbo, in the east of my country. In Changde, in the central areas of the north of my country.'

Silence.

'Over 200,000 of my fellow comrades dying as a consequence of these experiments. In 1945, your General Douglas MacArthur sent an intelligence team, on behalf of your American government to interrogate the Japanese scientists of Unit 731. Yes, Madam?'

'I believe that is correct.'

'The Japanese commanding officer, Shiro Ishii, and

the team of Unit 731, were given immunity from war crimes prosecutions in exchange for their data on human experimentation. Yes?'

'I cannot comment.'

'The data that your government received from the war criminals of Unit 731 formed the basis of your biological weapons programme for many decades. It placed America in the forefront of this field of research.'

Silence.

'So I do hope that you will not question me on any of the human rights issues that might arise from such research, Madam Negotiator. American hands, they are not exactly clean in this area.'

Silence, for many, many seconds. As if within that span of time, theirs were the only lives still beating on the planet.

'Madam, we have another Zhong Ma, another Pingfang. This is where these samples and data come from. But this time the project was started by one of our own, a rogue army officer, and the research conducted by an eminent Russian scientist. One well known to your own government.'

She trying to remember the name in last night's briefing papers.

'You are still thinking about the human rights issues, Madam Negotiator. I suppose that you will now walk away. Fly home to your God's own country?'

Not longer listening, just waiting for the next negotiating ploy.

'Madam Negotiator, there are other nations that would appreciate this data. Many nations, as you well know. But as I have stressed, our two nations have, have ... how can I say this without causing offence? Our two nations have a "history" in this field.'

Thinking, how could someone dealing in lives by the millions sound like a third-rate estate agent.

'It would be sad to end this special relationship at this point, Madam.'

Looking to the massive painting as if for inspiration.

'And the cost, Madam? Firstly your support and the support of America's friends at the IOC meeting in Geneva next week.'

His eyes, from Mao's, to the negotiator's.

'And secondly, Madam, the sum of $5 billion for the data and for the unique samples that resulted from this new research. Alternatively we will accept an offer of $15 billion for an opportunity for your nation to work in partnership with us in this exciting research opportunity.'

Not a flicker, the scene rehearsed a thousand times.

'This research is on-going?'

'Yes, Madam. Although we have moved it to an even more secure location.'

'But the Russian who led your research project, he is now dead.'

Smiling, the comrade.

'Wherever did you hear that, Madam Negotiator?'

Shaking his head.

'No, no, no, Madam. The Russian is still in harness, but now invisible to the world. He still heads this research project and will continue its excellent work.'

Suddenly standing, the negotiator, straightening her skirt. Without a word, moving to the large double doors. Hurriedly following in her footsteps, the *cadre*.

'Madam, Madam. I did not wish to offend you. If it is about your concerns with regards to human rights issues . . .'

'I need to get to a telephone.'

'That will not be necessary, Madam Negotiator. If you wish to call for your car I will . . .'

'Comrade . . .'

Turning, the American negotiator.

'I wish access to a secure telephone line. I need to call my superiors in Washington.'

The rubric glow from the Great Hall of the People, framing her.

'I only have the authorization from my government to offer up to $10 billion, and it is clear that this figure will need to be substantially increased.'

65

Two weeks later

Grey, the waters of the Pestovo, the Istra, the Pyalovo, as if 10,000 smelted steel statues of Stalin had been poured into them. Vast leaded eyes of lakes and reservoirs, turned to heaven in a blinded gaze, seeking a god who was no longer a good communist comrade.

Just beyond the dachas, nature was tamed and rearranged to a more acceptable design, preened lawns and clipped woods meeting the shore in a false embrace. Verdigris and slate grey in an acceptable stand-off. The lake's surface disturbed only by a dark splinter breaching its tarnished waters. Stroke after stroke through Pestovo's sluggish waves. A metronome of exactness.

At last turning, a figure moving from water to land. Catching the towel thrown to him. Taking the cigarette lit for him. Russian, Stolichnye, tasting of tears and cabbage. Drying himself vigorously between deep inhalations of piano wire smoke.

'Fucking cold, eh, Boss?'

Still the witnesses to the sun's vicious burn to his arms, back, face, and with it, remembering the orb's merciless ride across a sky as white as a sheet of paper.

Pulling deeply on the Russian cigarette, as if it would be the last one that he would ever smoke.

'No, not cold enough,' Piao said, as he moved towards the dacha dripping water as diamonds.

*

Dressing. On the spill of the bed, belongings that made up a life reattached. A shoulder holster. A pistol. A spare clip. Tweezers. A pen. A magnifying glass. Dog-eared wallet full of papers of authority.

Dressing. A uniform on a misshapen wire hanger in a large oak wardrobe. A life in an olive-green anaemic hanging.

'Thank you for bringing these.'

A nod.

'It's OK, Boss, just threw a few things in a bag. Essential things that anyone would fucking need. Evidence bags, pistol, spare clip . . .'

Moving to the bed.

'And these . . .'

Three CD-Roms over the balled, woollen blanket.

'I know what this one is, Boss, it's what the Wizard fucking emailed. But this and this?'

Piao, taking the first disk.

'Destroy it, we do not need it any more. It will have done its job.'

'But the other two Boss, you want them destroyed as well?'

'No, not yet, they contain extra material that the Wizard dug up for me on Comrade General Secretary Su-Tu and Comrade Citizen One. Information that we might need to use one day . . .'

'One day, Boss, but not fucking today, right?'

Piao, pulling on his jacket; smells of the *fen-chu* suddenly upon him.

'One should know one's enemies as intimately as one should know one's friends.'

Slipping the CD-Roms into his inside pocket.

'It is time to go home.'

'Now, Boss, why now? The couriered fucking letter?'

From a pocket in the cheap fake Nike sports bag, a pouch that had arrived that morning by courier. Within it, an official notification and a letter with the faintest scent of Chanel No.5 upon it. Opening the official note from the *danwei*, his finger tracing down its deeply entrenched print.

'Notification of a funeral in two days' time. The Party are meeting all of its costs . . .'

'A funeral? Whose, Boss?'

But as the words left his lips, the Big Man knowing.

'Lan Li's, Boss?'

Piao turned to the window, a sharp breeze had risen up, dancing the tops of the trees and fretting the lake's surface.

'Yes, Lan Li's. I must be there.'

'Sure, Boss, of course. And the letter?'

Turning back from the window, the lake, in the clasp of the fragrant letter's read and reread pages, a crisply monochrome photograph falling to the bare-boarded floor. Piao stooped, picked it up and handed it to Yaobang, watching the tethered string of profanity breeze over his bottom lip as he studied it in detail. A man, broadly smiling, being escorted up the stairs of an aeroplane. An American aeroplane. The Russian, Kanatjan Pasechnik.

'Fuck.'

'The photograph was taken three days ago. A flight direct to the USA, to Washington.'

Silver people living in a silver city.

'The letter, Boss, does it fucking say anything?'

Turning the page, Piao, last words before the flourish of a signature. Lingling. Last words, underlined in a slash of black ink.

Trust no one . . .

'Fuck.'

Opening the door, passing through it, the Senior Investigator. Turning.

'Come, Deputy, our People's Republic calls us back.'

A chill, deep from the heart of Siberia and marrow-deep, spearing him. Pulling the jacket tighter around

himself. Reaching to the top button to fasten it, but the button missing. Always missing. A shake of the head, the waters of the Huangpu already in his inner gaze.

He would have to learn to sew.

Glossary of Terms

Ankang: mental hospital / penal facility

Ashi: acupuncture point accessed by fingers during massage

A-yi: maid

Cadre or ganbu: someone in a position of leadership

Cao-mu jie-bing: 'the dead cat turned' / To take a chance or call a bluff

Cheng-fen: family origin

Dahu: 'new money people' / the new rich

Danwei: workplace / work unit, where in society you belong

Dao-mei: 'rotten luck' / menstruation (derogatory term used to women)

Dim sum: Cantonese buffet-style 'snack' meal

Fanshen: 'to turn over' / revolution

Fen: Chinese currency (coins)

Fen-chu: PSB Divisional Headquarters

Ganbu: cadre, boss, manager

Gongchandang: Communist Party

Guang guan: 'bare branches' / street name for young unmarried men

Guan-xi: black market / backdoor deals.

Guomindang: right-wing group led against Mao and the Communists

Hongcha: red leafed tea, known in the west as black tea

Hong-qi: 'Red Flag', Hand-built, high-status Chinese car

Hou-men-piao: 'backdoor tickets' / euphemism for toilet paper

Jiang: river

Jiaozi: ravioli

Jiudi jiejue: summary resolution

Ku-hai yu-sheng: 'alive in the bitter sea', a Buddhist adage about survival

Kuomintang: National Party, headed by Chiang Kai-shek

Lao gai: 'reform through labour'/ labour camp

Lao jiao: 'reform through education' / labour camp

Liu-mang: hooligan, petty thief

Long: alley

Lu: road

Lucha: green tea

Luxingshe: agency that deals with and monitors tourists

Mantou: steamed rolls

Maotai: strong alcoholic spirit distilled from must of corn and sorghum

Mei ming: no name

Nemma bai nemma pang: 'so white, so fat' / compliment to a healthy baby

Ni-ai: 'drown with love' / spoil

'Ni nar': who are you? / where are you?

Pa ma-fan: to fear trouble

Panda Brand: Chinese cigarettes

Patuo: district / borough

PLA: People's Liberation Army

PSB: Public Security Bureau

Renao: hot and spicy

Shar-pei: 'sand skin', Chinese breed of dog

Shen-jing shuai-ro: 'Weakness of the nerves' / depression or anxiety

Shou fa: hand techniques used in massage

'Spilt water': derogatory term for a baby girl

Tai ji: ancient form of callisthenics

Taijiquan: Chinese boxing

Tai zis: princelings, the sons of high *cadres*

Ta ma de: a mother-related profanity (the national swearword)

Tong zhi: comrade

Tsingtao: Chinese brand of beer

Tu-fei: bandits

Wai-guo-ren: 'external country persons'

Wangba dan: 'turtle's egg' / a mother-related swearword

Wawayu: a fish / salamander, that cries like a baby when caught

Wuliangye: alcoholic spirit made from millet, sorghum, rice and grass

Wushu: kungfu

Wu-wei: to do nothing or action through inaction

Xiao-dao xiao-xi: 'little road news' / hearing things on the grapevine

Xiao-xu: 'small group' / political study groups of ten members

Xiu-xi: siesta

Xunhuacha: perfumed tea

Yang-gui-zi: 'foreign devils'
Yeh-ji: 'wild pheasant' / prostitute
Yuan: Chinese currency
Zhau-dai-suo: dacha / villa